School of American Research
Southwest Indian Arts Series

DOUGLAS W. SCHWARTZ, GENERAL EDITOR

SCHOOL OF AMERICAN RESEARCH
SOUTHWEST INDIAN ARTS SERIES

This publication was made possible
by generous support from
THE WEATHERHEAD FOUNDATION

Southwest Indian Drypainting

SOUTHWEST INDIAN DRYPAINTING

Leland C. Wyman

SCHOOL OF AMERICAN RESEARCH

Santa Fe

UNIVERSITY OF NEW MEXICO PRESS

Albuquerque

Library of Congress Cataloging in Publications Data

Wyman, Leland Clifton, 1897–
 Southwest Indian drypainting.

 (Southwest Indian art series)
 Bibliography: p.
 Includes index.
 1. Indians of North America—Southwest, New—
Painting. 2. Sandpaintings. 3. Navaho Indians—
Painting. I. Title. II. Series.
E78.S7W95 1983 751.4′9 82–23891
ISBN 0-8263-0640-3

To drypainters the world over, perhaps not always conscious of their artistry but ever mindful of the symbolic utility of their creations, this book is respectfully dedicated.

Contents

Part I: Navajo Drypainting

Part II: Drypainting of the Apaches, Pueblos, Papagos, and California Indians

Part III: Conclusion

Figures

Plates

xv

Tables and Maps

Foreword

Navajo religion is an enormous subject: intricate, convoluted, and ramifying. Each myth and its attendant ceremonial network of religious art deals with a section of the story of the creation of the earth and its inhabitants, and there are some twenty-four of these great ceremonial complexes (although thirteen are now obsolescent or extinct). Some of them may require as much as nine days and nights in their performance. This material also entails interrelationships between the natural and supernatural worlds that few minds accustomed to Euro-American philosophy are prepared to grasp. We have spent the last two hundred years of our intellectual development disqualifying ourselves from perceiving connections between art and medicine, dance and weather conditions, and prayer and animals. Our genius has lain in the separation of entities into discrete categories for study, whereas the Navajo genius has lain in the combination of entities for functional religious interaction.

It takes an unusual outsider, then, to reach into Navajo thought, and Leland C. Wyman is one of these rare spirits. To begin with, the spiritual and aesthetic sides of his nature are in a harmonious balance with the scientific and analytical. As a member of the circle of intimates of Ananda K. Coomaraswamy in the 1920s and 1930s, Wyman brought his incisive and orderly mind without qualms into the ambiguous and teeming world of myriads of kalaeidoscope deities. The professor of biology, also the discriminating collector of East Indian and Persian miniatures and Japanese prints, studied and assimilated the complexities of Eastern theology and art with the same interest and sympathy he applied to the panorama of natural history.

This training produced a mind uniquely adapted to the study of Navajo religion. For fifty years Wyman's brilliant and sensitive intelligence has been bent on the study of Navajo mythology and its illumination in symbolic ritual, including the hundreds of sandpaintings that depict episodes in the vast interlocking network of creation stories.

Wyman's insights attracted the respect and colleagueship of the native ceremonial practitioners with whom he worked. His attention to detail and his prodigious memory were attributes they understood, essential to anyone who hoped to become a practitioner. He was welcomed to their ceremonies, and he discussed them, almost as a fellow professional, with such eminent Navajo intellectuals as Billy Norton, Slim Curly,

Yellow Singer, Dave Skeet, and numerous others. Three generations of outside scholars have also sought Wyman's insights and collaboration. The list includes Charles Amsden, Flora Bailey, Father Berard Haile, W. W. Hill, Clyde Kluckhohn, Franc Newcomb, Gladys Reichard, and Mary C. Wheelwright. Coming down a generation, the names include David Aberle, David McAllester, George Mills, and Maud Oakes. A still younger generation includes Sam Gill, Charlotte Frisbie, and Karl W. Luckert. Wyman's joint publications with Kluckhohn and Bailey are only the most massive evidence of the fruitfulness of these communications.

Few scholars can equal the unique contribution Wyman has made in unearthing valuable manuscripts and seeing them through their transformation into publications. Many of Father Berard's works have been made available to the scholarly world through Wyman's interest, skillful editorship, and judicious commentaries. The list of subjects sounds like an outline of Navajo religion itself: Red Antway, Navajo Windway, Beautyway, Blessingway, Mountainway. Another of his services to scholarship has been the publication and annotation of outstanding collections of sandpainting reproductions: Huckel, Wetherill, and Walcott. As Wyman marshaled this immense body of ceremonial art into a cumulative body of compared material, the retentive eye of the artist and the taxonomical bent of the biologist led to the steady accumulation of an incomparable illustrated index of every known Navajo sandpainting, whether published, in a private collection, or simply in some ethnographer's field notes. Box after box of annotated photographs was added to the file. Similarities, relationships, provenience, and meaning were all meticulously noted. One thinks of the lifelong collection by James Child of what came to be known as the Child Ballads. In Navajo studies the knowledge grew that Wyman had put together the only all-inclusive index of Navajo ceremonial art in existence (at the Museum of Northern Arizona, Flagstaff).

Placed in its context with the sandpaintings of other Native American cultures in the Southwest, this is the material we are privileged to study in the present work. This art, which has fascinated the world since Washington Matthews first published examples a hundred years ago, has at last been brought together in a definitive study. Perhaps the reason it was not done before was the very vastness of the subject. No two practitioners use exactly the same sandpaintings for any given ceremonial. For many ceremonials there might be fifty or sixty, or more, possible designs, of which a particular practitioner might use from one to seven or more, depending on the length determined for that performance. It took patience and lively interest, a formidable memory, and unflagging energy to assemble this mass of information and give it the searching scrutiny we find here.

Now the result of this lifetime of informed research is in hand. Scholarship in Navajo mythology has depended heavily on Wyman, among the several authorities on the subject. Scholarship on the sandpaintings will depend on Wyman, almost alone, in this first comprehensive work. A host of studies in the future will be inspired by this collection and the discerning analysis that accompanies the sandpaintings. Among the many monuments to Wyman's years of Navajo studies, *Southwest Indian Drypainting* will tower above all the rest.

DAVID P. McALLESTER
Wesleyan University
Middletown, Connecticut

Acknowledgments

First I wish to express my appreciation to Douglas W. Schwartz, president of the School of American Research in Santa Fe, New Mexico, for affording me the opportunity to put in writing a summary of the results of many years of study of the art of drypainting. My thanks also go to Harry O. King, Jr., the late Wanda Driskell, Beth Luey, Phillip Brittenham, and Martin Etter, editors for the School of American Research, for patiently and helpfully monitoring my efforts through the intricacies of preparation and publication.

Since this work is the culmination of more than forty years of studies, primarily among the Navajo Indians of the Southwest, the names of numerous friends, counselors, and colleagues now deceased come to mind. First, of course, the many Navajo Indians who allowed me to watch their work must be mentioned. Most of them are now gone. Outstanding among my fellow students of the Navajos who were important to me in many ways and who also are no longer with us were Flora L. Bailey, Kenneth E. Foster, Father Berard Haile, Willard W. Hill, Clyde Kluckhohn, Franc J. Newcomb, Gladys A. Reichard, and Mary C. Wheelwright.

Among those who proffered information or steered me toward it were Katherine Bartlett, librarian of the Museum of Northern Arizona (now emeritus and museum archivist), and her staff; Edwin Bernbaum of Cambridge, Massachusetts (an eyewitness account of drypainting among the lamas of northern Nepal); David M. Brugge, regional curator for the National Park Service, Albuquerque, New Mexico; Dorothy S. Hubbell of Sun City, Arizona; the late Kojiro Tomita, curator of Asiatic art, Boston Museum of Fine Arts; the late Chimyo Horioka, librarian of the same department, and the Japan Society of New York; Señora María Isabel Rodera de Kirn of Puebla, Mexico; the late Father Emanuel Trockur, O.F.M., Saint Michaels, Arizona; William C. Sturtevant, Center for the Study of Man, Smithsonian Institution, Washington, D.C.; and the late Milton Wetherill of the Museum of Northern Arizona. Special mention should be made of Donald M. Bahr, professor of anthropology, Arizona State University, Tempe, and Bernard L. Fontana, ethnologist, Arizona State Museum, Tucson, who provided all of the material for the chapter on Papago drypainting, and of Morris E. Opler, professor of anthropology, University of Oklahoma, Norman, who generously allowed the use of some of his unpublished notes on Apache drypainting. Moreover, Dr. Fontana con-

tributed the photographs he had taken during the making of a Papago drypainting (Figs. 109, 110, Plates 31, 32) and was instrumental in obtaining for me photographs and permission to use them from the Arizona State Museum (Figs. 21, 47, 105, Plates 13, 20) and the Arizona Sonora Desert Museum (Fig. 111). Thanks also are due, of course, to these two institutions for the use of their materials.

John Bierhorst of West Shokan, New York, graciously gave permission to quote a passage from his *Four Masterworks of American Indian Literature,* which was confirmed by the publishers, Farrar, Straus & Giroux, New York; William Morrow & Co., New York, gave permission to quote a sentence from William Brandon's *The Magic World* (1971:xiii). Polly Schaafsma of Santa Fe, New Mexico, kindly allowed the use of a figure from one of her monographs as an illustration (Fig. 6), permission being confirmed by the Museum of New Mexico Press; Conrad P. Lachel, manager of the Division of Publications of the Field Museum of Natural History, Chicago, gave permission to use illustrations from some of their early publications (Plates 24–27); Gordon Hubel, director of the Smithsonian Institution Press, likewise granted permission to republish plates from several of the annual reports of the Bureau of American Ethnology from around the turn of the century (Figs. 8, 108, Plates 22, 23, 28, 29). The National Anthropological Archives of the Smithsonian Institution, through the kind offices of Paula Richardson and Jan S. Danis, provided the photograph for Figure 10. The illustrations were immeasurably enriched by the photographs taken just after the beginning of this century by Brother Simeon Schwemberger, O.F.M., of the Franciscan Mission of Saint Michaels, Arizona, and permission to use them was most graciously granted by Father Roger Huser, O.F.M., minister provincial of the province of Saint John Baptist, Cincinnati, Ohio (Figs. 11, 14, 15, 97–100). Edward B. Danson, then director of the Museum of Northern Arizona, Flagstaff, readily gave permission to use photographs of Navajo Indians making sandpaintings that had been taken by members of the museum's staff, the late Parker Hamilton and Paul V. Long, Jr., at the annual Navajo Craftsman Exhibits, and William D. Lipe, then assistant director, was most helpful in obtaining prints (Figs. 16, 17, 30, 94–96). John Collier, Jr., graciously gave permission for the use of photographs taken at a Navajo curing ceremony north of Ganado, Arizona (Figs. 1–3, 18–20).

I am most grateful to the following individuals and institutions for permission to use as illustrations reproductions of sandpaintings under their care and in some cases for providing prints of them: John O. Brew, then president, Bertha P. Dutton, then director, and Steven H. Tremper, then curator, of the Museum of Navaho Ceremonial Art (now the Wheelwright Museum of the American Indian), Santa Fe, New Mexico (Figs. 5, 9, 22, 24, 85, 89, 93, 101–104, 106, Plates 4, 5, 6, 8, 10–12, 14, 16–19, 21); Edward B. Danson of the Museum of Northern Arizona, Flagstaff (Figs. 23, 25, 28, 37, 40, Plate 13); Kendra E. Bowers, curator of American Indian Art, the Taylor Museum of the Colorado Springs Fine Arts Center (Figs. 4, 7); Karl Erik Larsson, director, and Anna-Britta Hellbom, curator, Etnografiska Museet, Stockholm, Sweden (Figs. 12, 26, 34). The contributions of the Arizona State Museum were mentioned earlier.

Read Mullan of Phoenix, Arizona, and several other owners of sandpainting tapestries, who for security reasons wish to remain anonymous, very generously provided

photographs of their textiles for study, as did Richard Conn, curator, Department of Native Arts, the Denver Art Museum, and Claudia N. Medoff, American Section, the University Museum, University of Pennsylvania. Edward B. Danson allowed the use of photographs of two of the tapestries in the Museum of Northern Arizona as illustrations (Figs. 114, 115). Richard M. Lang was very helpful in analyzing these textiles when he was curator of the Museum of Navaho Ceremonial Art (now the Wheelwright Museum), but a special debt of gratitude is owed to Lee M. Copus of Oklahoma City, who enthusiastically went to considerable effort and expense in tracking down the whereabouts of four tapestries previously unknown to me and in obtaining photographs. He also gave permission to use his unique sandpainting tapestry (Plate 21) as an illustration. Moreover, Kendra E. Bowers of Colorado Springs and Edwin L. Kennedy of New Vernon, New Jersey, have been most generous with time, trouble, and no end of effort in providing photographs of tapestries and information about them.

Frederick W. Maynard of the Department of Biology of Boston University exercised his usual photographic wizardry in making excellent prints from bad negatives for the illustrations. Also, I wish to put on record my appreciation to Boston University for allowing me, as professor emeritus, the use of certain physical facilities. Finally, my late wife Paula, with infinite patience, jealously guarded my time for working on this book from any interference and also listened to readings of the manuscript and made helpful suggestions. Beloved companion, coworker, and fellow-traveler during nearly sixty years of marriage, she provided the spark for most of my writings on the Navajos. I will always regret that she did not live to see the finished book in which she was so interested.

LELAND C. WYMAN
Boston University
Boston, Massachusetts

Southwest Indian Drypainting

Some of the pages in this book are relics from a past now dead, some are living creatures of an endless present constantly absorbing an endless past.

WILLIAM BRANDON

1

Introduction

Though an artist may still be regarded as a "high priest" and his works occasionally cited for "cathartic" or "therapeutic" value, art in the West is no longer regarded as a department of religion, nor is it intimately associated with medicine. The traditional art of the New World, by contrast, has remained a *whole art,* capable of combining the aesthetic, the sacred, and the medicinal in varying proportions and without discrimination. The method of whole art is to create a model, a replica, such that the original may be forcibly perfected or, variously, manipulated for the benefit of the communicant. The original upon which the model is based may be anything in the environment that is thought to be worth controlling; it may be represented in effigy form, or re-created in a verbal formula, with the idea of coercing it, beseeching it, propitiating it, or disarming it through adoration. Or the original may be the environment itself, in which case the artist's work becomes a replica of the natural world as a whole, to be manipulated, or transfigured, with the intention of influencing communal (and personal) destiny.

—John Bierhorst, *Four Masterworks of American Indian Literature*

Drypainting is the art of making pictures, diagrams, or symbols by sprinkling, strewing, or otherwise placing dry pigments or other colored materials on a horizontal surface—the ground, the floor of a room, or a raised platform—usually on a background of earth, sand, animal skin, cloth, or other material. It is most often practiced in a religious context, although occasionally, as in Japan, it may be carried out solely for entertainment or decoration.[1] Since the pigments or colored substances are not fixed to the background in any way, drypainting is an evanescent art. When employed for a religious ceremony, the picture is usually destroyed deliberately at the end of the performance. Numerous names for drypaintings have been used by different writers: powder or sand paintings, pictures, or mosaics; earth or sand icons or altars; ground paintings or drawings.

Although drypainting is not common, it is practiced in many parts of the world. Drypaintings are made for religious or semireligious purposes in India, Tibet, and northeastern Nepal; they may be found in the service of Christianity in some places in Latin America; and as just noted, they are made in Japan for entertainment or decoration.

In India, powder painting was mentioned in a sixteenth-century manuscript that may

be the earliest literary reference to the art.[2] Today, in different parts of India, pictures of divinities and associated mythological events are still made on a horizontal surface in a particular part of a temple or shrine, using dry rice powder or flour of various colors. Another variety of drypainting is made outdoors, in courtyards, or on the floor in a house for weddings and semireligious festive occasions. (For a fuller description of these drypaintings and those of the other nations mentioned here, see Appendix A.)

Drypaintings are also used in certain rites of Lamaistic Buddhism practiced in Tibet and among the Sherpas of northeastern Nepal near the foot of Mount Everest.[3] The design is almost always a mandala (*kyilkhor* in Tibetan)—a holy magic or mystic circle or sacred surface representing the structure of the universe (Blofeld 1970) or the dwelling place of a deity and his retinue. Although originally mandalas were drawn on the ground (and still are during great festivals), over the course of time they came to be painted on cloth and used as objects of general worship; that is, they became confused with the *pata* (*thangka* in Tibetan)—the painted scroll or banner that is more widely used today.

In Australia, drypaintings are made mainly by the aborigines of the central part of the continent, but they have also been seen in other places. The designs often represent the country, the travels, or the camping places of some totemic ancestor, or the rock or pool where it first came to life. Ground drawings may be made for ceremonies connected with ant, lizard, snake, emu, wildcat, fire, or other totems. Some ceremonies are rituals of atonement and propitiation to avoid retribution for killing totemic animals (Levine 1957).

Drypaintings are used in Christian observances in parts of Latin America during Holy Week or when the feast days of a church are celebrated.[4] In Mexico these "carpets," as they are called, are made of dyed sawdust, flower petals, and sometimes coffee grounds. They are made in the atrium of a church (Plate 1) or in front of the houses of "humble folk," the latter usually with flowers only.

The forms of drypainting described so far have all served as sacred implements in the service of what we would call religious ceremonialism. In Japan, however, a similar art is entirely secular, used only for ornamentation or entertainment (except perhaps for rare occasions when it may serve a semireligious purpose as ornamentation for funerals or other solemn religious services). The Japanese art is of tray landscapes or tray pictures made in black lacquered wooden trays (Koehn 1937, Yanagisawa 1955). This art, like the Japanese temple garden, had a religious origin, for in earlier days the landscapes on trays represented realms with religious significance such as Hōraisan, the Taoist land of eternal youth, or Shumisen, the sacred mountain of Buddhism.[5]

In the United States, the term *drypainting* usually brings to mind the sandpaintings used in religious ceremonials by the Navajo Indians of the southwestern United States (Map 1). This is because these sacred designs have been extensively described and richly illustrated. Moreover, Navajo sandpaintings have been seen by thousands of other Americans as Indians have demonstrated this art in public exhibitions from coast to coast. In addition, the Navajos have always been willing to allow well-disposed aliens known or properly introduced to them to witness certain of their nonpublic ceremonies, including sandpainting procedures. Other southwestern Indian tribes

practice drypainting, or once did, but they have been more secretive about it, at least in recent years, so the art as they carry it out is relatively little known.

There are written descriptions of drypaintings and the attendant ceremonies witnessed by Spanish missionaries in northwestern Mexico, not too far from the U.S. border, as early as the late sixteenth century, almost three hundred years before the first published reports of Pueblo Indian drypaintings appeared (Beals 1943:66–68, 83–84, n. 84). We may regard these writings as the first reports of drypainting in the greater Southwest. These sixteenth-century paintings were made by the Cáhitas, a group of tribes speaking Uto-Aztecan languages (related to the Pimas and Papagos of Arizona), who lived on the coastal plain and in the adjoining mountains of southwestern Sonora and northwestern Sinaloa. The only survivors of these tribes, the Yaquis and the Mayos, no longer practice drypainting.[6]

Jesuit missionaries entered Cáhita territory in 1591. Pérez de Ribas (1645:40–41) gave a detailed description of what he thought was an adoption ceremony that was actually an initiation of boys, not unlike the ceremony carried out by the Pueblo Indians. Two huts were built of mats about a hundred paces apart. In one, the boys were isolated, fasting for eight days, while in the other a drypainting was made and dancing took place. No women were admitted to this performance. The painting was circular, on a sand background about seven or eight feet in diameter, and was made with "loose colors" kept in slender cane tubes. In the design were two human figures, one the mother of the other, representing the first two human beings from whom came all others. Around these figures were painted stalks of maize, beans, and squash, and

among the plants were snakes, birds, and other animals. The figures in the design were asked to guard the Indians' fields from the animals represented. After eight days of dancing, the boys were taken to the house with the drypainting, and their bodies were rubbed with the sand from it: "This we are instructing our sons so that thus they will do henceforth" (Pérez de Ribas 1645:40–41).

In the town of Ocoroni during the Christmas festival of 1592, missionaries saw another sandpainting which had three human figures in it—a man, a woman, and a child—as well as a river, snakes, lions, and other wild animals (*Memorias:* 38–39).[7] The three humans were interpreted as God the Father, the Holy Virgin, and the Christ Child, of whom the Indians asked protection for their fields from ferocious animals and floods. Apparently for the Cáhitas the danger of floods overshadowed the function of bringing rain, which is the main concern of Pueblo ceremonialism.

Although distant in time by several centuries, the circular design of the Cáhita drypaintings, filled with representations of all kinds of living things, is remarkably similar to the drypaintings of the Apaches, the Papagos, and southern California tribes that were seen, described, or illustrated much later. In a sense, all these circular designs are symbols of the Indians' universe and its inhabitants. As Kroeber (1925:664) remarked, "Having mapped his world, the Diegueño proceeds to fill it with living beings." Furthermore, Kroeber concluded that although California drypainting is "unquestionably" connected with that of the Pueblos and the Navajos, and although the art itself probably originated in the Pueblo area, the practice may rest on old cultural materials common to the Southwest and California. Perhaps the Cáhita sandpaint-

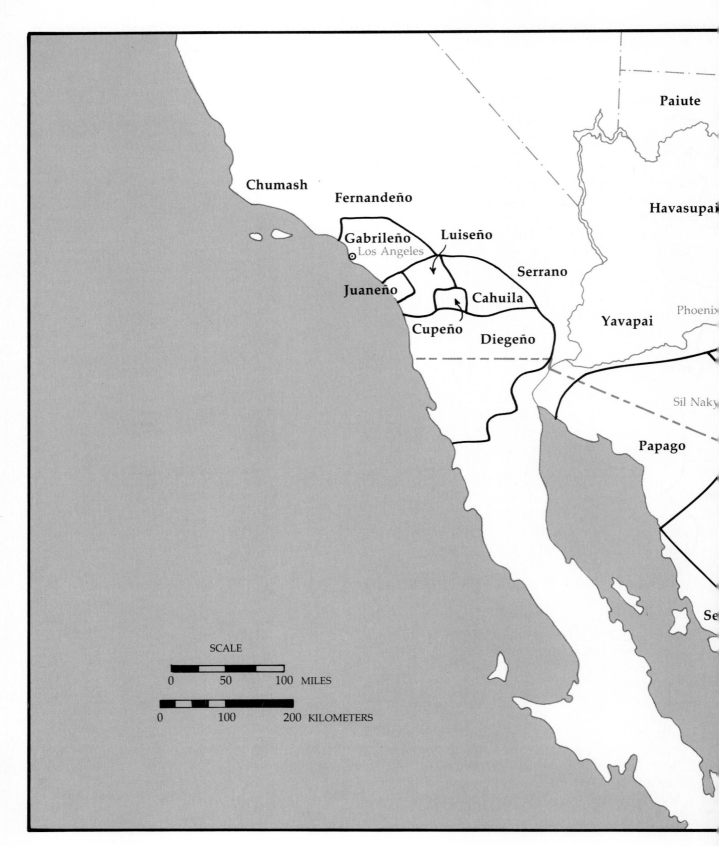

Chumash

Fernandeño

Gabrileño

Los Angeles

Juaneño

Luiseño

Serrano

Cahuila

Cupeño

Diegeño

Paiute

Havasupai

Yavapai

Phoenix

Sil Naky

Papago

Se

SCALE

| 0 | 50 | 100 | MILES |

| 0 | 100 | 200 | KILOMETERS |

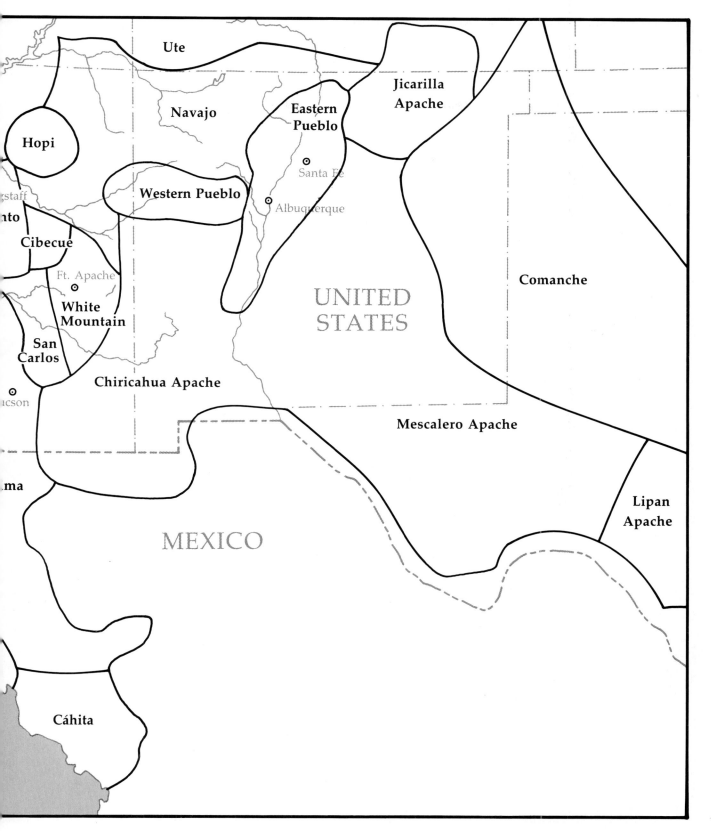

Map 1. The Southwest, showing traditional territories of Indian groups.

ings of almost four centuries ago are examples of such "old cultural materials."

In recent years it has been difficult to study directly the drypaintings of any southwestern Indian tribes other than the Navajos. In some cases the art has lapsed, as in numerous California tribes, so information must come from memories. Among other tribes, such as the Apaches and Papagos, only a few trusted aliens have been allowed to witness the practice. And among the Pueblos, especially in the eastern villages (as Leslie White found in working with the Keres), tribal restrictions against revealing sacred secrets have been so strict that defiance has incurred drastic punishment, perhaps even execution (White 1942:9–11). Therefore, except for information, photographs, and drawings obtained from the Pueblos around the turn of the century, our knowledge of their drypaintings depends largely on interviews with informants, carried out in strictest secrecy and at a considerable distance from the village. For these reasons and because of rich documentation and relative freedom allowed outsiders to see them being made, the term *sandpainting* has come to mean to people from coast to coast and even in parts of Europe the productions of the Navajo Indians, who have perhaps developed the art to the highest degree anywhere in the world. The first and largest portion of this book is devoted to a discussion of Navajo drypainting. Subsequent chapters describe, from the more limited information available, the drypainting of other southwestern tribes.

Navajo Drypainting

2

Navajo
Drypainting

In accordance with his basic pattern, your Navaho must reduce his ceremonial equipment to what is readily portable. A well-equipped singer can bring all his paraphernalia on the back of his saddle. It fits the pattern that the Pueblo element the Navahos have developed to the highest point, far beyond Pueblo imaginings, is one which requires no more than the grinding stone to be found in every hogan and the simplest raw materials, plus memory and skill, the hand and the brain: namely, the now world-famous sandpaintings.

—Oliver La Farge, foreword to
Navajo Religion by Gladys Reichard

The Navajo Tribe

The Athapascan ancestors of the Apacheans of the Southwest, the Navajos and the various Apache groups, are thought to have migrated from their homeland in western Canada and Alaska, probably by easy stages and in small groups, five hundred to a thousand years ago. Various types of evidence—archaeological, historical, and circumstantial—support this opinion. James Hester (1962:100) concluded that the Atha-pascans entered the Southwest closer to A.D. 1500 than to A.D. 1000. The earliest tree-ring dates for ancient Navajo hogan sites show them to be from the sixteenth century.[1] Hester also thought that the Navajos probably came along the western edge of the Great Plains and not by the intermontane route through the Great Basin, but he admitted that their route has not yet been definitely established.

The Navajos are the largest group of native Americans in the United States. Gladys Reichard wrote in 1950 that "from approximately eight thousand in 1868 the Navajo population has grown to more than fifty thousand" (Reichard 1970:xxxviii). In the ensuing thirty years it has increased to about 55,000, and the rate of increase of this ethnic group continues to be one of the greater in the country—between 2.5 and 3.0 percent a year—although recently population growth may have slowed somewhat as a result of greater acceptance of birth control (David Brugge 1979:personal communication). The Navajos have spread beyond the legal boundaries of their approximately eighteen million acres of reservation and leased lands; some have been resettled along the lower

SCALE

0 50 MILES

0 50 100 KILOMETERS

UTAH

ARIZONA

COLORADO RIVER

SAN JUAN RIVER

NAVAJO MOUNTAIN

NAVAJO

RESERVATION

Kayenta

COLORADO RIVER

BLACK

MESA

Tuba City

LITTLE COLORADO RIVER

JEDDITO WASH

Oraibi
HOPI
RESERVATION
Walpi
Awatovi

SAN FRANCISCO
MOUNTAINS

Flagstaff

Winslow

⊙ Towns

● Pueblos

▲ Archaeological Sites

Dinetah Region

Indian Reservation Land

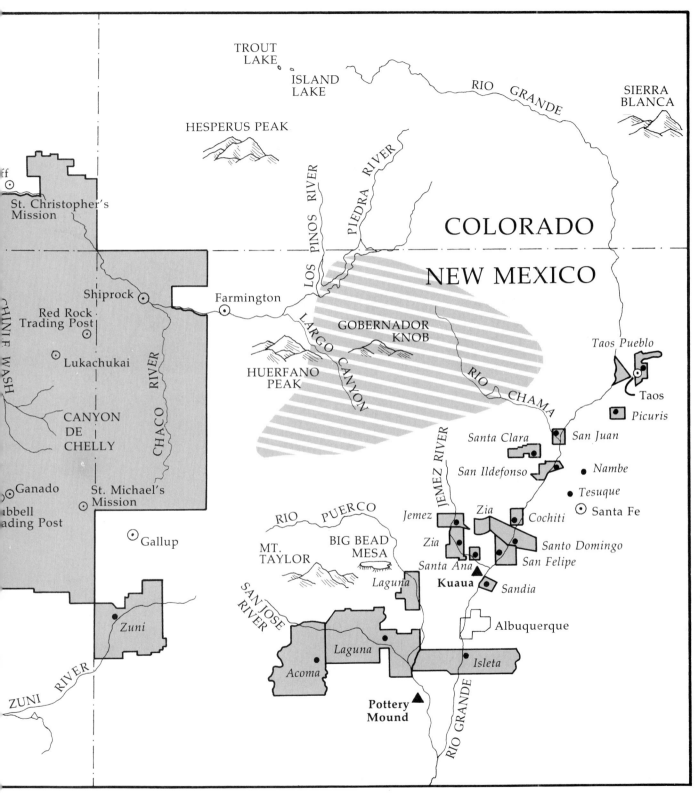

Map 2. The Navajo and Pueblo regions of the Southwest.

13

Colorado River, and others have been relocated in industrial centers.

The Navajo homeland, the severely eroded Colorado Plateau country where Arizona, New Mexico, Colorado, and Utah come together in the "Four Corners" (Map 2), is colorful and beautiful, but it is a hard place to make more than a bare subsistence living. The Navajos have supported themselves by agriculture and sheep and goat husbandry, by sales of traditional crafts, and recently by some wage work, but many are on welfare. Becoming increasingly acculturated, the Navajos now operate motels, restaurants, service stations, an industrial park (near Gallup, New Mexico), a successful lumber mill, irrigation projects, tribal parks like the U.S. national parks and monuments, and a tribal museum. They have attracted to their reservation small industries employing Navajo labor, and they have established their own community college. Their system of tribal government, the Navajo Tribal Council, patterned after the federal establishment and, in part, imposed on them by it, seems to be working well, with various branches such as the Tribal Utility Authority, the Tribal Tax Department, the Health Authority, and others. The Navajos also publish a weekly newspaper, *The Navajo Times,* with single issues running to forty pages or more.

The Navajos' homes are not assembled in any groupings that could be called villages or towns, such as those of the Pueblo Indians, but are scattered, often far apart, in little family groups. We call their house a hogan, anglicizing their word for it, *hooghan,* which means "the place home." Two types of hogans are still used: the conical or interlocked-forked-pole hogan, which some think is the older type, now common only in the remoter western parts of the reservation; and the round-roof type, circular,

hexagonal, or octagonal in shape, with walls of logs or stone chinked with mud, and an earth-covered, dome-shaped roof of timber cribbing converging to a central smoke hole (see Wyman 1970a:10–16). The doorway to any hogan faces east. In these crude but comfortable houses, the Navajos lead a semicamp life, and in the summer, much of their living is done in shade houses constructed of logs, poles, brush, and the like. Square frame houses are becoming more and more common, but only the traditional hogan may be used for a ceremonial. David and Susan McAllester have recently (1980) published a book of Navajo house songs and house photographs illustrating Navajo housing from the earliest types of hogans to contemporary frame homes.

The art-craft of Navajo women is weaving, and that of the men is silversmithing. Women also sometimes practice silversmithing, but men do not weave unless they are transvestites (see Appendix B). Navajo blankets and rugs and silver jewelry set with turquoise are known the world over.[2]

The Navajo Ceremonial System

In spite of the rapidly increasing acculturative changes in Navajo society and culture and in spite of their willingness to use the white man's medicine (most Navajo babies are now born in hospitals or clinics), the Navajos have preserved almost intact their traditional cultural inventory of beliefs concerning the dynamics of their universe and what we would call the "supernatural" (such matters seem quite natural to them). They have also preserved to a great extent their techniques for dealing with the dangers of that universe and with the misfortunes, such as sickness, which stem from

them. These techniques make up their ceremonial system (and it is in this connection that drypaintings are made and used) We would call all this their philosophy and their religion, although there is no word in their language that can be translated as religion as we know it. Thus, the Navajos' ceremonial system encompasses their theory and practice of native medicine, and its practitioners are doctors as well as priests. Recent surveys have shown that many Navajo young people still believe misfortune comes from supernatural causes and would like to know more about their ceremonial system, and that even those who have lost faith in the traditional beliefs think more ceremonials should be performed (perhaps as symbols of cultural identity). Nevertheless, few of them wish to devote the long study time necessary for becoming a practitioner. Another force operating against the ceremonial system is what may become a losing battle with the peyote cult, the Native American Church of North America, a nativistic movement that rejects traditional ceremonialism and in turn is vigorously opposed by conservative Navajos (see Aberle 1966).

The essence of Navajo philosophical thinking, which provides a rationale for the means they use to cope with sickness or other misfortune, is the belief that their universe is an all-inclusive unit in which all elements, from the tiniest object or creature to the most stupendous, including man himself, are interrelated in an orderly but delicate balance governed by the principle of reciprocity. As long as this balance is maintained, human beings enjoy that state expressed by the Navajo word *hózhǫ́*, which cannot be translated into a single English equivalent but expresses for the Navajos what the words *harmony, beauty, blessedness, normality, goodness,* and so on do for us. In short,

the term refers to whatever circumstances or entities are favorable to man as opposed to all that is unfavorable or evil; it is, therefore, the Navajos' basic value concept. The name of a rite designed to bring about such circumstances consists of this word with an ending added, which means "in the direction of," "side," "manner," or "way" (-*jí*). We translate this name as *Blessingway* (Wyman 1970a). The majority of Navajo ceremonials, however, are used to treat the actual or anticipated disease of an individual patient, "the one-sung-over," occasionally with one or two copatients (relatives or children) being treated as well. Even in a Blessingway rite there is usually one-sung-over, although the rite is not specifically concerned with curing.

Since it is all-inclusive, the universe has good and evil elements as complementary components, not as abstract ethical concepts. The evil component that every human being has, no matter how good he or she has been in life, is released at death as a dangerous ghost capable of harming the living. Although informants disagree, there is a belief that young infants before they have walked or talked and very aged or highly respected people who die natural deaths do not release malignant influences at death (see Wyman, Hill, and Ósanai 1942:16–18). There are innumerable powers in the universe, indifferent or good when under control and in harmony with man but dangerous or potentially evil when uncontrolled. Besides ghosts, there are many dangerous things, certain animals such as snakes, coyotes, or bears, and phenomena such as lightning or whirlwinds. Excessive activity of any kind is also dangerous. Improper contact with dangerous powers, even if unintentional or unconscious, that breaks traditional restrictions on behavior (taboos), or excesses of any kind, may upset the normal

harmony or balance among elements in the universe. This lack of harmony may exact its price from man, usually as sickness. The Navajo theory of disease presumes that contagion may occur prenatally as well as after birth. That is why pregnant women are not allowed to witness or take part in certain ceremonial procedures, such as making drypaintings: unborn children might be harmed. Acts that upset the harmony among elements in the universal continuum are not the sole cause of sickness or difficulties; certain individuals may be accused or suspected of causing troubles—very difficult to deal with by ordinary ceremonial treatment—by malevolently misusing ritual knowledge. These are the hated and feared witches.

Knowledge Is Power

Trained practitioners among the Navajos possess the knowledge of ritual that can control dangerous things, exorcise ghosts, restore universal harmony, sometimes cope with witchcraft, and establish immunity to future contagion from the same sources. The general public calls these individuals medicine men, but the Navajos call them *singers* because the singing that accompanies every important aspect of Navajo ritual is considered its one indispensable element. The correctness and completeness of a singer's performance are judged by the supernatural Holy People, who may be attracted to the scene by invocatory prayers and offerings, by repetition that compels them to come, by the colorful symbolism of the word imagery of the songs and the music accompanying them, and by their own likenesses drawn in the colored pigments of the drypaintings. If they are pleased, they must restore harmony and cure the patient. The ethic of reciprocity operates here, for Navajo prayers and offerings are designed not to glorify or thank the holy beings but to attract and obligate them.

A singer learns his trade by long and arduous apprenticeship, ratifying his accomplishments by paying his teacher. Navajo singers have no organized priesthoods or religious societies as do the Pueblo Indians; their practice is individualistic. Nor do they follow any religious calendar, but perform whenever their services are needed. A singer can specialize in only one or two, or at most half a dozen, complete ceremonials because each involves numerous songs, prayers, plant medicines, sacred objects, drypaintings, and ritualistic procedures. He may also learn to perform portions of several ceremonials besides his speciality. Every singer possesses one or more bundles, each containing the equipment necessary for his performance of a specific ceremonial. These are valuable, and they are inherited or transmitted in several ways. Women are seldom singers because of fear of prenatal infection, but there is no rule to keep them out of the profession. They are not absolutely forbidden to help make a sandpainting or to see one being made, but they are not welcome until the task has been completed. Some singers will not admit women to the hogan. If admitted, women may not watch the erasure of a painting and are sent out when this is about to occur. Even a man whose wife is pregnant should not witness the erasure.

Another category of practitioner, often including women, is that of the diagnostician or specialist in divination who is employed to discover the etiological factors that caused the patient's illness, to determine what ceremonial is needed to cure it, and to suggest which singer might be wisely chosen to perform the ceremonial, when a family confer-

ence has failed to provide this information. Diagnosticians may also use divination for other purposes, such as discovering lost articles. The technique used today is almost always hand-trembling: interpreting involuntary motions made while the diviner is in a trancelike state (see also Kluckhohn and Leighton 1962:209–12). The older techniques of stargazing and listening, interpreting things seen or heard, are now uncommon or obsolete.

An intermediary, usually a kinsman of the patient, goes to the singer's home to make an offer. Most often the singer agrees to come to sing in four days' time, and the intermediary takes the singer's bundle of ceremonial equipment back to the patient's home. Here the ceremonial will be held in the family hogan, which is emptied and swept clean for the performance. The cost in cash or kind to the patient and his family may vary from twenty-five dollars for a small two-night ceremonial to several thousand dollars for a nine-night performance during which hundreds of visitors may be hospitably fed.

There may be a few physically therapeutic procedures in a Navajo curing ceremonial, such as simple herbal medicines or occasional massage-like acts, but above all it constitutes a system of powerful psychotherapy, relieving psychosomatic ills and permitting the patient to carry on more comfortably with his organic troubles. Besides curing, other blessings extending to the family, the local community, or even the tribe may come from a ceremonial performance, such as rain in time of drought.[3]

The Holy Ones

Each ceremonial is especially related to a particular group of causative, or etiological, factors and also to certain supernatural powers, personalized in the Navajo mind as beings something like humans or capable of assuming human form. Natural phenomena such as mountains are said to have anthropomorphic inner forms. Various animals (such as snakes, deer, and ants), certain plants (such as cactus and corn), natural phenomena (such as thunders and winds), heavenly bodies (such as the sun, moon, and stars), mythological creatures (such as Big Snake or Water Monster), even material objects (such as arrows), and a host of others—in fact nearly every item in the universe—may be personalized, endowed with power, and thought of as "people," or, as the Navajos say, "they used to be people."

The powers of these Holy People, potent and therefore dangerous—not virtuously holy—vary, each being "in charge of" a certain group of things. All are interdependent, complementary items in a well-ordered universe, but there is no evidence that they form a well-ordered hierarchy. The Sun, of course, is a great power, and his twin children, Monster Slayer and Born-for-Water, born to the most beloved of Navajo deities, Changing Woman, are prominent in myth and ceremonialism. Changing Woman, the Slayer Twins, and the Sun form a sort of holy family. There was also a first family—First Man, Woman, Boy, and Girl—and their companions, irresponsible Coyote and Be'gochidi (for a description of Be'gochidi see Wheelwright 1946a:221, and Reichard 1970:386), who were important in shaping the world immediately after the Emergence of the Holy People from the underworlds. Then there is a group of Holy People called the Ye'i, led by Talking God and his companion, Calling God, who are impersonated by masked dancers in the public performances of some ceremonials such as the Night Chant.

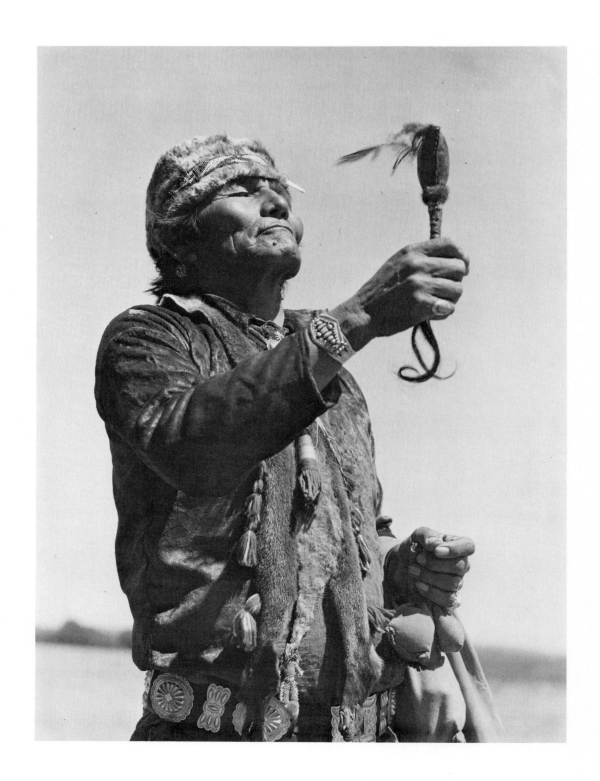

The doings of the Holy People, their homes, the way they instructed humans in ceremonialism, in short all essentials about them, are described in detail in a vast body of mythology transmitted orally from generation to generation in the family circle or from singer to apprentice. This mythology has two major sections, the story of the Emergence from the underworlds, or the general Origin Myth, and the origin legends of specific ceremonials that branch off from the Origin Myth at various points. These provide sanction and rationale for ceremonial practice. Each legend explains how a hero or heroine got into a series of predicaments and acquired the necessary knowledge for establishing a ceremonial while being extricated from misfortunes and ritually restored to health and normalcy by supernatural Holy People. There is much overlapping and interlocking in the various origin legends, with their vivid imagery, magnificent ritual poetry, and keen humor. Ideally a singer should know both the general Origin Myth and the myths of his specialty ceremonials, and the best ones do.

It is man's responsibility to maintain harmony between himself and the Holy People by keeping out of their way and not displeasing them in any manner. Otherwise he may fall ill or be injured by their power, not because they are inimical to man but because he stuck his fingers into the buzz saw, so to speak. An attack by a ghost or a witch, however, may be unprovoked, although a ghost may return because of improper burial or disturbance of a grave. The Holy People are mostly indifferent to man but may be persuaded or coerced to help cure the illnesses man may get from contact with them.

Rites and Chants

The late Franciscan scholar Father Berard Haile claimed that the Navajos employ their word *hatáál*, which we translate as *chant*, only for ceremonials in which shaking a rattle (Fig. 1) accompanies the singing (although there are a few exceptions). He suggested that all other kinds of ceremonials be called *rites*, since no one Navajo term distinguishes them (Haile 1938a:639; 1938b:10). This usage is followed here. Both rites and chants must be distinguished from *rituals*, which are general patterns governing the procedure by which chants are performed. Two major rites and the various types of chants (many of which are no longer practiced) are outlined here, and the chants that are performed according to the Holyway ritual are described in detail; Holyway ritual is most commonly employed and uses the largest number and variety of sandpainting designs. The ceremonials carried out according to the other rituals, like the various rites, employ decidedly fewer drypaintings or often do not use them at all. These ceremonials, therefore, will not be described as fully as the Holyway ones.

The Blessingway and Enemyway Rites

The Navajos sharply distinguish two of their great complexes of song and ritual, the Blessingway and the Enemyway rites, from their other song ceremonials, the chant-

Figure 1. A singer, Jim Smith, shakes his hide rattle during a Male Shootingway. He holds medicine bags in his left hand and wears the otter-skin collar with whistle attached that is part of the Shootingway bundle. Photograph, John Collier, Jr.

ways. (The term *chantway* is used hereinafter, usually as a synonym for chant, although it implies a somewhat wider range of practice—the whole of a specific ceremonial complex rather than one specific performance; the suffix *-way* is a rendering of the terminal enclitic of Navajo names for song ceremonials.) Except for being distinguished from the chants, however, Blessingway and Enemyway have nothing in common. Blessingway emphasizes peace, harmony, and good. Enemyway is used to exorcise the ghosts of aliens, threats of war, violence, and ugliness; in fact, it is in a Navajo category often translated as Evilway.

Five kinds of Blessingway rites, differing only slightly from one another, are used, not for curing disease, but for attracting good luck, averting misfortune, and invoking positive blessings upon man, his livestock, and all his possessions (see Wyman and Kluckhohn 1938:5, 18–19; Kluckhohn and Wyman 1940:184–87; Wyman 1970a:3–9). They fulfill a multitude of needs and are used to protect livestock, aid childbirth, bless a new hogan, consecrate ceremonial paraphernalia, install a tribal officer, protect soldiers, strengthen neophyte singers, consecrate a marriage, and celebrate a girl's adolescence. They formerly were used in a rain ceremonial, in salt-gathering rites, and probably in the obsolescent hunting rites. Every ceremonial includes a Blessingway song near the end to correct errors and ensure effectiveness. The Navajos say that Blessingway is the backbone of all ceremonialism and that it controls all other rites and chants. Blessingway rites are short and simple, lasting two nights (each night, by Navajo reckoning, lasts from sundown to sundown). They consist mainly of singing and praying while holding the mountain-soil bundle (a buckskin bundle containing some stone fetishes and pinches of soil from the tops of all the sacred mountains), much use of corn pollen in praying and consecration, a ritual bath, and sometimes drypaintings that differ in materials, designs, and use from the sandpaintings of the chantways.

The Enemyway rite was no doubt one of the obsolescent group of ancient war ceremonials used to protect warriors from the ghosts of slain enemies. It has been preserved as a cure for sickness believed to be caused by the ghosts of non-Navajos and is now classed with the other Evilway (also called Ghostway) ceremonials. It lasts three or five nights and is in the charge of more than one singer. Each performance begins at a "home place," continues at another locality usually reached on horseback, and concludes back at the home place.

The Chantways

The chantways, used for curing or preventing sickness, are by far the largest group of song ceremonials. There used to be some twenty-four chantway complexes; but now at least seven are extinct (Hailway, Mothway, Dogway, Ravenway, Awlway, Earthway, Reared-in-Earthway), and five or six are obsolescent or perhaps extinct (Waterway, Excessway, Coyoteway, Big Godway, Eagleway, and Beadway).[4] Singers may know a few songs or sandpaintings from the extinct or obsolescent chants, which they can use in short ceremonies. Only eleven chantway complexes are well known, and only seven of these are frequently performed (Shootingway, Flintway, Mountainway, Nightway, Navajo and Chiricahua Windways, and Hand-tremblingway). Red Antway, Big Starway, Beautyway, and Plumeway are known and sometimes performed in their entirety but are much less common than the other seven. Some confusion arises because

Navajos name ceremonials according to the rituals governing them, according to male or female branches (a distinction probably determined by the sex of the protagonist of the myth and involving slight differences in procedure), and occasionally for other reasons, so Navajo informants may give forty or fifty names for song ceremonials.

Any given performance of a chantway is under the influence of one of three rituals, or patterns of behavior governing procedure: Holyway, Evilway, or Lifeway. Most performances are concerned with the attraction of good and restoration of the patient following the ritual known as *Holyway.* This ritual, in turn, may be modified according to one of two subrituals: Peacefulway, concerned predominantly with attracting good and summoning the Holy People, and Injuryway (also called Angryway, Fightingway, Weaponway), which emphasizes exorcism. Unless otherwise stated, any Holyway chant may be assumed to be following Peacefulway subritual. Injuryway is for a patient who has been directly attacked by an etiological factor—for example, struck by lightning, bitten by a snake, or mauled by a bear. This subritual calls for reversing the usual position of the red and blue colors of symbols in sandpaintings and on prayer sticks so that the red is toward the inside instead of in its normal outside position. Navajos may, therefore, call the chant "red inside."

Exorcism of the ghosts of Navajos requires a chant done according to *Evilway* (Ghostway, literally Uglyway) ritual. It may be hoped that such a chant will also combat the effects of witchcraft. Ghost sickness or bewitchment may present such symptoms as bad dreams, insomnia, fainting, nervousness, mental disturbances, loss of appetite or weight, or general malaise. Evilway

techniques include big hoop ceremonies, garment or cincture ceremonies, overshooting, blackening the patient, and lightning-herb, ash-blowing, and brushing procedures (Haile 1950a; Wyman 1973:31–42). Shootingway, Red Antway, and Hand-tremblingway are known to be performed according to this ritual today, and Big Starway is usually, if not always, an Evilway chant. Moreover, Hand-tremblingway Evilway is much more common than the Holyway form. In addition, there is an exclusively and probably fundamentally Evilway ceremonial called Upward-reachingway (Wyman and Bailey 1943).

Injuries resulting from accidents, such as being thrown from a horse, are treated by chants conducted according to *Lifeway* ritual. Shootingway and (formerly) Hand-tremblingway may employ this ritual, and there is a separate ceremonial, Flintway, which is a fundamental chant of the Lifeway ritual. The distinctive feature of this ritual is painting the patient red, the color of flesh and blood, symbolizing return to health. These chants are simpler than most, lasting only two nights, but their duration is not fixed, and they may be continued as long as needed (Haile 1943; Wyman and Bailey 1945).

Shootingway is today the only chantway that can be conducted according to all three ritual modes, depending upon the purpose involved. There is no way of knowing whether this was once true of all the other chantways, although some have apparently lost one or another of the three rituals in recent times. It is possible that the present-day rituals have a common origin in an ancient ceremonial pattern that included all of them as ceremonies in a single chant. All Holyway chants do contain both invocatory and exorcistic elements.

The Holyway Chantways

The Navajos put their song ceremonials into categories according to interrelations in their myths, in the etiological factors they are supposed to combat, in ceremonial procedures, and so on. Ceremonials that fall in the same category have been termed "partner chants." There are seven groups of partner chants that may be performed according to Holyway ritual (Wyman and Kluckhohn 1938). (See Table 1.)

The Shooting Chant subgroup contains, besides the Shootingways themselves, the recently extinct Hailway (there are reports that it may be revived), the obsolescent Waterway, and the uncommon Red Antway and Big Starway (the last now performed mainly or perhaps always according to Evilway ritual). According to some presumptive evidence, the Shooting Chant subgroup may also include the fundamental Lifeway chant, Flintway, and perhaps the Windways as well. The popular and frequently performed Shootingways have preserved more ramifications and have more sandpaintings appropriate to them than any other ceremonial complex.[5] Moreover, they are the preferred treatment for ailments attributed to one of the most frequently invoked etiological factors, lightning, and its earthly cognates, snakes and arrows.

Associated with the Mountainways in the Mountain Chant subgroup are their less-common sister chant, Beautyway, and the extinct or decidedly obsolescent Excessway and Mothway. These last two are concerned with a moth-incest-insanity complex and the effects of all sorts of recklessness and excessive activity, but especially sexual irregularities. The Mountain chants are usually carried out as nine-night performances, but five-night chants may be given in the frostless months (Wyman 1975:15–16).

The God-Impersonators subgroup receives its name from the masked impersonators of the Ye'i who dance in the public exhibition of the final night of a nine-night performance of Nightway and, rarely, of a few other chants, and who are otherwise important ceremonial personages. Nightway is often called the *Ye'i bichai*, an anglicization of the Navajo term for granduncle or maternal grandfather of the Ye'i ("Grandfather-of-the-Gods"), because Talking God, the leader of the Ye'i, is so called. Nightway is the only one in this subgroup that is commonly carried out as a nine-night performance. Big Godway is closely related to Nightway—perhaps only a branch of it. Plumeway (Downway, Feather Chant) is rarely performed today. It stresses hunting and the origins of agriculture in its myth and sandpaintings. Coyoteway, like Excessway and Mothway, is related to the moth-incest-insanity idea and also like them is obsolescent, perhaps almost extinct (but see note 4). Dogway and Ravenway have long been extinct.

Both Windways in the Wind Chant subgroup are popular and often performed. Navajo Windway is subject to considerable elaboration and has a fair number of sandpaintings in its repertory. As many as twelve sandpaintings may be made in a single performance of one phase of the chant, called With-many-sandpaintings. In another phase, Chant-with-the-house, a painted wooden reredos representing Rainbow's House, like the Sun's House screen of male Shootingway, is set up inside the hogan at the back when sandpaintings are made (see note 5). The brief (two-night) Chiricahua Windway, one of the more popular chants, seems to have originated comparatively recently from an Apache ceremonial. It features rather small Sun and Moon sandpaintings and a complicated cactus prayer stick offering.

Hand-tremblingway has no partner chants and may be a relatively late derivation from Chiricahua-Mescalero ceremonials, divination rites, and Big Starway. The Evilway form is most commonly carried out today. Gila Monster, along with stars and Big Fly, figures prominently in the chant and its sandpaintings.

The two chants of the Eagle-Trapping subgroup, Eagleway and Beadway, should be grouped with the Gameway hunting rites, according to some Navajos. Perhaps they were hunting rites that developed into chantways. The sandpaintings of Beadway are the best examples of paintings as narrative illustrations of the myth, presenting quite well the adventures of Scavenger, the Navajo hero, with the Pueblo Indians and the Eagle and Hawk People.

The final group of extinct ceremonials of uncertain affiliation, Awlway, Earthway, and possibly one called Reared-in-Earthway, have been extinct for so long (perhaps more than a century) that we have only a few scraps of information about them and a few sandpaintings said to have been used in them.

Some chants have male and female branches; perhaps most of them did once. Today the only ones definitely known to have or have had them are Shootingway, Red Antway, Mountainway, Beautyway, Excessway, and Navajo Windway. Father Berard Haile thought that the sex of the protagonist of the myth determined the distinction. In any case, differences in ceremonial procedure in the two branches are probably slight.

Most Holyway chants have or had two-night and five-night forms, and some, perhaps most of them, had nine-night forms. Several still do, and they are constructed by moving some of the units of procedure (ceremonies) from the first four days (as they are in a five-night chant) to the last five days, not by adding new procedures or by repe-

TABLE ONE
THE HOLYWAY CHANTWAYS

Shooting Chant subgroup

Shootingway	Big Starway
Hailway*	Flintway (?)
Waterway*	Lifeway (?)
Red Antway	Windway (?)

Mountain Chant subgroup

Mountainway
Beautyway
Excessway*
Mothway*

God-Impersonators subgroup

Nightway
Big Godway*
Plumeway
Coyoteway*
Dogway*
Ravenway*

Wind Chant subgroup

Navajo Windway
Chiricahua Windway

Hand-trembling Chant subgroup

Hand-tremblingway

Eagle-Trapping subgroup

Eagleway*
Beadway*

Extinct Ceremonials of Uncertain Affiliation

Awlway*
Earthway*
Reared-in-Earthway (?)*

*An asterisk follows names of ceremonials that are extinct, obsolescent, or so rare that they are virtually obsolescent.

tition. A nine-night chant usually culminates in a public exhibition on the final night with either dances by God-Impersonators (Nightway) or a Dark Circle of Branches (Corral Dance or Fire Dance of Mountainway). Nine-night chants may be given only after the first killing frost in the fall and before the first thunderstorm in the spring, when rattlesnakes and bears are hibernating and there is no danger from lightning. Two- or five-night chants may be held in any month. Theoretically, a chant that has cured someone should be sung over him four times, alternating five- and two-night forms, to ensure a permanent cure or immunity, but this rule is not always followed; even when it is, the repetitions may be strung over many years.

Etiological Factors: The Dangerous Universe

Each Holyway or Evilway ceremonial aims to appease or exorcise particular etiological factors associated with it, which are believed to be causing the patient's troubles. It does not deal with the physical symptoms of disease. Prominent among the great multitude of etiological factors are numerous animals. Snakes (cognates of lightning), bears, porcupines, weasels, deer, coyotes, eagles, and ants figure importantly. Cactus is the only plant frequently cited. Thunder, lightning, and winds, especially whirlwinds, are preeminent among natural phenomena. Etiological factors also include the Holy People associated with the ceremonials, such as the Ye'i, and ghosts of the dead, against which Evilway ritual is employed. And of course witches, incest, and excesses also may cause illness. Killing, eating, or disturbing an animal (as by urinating on an anthill), using anything it has been in contact with (such as firewood), or being injured by it; using cactus for firewood; using wood or eating animals that have been affected by lightning or winds, seeing animals killed by them, or being affected by them oneself; misconduct in ceremonial procedure or breaking restrictions; burying the dead improperly or having any contact with their possessions; even dreaming of any of these things—all may lead to illness.

The association of etiological factors with specific disease categories is extremely loose. Almost any human ailment may be traced to any one of them. Thus, there are long lists of troubles for which a given chant is considered an efficacious cure (see Wyman 1962:20–22; 1975:17–21). In the myths or in statements of informants, and in the actual maladies that anthropologists have seen being treated, we find evidence that gastrointestinal, genitourinary, and skin diseases; head ailments; rheumatism and arthritis; throat, chest, and lung troubles; and paralysis may all be treated by any one of the six or seven chantways. Some illnesses, however, may be more often ascribed to certain factors than to others. Skin diseases such as itching, boils, sores, and rashes are often associated with eagles or wild turkeys; arthritis and mental disturbances, with bears; head ailments, with deer or the Ye'i; and kidney and bladder troubles, with ants. Table 2 shows the associations most often made among etiological factors, diseases, and ceremonials (see also Sandner 1979:Table II).

Inasmuch as some factors are connected with more than one chantway, care must be exercised in diagnosis. Snakes are important etiological factors for Shootingway, Beautyway, and Navajo Windway. In such instances an appropriate ceremonial may be

determined by performing a short excerpt, or one or a few ceremonies, from a chantway as a test; if the patient appears to benefit, the whole chant may be given.

Ceremonial Procedure: Attracting Good and Chasing Out Evil

The Navajo ceremonial system is not so complex as it first appears: chants are made up of more or less discrete units (ceremonies) that are used in different contexts with appropriate symbolic modifications and other alterations that may be inserted or omitted depending on the wishes of the singer, the patient, his family, or on the nature of the illness being treated.

A Holyway chant consists of about twelve ceremonies. Singing, led by the singer and joined by all present who know how, accompanies each ceremony. The singing is indispensable, and several hundred songs go with a single chant. Prayers are said at intervals, and prayerful eating and sprinkling of corn pollen close most ceremonies. Herbal medicines are administered or applied, and the patient is fumigated by vapors from substances put on hot coals. The bull-roarer is whirled outside to chase evil. The singer's bundle equipment—his rattles, bull-roarer, brush of eagle feathers, talking prayer sticks, fire drill, medicine cups of abalone or turtle shell, prehistoric stone implements, miniature bows, painted wooden paddles and feathered or plumed wands or sticks (wide boards and arrows, bundle prayer sticks), bundles of fluffy eagle plumes, feathered wool, woolen strings, perhaps a fur collar, and small buckskin bags of pollen, medicines, and materials for offerings—is laid out in a fixed order on a calico spread (layout) or arranged in a basket (basket lay-

out) (Figs. 2, 3; see Wyman 1972a, 1972b). Certain objects, especially the bundle prayer sticks, are applied to the patient's body by the singer. After a ceremony, helpers dispose of dispensable materials and objects that have served their purpose well away from the hogan in stated directions and situations. For four days after the chant, the patient must continue to observe the ceremonial restrictions against sexual activity and bathing, and to take care in all activities; having been identified with one of the Holy People, he is powerful and dangerous.

The organization of the dozen or so standard ceremonies of Holyway chants in two-, five-, and nine-night forms is shown in Table 3. The numerals designate the days (or rather nights, according to Navajo reckoning) on which the ceremonies occur. The time of day given is approximate, varying somewhat with circumstances. Consecration of the hogan, the bath, figure painting, token tying, all-night singing, and the dawn procedures occur only once in any chant. The other ceremonies are carried out four times in five- or nine-night ceremonials. The sweat-emetic ceremony must be performed four times; hence it cannot be done in a two-night chant; otherwise, the two-night form includes all the component ceremonies, but of course they can be performed only once. A nine-night chant is achieved by moving short singing, setting-out, and sandpainting ceremonies to the fifth through eighth days; thus, the bath, figure painting, and token tying come on the eighth day and the procedures of the final night on the ninth. We don't know which form was original— that is, whether a two-night performance was expanded by repetition and spacing or a nine-night form was condensed or a five-night form was concentrated into two nights and elaborated into nine. Perhaps the last,

TABLE TWO

FREQUENT ASSOCIATIONS AMONG CEREMONIALS, ETIOLOGICAL FACTORS, AND DISEASES

Chantway	Etiological Factors	Diseases
Hailway	Frost, snow, hail	Frostbite, lameness, sore muscles, fatigue
Waterway	Injury by water, waterfowl, Water Monsters (mythic)	Drowning, paralysis, deafness
Shootingway	Thunder and lightning, snakes, arrows (cognate factors)	Respiratory and gastrointestinal diseases
Red Antway	Ants (especially red ants), horned toad; secondarily, lightning, bear	Genitourinary,[1] gastrointestinal, and skin[2] diseases; venemous insect and spider bites; sore throat; fever; rheumatism
Big Starway	Stars (dreams about stars)	Ghost sickness, bewitchment[3]
Mountainway	Bear, porcupine, weasel, squirrels and chipmunks, mountain sheep, turkey, and other mountain birds and beasts	Arthritis, mental disturbances, gastrointestinal and genitourinary disease (porcupine), cough (squirrel), skin disease (turkey), deafness and eye trouble (mountain sheep)
Beautyway	Snakes, lizards, certain water creatures (frog, toad), weasel	Gastrointestinal, genitourinary, and skin disease; rheumatism; sore throat; snakebite
Excessway and Mothway	Excessive activity, recklessness, sexual irregularities (incest, promiscuity), breaking ceremonial restrictions	Insanity, mania (impulse to jump into fire or to clan incest)
Nightway and Big Godway	The Ye'i (supernatural beings), mountain sheep	Head ailments,[4] crippling, paralysis

Chantway	Etiological Factors	Diseases
Plumeway	Game animals, especially deer	Diseases of the head, rheumatism (deer disease)
Coyoteway and Dogway	Coyote, dog (overzealousness in trapping or killing)	Promiscuity, mania (effects of incest), rabies, sore throat, gastrointestinal and venereal disease
Ravenway	Raven's nest, crow, turkey, buzzard	Effects of incest, sores
Windways	Winds (especially whirlwinds), lightning, snakes, cactus	Gastrointestinal trouble (snake), eye trouble and itching (cactus), heart and lung disease
Hand-tremblingway	Overpracticing hand-trembling or stargazing divination	Nervousness, mental disease, paralysis of arms (handtrembling); impaired vision (stargazing); chest disease
Eagleway and Beadway	Eagles (hunting or trapping)	Head diseases, skin disease, anorexia, nausea, swollen legs
Awlway	Violation of restrictions on basketmaking	Headaches, baldness
Earthway	Earth infection (?)	Bad dreams about the earth

[1]Kidney and bladder troubles including anuria, hematuria, stones, venereal disease, pelvic pain.

[2]Cutaneous ailments including itching, pimples, sores, rashes, boils, swellings, sudoresis (excessive sweating).

[3]Mental distress, insomnia, bad dreams, anorexia, and emaciation are taken as symptoms of ghost infection or bewitchment and may be treated by any ceremonial performed according to Evilway ritual.

[4]Head ailments include eye troubles or blindness, earache or deafness, sore throat, headache, and insanity.

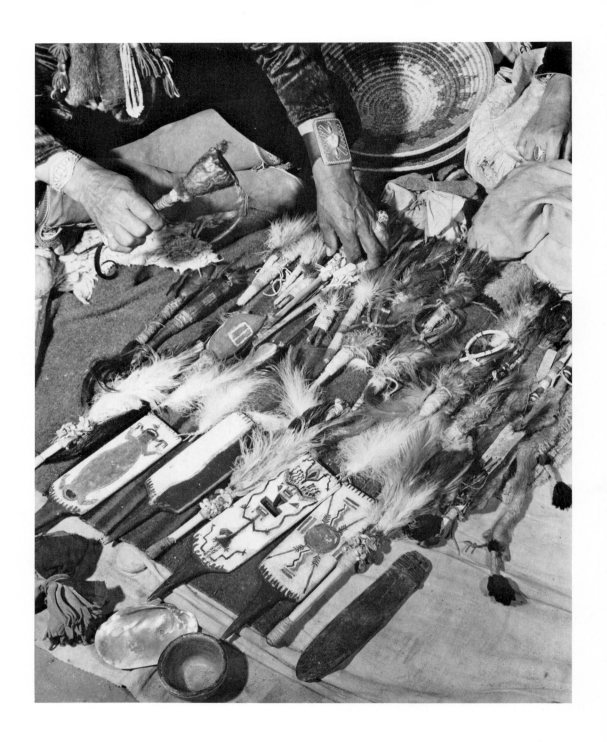

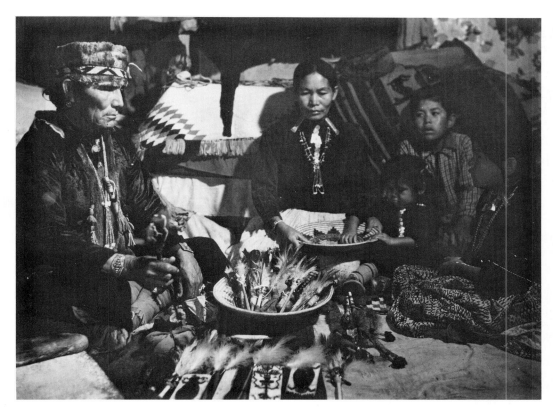

Figure 3. The basket layout for Male Shooting-way. The basket holds talking prayersticks and bundle prayersticks; in the foreground are wide boards and, outside them, a pair of talking prayersticks. At left, a singer shakes a hide rattle; in the center is a patient holding a basket. Photograph, John Collier, Jr.

Figure 2. The spread layout for Male Shooting-way. The singer's bundle equipment, including medicine cups (bottom left), bull roarer (bottom center), wide boards alternating with talking prayersticks, medicine bags, four rattles (upper left), and bundle prayersticks, is arranged on a cloth. A description of these items may be found in Wyman (1972b). Photograph, John Collier, Jr.

TABLE THREE

CEREMONIES OF HOLYWAY CHANTS

	Two-Night	Five-Night	Nine-Night	Time of Day
Consecrating the hogan	1	1	1	Sundown
Unraveling	1	1 2 3 4	1 2 3 4	Early evening
Short singing	1	1 2 3 4	5 6 7 8	Evening
Setting-out	1	1 2 3 4	5 6 7 8	Before dawn
Sweat and emetic	–	1 2 3 4	1 2 3 4	Dawn
Offering	1	1 2 3 4	1 2 3 4	Early forenoon
Bath	1	4	8	Forenoon
Sandpainting	1	1 2 3 4	5 6 7 8	Afternoon
Figure painting and token tying	1	4	8	During sandpainting
All-night singing	2	5	9	Late evening onward
Dawn procedures	2	5	9	Dawn

NOTE: Numerals indicate the days on which the ceremonies occur according to Navajo reckoning (sundown to sundown).

being a middle ground, is the safest assumption.

Theoretically, a ceremonial should be performed only in a hogan with a door opening to the east, whence good comes, and a smoke hole in the roof through which to drive evil. The singer opens the ceremonial at sundown the first evening by *consecrating the hogan* with cornmeal and oak twigs put on roof beams in the cardinal directions, thus notifying the Holy People of the doings therein (see Table 3; italics are used here and below to indicate major phases of ceremonials). After this, an *unraveling* ceremony may release evil and harm from the patient's body by pulling free the strings knotted around a stated number of bundles of herbs and feathers that are applied to him in ceremonial order. This takes about an hour. Then a *short singing* ceremony of an hour or so follows or is performed after sundown if unraveling has been omitted.

If a sandpainting is to be made, a *setting-out* ceremony just before dawn notifies humans and supernaturals of that fact. With song and prayer, bundle prayer sticks from the basket lay-out are stuck upright in a small earthen mound outside the hogan and to the east of the door by the singer, accompanied by the patient. Just after dawn a *sweat and emetic* ceremony is held in which the patient, singer, and others who wish, strip to a breechcloth or a skirt, sweat copiously around a great fire kindled previously with

a fire drill, drink an emetic, and vomit. This provides internal and external purification. Small sandpaintings (described in Chapter 8) are used in this ceremony. After breakfast, invocatory *offerings* of jewels (bits of turquoise, shell, and jet), short, painted reeds stuffed with wild tobacco ("cigarettes"), and/or small, cut and painted prayer sticks are prepared. The patient holds these while repeating a long litany after the singer, and a special helper deposits them in specified places where the Holy People can find them. A ritual *bath* in a basket of yucca-root suds purifies the patient still further in the forenoon of the last day.

After the bath or the offerings, helpers begin to make the *sandpainting*. In the late forenoon or early afternoon, the bundle prayer sticks are brought in from the set-out mound and stuck upright around the completed picture (sandpainting set-up). The singer sprinkles corn pollen on the painted figures and places small heaps of cornmeal on them for consecration, to be gathered later to use as medicine (Plate 2). Then the patient enters and sprinkles cornmeal from a basket onto the sandpainting, and others may do likewise. At some point during the singing, the patient strips to a G-string or one skirt and sits facing east on a specified figure in the painting. While singing, the singer presses his palms, moistened with herb medicine or saliva, to parts of the sandpainted figures, and applies the adhering sand to corresponding parts of the patient's body. He also applies bundle prayer sticks from the set-up to the patient's body, and he may touch the patient with parts of his own body. The prayer sticks or parts of the singer's body are applied to the patient in a ceremonial order, beginning at the feet and proceeding toward the head. Finally the patient leaves the hogan, the singer erases

the sandpainting, and the now infectious sands are gathered in a blanket and deposited north of the hogan.

One sandpainting is made in a two-night ceremonial; four different ones are made on four successive days in a five- or nine-night chant. Selection of the one or four from those the singer knows may be determined by the sponsor's ability to pay for more or less elaboration, by the singer's confidence in designs with which he has had the best success, by requests made by the sponsor or patient, by the nature of the illness being treated, or merely according to the singer's caprice.

On the last day only, immediately before these sandpainting procedures, symbolic designs in mineral pigments are painted on the patient's body from head to foot (*figure painting*), the tie-on (chant token, head feather bundle) of fluffy eagle plumes is tied to the forelock, and a bead of shell (for women) or turquoise (for men) is tied to the hair (*token tying*). This is a personal token that the patient may keep. All these procedures protect the patient, identify him with a Holy Person, and make him recognizable to the Holy People in general. An *all-night singing*, culminating in the dawn songs, closes the chant, and the patient leaves the hogan to "breathe in the dawn." A final prayer and a Blessingway song avert ill effects from any inadvertent errors made in the chant.

Certain ceremonies may be added to a chant if the patient wishes to pay for them. These may be *ritual eating* of cornmeal mush or a mixed stew to remove food restrictions, or a *shock rite*.

Evilway (Ghostway, Uglyway) chants have the same kinds of ceremonies as Holyway chants, except that setting-out and the usual type of offering ceremony are not performed; *blackening* the patient all over with charcoal greasepaint or sometimes *reddening*

with red paint is substituted for figure painting. Sandpaintings may be made at night, sometimes on buckskin or cloth, with the patient spending the night on a covering placed over some of the sand; and various exorcistic procedures are featured. One of these is the *big hoop* ceremony, in which the patient enters the hogan for the *sweat-emetic* through a series of four or five big hoops set up in front of the hogan, over a dry-painted trail, while a buckskin or cloth worn over his head and shoulders is gradually pulled off by the singer. This symbolizes restoration of a mythic hero who had been transformed into a snake or coyote when the supernatural beast had placed his hide upon him (see Wyman 1966; 1973:40, 58–60). Other specifically Evilway ceremonies are *overshooting* the patient with specially prepared symbolic arrows by costumed impersonators of the Slayer Twins, and cutting fir or plant *garments* or *cinctures,* or a tentlike *fir hogan,* away from the patient who had been wrapped in them, symbolizing release from evil. Evilway chants are confined to five nights or less.

Besides song ceremonials, there are prayer ceremonials in which long prayers are said without singing. They may last four nights, and drypaintings of pollen may be made. Prayer ceremonials are associated with Blessingway and may be added to a chant by request. They are thought to be the best protection against bewitchment.[6]

The Disposal of Drypaintings

After a sandpainting has served its purpose in a ceremony, has been sprinkled with pollen and cornmeal, has been walked on by the patient and singer, and has had portions picked off for application to the patient, the once neat and beautiful picture is a sorry mess. At the end of the ceremony, after the patient and all women have left the hogan, the singer obliterates the painting completely with some implement from his equipment—a rattle, bullroarer, or bundle prayer stick—proceeding in ceremonial order for each figure and erasing the encircling guardian last of all. If a sandpainting set-up is present, the singer knocks it down with the object used for erasing as he erases the guardian symbol that surrounds the design; he gathers the set-up in his free hand as he goes around or collects it later. Sometimes he gathers the set-up with his left hand, without knocking it down, as he erases the guardian. All the sand is gathered in a blanket, usually in several loads, carried out, and dumped north of the hogan some distance away. Sometimes the sand from the paintings of four successive days is dumped in one pile, but more often that from each succeeding day is dumped just north of that from the previous day. The last procedure is the rule in Evilway ceremonials and symbolizes evil moving northward away from the patient. The bark receptacles for the pigments are also disposed of toward the north.

In some Evilway chants, a sandpainting may be used at night or both made and used at night. It may also be made upon buckskin or cloth, and when this is done, the hide or fabric background is folded over the sands of the painting, the sand platform and trail, if present, are pushed under it, and the patient's bedding is placed over it. The patient then sits on it throughout the all-night singing. In other instances a portion of an Evilway sandpainting is placed under the patient's bed or pillow, on which he should sleep for four nights following the chant. This affords more time for absorption of power from the sand symbols.

A drypainting made in a Blessingway rite may also be covered with a blanket on which the patient and his family sit during the all-night singing. A painting made for Blessingway may also be left in the hogan to become part of the earthen floor, or the patient may sleep on it for four nights, after which it is disposed of in the usual manner (that is, carried out in a blanket and dumped to the north of the hogan).

The Purpose of Drypaintings

The late Kenneth Foster (1964a:3) stated the purpose of Navajo drypaintings very neatly when he said, "Their ephemeral beauty is not created for any aesthetic purpose, but to act as magnetic fields and diffusers of supernatural power. They are, in fact, holy altars, made on the ground or floor of the hogan." Among the many terms used by various authors to designate drypainting, the word *altar* is perhaps the most appropriate because it is a place where there is sacerdotal equipment and on which ritual behavior is carried out. The Navajo term for drypainting, *'iikááh,* according to Father Berard Haile, "suggests entry of several" (entities or beings) or, as the Franciscan Fathers (1910:398) put it, "the entry, or they (the gods) enter and go."

So far as benefit to the patient is concerned, the function of a drypainting is threefold: to attract supernatural beings and their power, to identify the one-sung-over with them, and to serve as a two-way path for the exchange of good and evil. The powers being invoked by depicting their likenesses or symbols in dry pigment are thought to be irresistibly attracted. They come to look at their portraits, for who does not like to see his portrait being made? Having arrived, they actually become the drypainted likenesses; these are "identified with the supernaturals themselves. . . . they enter the hogan in person" (Haile 1947a:xiv).

The second and perhaps the most important function is identification of the patient with the pictured supernaturals. He sits on the figures while the singer moistens his palms with herb medicine and presses them to various parts of the figures' bodies and to the corresponding parts of the patient's body. The singer likewise presses parts of his own body to corresponding places on the patient, knee to knee, shoulder to shoulder, head to head, while voicing the sound symbolism of the chant, an imitation of the cry or noise made by the supernaturals associated with the chant. Since the singer is the surrogate of these supernaturals, thought of as being a Holy Person while performing in the ceremonial, this physical contact reinforces the process of identification. Thus the patient becomes like the drypainted powers, strong and immune to further harm. Having partaken of the nature of divinity for a time, he is also dangerous, for his acquired power could harm others. Hence, four days of ceremonial, restricted behavior following the chant are required to keep him from inflicting any injury on people around him.

Finally, sandpaintings heal because they absorb evil from, and impart good to, the patient seated upon them. The late Gladys Reichard (1970:112) put it very succinctly: "The ritualistic process may be likened to a spiritual osmosis in which the evil in man and the good of deity penetrate the ceremonial membrane in both directions, the former being neutralized by the latter, but only if the exact conditions for interpenetration are fulfilled." Sometimes a portion of the collected pigments is placed under

the patient's bed so that he can absorb more good. After the ceremony, the sands of the picture, which has been erased, are carefully collected and deposited outside, away from the hogan, where the evil they have absorbed can do no harm. Thus, the drypainting's function as a sacred tool is fulfilled.

After the patient has left the hogan, copatients or spectators may hastily apply some of the sand to their own bodies or perhaps gather a little to take away for use as a home remedy, thus partaking of some of the same benefits as the patient. This practice, how-ever, is not common today. The chief benefit the spectators enjoy is being in the presence of the powers represented by the symbols in the painting; they no doubt feel that there may be some beneficial influence coming from the divine presences. They also may experience some aesthetic pleasure in contemplating the beauty of the painting as a work of art. Moreover, the spectator who knows the myth of the ceremonial and is adept in interpreting drypainting symbolism can also derive some enjoyment from seeing a pictorial reminder of the story.

3

The Origin of Navajo Drypainting Art

It has long been assumed that the Navajos derived their drypainting art from the Pueblo Indian practice of making dry ground paintings as a part of their altar complexes. After their arrival in the Southwest some five hundred or more years ago, these Athapascan invaders are supposed to have seen and borrowed the Pueblos' comparatively simple designs and, using their well-known imaginative artistry, elaborated them in their own resourceful way into the magnificent complex we see today. They embellished the art until they came to employ such a multitude of different designs that the number cannot accurately be estimated. The fact that the Navajos are much better artists than they are mechanics is seen in other fields. For instance, they did not contribute much to the technique of loom weaving, which they also no doubt learned from the Pueblo people; but they added such a wealth of design that the Navajo blanket or rug has become world famous.

There seems to be little question that much of Navajo ceremonialism was borrowed from the Pueblos. The late Elsie Clews Parsons, the outstanding authority on Pueblo religion (witness her massive two-volume work on the subject [1939]), cited over 160 parallels between Pueblo and Navajo ceremonial and ritualistic practices (Parsons 1939:1036–56). Ruth Underhill (1956:51) thinks that it must have taken many years for the Navajos to develop drypainting into a "high art," perhaps having "its beginning when a Pueblo-trained priest [singer] initiated his sister's son into the art of bringing spirits to the ceremony by drawing their symbols." We know, however, that the development was virtually complete by the late nineteenth century, when the first Navajo sandpaintings were discovered, recorded, and published by Washington Matthews and James Stevenson.[1] Comparison of the drypainting designs and other ceremonial procedures of those days with recent designs and practices shows that in 1880, when Jesús Alviso, the Mexican captive of the Navajos, said to Matthews (1897:39), "Los Indios hacen figures de todos sus diablos" ("The Indians make figures of all their devils"), the Navajos had already "built a structure Wagnerian in its grandeur" on "the skeleton of a mythology and the details of a complicated ritual" that they had taken from the Pueblos (Underhill 1956:50).

Clara Lee Tanner, in *Southwest Indian Painting* (1957:28), ventures the interesting

opinion that the Navajos, inspired by Pueblo wall and floor paintings and the accompanying reredos of the altar but restricted by their own house type, the hogan, with its rough, curving timber walls and dirt floor, turned to a more elaborate use of colored sands on the floor, combining all three Pueblo items into one, the sandpainting.[2]

There could be some question, in a few restricted areas, as to the direction of diffusion of drypainting practices. Parsons (1939: 1045) said, "That the mask cult spread from Zuni or Hopi to the Navajo and to the Apache there is to my mind no question, [for] the mask dance is so restricted among both Apache and Navajo, and the rest of the kachina complex . . . is so much simpler than among Pueblos." On the other hand, she wrote, "There is little question that the sand- or ground-painting reached Hopi through Navajo, in its later development" (Parsons 1939:1048–49). She went on to say, "The sandpainting situation is reversed for prayer stick ritual, which is more complex among western Pueblos than among Navajo, indicating that Navajo were the borrowers" (Parsons 1939:1049). Moreover, she noted that the colors the Navajos associated with the points of the compass are identical with those used in Isleta and Picurís. She suggested that this resemblance "indicates that in the earliest days when the intrusive Athapascans were integrating Pueblo-derived traits their contacts were with the Tiwa (possibly Tano and Piro had the Tiwa color-directions), *not* with Keres, Zuni, or Hopi" (Parsons 1939:1051 n.). It is unsafe to assume that complex to simple or the reverse indicates the direction of diffusion of a trait, for who is to say whether the adopting group elaborated or simplified the cultural traits it adopted? In the case of Navajo sandpainting, majority opinion holds that the Navajos adopted the art and elaborated it,[3] but in the last analysis we have to agree with Tanner (1948:27) "that the real beginnings of these [sand]paintings are shrouded in a mysterious past."

Although the evanescent character of the drypainting art does not allow the accumulation and preservation of records for studying its development in Navajo hands, we do have a body of materials that probably illustrates an early stage or stages in the evolution of the style and subject matter employed by the Navajos. These are the late seventeenth- and eighteenth-century Navajo rock paintings and carvings found on the sandstone cliffs of northwestern New Mexico and adjacent portions of Colorado. These pictographs have been documented in richly illustrated publications by Alfred Dittert, Jr., James Hester, and especially by Polly Schaafsma; most of the following discussion has been derived from her writings.

Navajo rock art consists of pictographs made by two techniques: painting on smooth rock surfaces, or pecking and occasionally incising into the surface (P. Schaafsma 1962, 1965, 1980:301–41). Paints were used of eight different colors—red, pink, white, cream, yellow, orange, light green, and blue—derived from colored minerals such as hematite and limonite (red and yellow ochers), white kaolin, calcium carbonate (limestone), perhaps gypsum, green malachite, and, rarely, blue azurite (copper carbonates). Six colors were used in one painting (P. Schaafsma 1963:Pl. IV). Navajo pictographs are concentrated in two general areas: the upper San Juan or Navajo Reservoir District in the canyons along the San Juan River and the lower portions of its tributaries, the Piedra and preeminently the Pinos, near the Colorado–New Mexico border; and the canyons of the Largo and Gobernador drain-

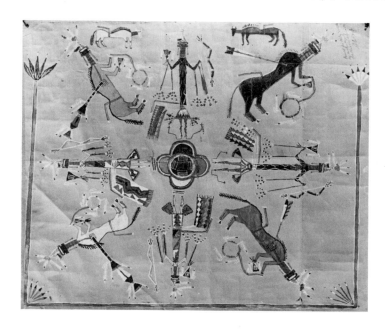

Figure 4. Holy People Kill Buffalo, Male Shootingway. Painting made by a Navajo singer. Courtesy Taylor Museum, Colorado Springs Fine Arts Center.

ages (Gobernador District) farther south. The abundance of pictographs in Largo Canyon suggested to Schaafsma that this area was a center for the development of Pueblo art and the early Navajo art that derived from it. These areas comprise the legendary Navajo homeland, the Dinetah (*dinétah*).

The pictographs from the Dinetah may all be dated to the Gobernador Phase of Navajo occupation (A.D. 1696–1775) when the Navajos left the area to migrate south and west to their present homeland. This was the time when refugees from the Rio Grande Valley pueblos came to live with or near the Navajos after their unsuccessful revolt against Spanish domination. It was, therefore, a period of intense Pueblo-Navajo acculturation, and was perhaps the time when the Navajos adopted much of the ceremonial paraphernalia and practice that they are supposed to have learned from the Pueblos. Archaeologists have found both Pueblo and Navajo ritual paraphernalia contiguous in the same excavated deposits.

Navajo pictographs include many symbols and figures found in Navajo drypainting art. Predominant are figures of supernatural beings wearing kilts or dresses, feather headdresses of various kinds, sashes, moccasins, necklaces, and earrings, with yellow pollen lines on their chins, and carrying bows and arrows, ears of corn, feathered wands and dance paddles, and possibly hide rattles, just as they do in the sandpaintings of today. Among the animals depicted are bison, deer, snakes, and various birds, especially the eagle. Tracks of these creatures are also present. The bison, like those of modern Navajo and Pueblo art, have the heart-line, a trait that Dittert thinks the Athapascans brought with them into the Southwest, either as their own invention or as an acquisition from Plains Indians (see P. Schaafsma 1963:57). Some of them are pierced by arrows, making them identical, except in style, to the bison in the Shooting Chant sandpainting called *Holy People Kill Buffalo* (Fig. 4).[4] In this design, the Holy People

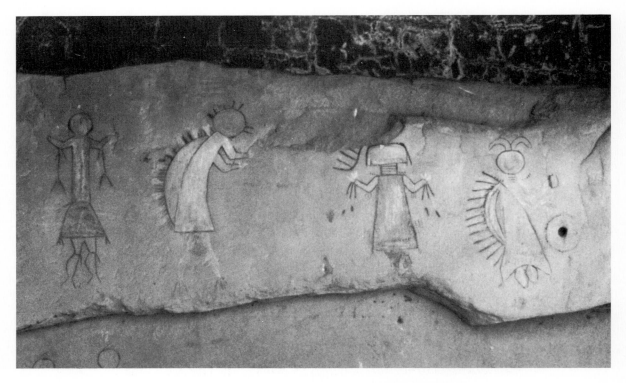

Figure 5. Navajo rock paintings (1696–1775) from a tributary to Largo Canyon, Gobernador District, New Mexico (now at the Wheelwright Museum). Left to right: male Ye'i(?), Person of the Myth with pack (Mountainway), female Ye'i, Humpback. Courtesy Wheelwright Museum.

have just shot the beasts with their arrows; they are about to pull out the arrows and restore the creatures. Also present among the rock paintings are human handprints and footprints, cornstalks, and symbols of celestial phenomena, including a horned face like the sun or moon of sandpaintings, stepped or terraced cloud symbols (some with zigzag lightning arrows flashing from them), stars, and rainbows.

A number of figures of supernaturals can be identified. Among these are the Slayer Twins, Monster Slayer and Born-for-Water, or their symbols; several Ye'i, such as Humpback, the deified mountain sheep with horns (Fig. 5), especially common in the Gobernador District (see P. Schaafsma 1966:Figs. 6, 7); Fringed Mouth with his longitudinally bicolored face and body (P. Schaafsma 1966:Fig. 4; Olin 1979), various male and female Ye'i (Fig. 5); and Thunder (thunderbird) (P. Schaafsma 1966:Fig. 14). There are also the questionable figures that might be called Talking God and Calling God, and the one identified as Born-for-Water because of the inverted triangle on his mask (P. Schaafsma 1963:Pl. II); the latter could be Red God, who wears a mask with a similar triangle (see Haile 1947a:Figs. 7, 11). Petroglyphs found on a boulder along the Piedra River in Colorado (Dittert, Hester, and Eddy 1961:Fig. 71 lower; P. Schaafsma

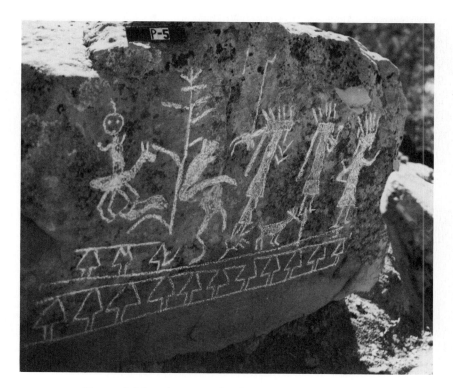

Figure 6. Navajo petroglyphs on a boulder along the Piedra River in Colorado, Upper San Juan District (1696–1775), with corn and figures like the *People with Long Hair* wearing tall feather headdresses, as in Mountainway sandpaintings, standing on a foundation bar with keystone-cloud symbols below it. From P. Schaafsma (1963:Fig. 53). Courtesy Polly Schaafsma and Museum of New Mexico.

1963:Fig. 53) show figures with appendages hanging down their backs that Schaafsma thought resembled the long, feathered headdresses of Plains Indians. These figures bear an extraordinary resemblance to those that appear in the Mountain Chant sandpaintings of *People with Long Hair* (compare Figs. 6 and 7).[5] Moreover, they wear tall feather headdresses characteristic of Mountainway sandpainting people, and the middle figure seems to be carrying a rattle. In addition, both arms are on the side of the body toward the direction in which they are moving. Along the base of the rock panel is a long foundation bar and below it a row of cloud symbols like those on which individual figures often stand in sandpaintings (Schaafsma called this merely a "decorative border"). The tall feather headdresses of the four figures shown in Plate IV of Schaafsma's 1963 monograph, and the headdresses of other figures scattered here and there among the Navajo pictographs, may also indicate an association with the Mountain Chant. Finally, the humpbacked figures without horns found in the Navajo Reser-

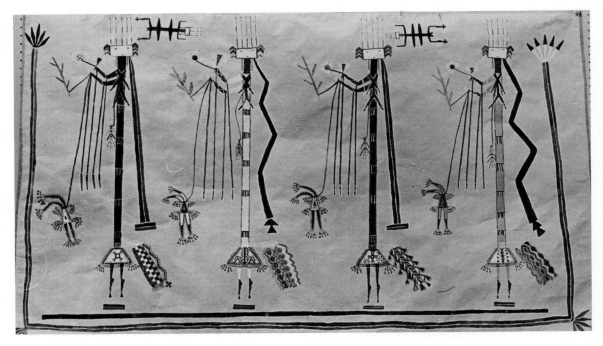

Figure 7. People with Long Hair wearing tall feather
headdresses, Mountainway (compare with Fig.
6). Courtesy Taylor Museum, Colorado Springs
Fine Arts Center.

voir District (P. Schaafsma 1963:Fig. 40) may
not be Humpback Ye'i, but the *People with
Packs* of Mountainway (Wyman 1971:Fig. 16;
1975:Figs. 19, 20).

The Navajo pictographs occur in groups,
but symmetrical compositions like those of
the drypaintings are conspicuously lack-
ing—unless the pair of figures surrounded
on three sides by a rainbow (P. Schaafsma
1963:Pl. II) or the figures in rows, with a
base line in one group (P. Schaafsma 1963:Pl.
IV, Fig. 53), may be regarded as composi-
tions corresponding to linear drypainting
compositions with foundation bars.
Schaafsma (1963:63) remarked that balanced
symmetry with emphasis on the directions
would be more readily developed in a hor-
izontal art such as drypainting than in a
vertical art done on the faces of cliffs.

We are now confronted by the question

of whether the designs as well as the tech-
nique of Navajo pictographs, and subse-
quently those of Navajo drypaintings, were
derived from Pueblo sources. Although older
by one or several centuries than either the
pictographs or any known sandpaintings,
the mural paintings discovered on the kiva
walls of the ancient Pueblo towns of Awa-
tovi and Kawaika-a, in the Jeddito River
drainage of the Hopi country of northeast-
ern Arizona, by the Peabody Museum Awa-
tovi Expedition (1935–39), and the kiva
murals found in the Pueblo IV village of
Kuaua, some eighteen miles north of Al-
buquerque in the Rio Grande Valley, pro-
vide us with more than suggestive hints.
These two groups of kiva paintings were
exhaustively discussed and illustrated in two
splendid monographs, by Watson Smith
(1952) and Bertha Dutton (1963).[6] Smith said

40

flatly, "There obviously exist many features of similitude between the Jeddito murals and Navajo sandpaintings," pointing out especially the "inescapable parallelism" between the face of a figure in a kiva mural and the mask of the Ye'i, Black God, of the Navajo Night Chant, and between what is without doubt a portrayal of the Hopi kachina, Ahül, with the inverted triangle on its face, and the mask of Born-for-Water, the "second born" of the Navajo Slayer Twins (Smith 1952:304, Figs. 28c, 79a; see P. Schaafsma 1963:Pl. II). Smith also expressed his belief that the descriptions of painted chamber walls in various canyons that appear in the myth of the Big Godway branch of Nightway are evidence that in early times the Navajos were well acquainted with Pueblo kiva wall paintings, since they themselves had no walls on which they could paint (Smith 1952:104; see also Matthews 1902:218 ff.).

Another group of Pueblo IV (A.D. 1300–1500) kiva wall paintings was found by the University of New Mexico summer field school in the site called Pottery Mound, some forty miles southwest of Albuquerque in the valley of the Rio Puerco, a tributary of the Rio Grande (Hibben 1955, 1960, 1967). A striking parallel is evident between the curved Rainbow Man of Pottery Mound (Hibben 1960:272, 274) and the extraordinarily similar figures of curved or whirling Rainbow People in the sandpaintings of several Navajo ceremonials (Wyman 1962:304–5, Fig. 43G).

Numerous other parallels could be pointed out between the figures in Navajo drypaintings and certain figures painted on pottery or stone slabs from prehispanic Pueblo sites.[7] Surely enough has been said, however, to establish an association between the two cultures. As a point of interest, it might be noted here that the nimble-minded Navajos

have no difficulty in correlating the figures in prehistoric kiva murals with their own supernaturals. Dutton (1963:40, n. 127) told how an old singer and his assistant identified the figures in the kiva at Kuaua in terms of Navajo mythology; she said that the Navajo wife of a Zuni man could do likewise.

Compared with the earlier Pueblo pictographs in the same area, the Navajo rock art is more complex, more realistic, and notably more dynamic, with motion expressed in linear sequences of progression, in the position of the limbs of figures (especially of the bison), and so on (Figs. 5, 6). The realistic, dynamic quality of Navajo paintings, as compared with Pueblo paintings, is still evident in the modern watercolor paintings on paper that are produced by both groups (Wyman 1959:25). Nevertheless, the style of the Navajo works shows strong Pueblo influences. Although it seems evident that the Navajos' concept of the appearance of their supernatural beings was influenced by Puebloan contacts, the supernaturals were substantially transformed in Navajo depictions. A comparison of the style of the pictographs with that of Navajo drypaintings, which had become crystallized at least by 1880 when the sandpaintings were first recorded, shows that the figures of the Navajo work were slimmed and elongated, natural body curves were eliminated, and there was less emphasis on realism, except for the depiction of certain birds, animals, and plants. The figures became more conventional and abstract, more angular—in fact, almost geometric. The abstraction and modification of these figures may serve to create physical distance, to invest the figures with an air of divinity remote from human experience, and to remove these objects of reverence from more profane contexts, as was done in Byzantine and

medieval religious art. Stylistically, Navajo pictographs therefore occupy an intermediate or transitional position between their Puebloan prototypes and recent drypainting art.[8] As time went on, Puebloan influences became less obvious, and although the eighteenth-century figures are within the tradition of modern sandpainting art in both style and subject matter, they represent Navajo art in a state of flux, before the rigid standards of religious art had been stabilized (P. Schaafsma 1963:66, 68).

Schaafsma (1963:66) concluded that the style of the Navajo pictographs is closer to that of the Kuaua murals in the Rio Grande Valley than it is to styles of kiva painting in other areas, suggesting that the art of the eastern Pueblos had the greatest influence on Navajo art and confirming Parsons's conclusion that the earliest Athapascan contacts were with the Tiwas, not with the Keres or the western Pueblos.

We can only speculate on the function of the early Navajo rock art, but since there is a remarkable concentration of pictographs in the neighborhood of the confluence of the Pinos and San Juan rivers in northwestern New Mexico (P. Schaafsma 1963:Fig. 2), a significant spot in Navajo mythology, it is likely that the pictograph sites were used as shrines, or at least were sacred spots. Moreover, according to a non-Navajo resident of the district, one of the sites was still used as a shrine until the 1950s (P. Schaafsma 1963:64). The confluence of the two rivers is known in Navajo mythology as River Junction (Waters Flowing Together), sometimes anglicized as Tho'hedlih, and was the eventual home of the Slayer Twins, Monster Slayer and Born-for-Water (Haile 1938b:138; Van Valkenburgh 1941:155; Wyman 1970a:xxii, n. 6, 58, 220). It is possible that some pictographs served as mnemonic devices. In Louisa Wade Wetherill's notes on her collection of sandpainting reproductions there is the statement, "The legend goes that [the Navajos] at one time put several of the drawings of paintings on the rock in a cave somewhere to the south of here [Kayenta, Arizona] so that even if they lost all of the medicine men in war or by some epidemic they would not lose all of the paintings" (quoted in Wyman 1952:13).

Finally we have to consider the apparent shift in the Navajo attitude toward making permanent representations of sacred themes. When and why did the Navajos cease making permanent records of their deities on the cliff walls and begin making them only in loose dry pigment, to be destroyed as soon as they had served their purpose? Is it not possible that because of pressure from the intrusive Spanish or Anglo cultures, the Navajos adopted the Pueblo custom of making impermanent drypaintings and gave up the practice of rock painting? The fact that Dorothy Keur found cached materials for sandpaintings in her excavations of late eighteenth-century Navajo hogan sites on Big Bead Mesa suggests that the shift in practice took place shortly after (if not before) the Navajos left their early homeland in northwestern New Mexico (Keur 1941:64, 70).

What the Navajos Say About the Origin of Drypainting

The Navajos have their own tradition about the origin of drypaintings. Their mythology tells us that the heroes and heroines of the origin myths undertook quests for ceremonial know-how. On these journeys they encountered supernatural beings who showed them the sacred pictures of the

chantways. They were told to study the pictures and remember them so that they could teach them to their people. The supernaturals' pictures were painted, according to various myths, on sheets of sky, cloud, or fog, and on deerskins, cotton blankets, or even spider webs (Mrs. Wetherill's notes on file at the Museum of Northern Arizona; Wyman 1952:56). In some accounts these pictures were said to be on "a sewing," or on a sheet of a substance referred to by the Navajo term applied today to embroidered Hopi fabrics (Matthews 1902:165). (Because of this, it has been suggested that sacred paintings on deerskin or on some other material were among the articles brought from the north by the ancestors of the Navajos, but there is no solid evidence for this hypothesis.) The supernaturals, however, refused to give their paintings to the Navajos lest they wear out or be stolen, soiled, or damaged; it was unthinkable to expose such holy objects to the hazards of everyday life on earth. Instead the Navajos were told to substitute an impermanent medium such as sand for making the pictures and to destroy them after they had served their purpose. For this reason, the Navajos have alway been very much opposed to photographing or copying sandpaintings in any permanent form; they have allowed this only occasionally, and usually only when tempted by considerable pecuniary persuasion. Washington Matthews (1897:45) said in his *Navaho Legends*, "No permanent copies of the pictures were ever preserved until the author [Matthews] painted them" (around 1884).

In the myths, the Holy People spoke:

If we give this (cotton) blanket (on which pictures were painted) to you, you will lose it. We will give you white earth and black coals which you will grind together to make black paint, and we will give you white sand, yellow sand, and red sand, and for the blue paint you will take white sand and black coals with a very little red and yellow sand. These together will give you blue (J. Stevenson 1891:278).

Next, four sheets of sky were brought forth. A white sheet was spread on the floor in the east; a blue sheet in the south; a yellow sheet in the west and a dark sheet in the north. On each of these was painted a picture, which the Navajo was told to study with care and remember. When he had done they rolled up again the sheets of sky and Nayenezgani said: "Such pictures you must teach your people to draw. They cannot do this on sheets of sky as we do; but they can grind to powder stones of various colors and draw their pictures on sand" (Matthews 1902:202).

The yéi who unfolded it to show the prophet said: "We will not give you this picture; men are not as good as we; they might quarrel over the picture and tear it, and that would bring misfortune; the black cloud would not come again, the rain would not fall, the corn would not grow, but you may paint it on the ground with colors of the earth" (Matthews 1902:165).

Another story (Mountainway) says, "They drew from one corner of the cave a great sheet of cloud, which they unrolled, and on it were painted the forms of the yays of the cultivated plants" (Matthews 1887:404).

In some accounts, pictures drawn by the supernaturals on black fog were thrown away to the north as sandpaintings are today, instead of being rolled up again and put away.

4

The Practice of Drypainting Art

A Record of Stability

Drypaintings are the means through which potent supernatural powers are made visible. In use they become the temporary residences of divinity. Thus, mishandled or incorrectly made drypaintings are not only ineffectual sacred instruments, they are extremely dangerous. For safety's sake, then, the range of drypainting designs has been frozen within traditional limits; the Indian artist works within a limited range of possibilities. This does not mean, however, that novelty was or is flatly rejected. The innumerable combinations of a limited number of symbols, producing many designs that appear distinct to non-Indian eyes, are evidence of much ingenious creativity in the past. Perhaps we have overemphasized compulsive correctness in Navajo ritual art. Most of this lateral variability within the confines of sanctioned style must have been achieved before the end of the nineteenth century, however, when Matthews and Stevenson made and published the first records. Since then there has in fact been remarkable stability.

Besides the variety produced by daring selection and subtle use of details, and the unexpected twists, there is also some evidence of local styles, of what might be called different "schools" of sandpainting. Reproductions of sandpaintings collected from nearly all parts of the Navajo country exhibit a style so uniform that we might call it standard style (Wyman 1952:15). Among the reproductions, however, may be seen slight deviations from this style that correspond to differences in local provenience. Although the decidedly unorthodox designs drawn by Mrs. Wetherill's informant, Sam Chief, were undoubtedly idiosyncratic, perhaps because the artist feared punishment if he made them too accurately, Clyde Kluckhohn did recall seeing actual sandpaintings on Black Mesa, only some twenty airline miles from Kayenta, that had the same curvilinear plant motifs as did Sam Chief's drawings. In my studies with Flora L. Bailey of representations of insects in sandpaintings (Wyman and Bailey 1964:138–45, Pls. II–IV), we also found at least two regional styles, one in the area east of Gallup, New Mexico, the other in the southeastern portion of the Arizona reservation. All these variations are minor, however, in the face of the stability to be described, a stability which is remarkable in a complex art trans-

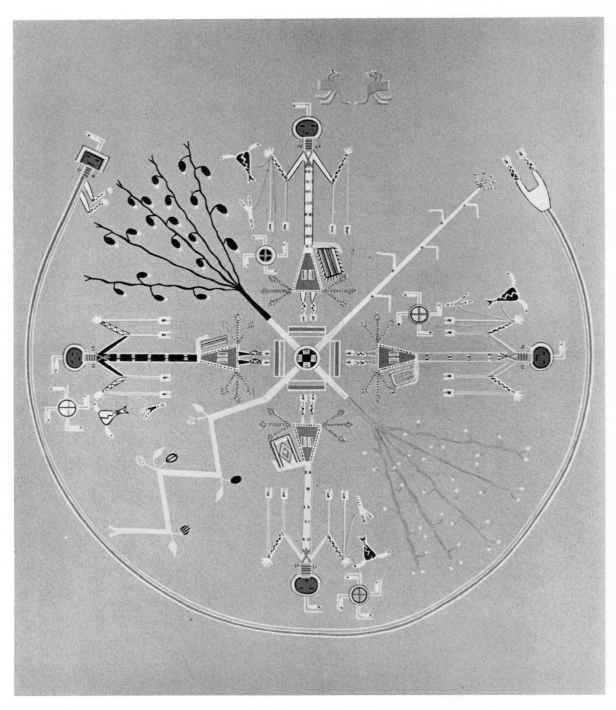

Figure 8. People of the Myth, Mountainway, recorded in 1884. From Matthews (1887:Pl. XVII). Photograph, Martin Etter.

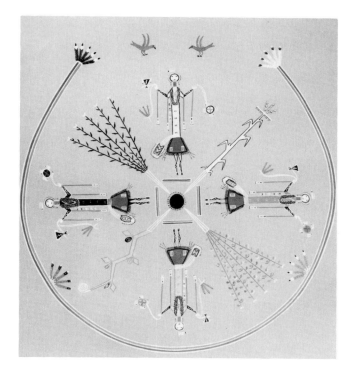

Figure 9. People of the Myth, Mountainway. Compare this design recorded about 1935 with the same one recorded in 1884 (Fig. 8) for a record of remarkable stability. Courtesy Wheelwright Museum. Photograph, Herbert Lotz.

mitted through apprenticeship and without permanent records.

There is an amazing similarity between the sandpainting designs for the Mountain Chant witnessed by Washington Matthews in 1884 and those for the Night Chant seen by James Stevenson in 1885, and paintings of the same subjects made over the years up to the present day (Figs. 8, 9)—a record of stability for almost a century.[1] Matthews, writing in 1887 and again in 1897, said that

he did not believe the pictures were transmitted unaltered from teacher to pupil, the designs being carried "in the memories of fallible men," although he did admit that if changes occurred they "were unintentional and wrought slowly" (Matthews 1887:445–46; 1897:45). Alfred Tozzer did not share these doubts, because a sandpainting of the Fringed Mouths of Nightway, which he saw in 1901 at least a hundred miles to the east of the locality where Matthews worked, was

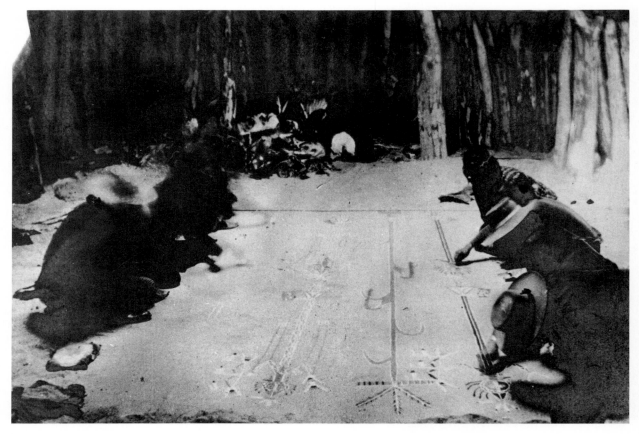

Figure 10.

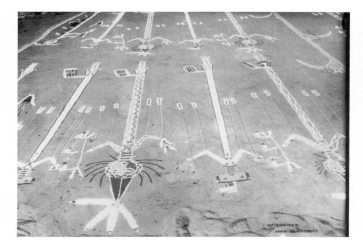

Figure 11.

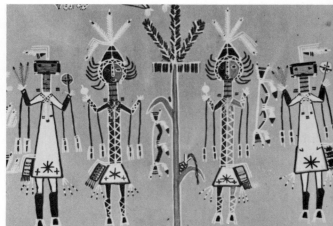

Figure 12.

48

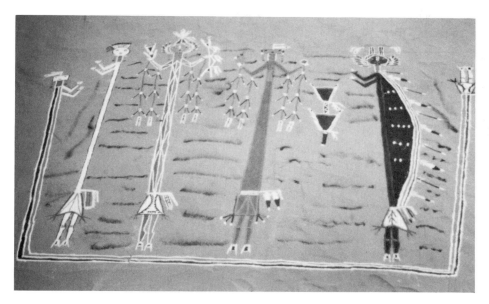

Figure 13. Four Ye'i, Nightway. Left to right: Talking God, Fringed Mouth, yellow female Ye'i, Humpback. Thin (summer) clouds of powdered charcoal to bring rain in background. Photograph, L. C. Wyman, Navajo Craftsman Exhibit, Museum of Northern Arizona, July 1967.

Figure 10. Navajos making the *Fringed Mouths with Corn* sandpainting from Nightway; singer's equipment in the background. Photograph, John F. Lime, 1894–1904. Comparison of the design with those of Figs. 11 and 12 again brings out the record of stability of this art. Courtesy Smithsonian Institution, National Anthropological Archives.

Figure 11. Portion of sandpainting of *Fringed Mouths with Corn* from Nightway. Courtesy Franciscan Fathers, Cincinnati, Ohio. Photograph, Brother Simeon Schwemberger, Saint Michaels Mission, Arizona, 1901–5.

Figure 12. Detail from a sandpainting of *Fringed Mouths with Corn* from Nightway, 1929 or 1930. Courtesy Etnografiska Museet, Stockholm, Sweden.

exactly like the one witnessed by Matthews some twenty years before (Tozzer 1909:328–29, Pl. IV).[2] Now we can reinforce Tozzer's observation with paintings of the same subject made between 1894 and 1904 (Fig. 10), around 1905 (Fig. 11), in 1929 or 1930 (Fig. 12), in 1961 (Plate 2), and in 1967 (Fig. 13), a span of around seventy years.

The same similarity may be seen between paintings in the Wetherill collection made between 1910 and 1918 (Wyman 1952:11), in the Huckel collection made from 1902 to 1905 (Wyman 1971:27), in the Walcott collection made between 1905 and 1912 (Wyman 1970b:30), a few in the Haile collection from 1908, a pair of unpublished photographs made by Brother Simeon Schwemberger around 1902 (archives of Saint Michaels Mis-

sion, Arizona, and the Museum of Northern Arizona, Flagstaff), and paintings of more recent date, up to the 1950s and even later. From a study of ten recorded versions of the Shooting Chant sandpainting called *Sky-reaching-Rock,* or the double sandpainting—one of the more complex designs of this art—well spaced in time (1905–57) and provenience (Newcomb, New Mexico, to Oljeto, Utah, to Tuba City, Arizona), I concluded that the variations were no greater than those seen at any one time among works by different singers—another record of remarkable stability in design over a period of around fifty years (Wyman 1970b:37–40, Pls. 9–16; Olin 1979:157). In fact, the two versions of this design in the Walcott collection (nos. 10, 11) made by the singer, Big Left-handed, presumably at approximately the same time, differ from each other almost as much as they do from those of later singers. Such variations as do occur are taken as evidence of the lack of precise standardization in Navajo ceremonialism and as a manifestation of characteristic Navajo flexibility—evident also in their social organization—that promotes persistence rather than change (Aberle 1963; Shepardson and Hammond 1964:1049).

The Number of Drypainting Designs

No one knows—not even the Navajos—how many different drypainting designs are known and used today, let alone how many have slipped from the memory of the singers through the obsolescence of the pertinent chants. In the notes accompanying Mrs. Wetherill's ethnobotanical collection, a sandpainting for the Raven Chant is mentioned (Wyman, 1951:44), and Mrs. Newcomb once said that she had reproductions

of a sandpainting for this chant as well as for the Dog Chant. Mrs. Armer recorded two and had notes for another painting for Awlway, and Maud Oakes recorded four paintings for Earthway. These paintings are in the Wheelwright Museum (formerly the Museum of Navajo Ceremonial Art) in Santa Fe. All Holyway chants except Excessway are known or are alleged to have used sandpaintings; most or perhaps all of the Evilway chants have or had them; and Blessingway rites employ drypaintings made of pigments of vegetable origin. For some chants, such as Hand-tremblingway and Eagleway, scarcely more designs are known today than the four needed for a five- or nine-night performance; for others, such as Shootingway, there may be around a hundred, although a Navajo count might be closer to fifty. Between five hundred and a thousand designs that would appear different to us, recorded by white artists and a few Navajos, are in collections (see Appendix C), so possibly around a thousand designs that we would distinguish from one another are known to the Navajos, but their estimate of the number would be much smaller.

The difficulty in precisely estimating the number of designs stems from the fact that Navajo criteria for likeness and difference vary greatly from ours. In making our own enumeration of distinct designs, it is hard to say just what features should qualify a design as distinct from others. For example, a count of 52 different designs among 133 reproductions of sandpaintings for Navajo Windway results from distinguishing radial from linear compositions, partially armored People from fully armored People, sun symbols from moon symbols, vertical rainbow bodies from horizontal ones, cactus plants from Cactus People, ascending cactus

branches from horizontal ones, cactus blossoms from cactus fruit, single-headed Cloud or Cactus People from their many-headed counterparts; and from differentiating paintings on the basis of the type, number, and location of the subsidiary symbols they contain. Discounting these differences and counting only the principal types of main theme symbols, however, discloses only 25 different designs (Wyman 1962:Table 9). Who is to say whether Sun and Moon with rays, guarded by snakes, clothed in snakes, or with Pollen Boy or Ripener Girl, constitute three, five, six, or ten different designs? If one took into account differences in numbers, shapes, and positions of body parts and decorations, objects carried by People, symbols under feet, horns, body markings, branches of plants, perching birds, foundation bars separate from or incorporated in the guardian, types of encircling and paired guardians, shapes of heads, colors of faces, direction of movement, color sequences, and countless other details, one could say that there are hardly two sandpaintings alike. Using the types of main theme symbols as criteria, I roughly estimate that there are 153 main themes used to form 228 different designs among some 851 reproductions of Holyway sandpaintings in collections.

Now let us see how a Navajo would categorize these paintings. One native criterion is merely the main theme symbol. For instance, the four buffalo sandpaintings published by Newcomb and Reichard (1937:Pls. XXIII–XXVI), and a number of others not illustrated in their book, would appear quite different to white American eyes, but would be all the same to the Navajos: they are all buffalo paintings. If paintings depict the same supernatural beings, they are the same in Navajo eyes. Another Navajo criterion is the purpose for which

the painting is used. Thus, slight differences which might be entirely overlooked by us— such as a shift in the relative position of two colors in a symbol, a red tongue on a snake instead of the usual yellow one, a red spot on the snake's head, or single instead of double red lines across the blue neck of a figure—would constitute important differences to the Navajos, for they shift the purpose of the painting from attraction of good to exorcism. A lapse in attention to such details that we would not notice would be most upsetting to the Navajos. In summary, then, a Navajo estimate of the number of sandpainting designs would be very much smaller than one made by us, no matter which of our criteria were used.

The Size of Drypaintings

Drypaintings have been reported to range in size from a few inches to over twenty feet across. The sandpaintings made for chantways (other than the small ones made for sweat-emetic ceremonies and so on, which measure approximately a foot) vary from a foot or two in diameter—as in the paintings of the Sun or Moon made for Chiricahua Windway (see Kluckhohn and Wyman 1940: Figs. 19, 20)—to the great creations for the nine-night chants in winter that require specially built large ceremonial hogans to contain them (Figs. 14, 15; also see Fig. 10). In his monograph on the Night Chant, Matthews (1902) said that the largest sandpaintings he saw were ten to twelve feet in diameter. Moreover, from James Stevenson's descriptions of Nightway paintings (1891), it appears that the largest paintings he witnessed were around twelve feet across, so the reports of twenty-foot paintings may have been somewhat exaggerated (see Jean-

çon and Douglas 1932:3). The size of the average sandpainting is limited, of course, by the size of the floor space in the family hogan where the chant takes place, so it is usually about six to eight feet across.

The size of the meal and pollen paintings of Blessingway rites, when made on buckskin or cloth, is limited by the size of the skin. When made on the ground, they may compare in size with chantway sandpaintings, although they are usually smaller, and designs as small as two or three inches in diameter are made for personal or family prayer rites.[3] The designs of Blessingway drypaintings are often strewn upon a buckskin laid down with its head toward the east (see Wyman 1971:Fig. 11), or if a hide cannot be obtained or afforded, upon a cloth substitute. Paintings on buckskin are sometimes used in supplementary prayer ceremonies such as the liberation prayer on buckskin performed as a continuation of a big hoop ceremony (Wyman 1973:40; Reichard 1970:672). If a buckskin or cloth background is lacking, a painting may be made on the ground, either in the hogan or outside; in a corral or on the path to it, to bless the livestock, or in a field to bless the crops (see Kluckhohn 1944:130). Drypaintings are rarely made for Blessingway—usually only for special types of rites—or, as Kluckhohn thought, for special prayer ceremonies. The sponsor or person for whom the rite is being given, such as a man leaving for war, usually stands upon the painting, rather than sitting as in chant practice.[4]

The Dry Pigments

The pigments for the majority of the so-called sandpaintings of the Holyway and Evilway chantways are five or six in number. These are white, blue, yellow, black, and red; when anthropomorphic symbols are shown unmasked so that the natural skin color of their faces can be seen, it is represented in brown. Occasionally seven colors are used—that is, when pink is needed for certain symbols, such as the Thunders in Shooting Chant sandpaintings.

White, yellow, and red pigments are obtained by grinding sandstones of these colors to a fine powder on a metate, or grinding stone, such as is used for grinding cornmeal. Black pigment is made by grinding charcoal with enough red or ordinary sand, preferably dark colored, to facilitate grinding and give the product some body and weight, so that it will pour easily. A similar mixture of sand with materials such as red and yellow ochers—which would be too powdery otherwise—might be used, but this is not common. The charcoal must be prepared from the root of hard oak (*Quercus undulata* Torr.) for all chants except Nightway, where any kind of wood—such as piñon pine—may be used. Blue pigment is a mixture of white sand and charcoal; this, of course, is really gray, but surprisingly enough it gives the effect of a soft gray blue in combination with the other colors in a sand-

Figure 14. Large, conical (interlocked forked pole) hogan made for a nine-night winter ceremonial; blanket over the doorway. Courtesy Franciscan Fathers, Cincinnati, Ohio. Photograph, Brother Simeon Schwemberger, Saint Michaels Mission, Arizona, 1901–5.

Figure 15. Another view of the large, conical hogan shown in Fig. 14. The interlocked forked poles may be seen protruding from the smokehole. Courtesy Franciscan Fathers, Cincinnati, Ohio. Photograph, Brother Simeon Schwemberger, Saint Michaels Mission, Arizona, 1901–5.

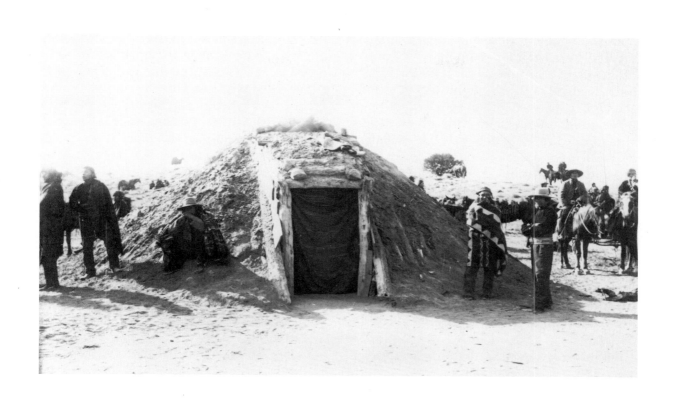

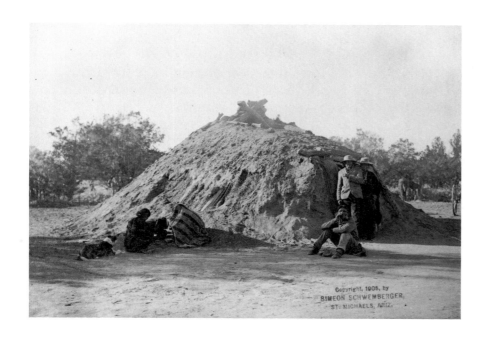

Copyright, 1906, by
SIMEON SCHWEMBERGER,
ST. MICHAELS, ARIZ.

painting.[5] Brown pigment, which is used relatively sparingly, is usually a mixture of charcoal and red sand, but Reichard (1939:25) said it is made of red, white, and yellow sand. She also said that pink is made by mixing red, white, tan, and yellow sands, sometimes with a touch of black (Reichard 1970:210), although ordinarily a mixture of red and white sand would no doubt suffice. Pink is said to represent sparkle, or a reddish, shimmering quality of light. These colored pigments are strewn on a background of clean, usually tan-colored, ordinary local sand, which is gathered in a cornfield or other place, brought into the ceremonial hogan in a blanket or a piece of burlap sacking, spread out in a layer from one to three inches thick, and smoothed with an oak weaving batten.

All materials for making sandpaintings are provided by the sponsor or the patient's family, not by the singer. The pigments are ground at the northeast side of the ceremonial hogan near the eastern door, usually by a woman past childbearing age so as to avoid the danger of prenatal infection from the ceremony. A younger woman or a man should be protected by the possession of a token from a chant in which she or he was sung over. Mrs. Newcomb said that only a relative or close friend will perform this task because it is considered unlucky, and that upon completion of the work the singer prays for the grinder and sprinkles pollen upon his or her hands and arms (Newcomb, Fishler, and Wheelwright 1956:4).

The Navajos have their own explanation for the origin of sandpainting pigments: when Monster Slayer shattered the Traveling Stone (a monster that destroyed people by rolling over them), pieces flew in all directions and became various kinds of rocks. Its bones became white rock, its flesh blue,

its hair black, its mouth and blood red, its intestines yellow (Matthews 1897:125; Reichard 1970:207, 487; Wyman 1970a:567–69).[6]

The pigments used in Blessingway rites or in rites derived from or associated with them, such as the obsolete rain ceremony, and the pigments employed in the paintings of the War Prophylactic rite published by Oakes, Campbell, and King (1969) are not sand but are mostly, and often entirely, of vegetable origin (see Reichard 1970:666–72; Wyman 1970a:65). These include cornmeal of various colors (usually white or yellow); corn pollen or the yellow pollen of other plants such as cattail flag or pine trees; dried and pulverized flower petals, especially from blue flowers such as larkspur, which is called "blue pollen" (powdered flower blossoms are all called "pollen"); and charcoal.

Drypainting Techniques

To provide space for a sandpainting, the ceremonial hogan is cleared of family belongings and swept, and the fire is moved from the center toward the door, where it may be kept burning east of the painting throughout the ceremony. An ordinary family hogan is not big enough to accommodate some of the large sandpaintings made in the nine-night winter ceremonials, so a special structure with a floor space thirty or more feet across may be built to serve as a ceremonial hogan for such a chant (Figs. 14, 15).

The prepared pigments are put on pieces of bark (usually from ponderosa pine), or on pieces of cardboard; today modern containers such as china saucers or plates may be used. With these close at hand on the floor beside them, one or more helpers kneel or sit and begin the work, under the direction of the singer (Figs. 16–19, Plate 3). Any-

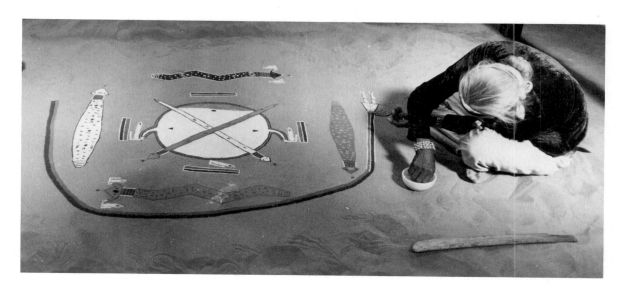

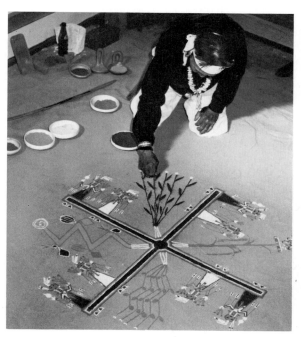

Figure 16. Singer taking dry pigment from a container while making the sandpainting *Moon Clothed in Snakes* from Navajo Windway. An oak weaving batten for smoothing the background is in the right foreground. Courtesy Museum of Northern Arizona. Photograph, Parker Hamilton, Navajo Craftsman Exhibit, Museum of Northern Arizona, Flagstaff, July 1959.

Figure 17. Singer making the tobacco plant in the sandpainting *Whirling Logs* from Nightway. Courtesy Museum of Northern Arizona. Photograph, Paul V. Long, Jr., Navajo Craftsman Exhibit, Museum of Northern Arizona, August 1963.

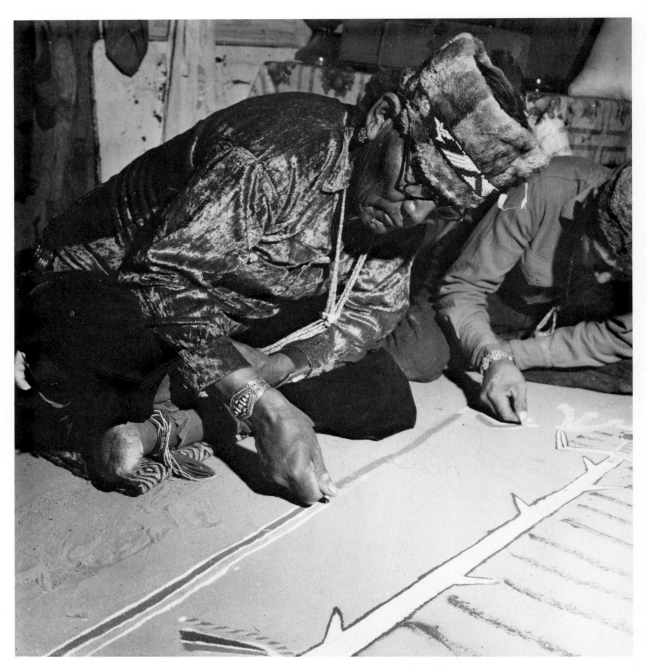

Figure 18. A singer (Jim Smith) and assistant make
one of the Slayer Twins in a sandpainting for
Male Shootingway. Photograph, John Collier, Jr.

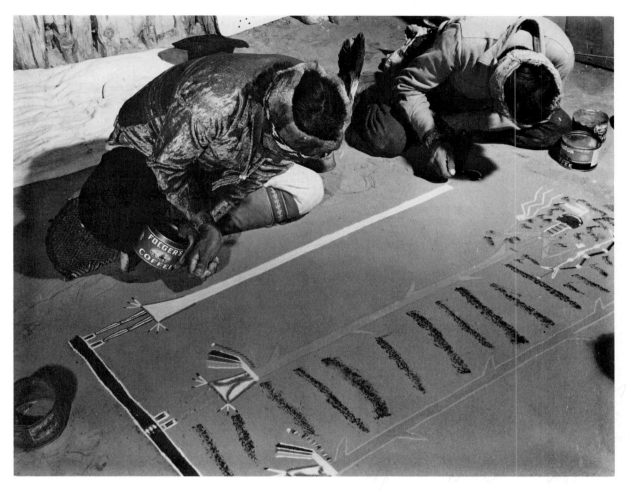

Figure 19. Singer making the Rainbow guardian
for a sandpainting of the *Slayer Twin Quartet,*
Male Shootingway. Photograph, John Collier, Jr.

one who knows how or wishes to learn may participate, but it is felt that it is dangerous for a Navajo to take part who has not been sung over at least once. The number of hands and the time required to make a sandpainting depend upon its size and complexity. A small, simple painting a foot or two across may be completed by one or two men in an hour or two. The average chantway sandpainting, usually about six feet across, re-quires the labor of four to six men working three to five hours. A large complicated one—such as those often made in the nine-night ceremonials in the winter—may be made by as many as a dozen helpers working from morning until late afternoon. Popular descriptions of the skill of Navajo sandpainters, usually based on seeing specially chosen experts work in public demonstrations at fairs and so on, have been romanticized.

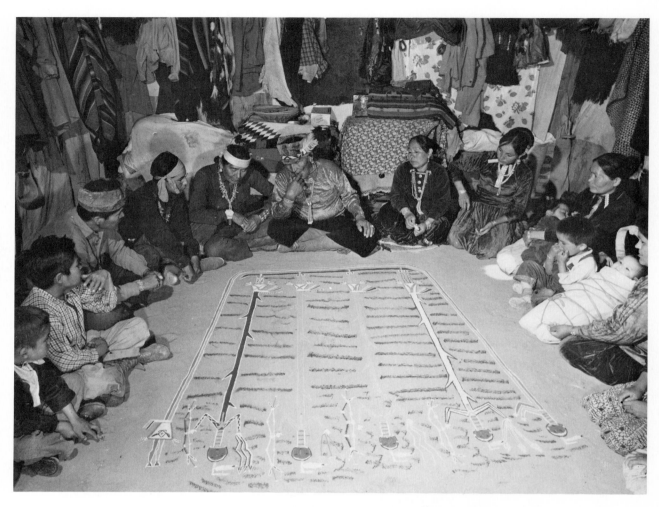

Figure 20. Completed sandpainting of the *Slayer Twin Quartet*, with encircling Rainbow guardian open to the east. Around the wall of the hogan sit the singer wearing his fur headband, studying the finished work for errors, and men and women in their accustomed places. Photograph, John Collier, Jr.

White men who have been allowed to participate in actual ceremonials have found that with a steady hand and a fair eye for accuracy, a passable competency may be picked up quite easily.

The singer conducting the ceremonial usually does not take part in the process of painting, except to lay out some preliminary guidelines, or perhaps to make an especially powerful symbol in the center to start the picture. Instead he sits in his customary place on the west side of the hogan, a little south of the center, and directs and criticizes the work (Fig. 20). On one occasion a singer was even seen to direct the making of a sandpainting from a seat under a shade outside the hogan. Mistakes in painting are corrected, not by erasing them but by covering the faulty area with background sand and painting anew on top of it. Layers of sand are superimposed in other instances, for example, when figures are to be shown clad in special costumes, flint armor, and the like, or the Long Bodies of the Mountain Chant are dressed in their four or five extra skirts (Wyman 1975:Figs. 21–23). The slim, straight bodies of the figures are painted first (in appropriate directional colors) as if naked, and the skirts or armor are then superimposed on them (Wyman 1975:Fig. 24). The patient in a curing ceremonial is not present while a sandpainting is being made unless he is learning the ceremonial, and then he may even help.

Unless the painting is to be a small one across which the painters can easily reach, they begin making figures in the center of the picture and gradually work outward, smoothing new areas of background sand with the weaving batten as they move away from the center. The designs are drawn by taking pinches of dry pigment from the bark receptacles; the pigment is held between the thumb and the flexed forefinger and is trickled onto the background by moving the thumb over the first two fingers (Figs. 17–19). The straightness of the fundamental lines in a painting—such as the long, slender bodies of symbols for People—is ensured by two helpers who take a piece of string, align it by eye, draw it taut, and snap it on the background so that it makes a line. A string is sometimes used to measure a figure already made and to mark off the position of a new figure of the same size. Measurements are also made by palms and spans. All symbols are drawn according to precise traditional rules carried in the mind of the singer, although helpers who have often taken part in making certain paintings usually have them well in mind and can work with a minimum of direction. In very few places may the painter indulge his fancy. Only in the depiction of the pouches suspended from the waists of anthropomorphic figures is painterly imagination commonly exercised; these may be made as handsome as the painter wishes.

5

The Nature of Drypainting Designs

This chapter attempts to dispel the mystery felt by a non-Navajo observer confronted for the first time by an apparently complex mélange of unfamiliar design elements. First, violating a fundamental Navajo principle—that all things in the universe are of equal importance—the outstanding parts of a drypainting are designated main theme symbols and subsidiary symbols. This distinction is made solely for analytic convenience. The former are those that give the name and principal symbolic meaning to the picture and are the ones a Navajo would select when he states the nature of the picture. The latter, no less important in Navajo eyes, seem less important to us because they are usually smaller than the main theme symbols and are tucked into the quadrants of a radial design or drawn parallel to or above or below the main themes in a linear arrangement. The composition of the design—linear, radial, or extended center—again has much less significance for the Navajos than for us. For the Navajos a radial design may permit the introduction of elements that could not be shown in another arrangement, but it is fundamentally the same as any other composition having the same main themes. To us, however, different modes of composition may produce a wealth of "different" designs.

Guardian symbols delimit, enclose, and protect the space occupied by the design, making it manageable, but they nevertheless, by certain conventions, provide for the exchange of evil and good with the outside world. The symbolism of number, of place or locality, of sex, of motion, and of direction—matters of considerable moment to the Navajos but much less obvious, often even invisible or unnoticeable to our eyes—will be discussed. In drypaintings, colors, too, hold meaning; they may be used to indicate gender or (perhaps more properly) male or female varieties of "power," but it will be seen that this symbolic usage is sometimes confusing, maybe even to a Navajo. The use of color to symbolize the properties of the compass directions, however, is much more standardized. In the concluding portion of this chapter the artistry and psychology of Navajo drypaintings are discussed, but of necessity and unfortunately in terms of our own aesthetic and psychological criteria. Although attempts are made to evaluate such matters through Navajo eyes and minds, we have not yet penetrated far enough into Navajo consciousness to do so adequately.

Main Theme Symbols

The principal elements in a Navajo drypainting are representations of the human protagonists who appear in the origin legend belonging to the ceremonial; the supernatural beings they encounter in their adventures, who instruct them in ceremonial procedure; important etiological factors associated with the ceremonial; or other powers connected with the chant or rite through its myth or through Navajo belief. These symbols represent Holy People, always thought of as human in form, or perhaps more often as anthropomorphized powers drawn from the countless number in the Navajo world—animals, plants, natural phenomena, geophysical features such as mountains, or even material objects. Thus, the Navajos depict Snake, Bear, Horned Toad, Ant, Cactus, Corn, Lightning (Thunders), Wind, Hail, Arrow, and many other kinds of "people." Certain animals such as bison, game animals such as deer or antelope, porcupines, reptiles such as horned toads or Gila monsters, various birds, eagles, hawks, and so on, are often shown in more or less naturalistic forms. Corn plants or Corn People often appear as main theme symbols in drypaintings (see Fig. 102, Plate 20). Then there are standardized symbols for mythological creatures such as Water Monster, Big Fly, and Big Snake; heavenly bodies—the Sun, Moon, and stars; Emergence Place; and Earth and Sky themselves. The relation of these symbols to various rites and chantways will be discussed later.

Subsidiary Symbols

Accompanying the main theme symbols, important subsidiary symbols are frequently depicted, particularly in radial designs. Probably we should call them symbols less immediately essential to the theme of the specific drypainting, because in Navajo eyes every item in their universe—even the tiny helpers, Big Fly and Ripener Girl, who are mythified insects—are as necessary to the harmonious scheme of things as are the great Slayer Twins, children of the Sun. In the vast majority of instances, these subsidiary symbols are the four sacred domesticated plants: corn, beans, squash, and tobacco (Figs. 17, 21, Plates 4, 8). Sometimes only one of these plants, most often corn, appears as a subsidiary symbol; sometimes several (usually four) are used. A small bird, or a pair of birds, may perch on top of each plant or only on the corn (Fig. 21). These may be yellow-headed blackbirds, yellow birds (goldfinch, yellow warbler), bluebirds, western tanagers, swallows, or some other bird. When only one kind of bird is depicted, it is usually a bluebird. Of the food plants, corn, symbol of fertility and life, is the most important (Wyman and Newcomb 1962:45–50). Mrs. Newcomb said, "Of the cultivated plants, corn takes precedence above all others . . . and there is no ceremony that does not use some symbol of corn" (Newcomb, Fishler, and Wheelwright 1956: 17). The Blessingway rite makes much of corn and everything associated with it (Wyman 1970a:78).

Among other subsidiary symbols, unspecified medicine herbs are perhaps most commonly depicted (see Fig. 103, Plate 5). Arrows or arrowpoints, clouds or Cloud People, Cactus People, coiled snakes, and mountains are seen more than once (Plate 13). Still other symbols occur infrequently or perhaps in only one or a few designs, and some are confined to the drypaintings of a single chant; anthills and horned toads, for example, appear only in paintings for Red Antway. This chant, unike most others,

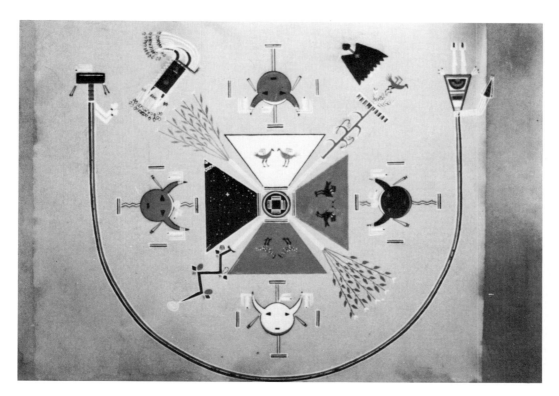

Figure 21. The Skies (trapezoid form), Male Shootingway, with corn, beans, squash, and tobacco as subsidiary symbols. Unique in that the Sun, Moon, and Winds are outside the Skies instead of in their usual inside position. Courtesy Arizona State Museum.

does not use the four domesticated plants; in fact, its subsidiary symbols are quite variable (see Wyman 1973:229). In sandpaintings of snakes or Snake People, as in numerous Shootingway paintings, the subsidiary figures are likely to be one of the varieties of snakes shown as main themes; either singly or in pairs or quartets. Sometimes subsidiary figures are animals or other symbols that pertain specifically to the chant for which the sandpainting is used, such as weasels in Beautyway paintings or dancing feathers in baskets for Mountain-Shootingway paintings (Wyman and Newcomb 1962: Fig. 5; Wyman 1970b:25–27, Pl. 24).[1] It follows that such symbols would not be seen in designs used for other chants. Another practice is to use as subsidiary symbols figures that appear as main theme symbols in other sandpaintings of the same chant. Thus, in Navajo Windway sandpaintings we find Cloud People as subsidiary symbols in a Cactus People painting and Cactus People in a Wind People design (Wyman 1962:Figs. 8, 49). Mrs. Newcomb said that when there is a place or locality symbol in the center of a sandpainting, the subsidiary symbols belong to it, whereas the main theme symbols "represent the immortals or powerful forces expected to arrive at the ceremony coming from the four directions" (Newcomb, Fishler, and Wheelwright 1956:9).

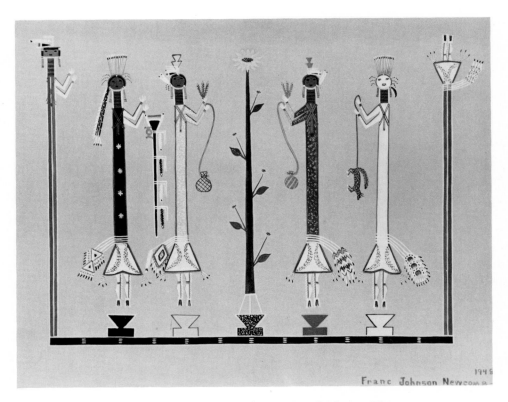

Figure 22. Ye'i with Sunflower, Big Godway. This linear composition has a sunflower plant in the center with Talking God and blue "misty" Water Sprinkler approaching it from the south and Calling God and yellow Water Sprinkler coming from the north. Courtesy Wheelwright Museum. Photograph, Martin Etter.

Composition

The main theme symbols, with a few exceptions, are arranged in drypaintings according to one of three types of composition: *linear,* with the symbols in a row, or several rows one above another, and the symbols repeated to increase their power, often standing on a foundation or locality bar (Fig. 22, Plate 6); *radial* or circular, with the main theme symbols cardinally oriented in the form of a Greek cross and with the subsidiary symbols in the quadrants in the form of a Saint Andrew's cross, around a central symbol of place or locality (see Fig. 9, Plates 5, 7, 8); and *extended-center,* with an enlarged symbol or group of symbols occupying most of the design (Figs. 23, 24). The first two predominate in chantway sandpaintings, with radial compositions prevalent, whereas in the drypaintings of the Blessingway rites the extended-center type is most common. For instance, in 35 recorded Red Antway sandpaintings, there are 16 radial, 14 linear, and only 5 extended-center compositions; of 225 reproductions of Shootingway paintings, 128 are radial, 56 are linear, and 41 are extended center; but among 50 Blessingway

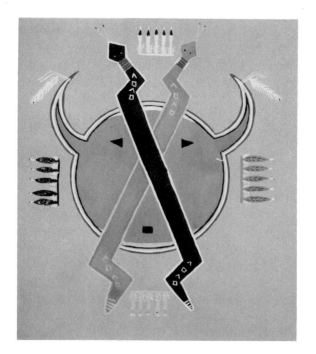

Figure 23. *Sun Clothed in Snakes*, Mountain-Shootingway. Extended-center composition showing black male and blue female snakes on blue Sun. Guardians are groups of five eagle (east; top), hawk, and magpie tail feathers. Courtesy Museum of Northern Arizona.

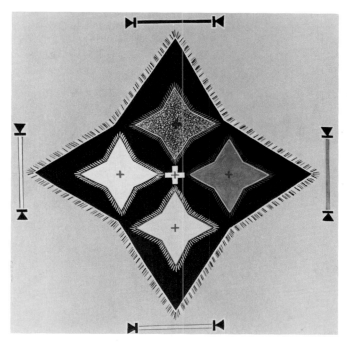

Figure 24. *Four Stars on Black Big Star*, Big Starway. Extended-center composition with sparkling (winking) star at the east (top), fire symbols (crosses) on stars. Guardians are shafts of light and darkness. Courtesy Wheelwright Museum. Photograph, Martin Etter.

drypaintings, 32 have the extended-center composition, and only 12 are radial, and 6 linear.

Although single figures or pairs may occur in drypaintings, especially in extended-center compositions, multiple pairs are the usual arrangement. Two pairs are most commonly depicted. The members of a pair are called male and female, sometimes implying biological sex but often indicating differences in power—stronger and weaker, dominant and submissive, active and passive. In four-figure groups, the male and female elements usually alternate.

The multiplication of pairs into quartets (or multiples thereof) may involve the principle of multiple selves: the ability of the supernaturals to appear simultaneously in several places, often under different names and in a variety of guises. Thus the Navajos span time and space in their myths and achieve rhythmic elaboration, balance, symmetry, and contrast in their drypaintings. Moreover, repetition of figures, one of the commoner symbolic devices, enhances their power and authority. So when space, time, the number of helpers, and the resources of the sponsor permit, the number of main

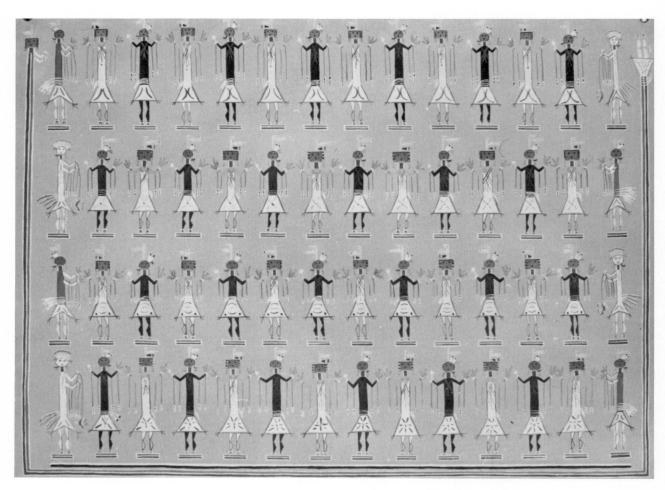

Figure 25. First Dancers, Nightway. Twenty-four pairs of male and female Ye'i with Talking God leading and Water Sprinkler following each of the four lines of six pairs, fifty-six figures in all, an example of repetition to enhance power. Courtesy Museum of Northern Arizona.

theme symbols in a sandpainting may be increased to sixteen, twenty, or even forty or fifty-six (Fig. 25, Plate 10). This proliferation of figures can be accomplished only in linear compositions. In radial pictures the main theme symbols in the cardinal positions occur singly, in pairs, or at most in quartets in each direction (see Fig. 9).

In an extended-center composition, when a single symbol is very much enlarged, its bigness is an abstraction indicating a whole standing for several of its kind. This was pointed out by Reichard: "A large central cornstalk represents all corn, a huge Thunder (with small Thunders painted on it) all thunders" (Reichard 1970:179; 1939:Frontispiece; Newcomb and Reichard 1937:Pl. III). The big twelve-eared cornstalk symbol will be discussed in Chapter 6 (see Figs. 26, 85) (Wyman and Newcomb 1962:Fig. 6).

The numbers of symbols just discussed are mostly even, with four—a number loaded with cosmic, directional, and geographic significance—predominating. Even numbers betoken blessing and divinity, whereas odd numbers, as commonly required in Evilway ceremonials, signify evil and harm (Reichard 1970:244–45). Reichard said, however, that the number five is transitional between good and evil and may even be a good number. The main theme symbols in some sandpaintings of Beadway occur in sets of five, and Reichard attributed this to the fact that they were representations of predatory hunting animals—hunting, like war rites, implying exorcistic Evilway procedures (Reichard 1939:Pls. VI, VIII). Odd numbers, especially three and five, are common in the subsidiary symbols in sandpaintings and also in the apurtenances of main theme symbols. Subsidiary symbols such as beans and tobacco, medicine herbs, feathers, and arrows occur in groups of five;

objects carried in the hands of people or deities such as sprigs of trees, stalks of plants, or lightning arrows are three or five in number; and the tassels on the skirts of people, and the roots and tassels of corn plants are usually in threes.[2]

After a sandpainting has been completed, the singer sometimes fills all vacant spaces in the background with wide, thinly strewn, wavy, horizontal black lines made by scattering powdered charcoal rather casually with rapid strokes. These are called thin clouds or summer clouds, and they are said to bring rain, so they are made especially if the weather has been dry. They are also said to add power, making the painting a living, potent, and dangerous thing. They have nothing to do with the design; in fact, they disfigure the composition somewhat (see Figs. 13, 20, Plates 2, 3). Matthews (1887:451) said that since men cannot paint on clouds as did the supernaturals, "they do the best they can on sand, and then sprinkle the sand with charcoal . . . to represent the cloudy scrolls whereon the primal designs of the celestial artists were painted." Sometimes streaks of several colors are used (Plate 9).

Guardians

A compositional feature of the great majority of sandpaintings that first impresses the observer is the guardian, an encircling border with an opening to the east. More often than not this is the anthropomorphized Rainbow supernatural (see Rainbow People, p. 117), a much elongated figure with a blue and red body, the two colors outlined with white, and with feet, legs, and skirt at one end and hands, arms, and head at the other (see Figs. 21, 25, Plate 10). The feet are always at the southeast, the head

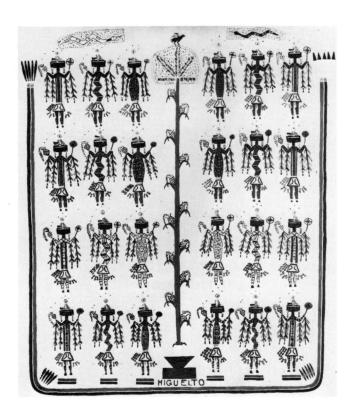

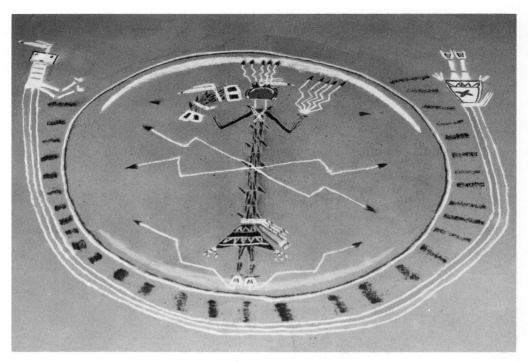

Figure 28. Black Endless (Coiled) Snake, Male Shootingway Evilway. Coiled snakes of four colors in cardinal positions; straight snake guardians. Courtesy Museum of Northern Arizona.

Figure 26. Twenty-four *Mixed Snake People with Twelve-eared Blue Corn,* Male Shootingway, Sun's House phase. The guardian is a garland in red and blue rainbow colors. Courtesy Etnografiska Museet, Stockholm, Sweden.

Figure 27. Monster Slayer on the Sun, from Female Shootingway, with curved Rainbow guardian. Photograph, L. C. Wyman, Navajo Craftsman Exhibit, Museum of Northern Arizona.

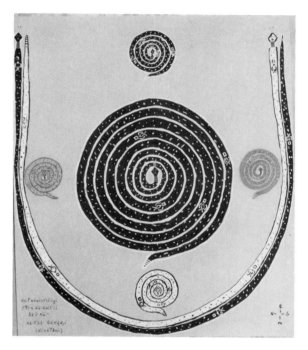

Figure 28.

side entirely open (Fig. 13, Plate 9), or it may be curved all the way around, especially in radial compositions (Fig. 27, Plate 5). Occasionally, as in some Mountainway paintings, the Rainbow's body or the garland may be looped around four mountains having the directional colors of the sacred mountains of the cardinal points.

Guardians somewhat less commonly seen are the anthropomorphized Mirage supernatural and the mirage or mist garland (Fig. 4). In these the body is spotted with dots of all the colors used in the painting. Garlands of the blue and red rainbow colors but without white outlines, with plain, white-bar, or black-cloud ends, are variously called rope of rain, sunray, or sunbeam. A pair of zigzag white (inner) and black (outer) lightning arrows form appropriate guardians for sandpaintings of Thunders (Plate 21) or the Slayer Twins. Snakes of various kinds (straight or crooked slender snakes, Big Snake, Endless Snake with four coils in its body, or pairs of slender snakes with their tails crossed) are guardians for snake or Snake People sandpaintings (Fig. 28). Guardians of other kinds occur occasionally or perhaps uniquely, among them the sunflower plants of Big Godway (Plates 4, 8); Sunray or Dawn supernaturals (the last with a white body); a black bar of darkness or "black mirage"; a rain rope, lozenge-checkered with all colors; lozenge-checkered "rainbow ladders" or "mist" incorporated in a rainbow rope (Reichard's term) or "trail"; or white and black lightning arrows with the west side a rainbow bar. In linear sandpainting designs sometimes the foundation or locality bar on which the figures stand is incorporated into the western side of the guardian (Fig. 27, Plates 6, 10).

Instead of a continuous encircling guardian, an interrupted one of several ele-

at the northeast. The head may have the shape, face color, and type of headdress characteristic of the main theme symbols of the chant (Plates 7, 13). Next in frequency is a garland fashioned of rainbow body colors, with bunches of five feathers placed at its southeast and northeast ends and in the opposite southwest and northwest corners of the painting (Fig. 26, Plates 5, 9). These feathers are usually white, blue, red, and black; they are said to be eagle feathers at the southeast end, bluebird or "blue hawk" at the southwest corner, red-shafted flicker at the northwest corner, and magpie at the northeast end.

The body of the Rainbow or the garland may be straight on the south, west, and north sides, with square or rounded corners at southwest and northwest and with the east

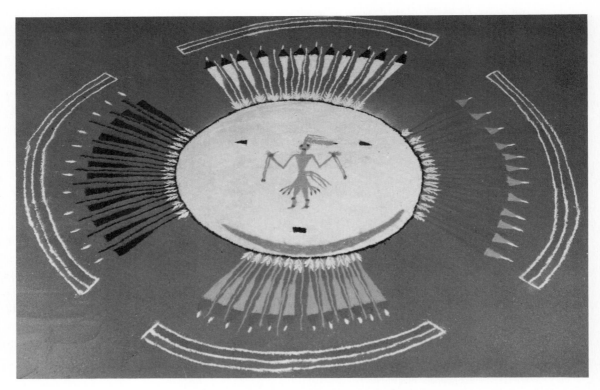

Figure 29. Ripener (Cornbug) Girl on the Moon with Feathers, from Navajo or Chiricahua Windway. Extended-center composition; interrupted guardian of four curved rainbow bars. Photograph, L. C. Wyman, Navajo Craftsman Exhibit, Museum of Northern Arizona.

ments—usually four at the cardinal sides—may be used, especially in extended-center compositions (Figs. 24, 29, Plates 11, 12). The commonest of these are straight or curved rainbow bars or arcs, and straight or crooked snakes, often in pairs and sometimes crossed, but other symbols, such as bows and arrows, may be employed.

Since the function of the encircling guardian is to protect the space within it, why should it be broken at the east or anywhere else? When a patient sits upon the sandpainting, he brings with him, if you will, the disease or evil for which he is being treated. The ceremonial is a mixture of exorcistic and invocatory procedures to drive out evil and bring in good. One exorcistic technique is to narrow the space within which evil may operate by means of boundaries, leaving an opening through which it may be driven. Moreover, in order to attract good, the singer must provide an opening for it to enter. As Reichard (1970:89) said, "The Navajo fears encirclement, since evils that might be with him in the circle cannot get out and good cannot get in to him" (also see Wyman 1959:19). Since Blessingway is entirely concerned with good things, its dry-

70

paintings may be enclosed without danger by a continuous border. The practice of leaving an opening in a circle or a break in an otherwise continuous line is observed in other southwestern Indian arts and crafts; it is found in ceramic and textile designs and elsewhere, not only among the Navajos but in other tribes as well.

Symbolically the encircling guardian with its eastern opening protects the painting and provides for the exchange of evil and good with the outside world. Artistically the guardian unifies the composition, and the opening in it prevents monotony and gives the design motion. Thus, it affords both psychological and aesthetic satisfaction. For the Navajos the former has by far the greater—if not the only—importance.

Paired Guardians of the East

There can be some measure of control over the single eastern opening in the guardian of a sandpainting, and sometimes this control is augmented by the addition of a pair of small symbols. Placed in the opening in the guardian, these two symbols serve as supplemental protection of that aperture. They are an optional feature seen in roughly half the reproductions of sandpaintings that have been made.

By far the most popular symbols for entrance guards are a pair of Big Flies, often, but not always, a black one and a white one (see Figs. 7, 104). Occasionally a Big Fly is paired with some other symbol, but two Big Flies is the rule. Big Flies appear in some capacity, usually as paired guardians but also as main theme or subsidiary symbols (Plates 7, 13), in some sandpaintings of all the well-known chantways; four extinct or obsolescent chantways provide too few data for valid generalization (Big God, Eagle, Awl, Earth).

Big Fly has been called the *deus ex machina* of Navajo mythology, for it is mentor and monitor of humans and supernaturals alike, mediating their disagreements, helping and instructing them. Because of its small size it can sit on one's ear or shoulder and whisper instructions, and it can go everywhere, even into the interior of a person's body; hence it is omniscient and can warn or inform and can circumvent the plans of the most powerful deities. When the hero of a myth gets into difficulty, it is almost invariably Big Fly who appears and tells him what to do (Wyman and Bailey 1964:51, 131, 137–42). It is said to have a white face and is so depicted in sandpaintings, and some of the biological species that are its earthly cognates, a few tachina flies, do have white heads. In the sandpaintings of Mountain-way, Big Fly is shown wearing a tall feather headdress like those of the main theme symbols for this chant.

Other pairs of symbols often used as small guardians of the east are bat and Sun's tobacco pouch (Fig. 21), a pair of bats, Sun and Moon, or Pollen Boy and Ripener Girl. Other combinations of these symbols are occasionally used, such as bat and Big Fly or Sun's tobacco pouch and Big Fly. Sun and Moon are depicted as the usual blue or white disks with black eyes and mouth, either horned or with feather rays. Pollen Boy (see Fig. 93)—personified corn pollen, symbol of male generative power and fertility—is painted all yellow. His companion, Ripener Girl (see Figs. 29, 82, 93), has usually been called Cornbug or Cornbeetle Girl by writers on Navajo ceremonialism, but the Navajo name for this mythified insect means ripener. Its biological representatives are lacewing flies, tree crickets, or occasionally ant lions, and not beetles at all (Wyman and Bailey 1964:29, 131–32, 142–44). Ripener Girl,

the female helper of deity and man, is a symbol of female generative power and fertility, happiness, and life itself. In drypaintings she is made all blue or sometimes yellow as if covered with pollen, and both she and Pollen Boy are often painted on speckled yellow patches, sometimes made of actual yellow pollen, to emphasize their role in the ripening of corn.

Still other symbols frequently used as paired guardians echo the main themes of the designs they guard: pairs of small snakes, usually crooked, for snake or Snake People sandpaintings (see Figs. 26, 85, Plate 5); pairs of buffalo for buffalo or Buffalo People paintings (see Fig. 4); beaver and otter for paintings of Thunders and Water Creatures (see Fig. 103); and pairs of arrows for the Arrow People of Shootingway. Other appropriate entrance guards are pairs of elements associated with the chant or its myth, such as weasels for Mountainway and Beautyway sandpaintings; bears, the preeminent animal of the Mountain Chant paintings; anthills for Red Antway; stars for Big Starway; and eagles for Beadway. In some instances the common guardian symbols are used with particular appropriateness; Sun and Moon appear in paintings of powerful and important supernaturals like the Slayer Twins; bat, a creature of the air, and the Sun's tobacco pouch guard pictures of cosmic and celestial beings; and those happy symbols of fertility, Pollen Boy and Ripener Girl, are found in paintings of corn or Corn People.

Besides these frequently employed guardian symbols, many are found only occasionally or perhaps uniquely. Among these are pairs of bluebirds (see Fig. 9), dragonflies, frogs, water spiders, crooked lightning arrows, clouds, short rainbow bars (see Fig. 102), hide rattles, medicine bundles or feathered cult objects, snakes crossed on Sun and Moon, bow and arrow, water jug and cloud, and black and white mountains with bear tracks on them. In Plumeway sandpaintings, paired guardians may be deer (Plate 20), mountain lions or wild cats, hornworms, Cactus People, canes, sunbeam and lightning, or wind circles (Plate 21).

Locality Symbols

A sense of place or locality is of the utmost importance to the Navajos. For example, myths begin with the establishment of the locale and characters of the story. Place is a power that must be brought under control (see Reichard 1970:152–58). In a discussion of the concept of life-space, George Mills said, "The Navaho aim is to transform the life-space into a zone of safety. Control is necessary: good in Navaho dogma is control. . . . Alien space is distant, powerful, and dangerous. . . . the Navaho tends to organize space concentrically, thereby facilitating the domestication and manipulation of power" (Mills 1959:184, 191–92). So the Navajos organize the space in which dangerous powers are to be dealt with into manageable units within the guardians of their drypaintings.

Within the painting itself, there is usually a conspicuous symbol of locality. In a radial composition this symbol is in the center; in a linear composition it is a bar on which the main theme symbols stand. These symbols represent the place where the event commemorated in the sandpainting took place; the home or homes of the supernaturals depicted in the painting; or the place where the ceremonial is carried out, such as the corral, with its central fire (a red cross), in which the Fire Dance of the final night of a Mountain Chant or a Mountain-Shootingway is held.

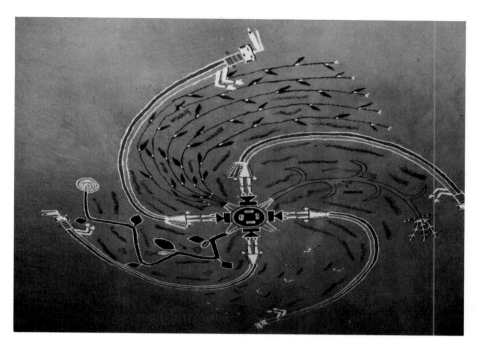

Figure 30. Whirling Rainbow People, Navajo Windway (also used in the Shooting, Mountain, Beauty, Night, and Plume chants). Note the rainbow bars in the central water symbol. Courtesy Museum of Northern Arizona. Photograph, Parker Hamilton, Navajo Craftsman Exhibit, Museum of Northern Arizona, July 1966.

In the majority of radial sandpaintings, the central symbol represents a place where water is found—a water hole, pool, lake, or spring—which may or may not be mentioned in the mythical anecdote concerned. Sometimes it stands for the watery home of certain creatures of the myth. The central water symbol is a circular, colored patch, usually black or sometimes blue, surrounded by colored outlines that symbolize various things, such as white foam. Outside these outlines there are often four other symbols: petal-shaped extensions (Plate 11) or keystone-cloud symbols (a rectangle with a triangle on it) attached to the center, in cardinal positions and of appropriate directional colors, each with a dragonfly, a sym-

bol of clear pure water, upon it; or four mountains, made of colors of the four directions. Rarely the center of a radial design is entirely surrounded by yellow blossoms of some kind. Often there are four short rainbow bars ("sundogs," reflected sunrays) on the surface of the water, protecting it (Fig. 30, Plates 4, 8). Sometimes a cup of real water is sunk flush with the surface of the sand background before the painting is started, the water is completely blackened by sprinkling charcoal on it, and the rainbow bars are made on the floating charcoal. The cup may be surrounded by a broad ring of yellow pollen, and a circular design may be painted around it. In one recorded instance, the water in the cup was covered

with pollen, blue pollen, and ground medicine herbs (Kluckhohn and Wyman 1940:180, Fig. 25). When plants are in the intercardinal quadrants, three white roots extend from each one to the central water symbol.

Square or rectangular centers of radial designs signify dwellings; a quadripartite circle of four colors or four coiled snakes represents the four sacred mountains; and circular or square centers of various colors may represent cave or mountain homes, Emergence Place, or other localities. Sometimes the center is a fairly complicated symbol with such figures as Sun and Moon or a ladder depicted on it. In some chantways the centers of the sandpaintings are symbols pertaining especially to the ceremonial in question, such as anthills or a figure of horned toad in Red Antway paintings. A multitude of other symbols are occasionally used for centers, far too many to be recounted here.

In linear sandpaintings, the main theme figures often stand above or upon a long bar, usually black but sometimes blue. The bar may be spotted all over with white or with spots of various colors, but most often the spots are in groups at intervals, frequently under the figures supported by the bar (see Fig. 22, Plate 6). The bars and the spots are variously interpreted by informants as water outlined with foam, a perpendicular cliff with entrances to cliff dwellings, a mountain with the seeds and berries of the plants growing on it, the dark underworld in which seeds are hidden, or the horizon line, but most often the bar is called the earth with seeds of vegetation on it. The foundation bar may lie between the figures and the body of the guardian (see Fig. 7), but often (perhaps in better than half of the recorded instances) it is incorporated into the west side of the guardian, which is com-

pleted first, with the bar then painted upon it (see Fig. 22, Plate 6). In radial sandpaintings that have pairs or quartets of figures on each side, there may be a foundation bar for each set of figures, but these are usually rainbow bars (Plate 5) or, rarely, bars made of the appropriate color of one of the four directions.

Color, Sex, and Directional Symbolism

In her monumental study of symbolism, Gladys Reichard (1970:187–208, 214–40) devoted two chapters to the Navajos' symbolic use of color. She concluded, "No color or sequence runs through a single chant consistently; none has the same meaning in every setting, nor does chance account for apparent exceptions to the rules; every detail is calculated. If there seems to be a variation, it is for cause" (Reichard 1970:187). Therefore, in stating the relations of colors to sexual and directional symbolism, it can only be said that certain color dyads or sequences predominate in given situations.

Most drypaintings depict both male and female symbols. Besides the statements of informants as to the sex of drypainting symbols, there are sometimes clues in the painting itself. One such distinction pointed out by Matthews long ago is that anthropomorphized male figures have round (or half-round) heads, whereas females have square (or rectangular) heads. This is true of paintings used in the Night Chant, which Matthews studied, and also of those employed in Mountain-Shootingway, Navajo Windway, and Red Antway, although, as Reichard noted, there are exceptions (1970:176–78). Reichard agreed with one of her informants that the head shape must be learned for each painting. In designs where both

round and square heads seem to be used indiscriminately for both sexes, she thought there is some reason to believe that square-headed figures represent people, the Holy People or their intermediaries, beings with secondary power, whereas round-headed figures are deities with dominant power (Reichard 1970:177–79). Thus, in a sand-painting for male Shootingway, square-headed Holy Man stands between (guarded by) the round-headed Slayer Twins (Rei-chard 1939:Pl. X; Wyman 1971:40). This equation between head shape and power does not hold, however, for Mountainway sandpaintings. Another distinction is that when figures have lightning marks on their legs, arms, and bodies, those on males are zigzag or crooked and those on females are straight. The same convention may apply to lightning arrows or snakes carried in the hands of figures; in paintings of snakes or Snake People, the bodies of males are usu-ally crooked, those of females straight. There are a few other clues, such as the shape of bear tracks and the pairing of certain animals.

According to these criteria, it is evident that no one color is exclusively male or fe-male. The commonest assignment is black or yellow for male figures in sandpaintings and blue or white for female figures (Big Starway, Nightway, Big Godway, Navajo Windway, Hand-tremblingway, Beadway). This is also the case in about half the paint-ings for Plumeway, whereas in the other half, black and white are male colors, blue and yellow are female. The other common arrangement is black and blue for males, white and yellow for females (Shootingway, Beautyway). In the sandpaintings of Moun-tainway both assignments are used almost equally. In about one-third of Red Antway paintings, black and blue are male colors, and white and yellow are female; in the rest,

the situation is reversed. For a given chant-way there seem to be preferred combina-tions of colors for bisexual pairs of figures. In the sandpaintings of Shootingway, for instance, black and white are commonly used for male-female pairs, with blue and yellow a second choice; in Navajo Windway paint-ings, black and blue are preferred; and in those of Mountainway, both this combina-tion and white and yellow pairs are found.

The cardinal points are important in Na-vajo thinking, and progression from east to south, to west, to north—which they call the sunwise circuit—governs all movements in a ceremonial: entering and leaving the ceremonial hogan, placing materials or ob-jects in containers or removing them, or act-ing upon or causing any objects to act in any manner. A color is assigned to each direction, and in drypaintings the sunwise sequence of colors has symbolic signifi-cance. In a radial composition this sequence is unmistakable, because the main theme symbols lie in the cardinal positions; but in a linear composition, according to inform-ants, from south to north is usually taken as the sunwise path, and procedures start at the south progressing northward. The re-verse (north to south), however, is consid-ered sunwise in a fair number of instances. A cross-sequence—from east to west, then to south and to north—is also not uncommon.

The two predominating directional se-quences of colors for east, south, west, and north are white, blue, yellow, and black; and black, blue, yellow, and white. In the second, the east and north have exchanged colors. The first, with white in the east, is also what Reichard called the Day-Sky se-quence, representing the subdivisions of the day associated with the directions: White Dawn in the east, Blue Day-Sky in the south,

Yellow Evening Light of sunset in the west, sinister Black Darkness or Night in the north (Reichard 1970:163, 190, 193, 195, 220). She also said that white differentiates the sacred from the profane (black or red); blue, the color of happiness symbolized by a bluebird, represents the earth's fructifying power, which is symbolized by the blue twelve-eared cornstalk standing for all corn (see Figs. 26, 85).[3] Yellow, the color of pollen, also represents fertility and fructification, and black not only threatens but also protects, since it confers invisibility. The Day-Sky sequence is pictured in the sandpainting of *The Skies* for male Shootingway (see Fig. 21).[4] This painting also shows the Sun-Wind sequence: Blue Sun, Black Wind, White Moon, Yellow Wind. The white, blue, yellow, black sunwise sequence predominates in the sandpaintings of Beautyway and Nightway and in the drypaintings of Blessingway.

The second sequence, with black in the east, is of higher potency than the one beginning with white, which Matthews (1897:216, n. 18) associated with places above ground, lucky and happy places. He said that the black-blue-yellow-white sequence is used in connection with dangerous underground places. Thus, it is employed in Evilway chants such as Big Starway or Handtremblingway as protection against witches and other malignant evils. It is also the sequence used for the sandpaintings of Hailway and Navajo Windway, concerned with the dangers of frost, snow, hail, and winds; and for the War Prophylactic Rite. Transferring black—which threatens danger but also protects against it—to the east, whence danger is likely to come through the opening in the guardian, provides greater protection (Oakes, Campbell, and King 1969:41 n. 14; Reichard 1970:221–22). Thus, in chantways that use both sequences in their

sandpaintings (Shootingway, Red Antway, Mountainway, Big Godway, Plumeway, Coyoteway), the sequence that Reichard termed the "danger" sequence is often employed in designs depicting dangerous creatures, beings, or events, such as Thunders, bears, snakes, the Slayer Twins, Whirling Rainbow People, and Holy Boy swallowed by Fish, and for the paintings used in the shock rite.

Pink is substituted for white in the danger sequence, and sometimes for black in the Day-Sky circuit, in sandpaintings depicting certain beings or creatures, including the Slayer Twins and Sky People (Shootingway), Thunders (Shootingway, Beautyway) (Plate 14), Water Monsters (Shootingway, Plumeway), stars (Nightway, Plumeway), and Sun and Moon (Chiricahua Windway). Reichard (1970:201) interpreted this use of pink as a striving for the power of celestial or deepwater beings, but a singer told her that a pink Thunder is made where a white one would be expected because the latter "is such a bad one that you don't put him in the sandpainting because he might come. You don't want him to come"—a neat bit of Navajo rationalization (Reichard 1970:189).

Other directional sequences are found in drypaintings (see, for instance, Wyman 1970b:13), including some that are difficult to explain, such as the black, blue, white, and yellow sequence for Chiricahua Windway, which is possibly an instance of sex pairing for opposite directions. The linear south-to-north series of yellow, blue, white, and black in Mountainway paintings is also puzzling.

Much more could be said about the meanings of specific colors and their combinations or about various manners of color application such as variegation, spotting, and striping. Reichard's extensive discussion

of color shows what a vast domain the subject of color symbolism encompasses. Obviously this domain cannot be entirely surveyed here, but two aspects of color use should be mentioned which significantly affect the reading of drypainting symbolism. These are the use of outlines and of the color red.

Every figure in a painting, with only one or two exceptions, is outlined with what Reichard called contrast colors—white figures have black outlines, black ones have white, and blue figures are outlined with yellow, yellow ones with blue. There are exceptions: Pollen Boy is often all yellow (pollen) and Ripener Girl is often all blue (blue pollen). Other contrast combinations exist. For instance, Pink Thunder is outlined with white, Black Wind with red, and Yellow Wind with white (Newcomb and Reichard 1937:Pl. IIA, IIC). The central motifs in drypaintings, such as locality symbols and the like, figures of the Sun and Moon, and often the main motif of extended-center compositions, usually have several colored outines, often five (Wyman 1957:Pls. XV, XVI; 1962:Figs. 11, 38, 47, 56). In these outlines the four directional colors occur in various sequences determined by the ritual requirements of the ceremonial, with red or the blue and red rainbow-color pair on the outside for protection, except in chants performed according to Injuryway subritual, where red outlines are inside. The red and blue portions of a Rainbow Person's body or of a rainbow garland or bar are outlined on both sides with white. Artistically, outlines provide clarity (making the figures stand out), variety, contrast, and balance. "Outlining also divides space into manageable units and keeps these units clearly distinguished" (Mills 1959:132).

Red, the most vivid and conspicuous of colors, is, as Mrs. Newcomb remarked, "a color of fierce power" in Navajo symbolism (Newcomb, Fishler, and Wheelwright 1956:16). It is associated with danger, war, and witchcraft, and being dangerous itself, it can also protect from danger. It appears, therefore, as the outside color of the encircling guardian Rainbow and of rainbow bars, or as the outermost member of a series of colored outlines around sandpainting figures. Paired with black it is especially effective. In special forms of the Flintway chant of the Lifeway used to remedy serious injury or chronic trouble, the patient is painted from feet to head with horizontal stripes of red and black grease paint (stripes are also terrifying; Wyman and Bailey 1945:347). Protection may be achieved by changing ordinary colors to red, and this is done in the sandpainting of *The Red Snake People from Red Mountain*, used in Male Shootingway Evilway ritual, which is like the painting of *Mixed Snake People* but with the center and all figures done in red (Reichard 1939:56, 81, Pls. XIV, XVI). Such a design is powerful in dealing with intractable disease attributed to witchcraft or other malignant evils, but it is also very dangerous to use. Artistically, red is a unifying color, and the exaggeration of red in this painting is one among many examples of an astonishing visual effect produced by a slight change in design.

In the sandpaintings of a chant performed according to Injuryway subritual, used in serious cases when a patient has been directly attacked by an etiological factor, the usual position of the red and blue colors is reversed in rainbow guardians, garlands, bars, or in any symbol having this pair of colors, so that the red is inside, the blue outside. This changes the emphasis of the ceremonial from the attraction of good to exorcism. As noted earlier, such a chant

may be called red-inside. Placing red inside is a dangerous procedure and must be used carefully. Changing the color of a snake's tongue from yellow to red or placing a red spot on its head signifies venom and danger (Wyman 1957:Pl. II); so does a red tip on an arrow.

In more beneficent ways, red, the color of flesh and blood, signifies plentiful meat and even life itself. Red is also the color of fire, so a red cross in a locality center means a fire in a hogan. Black God, the Navajo fire god, wears a red kilt when he is depicted in sandpaintings, and the figures in Mountainway paintings appropriately wear red dance kilts or skirts, because a fire dance is the main feature of the final night of this chant. Red skirts are sometimes worn by figures in Beautyway sandpaintings because this chant had a fire dance in its prototype (Wyman 1957:Pls. VII, XI).[5]

Movement

Motion leading to action and culminating in events is of primary interest to the Navajos. Like modern physicists who no longer talk about things but only about processes, to the Navajos the essence is in the bounce, not in the ball. To a non-Navajo observer, the figures in a drypainting seem to be doing nothing other than standing around with their various accoutrements as if waiting for something to happen. To a Navajo spectator, however, the painting is full of motion symbolically expressed.

Many internal details convey a sense of motion: swastikalike designs that seem to turn, such as the Whirling Log sandpainting of the Night Chant or the Turning Rainbows of Plumeway (see Fig. 104, Plate 4);[6] the zigzags of flashing lightning or of the bodies of crooked snakes or Snake People (see Fig. 26, Plates 3, 5);[7] or the spirals of coiling snakes (see Fig. 28).[8] Some entire compositions are extremely lively, such as the Whirling Snakes of Shootingway (Newcomb and Reichard 1937:Pl. X) or the Whirling Rainbow People used for several chants (see Fig. 30).[9] These designs fall short, however, of involving the onlooker in an unpleasant illusion of dizzy whirling with them because the motion of the main theme figures is counteracted by the restful smoothness or opposite motion of the guardians of the sandpaintings, which keep everything in place.

In the same way, the motion of the twisting curves of the white trails from the buffalo's feet to the central water pools in the Shootingway sandpainting, *The Home of the Buffalo People*, is prevented from dominating the scene by the geometrical austerity of the tipi-like homes (Reichard 1939:Pl. XXIII). These designs demonstrate a general principle of Navajo life: their aversion to overdoing. Like the ancient Greeks, they strive for moderation in all activities, and they even have a special ceremonial, Excessway, to treat the ill effects of overdoing.

The figures that seem most static to us, those of People or deities, are nevertheless marching sunwise around the center in radial drypaintings, and either south to north or north to south in linear compositions. As pointed out previously, either of these directions can be rationalized as sunwise. The direction of their movement is revealed by the bulge of the calves of their legs, naturally being in the rear, their decorated pouches hanging behind them, and their head plumes streaming out in the direction opposite to their movement. When the figures wear flint armor, its points on their bodies are directed up in front, down in back (Plate 3) (Wyman 1962:Figs. 5, 10, 12).

Occasionally the figures' arms are held out before them as they follow one another in the picture (see Fig. 7) (Wyman 1970b:Fig. 26). In a few linear sandpaintings the figures on each side of a central symbol, usually a cornstalk, are moving toward it from each side, thus making a design with bilateral or "mirror" symmetry (see Fig. 22).[10] The sandpaintings of Beadway are also bilaterally symmetrical (Reichard 1939:Pls. I–IX).

Certain symbols are usually or always shown as static: Thunders, eagles and hawks, and the Long-bodied anthropomorphized deities of Mountainway. This is accomplished symbolically by placing the calf bulges on opposite sides of the legs, usually on the inside, thus causing the figures to stand or sit. George Mills, who was interested in the psychological aspects of Navajo art, concluded that movement in designs is evidence of a rich inner life and acceptance of inner promptings (Mills 1959:136, 158, 178).

Artistry and Psychology

The Navajo judges and explains his drypaintings, not in terms of our criteria of artistic style or value but in terms of his own symbolism. His satisfaction derives from whether the picture is "right," whether it will work as a sacred tool to attract the supernatural beings depicted in it. He is not concerned with the sensory enjoyment of the beholder. It is not art alone that the painter sprinkles on the ground but a statement of belief to be shared with the members of his tribe. As George Santayana once said, a living art produces not curiosities to be collected but spiritual necessities to be diffused.

Although the Navajos do not employ aesthetic value terms corresponding to ours, they do apply to the drypaintings the term in their own language that we sometimes translate as "beauty"; it means much more than that, though, covering all that man desires in life. It has moral as well as aesthetic connotations and actually cannot be translated by a single English word or phrase; perhaps "harmony" is the best rendering. In the vast recorded Navajo mythology, however, there is nothing we would understand as an aesthetic value judgment concerning the drypaintings, although there are countless minute descriptions of their design, construction, and function.

Nevertheless, there is evidence that, mixed with the concern for function, there is an aesthetic component somewhat like our concept of the beautiful. As Ethel Albert (1956:234) remarked, the notion that something could be useless but pretty or beautiful but bad is foreign to Navajo thinking. Anything that is good is good for something. It is as if the Navajo is convinced that beauty must work as a powerful instrument. What but a sense of the beautiful can explain the elaboration—beyond a merely functional level—of drypainting designs, which in other Indian tribes are often crude and simple, sometimes mere lines or blobs of color, but nevertheless effective as sacred tools? The concern for harmonious relations between elements in a design, for balance of lights and darks, symmetry, contrast, and all the other aspects of the drypaintings is clearly an "artistic" concern, one that manifests the truth that the search for beauty is a universal in human experience. It is likely, then, that when the singer leans back with a sigh of satisfaction and silently observes the finished sandpainting, he is not only looking for mistakes that would interfere with its function but is also admiring its beauty.

Gladys Reichard (1939:74–83) devoted a

chapter of one of her books on sandpaintings to the artistry of legend and sandpainting, concluding with the statement, "In the entire complex the aesthetic is so closely involved with the religious that there is no possibility of separating the two. Rather we should be inclined to conclude that Navajo religion is one of the many examples which illustrate the fact that religion and aesthetics may be the same thing." Clyde Kluckhohn (1966:294) concluded:

> While the Zuni and the Navajo show both in their verbal and their nonverbal behavior that they are sensitive to the beautiful as such, the following represent reliable generalizations for both groups: what is considered to be morally good tends to be assimilated also to the aesthetically good; whatever promotes or represents human survival and human happiness tends to be felt as "beautiful"; anything that is nonfunctional (worn out or failing somehow to promote the satisfaction of needs) is considered "ugly."

George Mills, in *Navaho Art and Culture* (1959), assumed that the linkages inferred from studies of western art, between artistic forms or styles and the psychic qualities of artists, validly held in all cultures; using this assumption he attempted to derive generalizations about Navajo personality from an analysis of Navajo art. Clyde Kluckhohn (1966:282), an experienced observer of the Navajos, summarized one of Mills's major conclusions as follows:

> Perhaps more interesting is his finding that there are four pairs of traits that are about evenly balanced in the Navaho arts: carefulness-casualness, expansion-containment, fixity-variability of patterning, and restricted-liberal use of color. From this and from mythological and other materials Mills infers a "bipolarity of Navaho outlook and insight." This he links to their spatial orientation which does not, as does the Zuni,

emphasize the center but rather the successive boundaries of their life-space.

One of the principles that Mills felt is operative in Navajo drypainting art merits further discussion here because it is useful in reading drypainting symbolism. This is the principle of psychical distance put forward by the English psychologist Edward Bullough (1912). One technique for visual instruction of the masses in mystical doctrines is to exaggerate or distort intensely personal objects of common experience, such as the human body, so as to invest them with the aura and qualities of divinity. Thus, in drypainting, a distance is established between anthropomorphic figures and their more profane counterparts by exaggerated elongation of their bodies and extreme stylization of their heads and extremities. We are familiar with such lengthening of the human form in Byzantine and medieval religious art. Figures of animals and plants, although highly distanced when they are anthropomorphized, are much closer to biological realism when they are represented as if in their own forms. Mills suggests that this mixture of stylization and naturalism is related to the Navajo's fears of the dangers of his cosmos. Animals and plants provide a comforting link between his daily existence and the frighteningly distanced world of the Holy People (Mills 1959:55, 146–50). Moreover, symbols gain in power from elongation as well as from repetition. The highest degree of psychical distance would be pure abstraction, of which Navajo drypaintings contain numerous examples. Bigness indicating a whole, summarizing and integrating diverse constituent parts, was mentioned earlier. Arrows beside Thunder's head and curved featherlike motifs at the bottom of his tail represent abstractly his sound and its reverberation (Reichard 1970:201, 257).

6

The Nature of Symbols

In order to "read" a drypainting so that it makes sense, it is necessary to recognize the symbols in it and to know the significance of various parts of these symbols, features that would be immediately meaningful to a conservative Navajo observer. The following descriptions are confined to main theme symbols and to a few other symbols that do not appear as main themes but are prominent features in the designs. Only the symbols of chantway sandpaintings are considered here because those of the Blessingway rites are thoroughly discussed and illustrated.[1]

People

Representations of People—beings that appear always in human form or can take human form at will—are highly stylized (Fig. 31). Their peculiarities will be described in Navajo ceremonial order, from the feet upward. Occasionally feet are made semi-naturalistically and are of the same color as the rest of the figure, but in the majority of instances they are elongated trapezoids, in black outlined with white, with a small red mark in the center representing flesh. Protective symbols projecting from the bottom

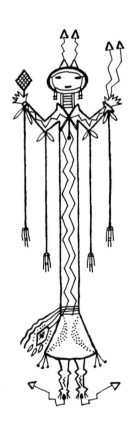

Figure 31. Male Person. (This and subsequent drawings by Betsy James.)

81

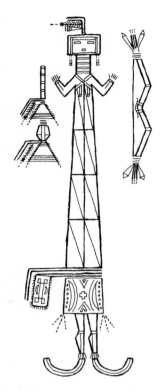

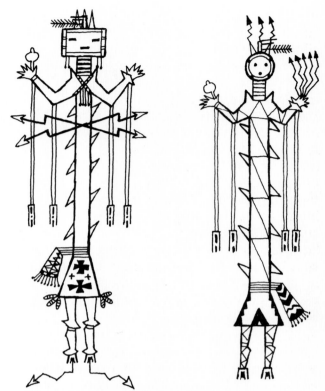

Figure 32. Female Person wearing long dress.

Figure 33. Armored People: male (right) and female.

of the feet are lightning arrows, zigzag on males and straight or smooth curved on females, or zigzag with simple cross ends instead of male barbed arrowpoints (Plate 3). Female figures may have red and blue rainbows or yellow and white sunbeams instead of lightning. If they lack such elements, the figures stand on individual, short rainbow bars that are means of travel as well as protection, or on triangular or keystone cloud symbols (see Figs. 22, 25). Pairs or quartets of figures may stand on longer rainbow bars (Plates 5, 8). Occasionally, People stand on arrows or other symbols.

The legs of People are the same color as the body, except that in Nightway sand-paintings the lower legs of dancers may be yellow because they are dancing knee-deep in pollen, and in Mountainway paintings the lower legs and also the forearms are black with white lightnings on them (see Fig. 7). This motif recalls lightning on black clouds, and gives speed as well as protection. Lightning marks made of contrast colors, symbols of power, are often put on the legs and arms of figures, zigzag on males, straight on females. The knee joints and the wrists are crossed by protective red and blue lines. Sometimes the shoulder joints are indicated by two white lines.

Skirts or kilts are usually white with blue and red (rainbow) borders and often are

decorated with patterns of red and blue dots curving from bottom to top (vegetation of all kinds) (see Fig. 22, Plates 5, 8). Blue or yellow crosses are of pollen (prayer). Frequently, however, skirts are elaborately decorated with patterns, like the dance kilts of the Pueblo Indians, according to the fancy or skill of the painter (see Fig. 7, Plate 3). It is in the kilts or skirts, in the sash or pouch hanging from the figure's waist, and sometimes in the tassels at the lower corner of the skirt, that the painter may exercise his imagination; all other parts of the figure must be made according to rigid prescriptions. Several painters working together may enter into a contest trying to surpass each other in elaborateness (see Newcomb and Reichard 1937:Pl. IB). Some decorations may be symbolic, such as stars, deer tracks, lightning, clouds, or mountains.

In Mountainway sandpaintings and in some Beautyway designs, the People wear red kilts reminiscent of the fire dance performed as part of the chant or its mythic prototype, and Black God may have a red kilt because he is the fire god. The three tassels at each corner of the kilt may be decorative red and white twisted figures or black and white "fawn hoofs" with a tiny red dot in them (flesh), referring to hunting. The jingle of deer toes which this symbolization is meant to recall also symbolizes the pattern of raindrops. The fancy pouch hanging from the belt is said to be like the Plains Indians' pouch: long, beaded, and embroidered with porcupine quills.

Some painters prefer to make female figures with long tapering bodies, often covered with elongated triangles of various colors representing a dress, instead of the usual elongated rectangular body with a skirt (Figs. 13, 32, Plate 2).[2]

The disproportionately elongated rectangular bodies of People are often marked with longitudinal zigzag (male) or straight (female) lightning, frequently double. Four sets of varicolored, short lines on the body represent clothing adorned with beads or porcupine quill embroidery, stolen by the hero from the Utes (Male Mountainway) (see Fig. 7) or from the Puebloan Spider People (Beadway). A red border on the body represents sunlight. People may wear brown otter- or beaver-skin collars with a whistle attached (see Fig. 7), and they always have a turquoise necklace with redstone or coral pendants across their chests (double blue lines with red ends). When they are wearing flint armor (Slayer Twins, Wind People), the obsidian coat with projecting stone knives is represented by five points on each side of the body, three on the head, and additional points at ankles, knees, shoulders, and wrists (Plate 3). Armored figures usually carry five zigzag (males) or straight (females) lightning arrows and have lightnings crossed over their bodies (Fig. 33) (Newcomb and Reichard 1937:Pl. XVI; Wyman 1962:Figs. 5, 10, 12). People may be partially armored with few points. There are distinctive characteristics for the People of the Myth of specific chants, such as the hourglass-shaped bodies of the Tornado and Whirlwind People of the Windways (Wyman 1962:Figs. 55–60).[3]

The arms of People are shown akimbo on either side of the body, except in guardian figures, on some of the Ye'i, on People with long hair hanging down behind them (see Fig. 7) or with packs ("mountains") on their backs, or on People bringing something to a central symbol between them, usually a corn plant, where the arms are on one side in their direction of movement (Wyman and Newcomb 1962:Fig. 3; Wyman 1971:Figs. 15, 16). Markings on the arms have been de-

scribed earlier. Small oblong red and blue medicine bundles or pouches edged with white hang on armstrings from the elbows and wrists; these armstrings may be yellow and brown (otter skin), blue and yellow (fox skin, light beams), or blue and red (rainbow). A pair of feathers marks their attachment to the arm, and there may be many feathers along the strings. Hands are white with five fingers.

Objects carried by People may be shown actually in the hands, attached to them by long strings, or simply beside them. There is a great variety of these objects. One often sees spruce boughs (three or five), medicine herbs, corn ears, twigs or branches of other plants such as chokecherries (Mountainway) or cactus (Navajo Windway); three or five zigzag or straight lightning arrows or sunrays; a hide or gourd rattle; and plumed wands, magic travel baskets or hoops, and bows and arrows. People may also carry a medicine pouch of squirrel, prairie dog, or weasel skin; a basket, pottery bowl, or wicker water bottle; feathers, a prayer stick, cane, flute, or quiver; a stone knife or club; clouds or hailstones (Hailway); or Sun's tobacco pouch or a head-skin hunting mask (Plumeway).

People's necks are always blue outlined with white and with four red cross bars. The blue may symbolize the earth or a collar of spruce twigs; the red cross lines, the rings of the trachea, the breath of life, or a neck ornament. The head is always shown full face, never in profile. As explained earlier, round and square or rectangular heads may or may not indicate male and female figures. Red-tipped blue ear strings, like the necklace, hang from the head. Peoples' faces are brown, white, blue, occasionally pink or yellow, or covered with the sunhouse or Day-Sky stripes: yellow, blue, black, and white,

from the chin up. Very rarely the face may be the same color as the body directional color (as in some Windway sandpaintings). A brown face is said to represent natural skin color, and when other colors are used, the face is first made brown and the others are laid over it. Brown faces are common in Shootingway paintings. White faces, the color of mist or clouds, occur in the sandpaintings of Waterway, on the square female faces of Red Antway, in some Mountainway paintings, in those of Beautyway and Beadway, and on some figures on sandpaintings of Mountain-Shootingway, Nightway, Plumeway, the extinct Awlway, and the Evilway chantway, Upward-reachingway. The faces of Rainbow People, including the Rainbow Person guardian, are also white (see Fig. 30). Blue faces, representing the sky or rain ("sky masks"), are characteristic of Coyote People; all of the Ye'i except Talking God, Fringed Mouth, and Black God; and some figures in sandpaintings of Big Godway and Plumeway. Pink faces in Mountain Chant sandpaintings represent masks of weasel or prairie dog hide, and yellow faces on the People of Hailway and Plumeway indicate evening light or pollen (fertility). Sunhouse stripes are used in many sandpaintings of Shootingway, on figures of Sky People, on the painting of Earth and Sky, and on some figures in paintings of Hailway and Upward-reachingway. Regular features are a yellow stripe across the chin, showing that the People have been fed food mixed with pollen ("a line of blessing"), and a white one across the forehead (dawn). Above this are a red line, a black line (hair), and another red one (hair from an elk or antelope chin). The sides of the face are also bordered with red (life). White lines or tiny blue circles on the forehead represent olivella shell or turquoise bead tokens. Short

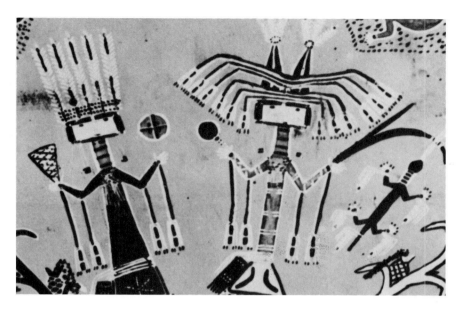

Figure 34. Detail from the sandpainting *People of the Myth* of Beautyway. Person on left wears a tall feather headdress; Person on right wears a double-pointed red hat. Courtesy Etnografiska Museet, Stockholm, Sweden.

black lines for mouth and eyes are the only features indicated. Colored faces have often been said to represent face paint or masks, but Father Berard Haile insisted that sandpainting figures are identified with the supernaturals themselves and therefore are not thought of as being masked. The colored faces are the "real looks" of the supernaturals: masks are used only when the supernaturals are being impersonated by humans (Haile 1947a:xiv).

The standard headdress is a fluffy, black-tipped white eagle plume streaming out behind, suggesting lightness and speed. In addition, headdresses of more or less complication are characteristic of specific chants. For Shootingway there is a medicine bundle of turkey tail feathers shown as a black triangle with red and blue stripes at the broad end and a white outline, like the water-spouts hanging below Thunder's wings (rain

symbol). With and sometimes without this, Shooting Chant People often wear pointed red feather hats with white eagle plumes attached to them, supposedly made of red woodpecker scalps; in actual dance practice the hat is made of red-dyed wool or horsehair (Plate 15) (see also Newcomb and Reichard 1937:Pls. IV, XIV). This red bonnet represents the red afterglow of the setting sun. Scavenger, hero of the Bead Chant, wears a similar red hat, which he took from the daughter of a Pueblo chief and later gave to the Sun in the skyland (Reichard 1939:Pl. I). A red hat also occurs in sandpaintings of Awlway. Sky People in Shootingway and dancers in Mountain-Shootingway sandpaintings have pointed red hats with bison horns attached to them (horns of power, the crescent moon; Reichard 1939:Pl. XXII; Wyman 1970b:Pls. 24–26). People in Beautyway sandpaintings wear distinctive headdresses

85

of two types: one bears four or five long, white or variegated, erect feathers; and the other consists of a single- or double-pointed red hat with several yellow and white streamers, either erect or bent and drooping at each side (Fig. 34, Plate 15). These are said to be made of weasel skin (Wyman 1957:Pls. VI–XI, XV, XVI). The Mountain Chant, which is related to Beautyway, also features tall feather and weasel-skin headdresses (see Fig. 7); but these headdresses do not include the red feather hat, and some are very elaborate, with bison horns and other appurtenances attached (Wyman 1975:Figs. 7–18, 24). Some female Rain People of Waterway sandpaintings also wear variegated tall feather headdresses, but theirs are long and curved. The male Rain People have five zigzag lightning arrows on their heads (Wheelwright 1946a:195, 197). Rain People of Hailway, Waterway, and Plumeway; some People of the Myth of Mountainway and of Beautyway; and Coyote People are shown with long strands of black hair hanging down from their heads, zigzag on males, straight on females (Wheelwright 1946a:181, 185, 189, 195, 197; 1956:Pls. XVII, XVIII; Wyman and Newcomb 1962:Fig. 3; Wyman 1971:Fig. 15; 1975:Figs. 15–18). Finally, the People sometimes have small birds perched on their heads (Wyman 1962: Fig. 6).

The specific People who appear in nearly every chantway myth have distinguishing characteristics in addition to the general ones just described. Two groups of supernaturals who always appear in the form of People in the drypaintings of a number of ceremonials, but especially in those of the Shooting Chant, are so important that they will be described in detail. These are the Holy People and the Slayer Twins.

The Holy People

The quartet of Holy People—Holy Man, Holy Woman, Holy Boy, and Holy Girl— bears the characteristics of Shootingway People in drypaintings described previously. They have sunhouse-striped faces, carry bows and arrows, and show the usual sex distinctions in their appurtenances. The males frequently have black bodies with longitudinal, double white zigzag lightnings, and the females have variegated elongated triangles covering their clothing (see Fig. 4). Holy Man and Boy may be indistinguishable except for the nature of their arrows and their foot protection; Holy Woman and Girl are similarly difficult to distinguish (Newcomb and Reichard 1937:Pl. XIV). Mythologically, Holy Man and Boy are considered to be the counterparts of the Slayer Twins, and in Shootingway myth the Twins may be the heroes in the first part of the story, while Holy Man and Boy take over later.

The Slayer Twins

According to Navajo myth, Monster Slayer and his younger brother Born-for-Water, children of Changing Woman and the Sun, visited their father to obtain weapons and then killed the monsters who lived on earth, thus making the earth safe for its human inhabitants. In drypaintings, Monster Slayer is covered from head to feet with black flint armor with zigzag lightnings flashing from his feet and across his body. Triangular divisions on his black body represent flint points. He carries five male lightning arrows in his left hand and a stone club with five flint points on it in his right (Fig. 27). With this club he can cause earthquakes. Five zigzag lightning marks are on the right

cheek of his brown face (Newcomb and Reichard 1937:Pls. XV, XVI). His weaker companion, Born-for-Water, is armored with blue flint and has blue flint weapons. Sometimes the pair are shown unclothed—that is, without skirts—and Reichard suggested that in this form they represent the Twins in their basic form as armed powers, not as People, somewhat as snakes are related to Snake People (Newcomb and Reichard 1937:48). When the Twins are multiplied into a quartet (Plate 3), the counterpart of older brother is usually called Reared-in-the-Earth (Reared Underground), whereas that of younger brother is called Changing Grandchild. Some singers reverse these identifications.

The Ye'i

The Ye'i are a group of supernatural beings who, after their creation, tried but failed to speak (Haile 1947a:3, 15). Hence, they are called by a term *hashch'ééh*, which could be rendered "the Speechless Ones." The Ripener Girl (Cornbeetle) gave them their calls, the only voice they have. They appear in the sandpaintings of all the chants of the God-Impersonators subgroup, the Night, Big God, Plume, and Coyote chants, and in a unique painting made for Beautyway (Wyman 1957:Pl. XII). Except for two designs of Rainbow People and one of corn, they are the only main theme symbols of Nightway paintings. Eight of the twelve Ye'i are depicted in sandpaintings (J. Stevenson 1891:Pls. CXX–CXXIII; Matthews 1902:9–29, Pls. IID, VI–VIII; Haile 1947a:13–31, 60–62, 66–72).

Talking God

The leader of the Ye'i is Talking God,[4] known as the Ye'i bichai, maternal grand-

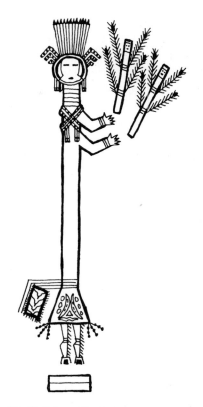

Figure 35. Talking God.

father of the Ye'i. He wears a robe of white buckskin bordered with red sunlight and carries a medicine bag of gray Abert's squirrel skin. A yellow, blue, and black triangular motif at the side of his neck symbolizes his fox skin collar. On his white face the mouth and eyes are surrounded by concentric black squares open at their bottom edge. The outer shape represents a hanging rain cloud, the inner a rising mist. In the center of his face there is a cornstalk. All other Ye'i, except the Fringed Mouth and Black God, have blue (sky) faces. A characteristic feature is Talking God's headdress of twelve (ideally) tall white eagle tail feathers tipped with black (Figs. 22, 35–37, Plates 2, 6, 16).

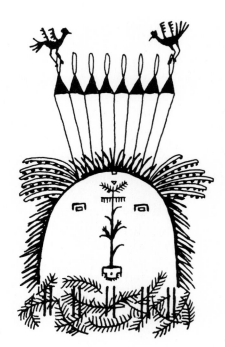

Figure 36. Talking God's mask.

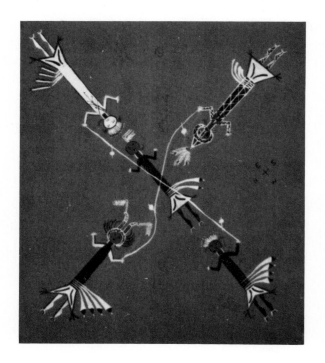

Figure 37. Sandpainting for the rattle shock rite of Nightway. Male Ye'i in the center with Talking God (east), Fringed Mouth, Calling God, and Humpback around him. The cornmeal trail with footprints leading to the center is dimly sketched in. The white lines from the left hands of the figures, crossing in the center, represent cords with rattles attached to them, which are strung over the smokehole of the hogan and pulled by impersonators of the Ye'i to frighten (shock) the patient. Courtesy Museum of Northern Arizona.

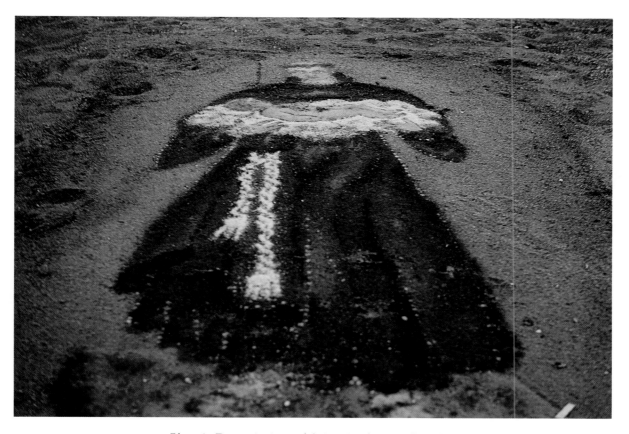

Plate 1. Drypainting of Saint Anthony of Padua with the Christ Child made of dyed sawdust on the floor of the Capilla Real, Cholula, Puebla, Mexico, during the fiesta of Our Lady of Carmen. Photograph, L. C. Wyman, July 1956.

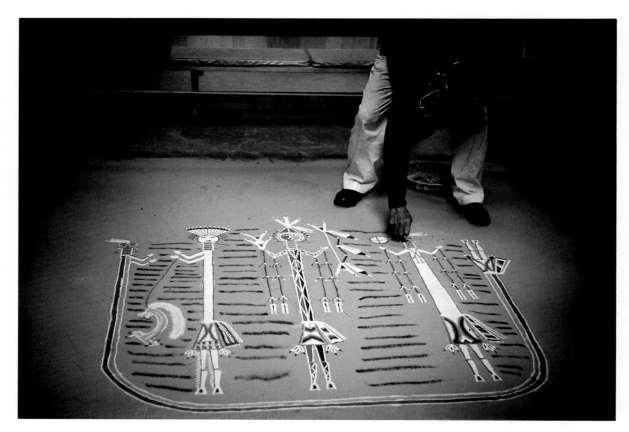

Plate 2. Singer applying corn pollen for consecration to the mouth of a white female Ye'i in a sandpainting of three Ye'i (female Ye'i, black and red Fringed Mouth, Talking God) from Nightway. Photograph, L. C. Wyman, Navajo Craftsman Exhibit, Museum of Northern Arizona, 1961.

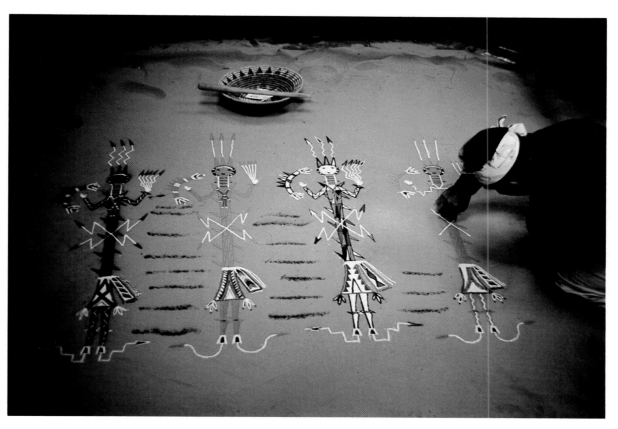

Plate 3. Singer putting white lightning across the body of the southern figure in a sandpainting of the quartet of flint- and lightning-armored *Slayer Twins* from Male Shootingway. Photograph, L. C. Wyman, Navajo Craftsman Exhibit, Museum of Northern Arizona, 1964.

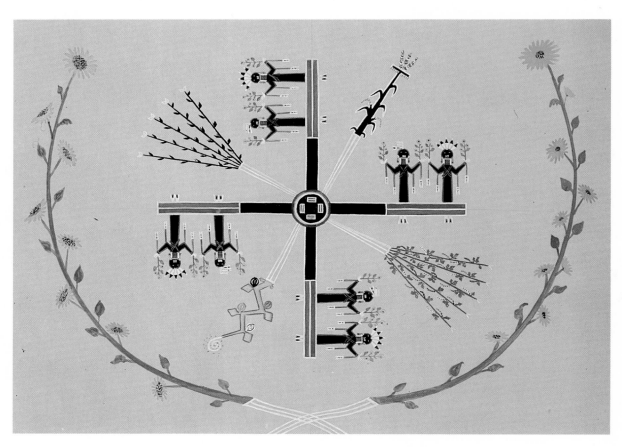

Plate 4. Big Gods on Whirling Logs, Big Godway.
Guardian of two sunflower plants. Courtesy
Wheelwright Museum. Photograph, Martin Etter.

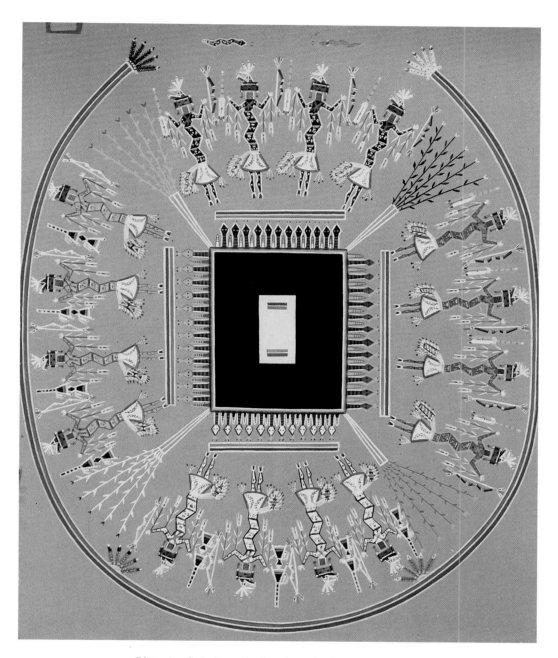

Plate 5. Grinding Snakes (crooked snakes move their home), Male Shootingway. Four quartets of Crooked Snake People and forty-eight snakes under the central rectangle (their home, or a set of grinding stones). Courtesy Wheelwright Museum. Photograph, Martin Etter.

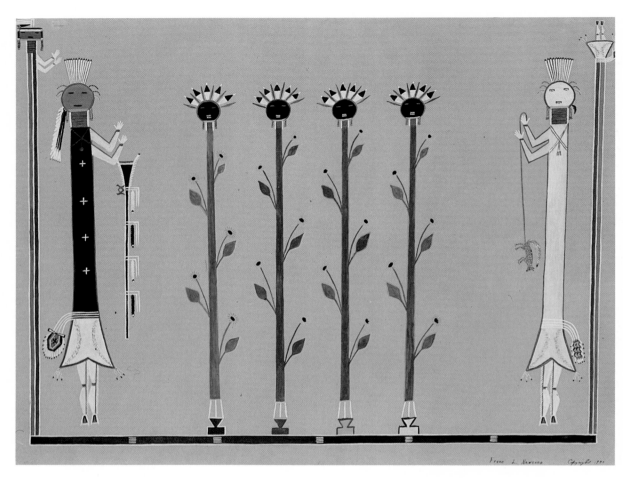

Plate 6. Talking God and Calling God with Sunflower People, Big Godway. Courtesy Wheelwright Museum. Photograph, Martin Etter.

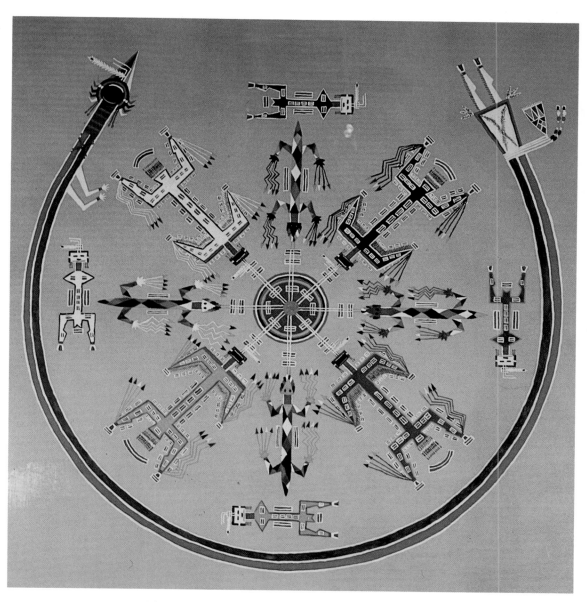

Plate 7. Gila Monsters with Thunders, Hand-trembling Evilway. Subsidiary figures are Big Flies. Painting by L. C. Wyman, collection, L. C. Wyman.

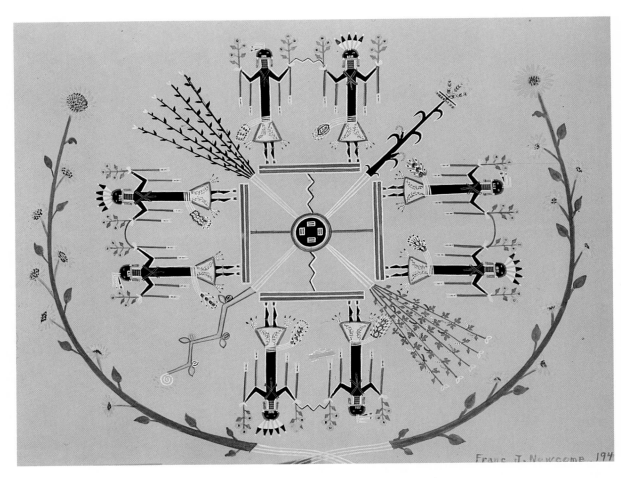

Plate 8. Big Gods, Big Godway. Four pairs of Big
Gods, radial composition; encircling guardian of
two sunflower plants. Courtesy Wheelwright
Museum. Photograph, Martin Etter.

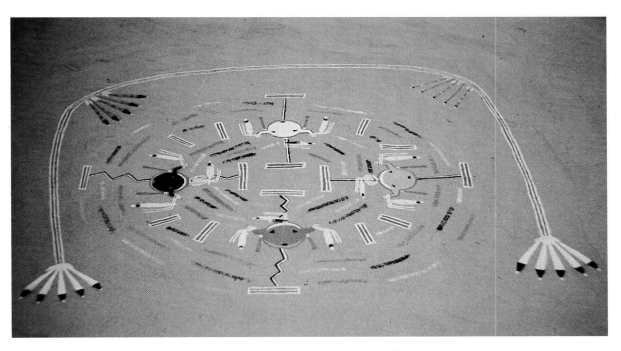

Plate 9. Sun, Moon, and Winds, Male Shooting-
way. Blue Sun, Black Wind, White Moon, Yellow
Wind. Instead of all being made of black char-
coal, the thin clouds in the background are of
four colors. Photograph, L. C. Wyman, Navajo
Craftsman Exhibit, Museum of Northern Ari-
zona, 1961.

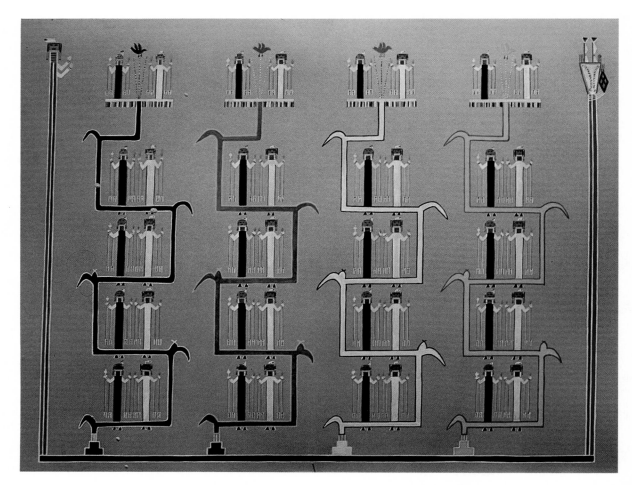

Plate 10. Angled corn with Ye'i, Nightway, Pollen
Branch. Twenty pairs of male and female Ye'i
sitting on the tassels and horizontal portions of
the stalks of the corn plants. Compare with the
sandpainting tapestry woven by the same singer,
Lefthanded (Figure 114). Courtesy Wheelwright
Museum.

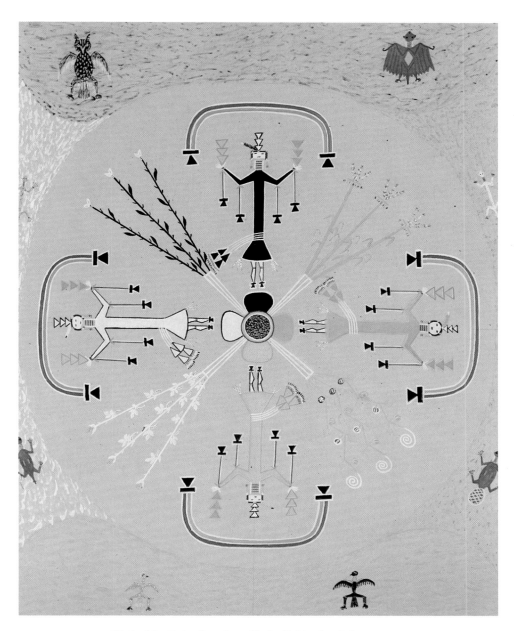

*Plate 11. Rain People with individual rainbow gar-
land guardians,* Waterway. Owl and bat in the
"spreading mists" at the east (top), "salamander"
and beaver at the south, blackbird and pine mar-
tin at the west, and otter and "salamander" at
the north. Courtesy Wheelwright Museum.
Photograph, Martin Etter.

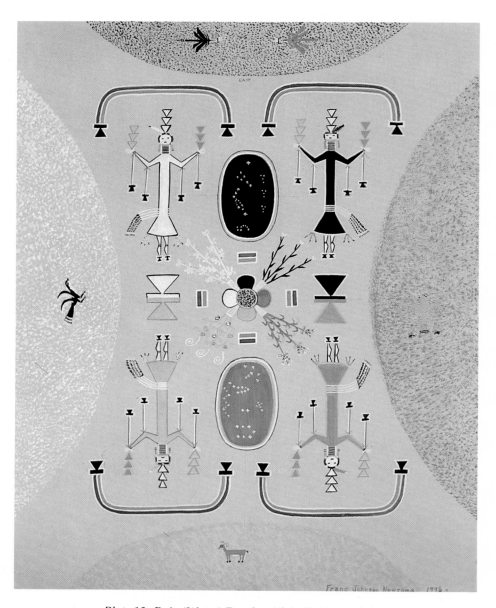

Plate 12. Rain (Water) People with individual rainbow garland guardians, Waterway. Ovals are east and west oceans reflecting the stars; dragonflies in the mist of the east (top), flicker at the south, mountain sheep at the west, magpie at the north. Courtesy Wheelwright Museum. Photograph, Martin Etter.

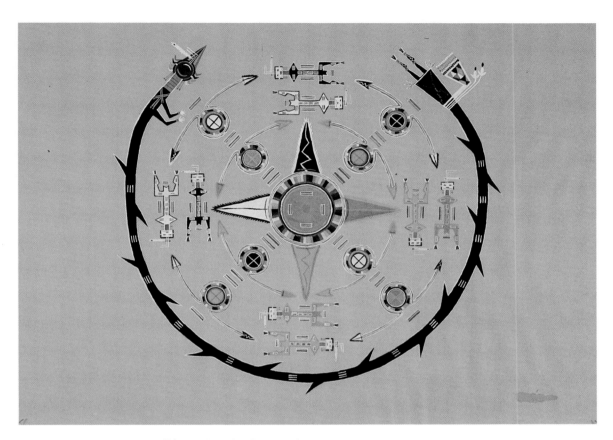

Plate 13. Big Star with Big Flies and Mountains Guarded by Arrows, Hand-tremblingway Evilway. Blue Female Big Star ("branching Big Star") in center; the Rainbow guardian wears black flint armor. Courtesy Museum of Northern Arizona.

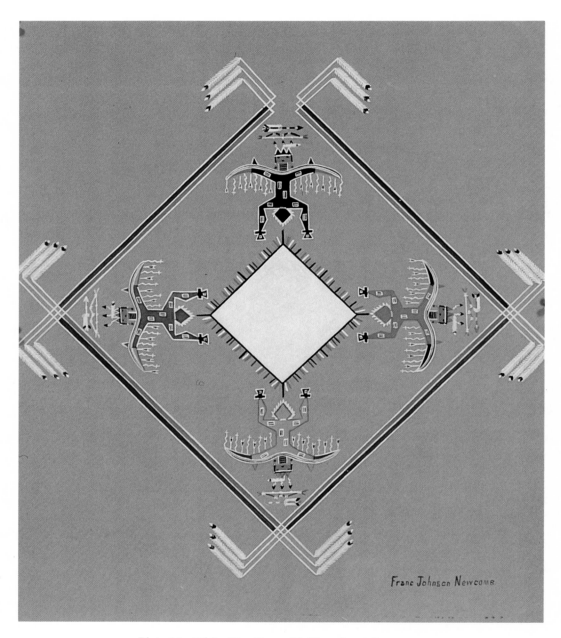

Plate 14. White Big Star with Thunders. Compare the guardian of this Navajo sandpainting composed of four straight rainbow-bars with feathered ends with the "planks" with ends crossed in the Hopi "house" sandpainting for *powamu* initiation rites (Plate 25). Courtesy Wheelwright Museum. Photograph, Martin Etter.

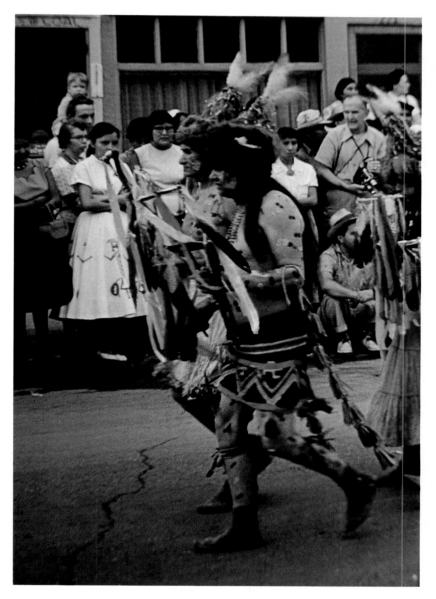

Plate 15. Shootingway dancers carrying dance wands and wearing the characteristic pointed red hat (feather, wool, or horsehair) with white eagle plumes attached to it. Costumed and painted as for a performance of their specialty in a Corral Dance of a Mountain Chant, they march in a parade of the Intertribal Indian Ceremonial, Gallup, New Mexico, in 1955. Photograph, L. C. Wyman.

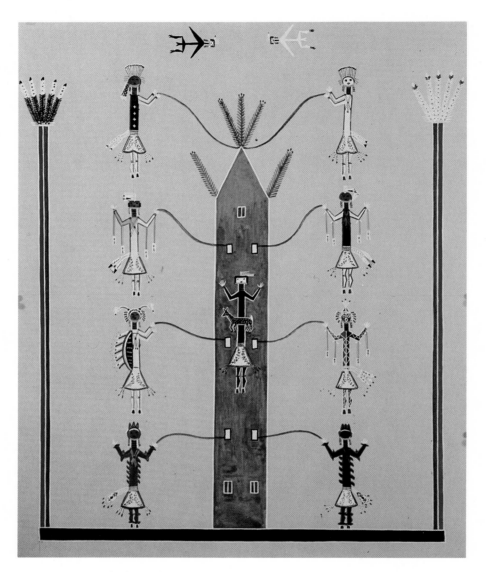

Plate 16. The Floating Log (Hollow Log Trip), Plume-way. The hollow log with the hero of the myth in it floating down the San Juan River, guided by Talking God and Calling God, male and female Ye'i, Fringed Mouth and Humpback, and Black Wind and Blue Wind. This and Figures 102–7 and Plates 17–21 illustrate the myth of Plumeway. Courtesy Wheelwright Museum. Photograph, Martin Etter.

Calling God

Talking God's companion, Calling God (formerly mistranslated as House God), has a black body and either black or white legs, all outlined with red sunlight. On his body there are four white crosses or stars of all colors supposed to be fashioned of porcupine quill embroidery. His blue face is the sky. There may be an otter skin and six deerskin strings at his neck. He carries a black staff with a gaming ring and two bluebird skins attached to it. His headdress of twelve feathers is like that of Talking God's (see Figs. 22, 37, Plates 6, 16).

Male and Female Ye'i

Male and female Ye'i have the usual characteristics of People in sandpaintings. Males' heads are round or half-round, females' are square. Males' bodies may be black or white, females' white, both with red outlines. Their lower legs are yellow (pollen) and so are the forearms of males and the entire chest, shoulders, and arms of females (see Figs. 13, 25, Plates 2, 10, 16). Rainbow People in Nightway sandpaintings may also have yellow legs and arms like these. Most authors refer to these Ye'i as Male and Female Gods.

Humpback

Humpback, a personified mountain sheep, has a white body with red outline, a long black hump with four or more groups of white spots or marks on it, and black-tipped white and/or red (flicker) feathers attached to it (sunbeams at edge of storm cloud; bag of black cloud filled with fruit). He carries a long black staff. His blue face is surrounded by a black (jet) ring with white zigzag lightnings on it. When Humpback is

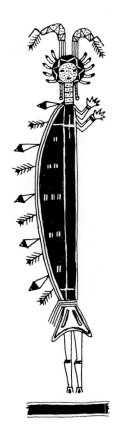

Figure 38. Humpback.

impersonated by a human actor, this ring is represented as a basket with its bottom cut away, which surmounts the mask of the impersonator. Attached to each side are five red-shafted woodpecker tail feathers (sun rays), and on top are blue imitations of bighorn sheep with white male lightnings on them and white plume feathers at the tips (Figs. 13, 37, 38, Plate 16).

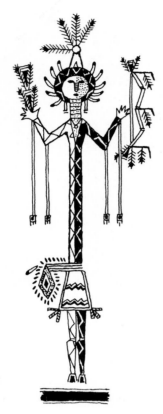

Figure 39. Fringed Mouth.

Fringed Mouth

There are two kinds of Ye'i called Fringed Mouth: Fringed Mouth of the land, whose body is longitudinally half black (right) and half red, and Fringed Mouth under the water, with a blue and yellow body. Their legs also show the two colors. Both are outlined with white and have white zigzag lightnings on them, which are double on the body. The left side of their faces is always blue, but the right side is the color of the corresponding half of their bodies. Around their faces is the cut-out basket symbol like that of Humpback's, surmounted by a pointed red hat like the Shootingway hat. They carry bows and arrows (Figs. 10–13, 37, 39, Plates 2, 16) (Olin 1979).

Water Sprinkler

Also known as Gray God, Water Sprinkler is the clown of the Ye'i. His body may be black with a red outline or, where he appears duplicated four times, he may be made of one of the four directional colors. He carries a black wicker water jar with white markings suspended on a long string. A line of pollen from his mouth to the bird perched on his head represents song (Figs. 22, 40).

Black God

Black God, the Navajo fire god, wears a red kilt over a black body outlined in red. His eyes and mouth are white circles, a white line leads from his mouth (full moon) to a white crescent on his forehead (new moon), the seven white dots of the Pleiades are on his left cheek, and the white Milky Way is drawn across his shoulders and arms. All this indicates that Black God is in charge of months and seasons and of constellations

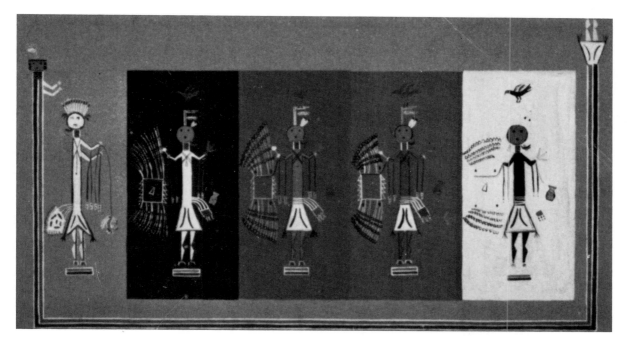

Figure 40. Water Sprinkler, white, blue, yellow,
and black, each on a panel of contrast color, led
by Talking God; Nightway. Courtesy Museum
of Northern Arizona.

and the stellar heavens. He carries his fire
drill or fire brand and four round slap cakes
(patted corn bread) strung on a yucca hoop.

Big God

In some of the recorded sandpaintings for
the Big God Chant, there are figures so like
Black God that they could be confused with
him (Plates 4, 8). They do not, however,
have the heavenly bodies that are shown on
the person of Black God, and they do not
carry his torch and cakes. Instead the mouth
is shown as a row of white teeth, reminding
us of Father Berard Haile's informant of 1908
who spoke of Big God as the "one with the
double row of white teeth" (Haile 1947a:13).
In two recorded designs, figures of Big God
carry sunflower plants. Moreover, one of a
pair wears the standard headdress, but the
other has five erect, black-tipped white tail

feathers, and the myth says that Black God
gave Big God six feathers for his mask dec-
orations (Haile 1947a:78).

Cosmic and Celestial Beings

Earth and Sky

Some Navajo informants say that the
sandpainting of Earth and Sky together may
be used on the last day of any ceremonial,
but this is doubtful, since this usage has
been recorded only for the Shootingways
and once for the extinct Earth Chant (by
Maud Oakes). Drypaintings of the Earth or
of the Sky as separate beings are made for
Blessingway, Big Starway, and Plumeway.
When together, Earth's and Sky's legs and
arms cross below and above (Douglas and
D'Harnoncourt 1941:29; Levy 1972:58). Their

107

Figure 41.
Earth and
Sky.

feet and hands are yellow (pollen, fertility). Earth sits on a cloud of black mist held together by a rainbow, Sky on rainbow-bound blue mist. Their bodies are somewhat lozenge shaped, resembling those of frogs in sandpaintings. The body of Earth (thought of as female) is blue (a turquoise dress of summer sky with a pollen outline), that of Sky (male) is the black of night. The designs on their bodies may vary somewhat, but Earth customarily has a black lake (which filled the place from which the Navajos emerged) in the center with the four sacred domesticated plants—corn, beans, squash, and tobacco—growing out of it. Sun and Moon, the white Milky Way, stars and constellations speckle the black night of Sky's body. Earth and Sky carry various things, often corn stalks or ears and/or turquoise and white shell bowls of food and water. Sky may hold Sun's tobacco pouch. Their necks are like those of People. Their faces bear sunhouse stripes, and a line of pollen or white meal (prayer) connects their mouths. They have lightning-marked horns of power and wear Shooting Chant headgear (Fig. 41).

When made separately, Earth and Sky usually differ somewhat from this descrip-

tion (Wheelwright 1949:147, 149, 153, 155; 1956:Pl. IX; Wyman and Newcomb 1963:Fig. 3). They often have keystone-cloud symbol feet and hands, the plants of Earth may grow out beyond her shoulders (Big Starway), and in paintings for Plumeway there are frogs instead of plants around the blue pool on Earth and five Big Stars as well as the others on Sky. Also, they may have white faces.

A sandpainting confined to the Hail Chant shows the night sky as a rectangular extended center with the sunhouse-striped heads of twelve Storm People peeping over the sides (Wheelwright 1946a:193). The symbols that adorn the sky are like those described above. A unique painting of a star map said to be for Big Starway is among the rather offbeat creations of Sam Chief in the Wetherill collection (Wyman 1952:Fig. 13), and a celestial map with Sun and Moon on it forms the background for the Gila Monster painting on buckskin or white cloth made on the final night of Hand-tremblingway Evilway (Kluckhohn and Wyman 1940:Fig. 26).

The Skies

Among the main theme symbols belonging exclusively to the Shooting Chant are the Skies, symbolized in trapezoid or keystone form (Figs. 21, 42).[5] They represent the passing of the Sun through the hours of the day. Their colors are the white of dawn, blue of day-sky, yellow of evening light, and black of darkness—the Day-Sky sequence. A blue mountain sheep is on the eastern dawn symbol, and various birds are on the dawn symbol and on the southern and western Skies; the northern night Sky bears the usual celestial bodies. Twelve tail feathers of appropriate color extend outward from the broad side of each one. These feathers

Figure 42. Keystone-cloud Sky with Sky People.

represent rays of power. The figures of Dawn Boy, Blue Sky Man, Yellow Evening Light Girl, and Darkness Girl may stand on the keystone-shaped Skies, and the heads of seven Sky People (Sky, Sun, Water, and Summer People) may emerge from each of the Skies when they are used with other symbols (Newcomb and Reichard 1937:Pl. XIX).

Sun, Moon, and Winds

A group of symbols peculiar to Shootingway are the Blue Sun, Black Wind, White Moon, and Yellow Wind depicted as horned disks with black eyes and mouth (blue on Black Wind), and with yellow chin and white forehead stripes, or covered with sunhouse stripes (Newcomb and Reichard 1937:Fig. 8, Pls. XVIII, XX). They are surrounded by protective red outlines. Crooked (male) and straight (female) four-colored lines of rain extend from them to protective rainbow bars, all have eagle plumes, the two Winds have

Figure 43. A Wind.

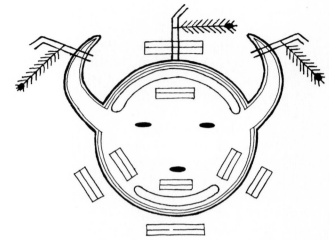

Figure 44. Sun or Moon.

coiled whirlwinds (white cotton cords) on their heads, and Sun and Moon have the turkey tail-feather bundle of Shootingway. The Sun, Moon, and Winds may be used as a group alone or as the central symbols of sandpaintings of the Skies or of Cloud Houses (Figs. 21, 43, Plate 9).

Sun and Moon

The Sun and Moon appear in prominent central positions or as main theme symbols in the sandpaintings of nine of the eighteen chantways that are known to use or to have used drypaintings in their rituals (Hailway, Shootingway, Red Antway, Big Starway, Beautyway, Plumeway, Navajo and Chiricahua Windway, Hand-tremblingway). They are especially frequent in the paintings of Shootingways and the Windways. They may support horns of power with the usual facial features, outlines, and plume feathers (Figs. 16, 23, 44, 106, 107, Plate 21), or they may be unhorned disks, from which twelve rays

of directional colors lead to rainbow bars at each cardinal point (Sun and Moon with rays; Fig. 45). This form usually has two feathers, often red, at each intercardinal (NE, SE, SW, NW) point. Sometimes two sets of zigzags and two of straight lightning arrows appear in place of the rays (Sun and Moon with lightnings).

In another depiction, the celestial orbs are surrounded by forty-eight long tail feathers radiating from them, sometimes interspersed with rays, in sets of twelve each of the four directional colors (Sun and Moon with feathers; Figs. 29, 46). Here the northern set may be red instead of black. In this form these symbols resemble the Whirling Tail Feathers that are shown being overcome by the Holy People in a design that belongs solely to the Shooting Chant (Newcomb and Reichard 1937:Pl. XXXIV; Wyman 1970b:Pl. 1).

Frequent variations are the Sun with yellow Pollen Boy and the Moon with blue Ripener Girl on their faces. Others are the Sun

110

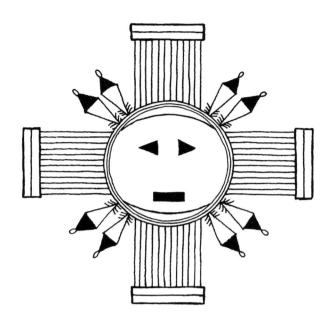

Figure 45. Sun or Moon with rays.

Figure 46. Sun with feathers and rays.

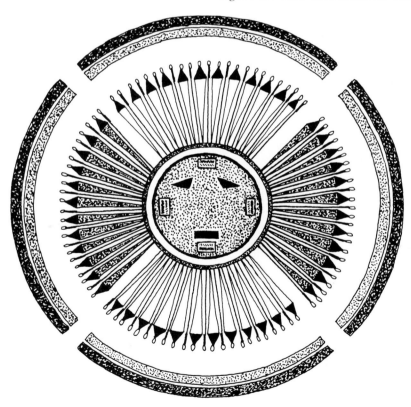

111

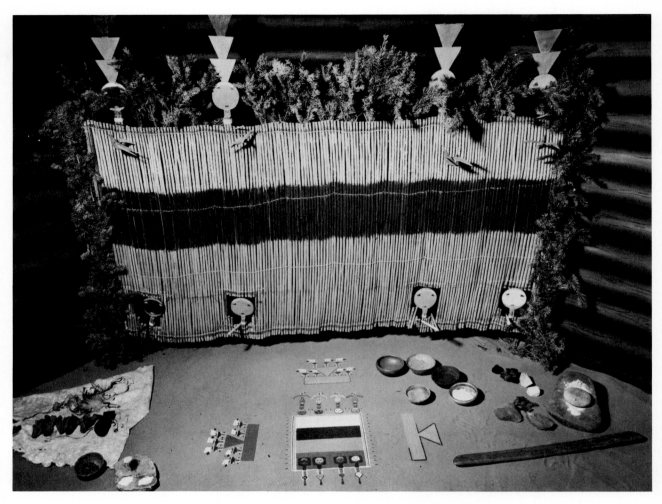

Figure 47. The wooden Sun's House screen setup as it would be at the west (back) side of the ceremonial hogan in a performance of Male Shootingway, Sun's House phase (chant with house). Equipment for sandpainting ceremony (pigments, grinding stones, weaving batten) and partially completed sandpainting *Sun's House with Sky People on Clouds* in front of the screen. Exhibit in the Arizona State Museum, University of Arizona, Tucson, 1940s. Courtesy Arizona State Museum.

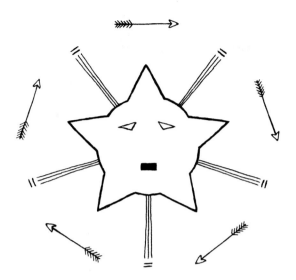

Figure 48. Big Star.

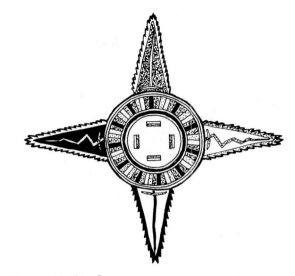

Figure 49. Big Star.

or Moon guarded by snakes, in which snakes of various kinds stand guard beside or around the orbs, and Sun or Moon clothed in snakes, a design in which the heavenly body has a pair of crooked or straight snakes crossed over it (see Figs. 16, 23).[6]

Sun's House

Another design peculiar to the Shooting Chant is the picture of the Sun's House. If the singer does not own a screen, this dry-painting may be substituted for the Sun's House screen in a nine-night performance of the Chant-with-the-house phase of Male Shootingway (Wyman 1970b:15–18, 21, 35, Pl. 7). If a screen is used, it is made of wooden rods or reeds and is set up at the west side in the ceremonial hogan on the fifth night and left there during the remainder of the chant (Fig. 47). The colors of the house—yellow, blue, black, and white in ascending sequence—are painted on the patient's face (yellow across chin, blue over nose and cheeks, black across eyes, white over forehead) in the figure painting ceremony or are

superimposed on the natural brown faces of sandpainting figures. These sunhouse stripes represent four houses placed one above the other, those of Yellow Wind, Sun, Dark Wind, and Moon. Through four windows in the lowest house are visible the faces of these four beings and the protruding heads of snakes. The same faces, together with four-tiered cloud columns, each surmounted by a bird or sometimes by ears of corn, are on the top house. This sandpainting may be elaborated by combining the Sun's House with other symbols, such as the Day-Sky sequence (Fig. 47). The most elaborate version shows the Slayer Twins surrounded by four complete Sun's houses (Newcomb and Reichard 1937:Pl. XIX; Wyman 1970b:Pl. 36).

Stars

Stars and Star People are featured in the sandpaintings of the Big Star Chant, but these motifs also appear prominently in some paintings of the Night, Plume, and Hand-trembling chants (Figs. 48, 49, Plate 13). On

Figure 50. Clouds: triangular, keystone, and terrace.

cloud terrace (a rectangle with a smaller one upon it) (Fig. 50). These symbols frequently form the foundations on which People stand or in which plants are rooted. Cloud columns are strings of three to twelve (most commonly four to six) abutting triangular symbols. They often have birds perched on them.

Cloud People. Cloud columns are made into Cloud People by placing a human head and neck, and occasionally arms, on the topmost segment (Figs. 51, 52). Cloud symbols with many heads have two or three faces on the top segment and two on each of the other segments, sometimes as many as thirteen in all (Fig. 53) (Wheelwright 1946a:191; 1956:Pl. VII; Wyman 1962:Figs. 46, 47). These faces represent the children of the Clouds or the Wind, or Sky People coming through the air wrapped in clouds. In a Hailway sandpainting there is a black lozenge-shaped hailstone (white on black cloud) on each segment. Cloud People appear in the paintings of Hailway and Big Starway, but they are especially featured in those of Navajo Windway.

Cloud Houses. A sandpainting belonging exclusively to the Shooting Chant depicts four rectangular cloud houses, blue, black, white, and yellow, around the Sun, Moon, and Winds in the center of the picture (Newcomb and Reichard 1937:Pl. XX; Wyman 1970b:Pls. 6, 7). On each house, representing windows, are two keystone-cloud symbols made of the appropriate contrast color. Each is surmounted by the face of the Sun, Moon, or Wind, by two four-tiered cloud columns with birds on them, sometimes guarded by two feathers, and by two ears of corn, also guarded by feathers. This painting has a bunch of five tail feathers in each quadrant.

pictures of the night sky they are white dots or crosses, but as main theme or subsidiary symbols they are four- or eight-pointed stars, or lozenge shaped or square bodied (oriented like a diamond shape) and are bordered with short rays of all colors (see Fig. 24). When stars are shown with Holy People or Ye'i on them, the square-bodied form is used (Wheelwright 1956:Pls. I–XIV).

Clouds and Cloud People

Clouds. Cloud symbols are used in minor positions in the sandpaintings of numerous chants, but as main theme symbols they occur only once, in a unique design for Big Godway recorded by Maud Oakes. There are three kinds of single cloud symbols: triangular with the base up; keystone-cloud shape (a triangle on a rectangle); and the

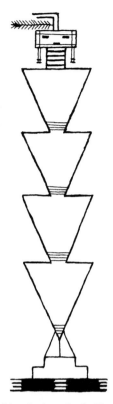

Figure 51. Single-headed Cloud Person.

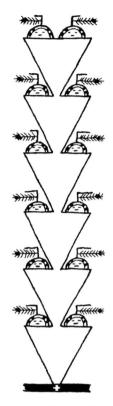

Figure 53. Cloud People.

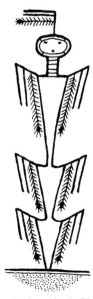

Figure 52. Single-headed Cloud Person.

115

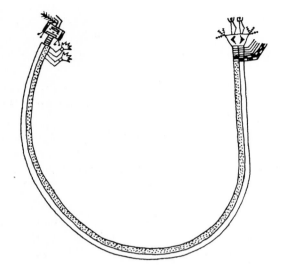

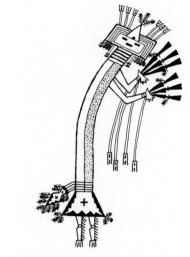

Figure 54. Rainbow guardian.

Figure 55. Rainbow Person.

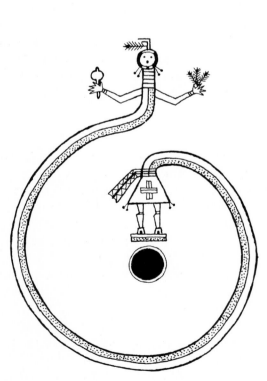

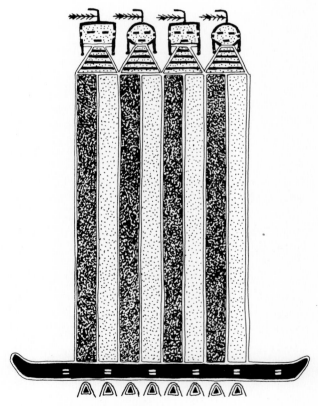

Figure 56. Whirling Rainbow Person.

Figure 57. Rainbow's House.

116

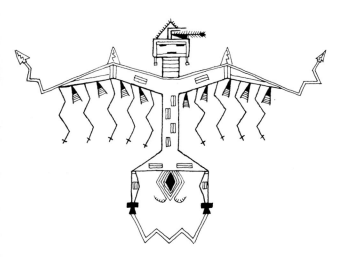

Figure 58. Thunder.

Rainbow People

Rainbow supernaturals have white faces and bodies longitudinally colored half in red and half in blue, with each color outlined in white (Fig. 54). The Rainbow Person guardian has white legs and arms, usually bordered with red, but when used as main theme symbols, Rainbow People may have limbs of directional colors. They may have ordinary straight bodies, slightly curved bodies, or very much elongated curving bodies curled around the center of the sandpainting (Figs. 30, 55, 56).[7] Called *Whirling Rainbow People*, these last forms are found in sandpaintings of Male Shootingway, Mountainway, Beautyway, Nightway,

Plumeway, and Navajo Windway. I discussed them in an earlier publication and suggested a prehistoric origin for them (Wyman 1962:304–5).

Another type of Rainbow People design, called Rainbow's House, consists of a solid block of four, six, or twelve vertical or horizontal (Stubby Rainbow People) red and blue rainbow bodies with alternating round, brown (male) heads and square, blue (female) heads on top of them (Fig. 57) (Wyman 1962:Figs. 39–42). All but one of the recorded examples pertain to Navajo Windway, the exception being a design made for Male Shootingway. The examples that have been illustrated are probably pictures of a reed or wooden slat reredos, a property of the singer, set up at the west in the hogan in a nine-night performance of the Chant-with-the-house phase of Navajo Windway. In similar fashion, the Sun's House screen is used in a phase of Male Shootingway (Wyman 1970b:15–17). If the singer does not own a screen, a sandpainting of it may be substituted.

Thunders

The Navajos' representation of the power of thunderstorms and lightning is something like a bird; indeed it is sometimes called a "thunderbird" (Fig. 58). It is drawn as if sitting—that is, with the legs widespread akimbo and both calves turned inward. Details differ in the sandpaintings of different chants. In general, the feet are black keystone-cloud symbols from which lightnings spring; the tail is lozenge shaped or fan shaped and made of tail feathers of various colors. The wings may have an upper border of rainbow and tips of contrast colors. From the lower border of the wings hang five or more zigzag white lightnings (water

117

spouts) with crossed ends (female) and/or objects like the turkey tail-feather bundle of Shootingway (rain bundles). The necks and heads of Thunders are like those of People; the faces and headdresses often have the color and characteristics specifically appropriate to the chant in which they are used (such as sunhouse stripes in Shootingway paintings), and there are arrowpoints on the heads and on or above the wings (Plates 14, 17, 21).[8] When Thunders appear in a quartet in radial compositions for Shootingway, the northern Thunder is pink. Thunder sandpaintings have been recorded for eight chants: Hail, Shooting, Beauty, Big God (in a unique sandpainting recorded by Maud Oakes), Plume, Coyote, Navajo Wind, and Hand-trembling.

Big Thunder

Big Thunder, a huge Thunder standing for all the diverse kinds of Thunders, sometimes with four small Thunders on its body, may appear in the sandpaintings of Shootingway (black; Reichard 1939:Frontispiece), Beautyway (blue; Wyman 1957:Pl. XV), and Plumeway (pink; Plate 21).

Animals

When animals are represented in sandpaintings in their own form rather than being anthropomorphized, they are less stylized (that is, shown with less psychical distance) than are other symbols. They are drawn as if seen from one of two standpoints: from the side (in profile) or from above (in plan, as it were). Again, living creatures drawn according to the first method are considerably closer to biological realism than are those shown in a top view. All mammals except

bats, weasels, prairie dogs, otters, and beavers are customarily shown in profile, as is the mythological Water Horse; all birds except eagles, hawks, and small birds in certain sandpaintings are also drawn in profile. Beings shown in top view are all water creatures except the Water Horse, all reptiles and amphibians, all insects (except for one naturalistic representation of hornworm), eagles and hawks (like Thunders), the small birds in sandpaintings of celestial realms for Shootingway (*The Skies, Cloud Houses, Sun's House*) and Hailway (*The Night Sky*), and the mammals just mentioned.

Personified animals have feet and legs, skirts and bodies, arms and hands, necks, heads, and headdresses like those of People. Usually they retain some clue as to their animal origin, such as the body markings and shape or the rattle tail of Snake People, the spines (flint points) of Horned Toad People, or the horns or antlers of Big-Game People. Buffalo People have an entirely animal body except for the human arms, hands, neck, head, and Shootingway headgear. Some anthropomorphized animals, however, look exactly like ordinary People and can only be recognized by external clues, such as the anthills above the heads of Ant People. A quartet of People seen in several Plumeway sandpaintings exhibit no hints whatever as to their nature. They are called Gila Monster and Frog Man, Chipmunk and Hornworm Woman.

Water Creatures

Water Monster. The Navajo name of the usually benevolent Water Monster, described in myths as an inhabitant of the lower worlds, means one-who-grabs-in-deep-water (water grabber). As the origin of cloudbursts and destructive rains, Water Monster is given

Figure 59. Water Monster.

Figure 60. Water Horse.

diverse representation in the sandpaintings of the Water, Shooting, Beauty, and Plume chants where it occurs. In Shootingway paintings, Water Monster is like Thunder (it is the adulterine child of Thunder), except that it has arms instead of wings, has horns (power) and five lightnings on its head, and carries five lightnings in its right hand and a wicker water jar suspended from its left wrist by a long string of sunray. In some paintings of other chants, it is made much like the rotund representations of frogs or turtles, sometimes with a variegated body of lozenge-shaped checks; in other instances it looks much like figures of otter or other beasts (Fig. 59, Plates 17, 18).[9]

Water Horse. Another water beast described in Navajo myths is Water Horse (deepwater pet), Water Monster's pet and the guardian of his home. Seen in Shootingway and Plumeway sandpaintings, it looks like the representations of buffalo, with keystone-cloud symbol feet and sometimes nose, with legs bent inward, with mane, leg hair, and sometimes tail of rainbow colors, horns on the head, and sometimes a heart line and restoration symbol (Fig. 60, Plate 18); the last is a cranklike projection from the figure, made in red and blue (Newcomb and Reichard 1937:Pls. XXIX, XXXIII). The Moisture Boys in a Plume Chant sandpainting have been said to be Water Horse in human form.

Fish. Figures of fish in Shootingway and Plumeway sandpaintings remind us of the episode told in the myths of Holy Boy Swallowed by Big Fish. This theme is represented in the double sandpainting called *Sky-Reaching Rock* (Wyman 1970b:37–40, Pls. 9–16). The figures are sometimes quite fish-like, with forked tail and fins, but in other instances they may have legs and arms in addition to the fins and look more like sand-

119

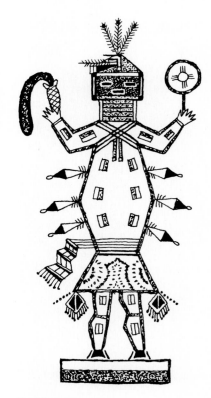

Figure 61. Fish.

Figure 62. Fish Person.

painting figures of otter than like real fish (Figs. 61, 103, Plate 18). Sometimes a fish has an air bubble (circle) at its mouth to symbolize its ability to breathe under water. Big Fish appears as a main theme in some Plumeway paintings (see Fig. 103).

Fish People. A unique sandpainting for Shootingway shows personified fish. They are like Shooting Chant People wearing the characteristic headdress, except that they are short and stocky with bodies bulging at the sides. Three black and white feathers are attached to each side of the body (Fig. 62) (Wyman 1970b:36, Frontispiece).

Frogs, Toads, and Turtles. Frogs, toads, and turtles are usually shown in subsidiary po-

sitions in sandpaintings, especially in those of the Plume Chant, where mixtures of water creatures are common. The three are made much alike, with fat, rotund bodies and short limbs and neck (Fig. 63, Plate 17). Frogs and toads are not differentiated visually. Frogs appear once as the main theme of a unique Beautyway sandpainting. Here they are quite naturalistic, but they do not have forelimbs (Wyman 1957:Pl. XIV). This may refer to a mythic episode in which frog lost his arms in gambling. Similar frogs on the body of Earth in a Plumeway painting do have forelegs. This painting appears to refer to a later stage of the myth, after frog bought back his arms by trading away his stone pipe and tobacco (shown in the quadrants). Figures said to be Frog Man in some Plume Chant

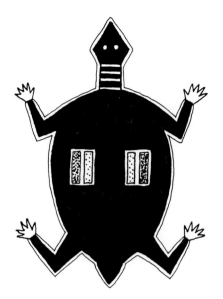

Figure 63. Frog.

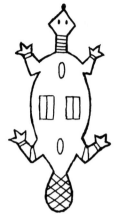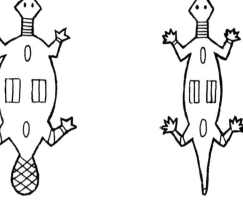

Figure 64. Beaver and otter.

designs are indistinguishable from any other People.

Beavers and Otters. Although they are mammals, beavers and otters generally appear in sandpaintings with other Water Creatures or Thunders, where they serve in pairs as guardians of the eastern opening. They are represented quite realistically with brown fur, but sometimes they have necks like People. The beaver's characteristic flat tail is shown, crosshatched with white lines (Figs. 64, 103, Plates 11, 17) (Newcomb and Reichard 1937:Pl. XXXIII).

Snakes and Snake People

Snakes are the animals most frequently shown in sandpaintings. They are found in pictures made for the Shooting, Big Star, Mountain, Beauty, Navajo and Chiricahua Wind, and Bead chants, and in one for an

Upward-reachingway (Evilway) rite (Newcomb and Reichard 1937:Pls. III–XIII; Reichard 1939:Pls. II, III, IX, XIV–XVI; Wheelwright 1949:139; 1956:Pl. VI; Wyman 1957:Pls. I–VI; 1962:Figs. 22–30). It is remarkable that the sandpaintings of Plumeway, with their profusion of other animals and birds, do not have them. They are especially featured in three chants: Shootingway, which is used to treat damage caused by snakes or by the cognate symbols, arrows or lightning; Navajo Windway, in which snakes are important in its myth and as etiological factors; and Beautyway, in which the myth is a story of a girl relentlessly pursued by Big Snake Man. The last is sometimes called "the snake chant" by English-speaking Navajos.

Snakes may be crooked (male) or straight (female), and, according to the habit of pairing common in Navajo symbolism, associated respectively with zigzag and flash

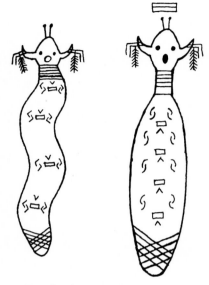

Figure 65. Big Snakes.

lightning. Crooked snakes are strong, active, and dominant, while straight snakes may be thought of as weak, passive, and submissive. Crooked snakes have four angles, two on each side. Snakes have various combinations and arrangements of three kinds of marks in longitudinal sets of four on their bodies: squares or rectangles (their dens), chevrons (deer tracks), and lunate curves (phases of the moon). Crooked snakes sometimes have lines of all colors across their bodies at the angles. Four crosslines near the tail indicate that all are thought of as rattlesnakes. They have necks like those of People. Making a snake's tongue red (venom) instead of the usual yellow injects exorcistic emphasis, making the painting suitable for use in Injuryway subritual. As in all sand-painting figures, outlines and body markings are made in contrasting colors.

Big Snakes. A mythical creature called Big Snake or Big Snake Man cannot be equated with any known biological species. As Reichard remarked in conversation, "No one has ever seen this snake, but almost everyone has a relative who has." Big Snakes are represented with short, thick bodies, either straight or crooked, often swelling considerably in the middle. Sometimes they have horns of power with white eagle plumes at the tips (motion and speed), yellow spots on their heads (pollen), or red spots instead (venom and danger, exorcism). There may be small spots all over their bodies (snake-skin patterns). Speckled bodies make them more terrifying (Figs. 16, 65).

Slender Snakes. Ordinary slim snakes (sometimes equated with the bullsnake, *Pituophis melanoleucus*) may be crooked (male) or smooth and straight (female). They have the snake characteristics described previously

Figure 66. Straight and crooked slender snakes.

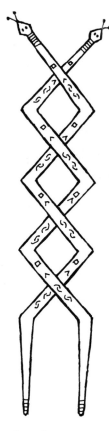

Figure 67. Twined snakes.

(Figs. 16, 23, 66). Some are called arrow snakes and are equated with racers (*Masticophis flagellum*). In sandpaintings of the Bead Chant, the slender snakes that helped the eagles and hawks lift the mythic hero Scavenger from the earth to the sky are supplied with plume feathers at their angles, symboling their speed, and some even have bird's heads to connote the same capacity (Reichard 1939:Pls. II, III).

Twined Snakes. In some designs, pairs of crooked snakes are shown with their bodies twisted or twined about each other (Fig. 67) (Wyman 1962:Figs. 28, 29). Informants may say that they are breeding.

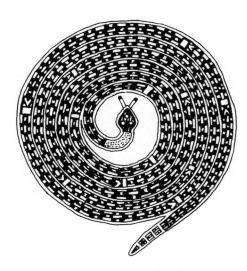

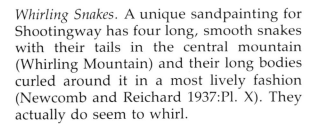

Figure 68. Endless (Coiled) Snake.

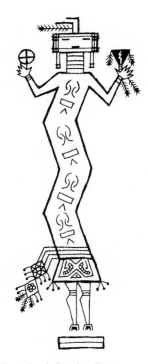

Figure 69. Crooked Snake Person.

Whirling Snakes. A unique sandpainting for Shootingway has four long, smooth snakes with their tails in the central mountain (Whirling Mountain) and their long bodies curled around it in a most lively fashion (Newcomb and Reichard 1937:Pl. X). They actually do seem to whirl.

Endless (Coiled) Snakes. A mythical variety called Never-ending-snake is depicted as a long, smooth snake in a tight coil (Figs. 28, 68) (Newcomb and Reichard 1937:Pls. XII, XIII). It is evil and dangerous and therefore appropriate in sandpaintings made for exorcistic ceremonials. Reichard (1970:454) said of Never-ending-snake, "He is wholly evil and destroys the mind and consciousness by coiling about and squeezing his victim. He symbolizes the danger of getting into a circle, and only valuable offerings and exorcistic ritual can release a person from his embrace."

Snake People. Anthropomorphized snakes have bodies like those of the animal forms, crooked or straight, or flat and bulging in Big Snake People, all with the characteristic markings. Sometimes the rattle-tipped tail is shown between their human legs. Otherwise they are like any People in sandpaintings (Figs. 26, 69, 85, Plate 5). Snake People often carry a bow and arrow. A unique painting for Shootingway shows two Big Snake People that have snake-shaped heads instead of the customary human heads, the yellow tongue bent down over the forehead so as to accommodate the pointed red feather hat of the chant.[10]

Horned Toads and Horned Toad People

Horned toads and Horned Toad People are confined to the sandpaintings of the Red Ant Chant, save for one painting used for hand trembling divination that includes horned toads (Newcomb 1940:64–65) and one for Mountain-Shootingway that shows Horned Toad Man (Wyman 1970b:Pl. 42). The latter painting depicts the mythic episode wherein Horned Toad Man is swallowed by Big Fish, whose sides he cuts with a flint knife and escapes; there is a similar episode in the myth of Male Shootingway. It is likely that Red Antway emphasizes Horned Toad Man because in the myth it was he who deprived the wicked Ant People of their weapons for the benefit of mankind.

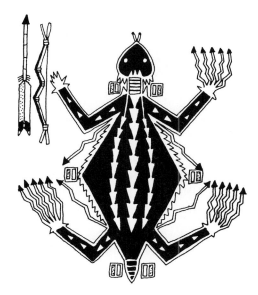

Figure 70. Horned toad.

Horned Toads. The animal form of horned toad is drawn with considerable realism, the numerous flint points upon or projecting from its body exemplifying its scaly back, the armor that was part of the fee it extracted from the Ant People for restoring them to life after their internecine slaughters. Horned toad's armor leaves no portion of its surface exposed to attack from Thunder, so it has no fear of lightning. Five zigzag lightnings spring from each hindfoot and from its axillae and hips. In its left forefoot it may carry a variegated curling symbol of thunder sound, resembling the featherlike curves beside Thunder's tail that symbolize its reverberations—an example of the fertility of the Navajo mind in devising charming and attractive abstract symbols. Horned toad's right forefoot usually holds a bow and arrow. It has a neck like People, and its yellow tongue is like that of a snake (Fig. 70). Horned toads often appear in sand-

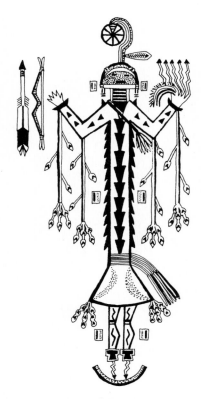

Figure 71. Horned Toad Person.

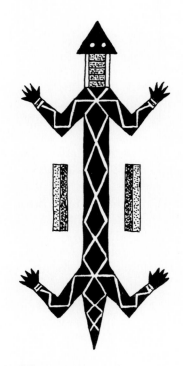

Figure 72. Gila monster.

paintings with anthills, their source of food (Wyman 1973:Figs. 44–55).

Horned Toad People. Horned Toad People are drawn with the same equipment as horned toads: flint armor, lightning weapons, bows and arrows, and sounds of thunder (Fig. 71). Flint points project up from their heads (Wyman 1973:Figs. 35–40). Clad in the flint-armored garments of the Ant People, they too are immune to lightning strokes.

Gila Monster

Gila monster, the originator of hand-trembling divination, is seen only in the sandpaintings of the Hand-trembling Chant. This lizard is drawn less naturalistically than horned toad. Its elongated body may be covered with lozenge shapes of all colors or with lightnings, symbolizing the animal's scaly skin (Fig. 72, Plate 7). In one painting it is provided with points somewhat like those of a horned toad (Kluckhohn and Wyman 1940:Figs. 25, 26; Newcomb 1940:64–65). Except for Gila Monster Man, seen in a few Plumeway sandpaintings with no distinguishing marks, this creature is not made in human form.

Another lizard identified by informants as a chuckwalla, a large species found in the southwestern United States, sometimes ap-

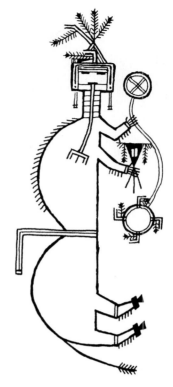

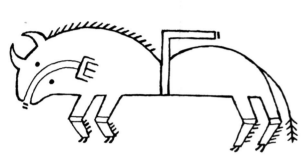

Figure 73. Buffalo.

pears, not very realistically, in a subsidiary position in a few sandpaintings of the Plume Chant.

Buffalo and Buffalo People

Figure 74. Buffalo Person.

Buffalo. Except for a single sandpainting for the Plume Chant, buffalo (bison) are found only in paintings for Shootingway. This beast is drawn with a long body constricted in the middle so that it appears to have two humps. A cranklike red and blue restoration symbol crosses the body and arises from the junction between the humps. Also a red and blue life or heart line leads from the heart through the mouth and sometimes beyond it. This line symbolizes the breath and bloodstream of the beast. The belly is bordered with yellow, representing pollen from the vegetation through which the animal runs. The creature has a mane, hairy legs bent toward the center at the knee, split hooves, and black horns (Fig. 73) (Newcomb and Reichard 1937:Pls. XXIII–XXVIII;

Reichard 1939:Pls. XXII–XXIV). A mirage garland is often used as the guardian for buffalo sandpaintings, signifying the dust and mist enveloping the moving herds seen at a distance (see Fig. 4).

Buffalo People. Buffalo are made into Buffalo People by providing them with human arms, hands, neck, head, and a Shooting Chant headdress. Otherwise they retain their animal form. They carry feathered travel hoops, a magic means of travel. According to some myths, Buffalo People are the monstrous children, part human and part beast, born of the adultery of Holy Man and Buffalo Woman (Figs. 4, 74).

Figure 75. Bear.

Bear

The bear is *the* animal of the Mountain Chant, important in all aspects of its theory and practice. It is used as a main theme symbol in the sandpaintings of that chant and in one unique painting for its sister chant, Beautyway. It is also seen in paintings for the extinct chants of Awlway and Earthway. In subsidiary roles, usually as a small paired guardian of the east, the bear appears in sandpaintings for Mountain-Shootingway, Red Antway, Big Starway, and Plumeway (Plate 19). Bears and bear tracks in the small paintings for big hoop ceremony trails were mentioned earlier. The bear is usually drawn naturalistically, as a stocky beast (Fig. 75) (Wyman 1957:Pl. XII; 1973:Fig. 56). Sometimes a bear has cloud symbol feet and nose, and white dots over its shoulders, indicating that it is a sky or constellation symbol. Red-shafted flicker feathers along its back represent a red glow, for a myth of Shootingway says that as bear ran away from the moccasin game, his fur looked red in the sunlight. Bears are not personified in sandpaintings.

Porcupine

The porcupine is among the mountain animals that are important etiological factors in afflictions treated by Mountainway. It is drawn in sandpaintings in two forms: one is a seminaturalistic humpbacked figure easily identified by the short lines representing its quills, and another is more stylized with a neck like one of the People and a triangular head (Fig. 76) (Wyman 1975:Figs. 27, 28). Porcupines are main theme symbols in sandpaintings of the Mountain Chant and subsidiary symbols in those of the Plume Chant (see Fig. 106).

Hunting Animals: Predators

A group of predatory animals—wolf (their leader), mountain lion (Fig. 77), wildcat (bobcat), lynx, "spotted lion" (probably the

Figure 76. Porcupine.

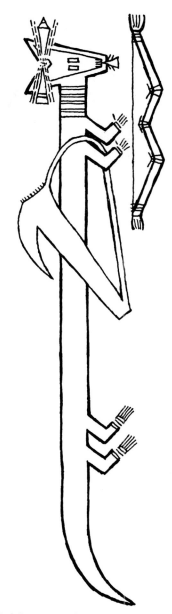

Figure 77. Mountain lion.

Mexican jaguar), and badger—are prominent in the myth and the sandpaintings of the Bead Chant (Reichard 1939:Pls. V–VII). Here they are highly stylized with much-elongated bodies, human-type necks, and triangular heads set at right angles to their bodies. Bobcat and lynx have stubby up-curled tails, and the others have straight, pointed tails. Much more realistic representations of them are made as subsidiary figures, in quadrants or as paired guardians, in the sandpaintings of other chants, such as Shootingway, Mountain-Shootingway, and Plumeway. The wolf is usually white but sometimes yellow.

Big-Game Animals and Big-Game People

Big-Game Animals. Deer, antelope, mountain sheep (bighorn), and less often elk are portrayed very realistically, usually in subsidiary positions or as paired guardians, in many of the sandpaintings of Plumeway and occasionally in paintings for Shootingway and Mountain-Shootingway (see Figs. 89, 104–107, Plates 12, 19, 20).[11] They may or may not have the heart line and the restoration symbol. Two sandpaintings supposed to be for Red Antway but probably derived from Plumeway also have deer and antelope in one painting and porcupine, squirrel, and gopher in the other (Wyman 1973:Figs. 60, 61). Big-game animals, especially deer, are important in the myth of the Plume Chant, which is the favored treatment for deer disease. Hunting masks made of the dead skin of the game animals are occasionally seen in sandpaintings, either in the quadrants or carried by People (Figs. 106, 107). Mrs. Newcomb suggested that the realism in depicting these animals came from the fact that the pictures "are not symbols of abstract powers, but simply stylized sketches of the

actual animal" (Newcomb, Fishler, and Wheelwright 1956:33).

Big-Game People. All of the big-game animals are shown in human form in the sandpaintings of Plumeway, and Mountain Sheep People appear in some paintings for Mountain-Shootingway (Wyman 1970b:Pls. 40, 41). Usually they have horns or antlers on their heads, which allow recognition of their animal nature, but occasionally they do not, so identification has to depend upon other kinds of information.

Miscellaneous Mammals

Coyotes and foxes, drawn quite realistically, occur in sandpaintings for the Coyote Chant (Wheelwright 1956:Pls. XVI–XVIII). Coyote People, looking like ordinary People, are also made in these paintings and allegedly in a painting for Plumeway.

The bat, highly stylized and usually paired with Sun's tobacco pouch, is one of the commoner symbols used as a guardian of the east. Only one recorded sandpainting for Plumeway, said to be a "small sandpainting used for special purposes," has bats as main theme symbols. A yellow diamond on the bat's body represents a small skin it once received as a reward for its help. Bats are associated with insects, such as Big Fly, as helpers in myths (Figs. 21, 78, Plate 11).

Weasels are important etiological factors for illnesses treated by Mountainway and occur as paired guardians in a few of its sandpaintings. Weasel skins are seen as medicine bags or as subsidiary symbols in the paintings of Beautyway, whose myth recounts the adventures of the sister of the heroine of the Mountainway myth (Wyman 1957:Pls. VIII–X). A red line on an animal's pelt, signifying death, shows where the knife

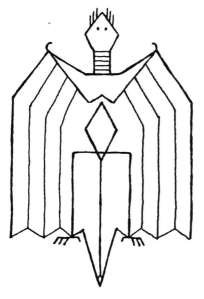

Figure 78. Bat.

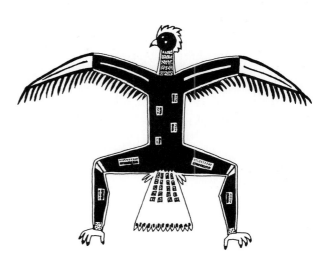

Figure 79. Bird (stylized).

slit the hide. Much-elongated weasels also occur in the center of Awlway paintings.

Rabbits (cottontails and jackrabbits) and prairie dogs are used today by Navajos as food animals. They occur as food for eagles in sandpaintings of the Eagle and Bead chants, and are shown outside their nests. They are also subsidiary symbols in paintings for Plumeway. Prairie dog hide may be used for the medicine pouches carried by People.

Other small mammals—squirrels, chipmunks, wood rats (pack rats), and gophers—are seen as subsidiary symbols in Plumeway sandpaintings. Medicine bags, like the one carried by Talking God, may be made of squirrel as well as of prairie dog skin. Chipmunk Woman is the only small animal shown in human form, one of the ordinary-looking People in a quartet in some Plume Chant paintings.

Birds

Eagles and Hawks. The birds of prey shown in profusion in the sandpaintings of the Eagle and Bead chants are posed like Thunders, as if sitting with their wings spread wide and their legs widespread akimbo with calves turned inward. They have claws or cloud-symbol feet, sometimes necks like People, and a fan-shaped tail; the head is made in profile but with both eyes depicted, showing which way the bird is facing (Fig. 79) (Reichard 1939:Pls. II, III, VIII). Informants have identified the birds in Beadway paintings as bald eagles, black and white eagles, big black hawks, white hawks (made pink), big blue hawks, and yellow-tailed hawks.

Big Birds. Ducks (Shootingway), turkeys (Plumeway; see Figs. 102, 106), and four great

131

Figure 80. Bird (naturalistic).

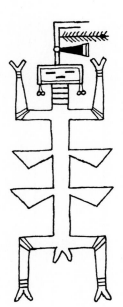

Figure 81. Big Fly.

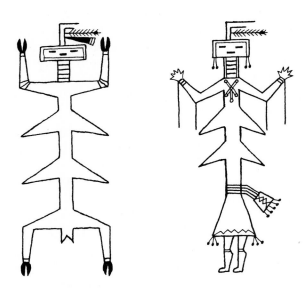

Figure 82. Ripener (left) and Ripener (Corn-beetle) Girl.

birds in one Plumeway painting (which Mrs. Newcomb thought were the crane, heron, grebe, and loon, who in myth contended with Cicada for possession of the earth immediately after the Emergence) are drawn realistically in profile. The turkeys are especially natural looking.

Small Birds. Various species of small birds are also drawn in profile (Fig. 80), except for those on the skies and heavenly houses of Shooting Chant and Hail Chant sandpaintings mentioned earlier (Newcomb and Reichard 1937:Pls. XV, XVIII, XIX; Wheelwright 1946a:193), where they are posed like eagles and hawks—that is, seen in top view. A somewhat standard quartet of birds frequently found perching on the heads of People or on corn plants or Corn People includes bluebirds (harbingers of peace and happiness and heralds of the dawn), yellow-headed blackbirds, yellowbirds (goldfinches or yellow warblers), and a fourth that varies (western tanager, blue swallow, blue swift, or some other). A yellow line drawn from a bird's beak to a Person's mouth signifies pollen or song. Among the species that may appear are the red-shafted flicker, black-tailed swallow, and night hawk. Small birds can be recognized by their color and sometimes by distinctive characteristics such as forked tails on swallows. Birds occur in the sandpaintings of many chants (for example, see Figs. 8, 21, 40, 102, Plates 11, 12).

A unique sandpainting for Female Shootingway has blue Kingbird People or Titmouse People as main theme symbols. They are shown sitting with cloud-symbol feet like Thunders; they have human arms and hands and a crested bird's head turned in profile (Wyman 1970b:Pl. 38).

Insects and Spiders

Big Fly and Ripener. The biological cognates, functions, nature, and references to illustrations of the mythical insects, Big Fly and Ripener, were given under the heading "Paired Guardians of the East." Big Fly appears in this role or as a subsidiary figure elsewhere in sandpaintings of nearly every chantway (Figs. 81, 89, 104, Plates 7, 13). The only chantways that do not have this symbol are the extinct or obsolescent Big God, Eagle, Awl, and Earth chants, and the recorded materials for these are so meager that we cannot be sure that they never had it. Ripener (Cornbeetle) occurs only in paintings for Shootingway, Plumeway (Figs. 102, 103, Plates 17, 18) and Navajo Windway, but it is important (along with Pollen Boy) in the drypaintings of Blessingway. Big Fly is also a main theme symbol in sandpaintings for the Hail, Big Star, and Handtrembling chants (Kluckhohn and Wyman 1940:Figs. 23, 24; Wheelwright 1946a:175; 1956:Pl. XII), and Ripener Girls are main themes in two paintings for Plumeway. These two creatures are made with legs and standard or forked clawlike feet in sitting position; a forked tail; one or two pairs of triangular wings, those of the Ripener sloping downward; raised arms with claws or fingers, or sometimes with no arms; and a human-type head and headgear. Big Fly's face is usually white; that of Ripener may be brown, white, or the color of the body.[12] The Ripener may be partially or completely anthropomorphized as Ripener Girl (Fig. 82).

Dragonfly. The third most common insect symbol in drypaintings is the dragonfly, seen in paintings for Hail, Water, Shooting, Mountain, Beauty, Plume, and Navajo Wind chants. This symbol of pure water often ap-

pears in groups of four on circular or petal-shaped appendages or on keystone-clouds attached to the central pool of radial designs, as if hovering over or drinking from it. As mentioned earlier, dragonflies may also function as paired guardians of the east. This insect is often more highly stylized than Big Fly or Ripener, sometimes being an almost entirely abstract symbol without legs or arms and with a simple cross for a head (Fig. 83). Otherwise it is made somewhat like them, with one or two pairs of triangular wings, and so on (Plates 12, 16). Its distinctive identifying characteristic is its body, which is usually covered with spots of one or all colors (Wyman and Bailey 1964:144–46, Pl. IV).

Butterfly. Quite naturalistic butterflies appear in the quadrants of a sandpainting for Coyoteway (Wheelwright 1956:Pl. XVI), and a stylized one occurs in the Beadway painting of Scavenger in the eagle's nest, sometimes with legs and arms like Big Fly or spotted like the dragonfly (Reichard 1939:Pl. I; Wyman and Bailey 1964:148, Pl. V). The butterfly is a symbol of temptation and foolishness and is therefore appropriate for Coyoteway, a chant which may be used as a cure for the ill effects of incest.

Ants and Ant People. It is extraordinary that representations of ants as insects do not occur in the sandpaintings of the Red Ant Chant (except as tiny red dots around anthills). Ant People—red, black, yellow, blue, brown, or white—are, however, one of the three predominant types of sandpainting symbols in this chant. They are provided with ample lightning protection, carry bows and arrows and stone clubs, and occasionally are flint armored (Wyman 1973:214–18, Figs. 10, 29–34). Except for the anthills made in relief

over their heads, they are indistinguishable from any other similarly equipped People. Ants in insect form have been recorded only once, highly stylized, in a painting for the extinct Earthway (Wyman and Bailey 1964:149, Pl. V).

Hornworm. Hornworms or sphinx moth caterpillars, called "neck or shoulder humped insect" by the Navajos, helpers of the Hero Twins of the myth of Monsterway, are found only as small guardians of the eastern opening in three sandpaintings for Plumeway. In one instance the figure is very realistic; in the others it is considerably stylized (Wyman and Bailey 1964:150, Pl. V).

Spider. Highly realistic representations of these arachnids sitting on their webs have been recorded in a small sandpainting for Male Shootingway Evilway and in two for Plumeway. Most of them are unmistakably black widow spiders. The Plumeway paintings were said to be used to cure spider bites, scorpion or centipede stings, or skin rashes caused by spider infection (Wyman and Bailey 1964:143, Pl. V).

Miscellaneous Insects. Bees appear in two paintings for the extinct Earthway, a cicada is shown as a minor detail in one for Male Shootingway, and four alleged "bluebottle flies" are seen in one of the somewhat fanciful Beadway drawings made by Sam Chief for Mrs. Wetherill (Wyman and Bailey 1964:148, Pl. V).

Plants

Corn and Corn People

Corn. Besides their frequent use as quadrantal symbols and in a few other positions, corn plants are main themes in sandpaint-

Figure 83. Dragonfly.

Figure 84. Corn.

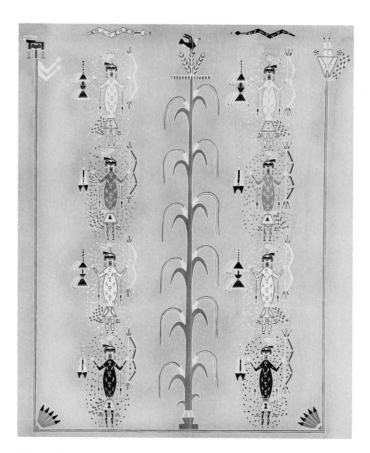

Figure 85. Eight *Big Snake People with Twelve-eared Blue Corn,* Male Shootingway, Sun's House phase. Courtesy Wheelwright Museum. Photograph, Martin Etter.

ings of the Red Ant, Beauty, Night, and Plume chants. Ordinarily a corn plant has three white roots stemming from a cloud symbol, from an earth bar, or from the painting's central body of water. The stalk bears one ear on each side, two leaves on one side and three on the other, and a tassel of all colors made up of one horizontal and three diverging vertical branches (Figs. 84, 102, Plates 17, 19, 20). Often one or two birds perch on the tassel and, in some designs, on each leaf. A much rarer variety has twelve leaves and ears, six on a side (Figs. 26, 85). A twelve-eared corn plant is

Figure 86. Corn Person. *Figure 87.* Cactus with fruit. *Figure 88.* Cactus Person.

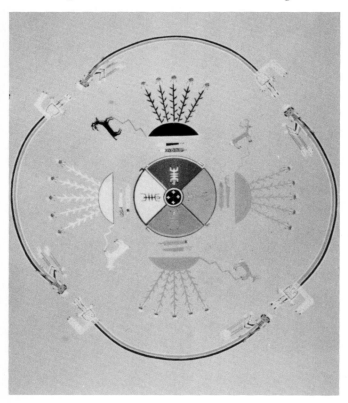

Figure 89. Water-gazing divination drypainting. Four Big Flies on segments of the circular center; feathers, stone pipes, and mountains each with five Medicine Herb People on it in cardinal positions; a unique guardian of four separate Rainbow People. The central portion of this design is used in a form of divination in which the diviner gazes at stars reflected in a pool or container of water. Courtesy Wheelwright Museum.

usually the central figure in a linear composition, approached from both sides by the figures of People. An ordinary two-eared plant may also be depicted in this position. Twelve-eared corn may or may not have pairs of birds on the leaves and tassel (Newcomb and Reichard 1937:Pl. III; Wyman 1957:Pl. X; Wyman and Newcomb 1962:Figs. 3, 5, 6). A unique variety in a Nightway sandpainting made by the famous singer Lefthanded is two eared and five leaved, but the stalk is bent at right angles in ten places with a pair of Ye'i, black male and white female, sitting on the tassel and four other pairs perched on four of the horizontal portions of the stalk. Also, a bird perches on the tassel of each of the four plants in the painting (Plate 10).

Corn People. Personified corn retains all the characteristics of the corn plant and, in addition, has human arms, hands, neck, and head, with the tassel doing duty as or along with the usual headgear (Fig. 86) (Newcomb and Reichard 1937:Fig. 10, Pls. XXI, XXII; Wyman 1970b:Pl. 22; 1973:Fig. 13). Sometimes a one- or two-tiered cloud symbol is interposed between the head and the corn tassel, on which there may or may not be perching birds with the mouth-to-mouth pollen line of song. The Corn People may carry an ear of corn and a basket (of pollen). Corn People or plants are the most frequently used symbols in Blessingway drypaintings.

Cactus and Cactus People

Cactus. Although not strictly confined to the two windways, cactus and Cactus People are particularly featured in the myths and sandpaintings of these chantways (Wyman 1962:308–9, Figs. 8, 49–51, 56, 59). Shown as a plant, cactus has white roots like corn, two spiny ascending branches on each side of a spine-covered stem, and either yellow flowers or round yellow fruit at the top of the stem and at the end of each branch (Fig. 87).

Cactus People. Anthropomorphized cactus is commoner in sandpaintings than the plant itself. Cactus People have from two to five branches on a side, and their only marks of personification are one or more humanlike necks and heads. Sometimes they have a single head and branches in bloom. The head may bear a two-tiered cloud symbol (Fig. 88). Others not only have a head on top of the central stem but have one at the end of each branch, up to eleven in all. The branches may be ascending and either alternate or opposite, or horizontal and opposite. Variations such as these, and variations in the colors and arrangements of the spines or in the roots, illustrate a significant source of originality in sandpainting artistry, not in invention, but in variation within a traditional framework and in the degree of adornment of the symbols.

Medicine Herbs and Medicine Herb People

Medicine herbs sometimes occur in the quadrants of radial sandpaintings, replacing or accompanying the four sacred plants. They have three white roots and five leafy stalks with white flowers at the tips (Figs. 103, 105, Plates 5, 17, 20) (Newcomb and Reichard 1937:Pls. IX, XVII, XXIII, XXV, XXX). The herbs are turned into Medicine Herb People by thickening the central stalk a bit and putting a human neck and head at the top, or by adding heads to all five stalks (Fig. 89) (Newcomb and Reichard 1937:Pl. XXVIII). A Shooting Chant design, *Emergence of Med-*

icine People, shows only their heads coming out of each side of the square, with black Emergence Place in the center (Reichard 1939:Fig. 3).

Sunflowers and Sunflower People

Of four designs for the obsolescent Big God Chant, three include sunflower plants; the fourth contains Sunflower People. Two sandpaintings of four pairs of Big Gods, in radial arrangement in one (Plate 8) and on whirling logs in the other (Plate 4) (Foster 1964b:609), have guardians composed of two sunflower plants with their three white roots crossed at the west. Each plant has a yellow flower at the tip and several flowers and green leaves on each side of the stem. "The southern plant has large blossoms and leaves and small seed centers and is male, the northern one has small blossoms and large seed centers and is female" (Newcomb: notes typed on pieces of paper attached to her watercolor sandpainting reproductions). Sunflower seeds were an important source of food "in the old days" and were carried by the Stricken Twins of the myth of Big Godway in their travels seeking to be healed (Newcomb: sandpainting notes). One linear painting has a sunflower plant in the center with two Ye'i approaching it on each side (Fig. 22). The plant has three white roots stemming from a keystone-cloud symbol, a flower at the top, three flowers and leaves on one side, and two on the other. Another linear design has four Sunflower People as main themes, with Talking God approaching them from the south, and Calling God from the north. The plant has been personified merely by substituting the head of Big God with its white teeth and five head feathers for the terminal blossom (Plate 6).

Wild Food Plants

In some sandpaintings for Plumeway, especially in the design of *The Farms,* certain wild food plants, such as Rocky Mountain bee balm or pigweed, are shown in the quadrants. These accompany the corn that the hero of the Plumeway myth planted, with seeds provided by his pet turkey, after he had floated down the San Juan River in a hollow log, assisted by the Ye'i (Plate 20) (Wyman 1970b:Pl. 34). These plants usually have three stalks with numerous leaves and sometimes flowers.

The Four Sacred Plants

Of the four sacred domesticated plants, which are the subsidiary symbols most often placed in the quadrants of radial compositions, corn has been sufficiently described above. Beans are made with five stalks bearing white flowers at the ends, and numerous leaves and pods, with the seeds showing in them, along each stalk. Squash has a single stem bent in four places, with a leaf and fruit at each angle and a coiled tendril at the tip. Tobacco also has five stems with numerous leaves and white flowers and is often indistinguishable from the medicine herbs. Examples of these plants may be seen in Figures 8, 9, 17, 30, and 90, and in Plates 4, 8, and 17.

Arrows and Arrow People

Bows and arrows are carried by many types of People in the sandpaintings of many chantways. Arrows, the earthly cognates of lightning, also frequently appear alone, as subsidiary symbols or minor details (Plate 13). Arrows, of course, are the main theme

symbols of the sandpaintings of the *Great Plumed Arrows,* which belong exclusively to the Mountain Chant (Matthews 1887:Pl. VIII; Wyman 1975:Figs. 29–32). Bows and arrows are also the main theme symbols of a sandpainting for the Red Ant Chant (Wyman 1973:Fig. 59). Otherwise they do not appear as main themes unless we include the design of *Baskets of Arrows* (actually merely arrowpoints) from Male Shootingway Evilway (Wyman 1970b:Pl. 44).

Anthropomorphized arrows are made in sandpaintings only for the Male Shooting Chant. The legs, lower bodies, necks, and heads of Arrow People are like those of any human figure, and naturally they carry bows and arrows. Their nature is shown by several signs: their arms form a bow, their chests are the fletching of the arrow, and their shoulders form the neck. Thus the upper part of their bodies is like the bow with an arrow across it in position to be discharged (Fig. 91) (Newcomb and Reichard 1937:Pl. XXXV; Reichard 1939:Pls. XI–XIII; Wyman 1970b:Pl. 23).

Houses

Houses are usually seen as locality centers in sandpaintings, one or sometimes a group of four signifying the domicile of the main theme beings around them. Houses do appear, however, as main theme symbols themselves, or at least as important major symbols, in the sandpaintings of several chants. The *Sun's House* and *Cloud Houses* of

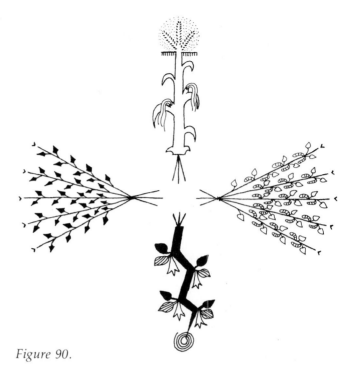

Figure 90.

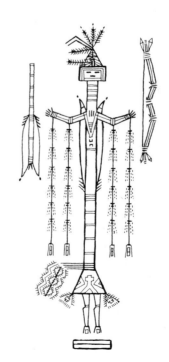

Figure 90. The four sacred plants: corn, beans, squash, tobacco (clockwise from top).

Figure 91. Arrow Person.

139

Shootingway and *Rainbow's House* of Navajo Windway (see Fig. 57) have been described earlier. Also used as main themes are the rectangular houses of White Thunder and of Toad Man in two small sandpaintings of the Hail Chant (Wheelwright 1946a:166, 169); the circular abodes in the paintings of *Snakes on House* for the Shooting, Beauty, and Navajo Wind chants (Wyman 1957:Pl. III); the circular home of the Star People in Big Starway paintings (Wheelwright 1956:Pl. IV); the circular bears' den of the shock rite sandpaintings for Mountainway (Wyman 1971:Figs. 18–20); the rectangular terraced houses of the deer in Plumeway paintings (Plate 19); the trapezoidal Coyote homes of Coyoteway (Wheelwright 1956:Pl. XVI); the two rectangular two-story houses of the eagles and hawks in the Skyland (actually a symbolic representation of four houses in the cardinal directions) of Beadway (Reichard 1939:Pl. IV); and the circular eagles' nests of Eagleway and Beadway paintings (Reichard 1939:Pl. I). It is evident that houses are usually rectangular or circular, or occasionally square, as are the underground homes of Gila Monster and Horned Toad (Newcomb 1940:64–65). Rare exceptions are the trapezoidal and terraced shapes, and the tipilike homes of the buffalo seen in a Male Shooting Chant painting (Reichard 1939:Pl. XXIII). Further examples of circular abodes are the Winds' homes of Hailway (Wheelwright 1946a:177); Changing Woman's home of Male Shootingway (Wheelwright 1946a: Pls. XVII, XIX); the raised anthills of Red Antway (Wyman 1973:Figs. 10, 36); and the home of Bear and Snake in the Mountain Chant painting (Matthews 1887:Pl. XV). Examples of the rectangular form are the houses of Big Fly of Hailway (Wheelwright 1946a: 175).

Geographical Features

Mountains

Round or oval symbols representing mountains appear in subsidiary positions in the sandpaintings of many chants. These are made in relief by making heaps of ordinary sand and covering them with dry pigments. The mountains made on the big hoop ceremony trail were described earlier. In Blessingway drypaintings, mountains may also be rectangular or shown in profile. When four mountains are shown, they represent the traditional boundary peaks surrounding the Navajo homeland: in the east (Sierra Blanca Peak, Sangre de Cristo Range, Colorado), south (Mount Taylor, San Mateo Range, New Mexico), west (Mount Humphrey, San Francisco Peaks, Arizona), and north (Hesperus Peak, La Plata Range, Colorado). Two other mountains important in Navajo mythology may also be shown, Spruce Hill (Gobernador Knob, New Mexico) and Mountain-around-which-moving-was-done (Huérfano Mountain, New Mexico). Huérfano was the birthplace and early home of Changing Woman and her adopted family, the First Man Group (Wyman 1970a:16–20). Animal or bird tracks made on a mountain show who lives there (Fig. 92). The sacred mountains are the main theme symbols in two sandpaintings, one for the Hail Chant (Wheelwright 1946a:179), and in a small painting for the liberation prayer on buckskin in the Night Chant (Matthews 1902:Pl. II-C).

Sky-reaching Rock

A locality occurring in several myths and represented symbolically in the double

sandpainting of Male Shootingway is Sky-reaching Rock (Wyman 1970b:37–40, Pls. 9–16). It is supposed to be a black lava pinnacle north of Mount Taylor, New Mexico. It is made differently from the usual mountains of drypaintings, being a carefully shaped, bluntly truncated cone of clay perhaps a foot tall. It is placed in the center of an extended-center composition between the two radial designs of the double sandpainting, *Holy Man Captured by Thunders* and *Holy Boy Swallowed by Fish*. The rock was the home of the Thunders.

Figure 92. A mountain with animal tracks.

Emergence Place

The place where People emerged upon the earth's surface after escaping from the floods in the underworlds, as told in the Navajo origin myth, has been variously identified as Island Lake in La Plata Range or Trout Lake, both in Colorado. Representations of Emergence Place are usually in the center of a painting, but sometimes they form the major part of an extended-center composition. Emergence Place occurs in a number of Blessingway drypaintings. It may be circular, square, or rectangular, and is usually black. It often has a ladder or steps leading out of it, sometimes with human footprints on them (Wheelwright 1949:163). One circular variety has four jagged thunderbolt symbols on it, and lightnings shooting out from it (Wyman 1973:Figs. 40, 56). Sometimes there is a one- or two-tiered cloud symbol attached to it at each cardinal point.

7

Symbols and Designs in Rites and Chants

A rough idea of the number of drypaintings for specific ceremonials that have been recorded may be gleaned from the table in Appendix C. Of course the figures depend somewhat on the interests of the recorders and their opportunities to study given ceremonials. Moreover, these numbers include duplicates of the same or similar designs in different collections. More sandpaintings have been recorded for the Shooting Chant complex than for any other—around two hundred and fifty—twice as many as for its nearest competitor, Navajo Windway. Other ceremonials appear to fall into two groups: those with about forty to seventy recorded paintings (in order of increasing numbers: Hailway, Red Antway, Blessingway, Nightway, Beadway, Big Starway, Plumeway, Mountainway, Beautyway) and those with around ten to twenty paintings (Chiricahua Windway, Coyoteway, Big Godway, Handtremblingway, Eagleway, Waterway). Except for Chiricahua Windway and Handtremblingway, which are well known and often performed and for which the numbers of appropriate sandpaintings seem to be fixed and small, the paucity of recorded designs for the others in this group may reflect the fact that they are obsolescent or perhaps ex-

tinct. The recently extinct Hail Chant has many designs recorded for it because the last singer to know it completely, the famous Lefthanded, was a friend and close associate of the most prolific recorder of sandpaintings, Franc J. Newcomb. The long-extinct Awl and Earth chants have afforded only four sandpaintings apiece, dredged from the minds of singers who remembered portions of them. Doubtless these chants once employed other paintings now forgotten.

The number of drypainting main theme symbols and designs has never even been estimated. In some instances, especially in extended-center compositions, it is difficult or impossible to say which of a variety of symbols are the main themes; the choice depends largely on the point of view of the analyst. In linear and radial compositions this task is much easier, because main theme symbols are customarily in rows or in the cardinal positions.

Tables of main theme symbols and designs for Blessingway rites and for six chantways have been published (Wyman 1962: Table 9, Navajo Windway and Chiricahua Windway; 1970a:Table 4, Blessingway; 1970b:Table 3, Shootingway; 1975:Table 2, Mountainway; Wyman and Newcomb 1962:

Table 1, Beautyway). Similar tables for all the other chantways are in the Wyman Drypainting File in the Museum of Northern Arizona, described in Appendix C.

In the following lists of main theme symbols and designs found in the drypaintings of the Blessingway rites and the chantways, those that are peculiar to the ceremonial being considered are printed in boldface, those that are prominently featured but are shared by other ceremonials are italicized, and those which are merely present are in roman type. They are listed in order of their importance and/or frequency. The drypaintings of all ceremonials except Hand-tremblingway emphasize People of the accompanying myths, who are usually recognizable as belonging to a given ceremonial because of distinguishing characteristics. For an unknown reason, anthropomorphic figures do not appear in the four or five designs used in the Hand-trembling Chant. References are given only for sources that contain illustrations of the paintings.

Blessingway

Main Themes: *corn and Corn People; Pollen Boy and Ripener Girl; Emergence Place; Earth; Sky; sacred mountains;* **Changing Woman; First Man Group** (**First Family**); **Follower Pair;** miscellaneous People; plants; animals and birds; Sun.

Designs: **Changing Woman in cornfield and/or on mountain; Changing Woman's House; Coyote steals fire from Black God for First Family; the Emergence.**

A number of ways of representing Earth, and corn plants in varying arrangements, are peculiar to Blessingway drypaintings. This emphasis on corn and its associated beings, and on the Emergence, the Earth,

and the sacred mountains is compatible with the myths of Blessingway (for illustrations see Wheelwright 1942, 1949; Wyman 1970a).

Hailway

Main Themes: *Rain (Storm), Thunder,* and *Wind People; Cloud People; Sun and Moon* (with rays, with mountains); Big Fly; Thunders; supernaturals' houses.

Designs: **Night Sky;** People with corn.

The People of Hailway sandpaintings may have distinctive headdresses or head protection, feathered angled lightning (males) or a curved feathered rainbow (females), sunhouse face stripes, and long (rain) hair. Lozenge-checkered guardians are common (see Wheelwright 1946a).

Waterway

Main Themes: *Rain (Water) People; Water Monsters.*

Designs: Rain People with individual rainbow garland guardians (Plates 11, 12); Rain People with corn; dancers with Sun and Moon. The headgear of Water People may be five zigzag lightnings (males), long, curved variegated tail feathers (females), or triple cloud symbols; they may have long hair (see Wheelwright 1946a, Haile 1979).

Shootingway

Main Themes: *Holy People (Holy Man, Woman, Boy, Girl); Slayer Twins (Monster Slayer, Born-for-Water, Reared Underground, Changing Grandchild)* (Plate 3); Earth and Sky; **The Skies** (Fig. 21); **Cloud houses; Sun, Moon,** and **Winds** (Plate 9); **Sun's House;** *Thunders* (Big Thunder); *Water Creatures* (Fish People, Water

Monsters); Rainbow People (Rainbow's House, Whirling Rainbows); *snakes* (*Big, slender; straight, crooked; coiled-Endless*) (Fig. 28); *Snake People* (Figs. 26, 85); **buffalo; Buffalo People** (Fig. 4); **Kingbird People;** *Corn People;* **Arrow People.**

Designs: **whirling tail feathers; taking down the Sun; emergence of Medicine People; Slayer Twins on Sun or Moon** (Fig. 27); **Pollen Boy or Ripener Girl on Sun or Moon with snake guards; Holy Man in the Sky; Holy Man captured by Thunders; Sky-reaching Rock (the double sandpainting, Holy Man captured by Thunders and Holy Boy swallowed by Fish); Sun's House with Sky People** (Fig. 47); **Sun's houses with Slayer Twins; whirling snakes; snakes on house; grinding snakes** (Plate 5); **Holy People kill buffalo** (Fig. 4); **Corn People with Pollen Boy and Ripener Girl.**

Shootingway sandpaintings have more main theme symbols and design types belonging exclusively to the chantway than do the sandpaintings of any other ceremonial. Moreover, numerous main theme symbols that are shared with other chantways occur in designs peculiar to Shootingway, such as Holy People or Slayer Twins involved in various kinds of actions (see Newcomb and Reichard 1937; Reichard 1939; Wyman 1970b, 1972c).

Shootingway Evilway

Main Themes: *Slayer Twins;* snakes (Big, slender, crooked, coiled-Endless).

Designs: **Slayer Twins within mountains; Slayer Twins with Endless Snake guardian around mountains;** snakes around Big Star.

The Evilway ritual of Shootingway does not hesitate to draw upon certain sandpaintings used in Holyway chants (see Wyman 1970b).

Mountain-Shootingway

Main Themes: **People of the Myth (White Nostril People,** Mountain Sheep People); **Sky People;** Slayer Twins; snakes.

Designs: **dancers with various properties;** swallowed by Fish; *Sun or Moon clothed in snakes* (Fig. 23).

Besides these, some fourteen types of designs that are used generally in Male Shootingway are employed in the Dark Circle of Branches phase (corral dance, fire dance)— that is, in Mountain-Shootingway (see Wyman 1970b:26). The sandpaintings uniquely characteristic of this phase contain a combination of Mountainway and Shootingway elements.

Red Antway

Main Themes: **Ant People; Horned Toad People; horned toads;** Emergence Place; corn; Corn People; bows and arrows.

Designs: **horned toads and anthills.**

Other symbols such as Pollen People may be used for special purposes (Fig. 93) (see Wyman 1973:221).

Big Starway

Main Themes: **Star People;** *Slayer Twins;* Rain People; *stars* (*Big Star*); Earth; Sky; Cloud People; Thunders (Plate 14); Big Flies; snakes; mountains.

Designs: **stars in house; stars with snake guards; Pollen Boy or Ripener Girl on Big Star; Slayer Twin(s) on or with stars; stars on or around Big Star** (Fig. 24).

Various combinations and arrangements of People, snakes, bows and arrows, and stars provide a number of unique designs

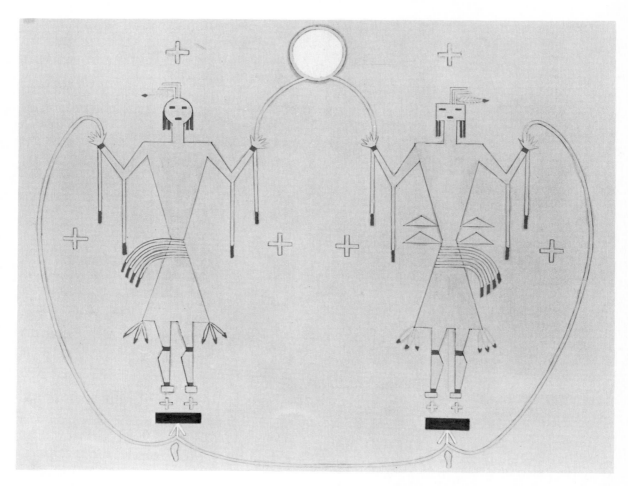

Figure 93. Pollen Boy and Ripener Girl, Red Antway. A pollen and cornmeal painting for the bath ceremony. Courtesy Wheelwright Museum. Photograph, Martin Etter.

for this chant. The center of a radial composition is usually a large star (Plate 14). Distinctive guardians are Endless Snake coiled in each quadrant and four feathered rainbow bars making a square around the painting (Plate 14). Star People are usually flint armored (see Wheelwright 1956). Special sandpaintings associated with Big Starway or portions of its regular sandpaintings are used in star-gazing divination (Wyman and Newcomb 1963).

Mountainway

Main Themes: **Mountain Gods and Goddesses** (Figs. 8, 9); heroine of myth; dancers; **the Long Bodies;** Whirling Rainbow People; **bears; porcupines; great plumed arrows.**

Designs: **Home of Bear and Snake; People with Packs; People with Long Hair** (Fig. 7); **Bear's Den** (shock rite).

A large proportion of Mountainway symbols and designs are confined to this chantway or are shared with comparatively few other ceremonials. Certain characteristics of the People of Mountain Chant sandpaintings, such as their headdresses and white faces, are confined to the chant or are shared with the sister chant, Beautyway (see Matthews 1887; Wyman 1971:Figs. 15–20; 1975: passim).

Beautyway

Main Themes: **People of the Myth** (Figs. 34, 101); **Mountain People;** Dancers; *snakes* (*Big, slender; straight, crooked; coiled-Endless*); *Sun; Moon;* Thunders (Big Thunder); Rainbow People (curved); *Water Creatures;* **frogs;** *corn* (*twelve-eared*).

Designs: **Mountain People with water bottles and corn;** People with Ripeners; **Dancers with feathered arcs;** *People with twelve-eared corn; snakes on house; snakes with clouds or corn; twined snakes; Pollen Boy or Ripener Girl on Sun or Moon; Sun clothed in snakes.*

Beautyway sandpaintings emphasize snakes, as do Shootingway and Navajo Windway. This is congruous with the Beautyway myth, which relates younger sister's pursuit by Big Snake Man, her encounters with Snake People during her flight, and her sojourn in the home of the Snakes while being instructed in Beautyway by them. Figures in the sandpaintings that are designated as Snake People by informants do not have the snake characteristics (body form and markings, rattle tail) of Snake People in the paintings of other chants but look like

ordinary People (Fig. 101). Items shared by Beautyway and the related Mountainway are certain types of headgear already mentioned (Fig. 34), weasels or weasel skins, and red dance kilts (see Wyman 1957; Wyman and Newcomb 1962).

Nightway

Main Themes: *the Ye'i* (Fig. 13, Plate 2); Monster Slayer; Rainbow People (Whirling, straight); corn.

Designs: **Talking Gods and Calling Gods with corn** (Plate 30); **First Dancers** (Fig. 25); *Male and Female Ye'i with corn; Whirling Logs* (Fig. 17); *Black Gods;* **Black Gods on stars with Monster Slayer; Water Sprinklers** (Fig. 40); **Fringed Mouths** (trinity, with corn, radial; Figs. 10–12, Plate 2); **angled corn with Ye'i** (Plate 10); **Talking God trinity** (shock rite); **rattle shock rite painting** (Fig. 37); **Pollen Boy or Ripener Girl with mountains** (prayer ceremony; Fig. 99).

The sandpaintings of the Night Chant do not have many kinds of symbols, unless the numerous Ye'i that are featured in practically all of them are counted separately, but they do present a goodly number of firmly crystallized designs, rather more in this respect than most chantways. Perhaps the best known and most widely publicized is the Whirling Logs, the swastika motif of the Navajo (Fig. 17). See illustrations in J. Stevenson (1891), Matthews (1902), and Tozzer (1909).

Big Godway

Main Themes: **Big Gods** (Plate 8); *Black God; Ye'i;* **Sunflower People** (Plate 6); First Dancers.

Designs: *Whirling Logs* (**with Big Gods;** Plate 4); **Ye'i with sunflower** (Fig. 22); **Ye'i with Sunflower People** (Plate 6).

Some of the People in Big Godway sandpaintings may represent the Stricken Twins of the Big Godway myth. The unusual features of Big God paintings, besides the portrayal of Big God himself, are the sunflowers and Sunflower People. Two sunflower plants with crossed roots serve as the encircling guardian in some paintings (Plates 4, 8).

Plumeway

Main Themes: **Big-Game People** (**Deer, Antelope, Elk, Mountain Sheep**); **People** (**Chipmunk, Gila Monster, Frog, Hornworm**); *Ye'i* (Plate 16); **the hero of the myth; Deer Raiser and his daughter;** Earth; Sky; *Sun; Moon* (Figs. 106, 107); Rainbow People (curved); *Thunders* (Big Thunder; Plate 21); *stars; Water Creatures* (Fig. 103, Plates 17, 18); **big-game animals,** especially *deer* (Figs. 104, 105, 106, Plates 19, 20); birds (turkey, Fig. 102); *Ripeners; corn* (Fig. 102); *domesticated plants* (Plate 20).

Designs: **Floating Log** (with Ye'i, Plate 16); Whirling Logs (turning rainbows, Fig. 104); swallowed (captured) by Fish (Plate 18); Pollen Boy or Ripener Girl on Sun or Moon; **Sun and Big Thunder** (Plate 21); **Sun and/ or Moon with big game** (Figs. 106, 107); **Thunders and Water Creatures** (Plate 17); **deer in or with houses** (Plate 19); **the Farms** (corn and game; Plate 20).

The sandpaintings of the Plume Chant exhibit a confusing profusion of animal, bird, plant, and anthropomorphic symbols, which have not been completely analyzed. Big-game animals stand out in many different combinations with People, Ye'i, mountains, and other elements. Turkey, important in the myth, is a prominent subsidiary symbol (Fig. 102). Game, hunting, and the origins of agriculture are stressed both in the myth and in the sandpaintings (see Chapter 9).

Coyoteway

Main Themes: **Coyote People; coyotes; Day-Sky People; houses.**

Designs: **Coyotes in houses (with butterflies).**

Some of the sandpaintings of this obsolescent chant have been published by Wheelwright (1956:Plates XV–XVIII), and all that have been recorded were published by Luckert (1979:225–33). Few are known, probably because the chant is almost extinct. Butterfly, a creature that like the chant itself is associated with the moth-incest-insanity complex, is a prominent subsidiary symbol in one design. Luckert gives a thorough discussion of the symbolism of Coyoteway sandpaintings (1979:121–41, 159, 160, 224–33).

Navajo Windway

Main Themes: **Wind People** (Fig. 94); **Cyclone People;** Whirlwind People; Pollen People; *snakes (Big, slender; straight, crooked; coiled-Endless);* Snake People; *Sun; Moon* (Fig. 95); *Rainbow People (Rainbow's House, Whirling Rainbows;* Fig. 30); Thunders; *Cloud People; cactus; Cactus People.*

Designs: **Wind People dressed in snakes; Wind People crossed by snakes;** *twined snakes;* Sun or Moon guarded by snakes; *Sun or Moon clothed in snakes* (Figs. 16, 96); *Pollen Boy or Ripener Girl on Sun or Moon.*

Except for the Wind People, no symbols are exclusively the property of Navajo Windway; but snakes are emphasized (as in

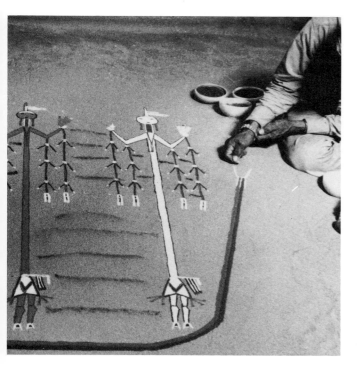

Figure 94. Singer making the skirt of the Rainbow guardian of a sandpainting of unarmored *Wind People* from Navajo Windway. Courtesy Museum of Northern Arizona. Photograph, Paul V. Long, Jr., Navajo Craftsman Exhibit, Museum of Northern Arizona, 1963.

Figure 95. Singer making the arms of the Rainbow guardian of the sandpainting *Moon with Rays* from Navajo Windway. Courtesy Museum of Northern Arizona. Photograph, Paul V. Long, Jr., Navajo Craftsman Exhibit, Museum of Northern Arizona, August 1963.

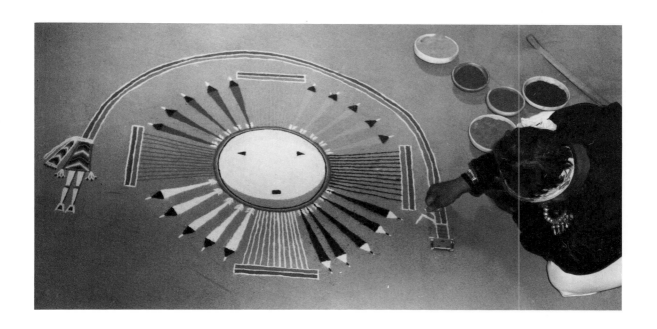

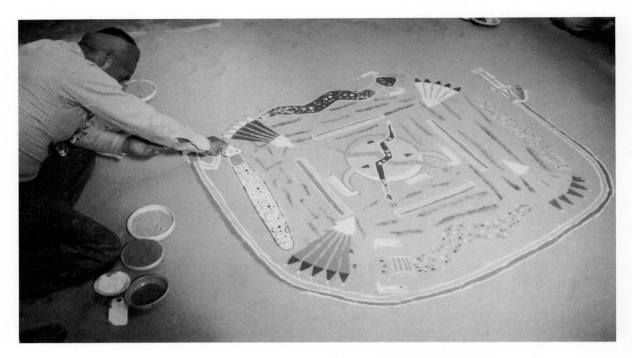

Figure 96. Singer making the hands of the Rainbow guardian of the sandpainting *Sun Clothed in Snakes* from Navajo Windway. Courtesy Museum of Northern Arizona. Photograph, Parker Hamilton, Navajo Craftsman Exhibit, Museum of Northern Arizona, July 1966.

Shootingway and Beautyway), and the chant has a profusion of Cloud People, cactus and Cactus People sandpaintings. Sun and Moon sandpaintings are also somewhat more common than in other chants (see Kluckhohn and Wyman 1940:111–39; Dutton 1941; Wyman 1962).

Chiricahua Windway

Main Themes: *Sun and Moon* (*with horns, with feathers*), *Whirlwind People.*

Designs: Pollen Boy on Sun; Ripener on Moon (Fig. 29); Whirling Logs (with Whirlwind People); **Whirlwind People with Cactus People; Whirlwind People with Big Snake** (shock rite).

Like the chant itself, the sandpaintings of Chiricahua Windway are comparatively simple and few in number, featuring the Sun and Moon (Kluckhohn and Wyman 1940: 140–54; Wyman 1962).

Hand-tremblingway

Main Themes: *Big Star;* **Gila Monsters;** *Big Flies.*

Designs: **Big Star with Big Flies and mountains guarded by arrows** (Plate 13); **Gila Monsters with Thunders** (Plate 7); **Gila Monsters with Sun, Moon, and constellations.**

Unlike most well-known and often performed chants, Hand-tremblingway em-

ploys a limited number of sandpaintings, possibly only the four designs used in a five-night ceremonial or variants of them. Subsidiary symbols such as the Thunders in a Gila Monster painting are as prominent as the main themes (or even more so). An unusual guardian is the Rainbow wearing black flint armor (see Kluckhohn and Wyman 1940: 169–83).

Eagleway

Main Themes: **Eagle People** (armored); **Eagle Catcher;** *eagles, hawks, and small birds; eagle's nest.*

Designs: **eagle trap with eagle and rabbit decoys; eagles' nest with young eagles and food animals.**

Most of the relatively few designs for the Eagle Chant are extended-center compositions (see Kluckhohn 1941; Wyman 1971:Fig. 21).

Beadway

Main Themes: **Scavenger (the hero);** *eagles and hawks;* **crooked feathered (arrow) snakes; predatory (hunting) animals;** *houses.*

Designs: **eagles' nest before Scavenger's arrival; Scavenger in the eagles' nest; ascension of Scavenger assisted by eagles** and snakes; the home of the eagles; the exchange of quivers; hunting animals with corn packs; the final ascension of Scavenger (with eagles, with snakes).

Like Nightway and Hand-tremblingway, the Bead Chant has a small number of well-established designs. Moreover, these present a more continuous narrative than do the designs of most chants. The painting of the nest before the arrival of the hero resembles the eagles'-nest painting of Eagleway. The extended-center composition of Scavenger in the nest includes numerous symbols of events related in the myth, some of them presaging future episodes: the parent eagles, their food animals, the eaglets, a food bowl, Big Fly, White Butterfly, and a swallow (see Reichard 1939).

Awlway and Earthway

Too little is known about the sandpaintings of these extinct chants to merit analysis here. The four paintings for Awlway recorded or described by Laura Armer contain People, bears, weasels, and Water Creatures, and the four for Earthway recorded by Maud Oakes include designs of bears' house with representations of bears and bees, a linear design of People carrying weapons and ants, and one of Earth and Sky.

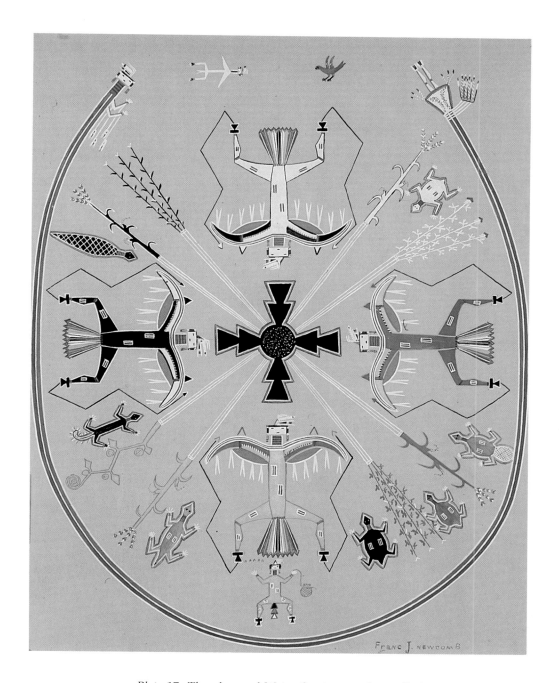

Plate 17. Thunders and Water Creatures, who pulled
the hollow log containing Self Teacher, the hero,
down to their underwater home, the black center;
Plumeway. Courtesy Wheelwright Museum.
Photograph, Martin Etter.

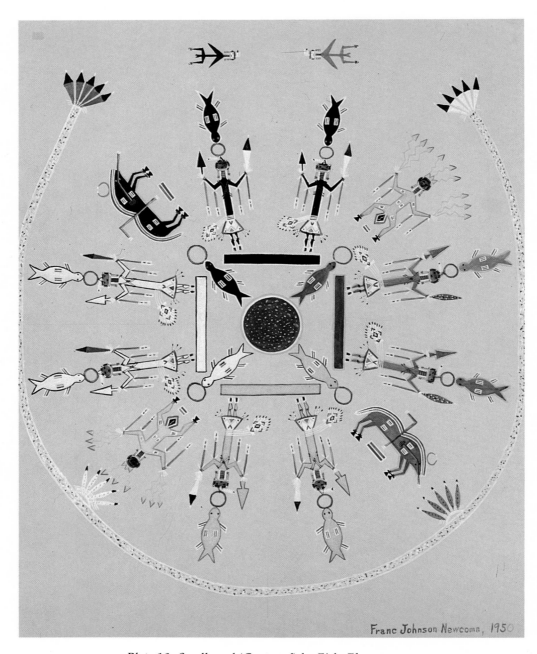

Franc Johnson Newcomb, 1950

Plate 18. Swallowed (Captured) by Fish, Plumeway.
Like Figure 103, this design of People and var-
ious water creatures commemorates the capture
of the hero by the water creatures or a *Swallowed
by Fish* episode. Courtesy Wheelwright Mu-
seum. Photograph, Martin Etter.

154

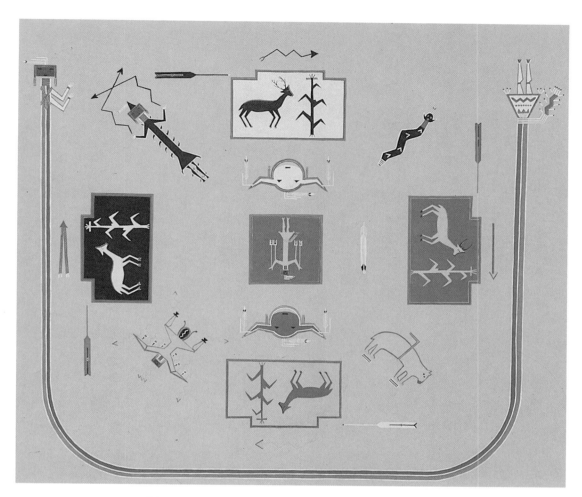

Plate 19. Deer in Houses, Plumeway. The corn
plants and deer in their houses and the snake,
bear, Thunder, and Black Wind in the quadrants
symbolize the hero's agricultural experience and
his acquisition of hunting knowledge from his
dangerous *Witch Father-in-law,* Deer Raiser.
Courtesy Wheelwright Museum. Photograph,
Martin Etter.

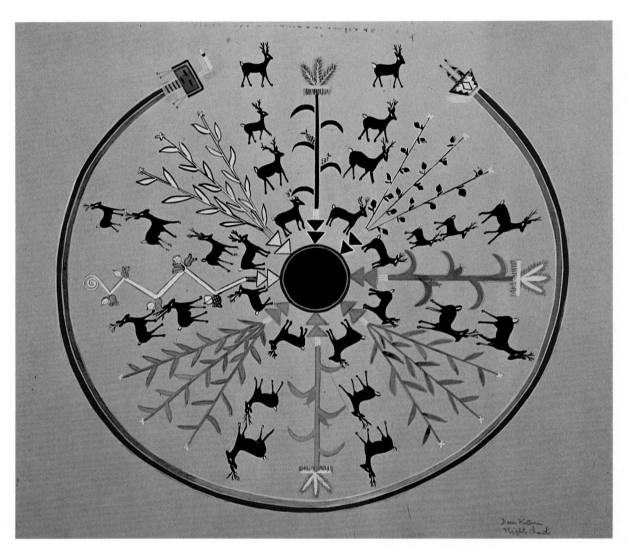

Plate 20. The Farms, Plumeway. This illustrates the farm planted by Self Teacher with seeds provided by his turkey and shows the underground big-game farm kept by Deer Raiser, thus symbolizing the acquisition of knowledge of agriculture and hunting. Copy by M. E. Schevill Link of Walcott Collection 27. Courtesy Arizona State Museum. Photograph, Bernard L. Fontana.

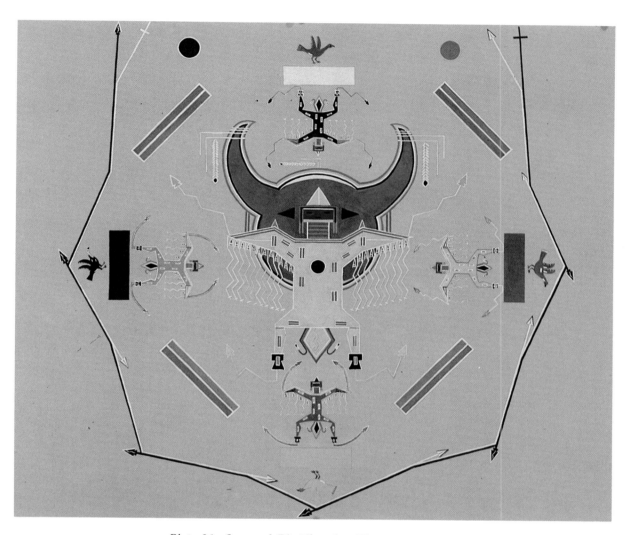

Plate 21. Sun and Big Thunder, Plumeway. Pink Big Thunder (symbolic of all Thunders), with the blue-horned Sun on his back, and four smaller Thunders. These are probably invocations of the powers they represent. The guardian is zigzag lightning. Courtesy Wheelwright Museum. Photograph, Martin Etter.

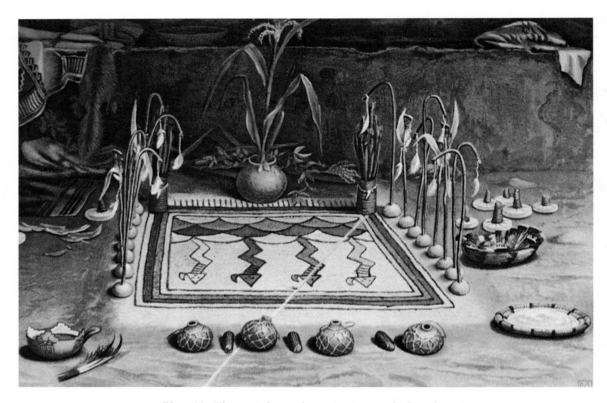

Plate 22. The antelope drypainting and altar for the Hopi snake-antelope ceremony at Mishongnovi in 1897. Four lightnings in directional colors (snakes), clouds, and Rainbow House (square outlines). From Fewkes (1900:Pl. XLVI). Photograph, Martin Etter.

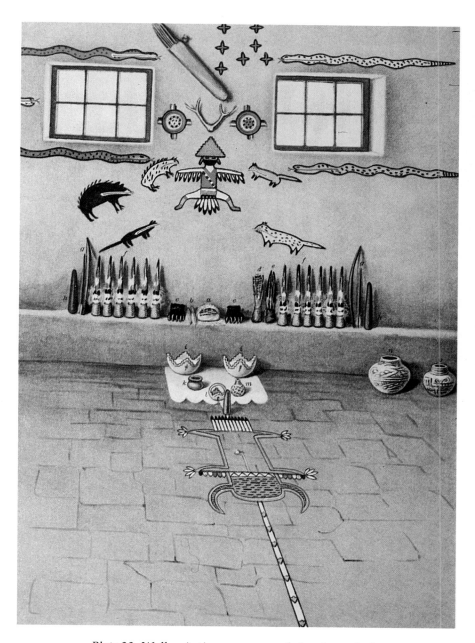

Plate 23. Wall paintings, cornmeal cloud symbol, and sandpainting of the knife-wing (*achiyala-topa*), beast god of the zenith (also on the wall), for a ceremony of the Zuni wood society (*thle'wekwe;* sword-swallowers); wrapped corn-ear fetishes on ledge below wall paintings. From M. Stevenson (1904:Pl. CVIII).

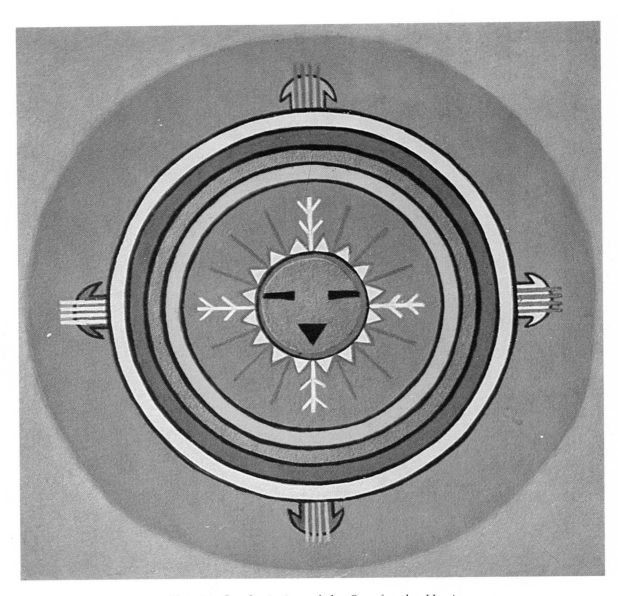

Plate 24. Sandpainting of the Sun for the Hopi *powalalu* ceremony (introductory of the *powamu* kachina ceremony; bean festival), showing the Sun's rays, house (circular outlines), and house blossoms (at the cardinal points); compare with a Navajo sandpainting of the *Moon with Rays* (see Fig. 95). From Voth (1901:Pl. XLII). Photograph, Martin Etter.

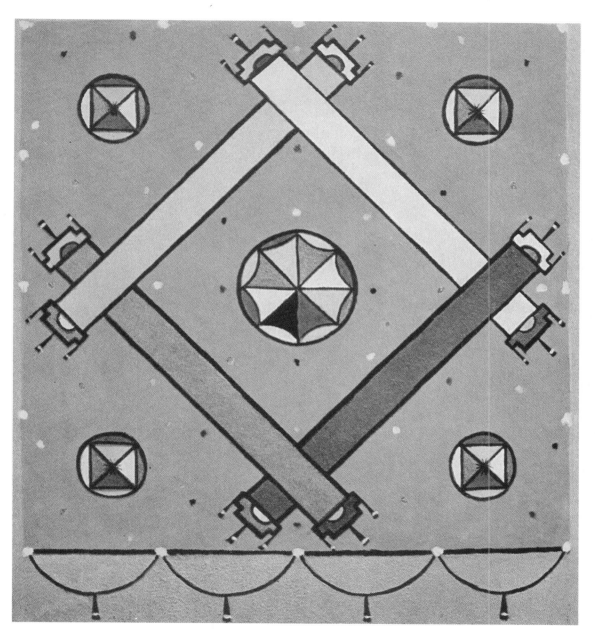

Plate 25. "House" sandpainting for the initiation rites of the Hopi *powamu* ceremony. The "planks" of the house crossed at their ends resemble the guardian of four straight rainbow-bars with feathered ends used for some Navajo Big Star Chant sandpaintings (see Plate 14). From Voth (1901:Pl. XLVII).

161

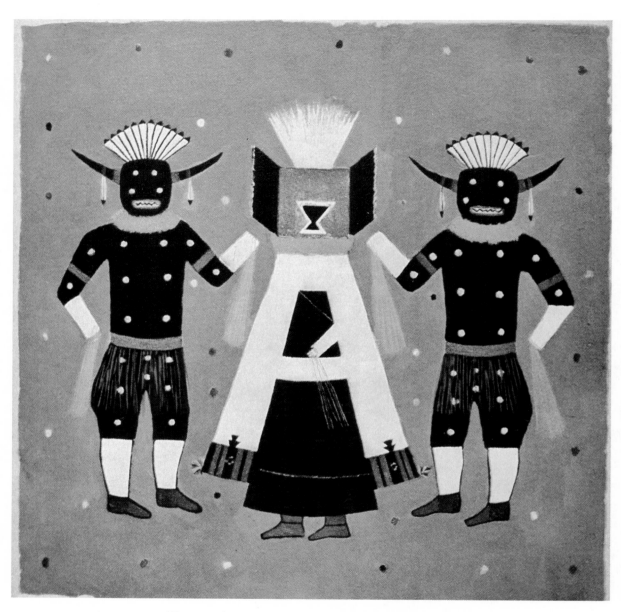

Plate 26. Sandpainting for the initiation of children in the Hopi *powamu* ceremony. *Hahaiyi*, the mother of the kachinas, between two whipper kachinas carrying yucca leaf switches. From Voth (1901:Pl. LII).

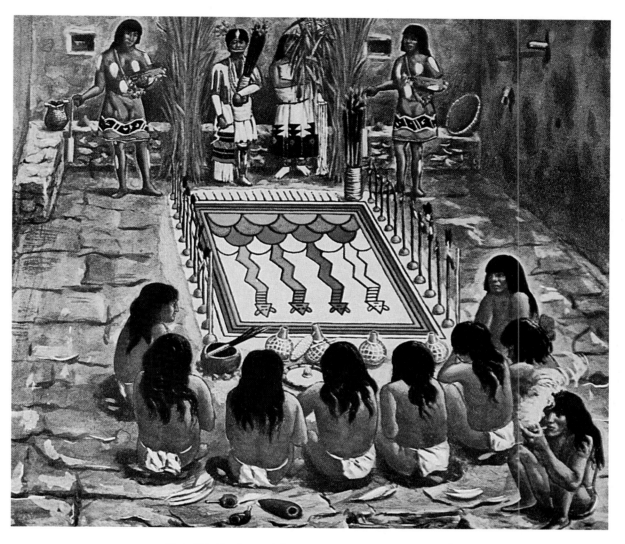

Plate 27. Snake-antelope song ceremony around the antelope altar and drypainting at Mishong-novi; antelope youth and snake maid behind the altar with snake priests on each side of them. From Dorsey and Voth (1902:Pl. CXXII).

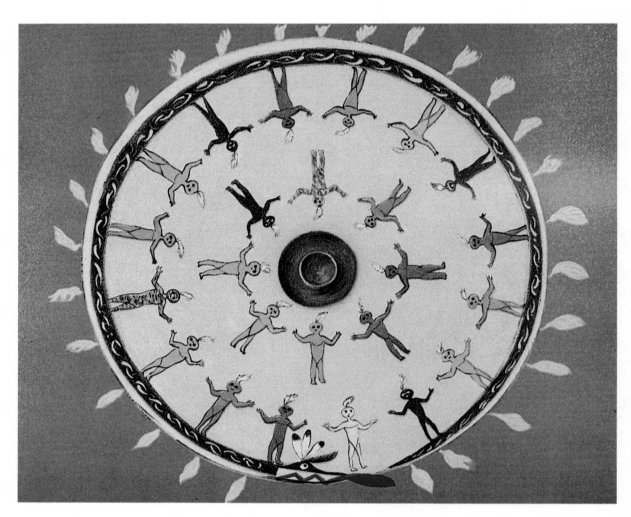

Plate 28. Sandpainting for the initiation of boys into the Zuni kachina (*koko*) society (1884); twenty-four whipper kachinas (*salimopiya*) in the six directional colors, surrounded (guarded) by the great plumed water serpent (*kolowisi*). From M. Stevenson (1887:Pl. XXII). Photograph, Martin Etter.

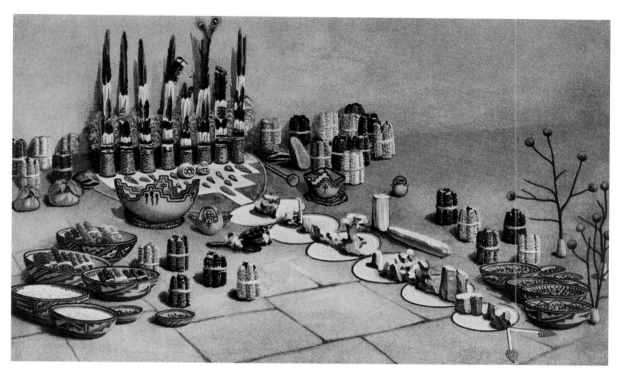

Plate 29. Cornmeal, corn pollen, and charred corncob drypainting, and altar for the winter retreat of the rain priest (*shi'wanni*) of the nadir at Zuni, wrapped corn-ear fetishes in the rear. From M. Stevenson (1904:Pl. XXXV).

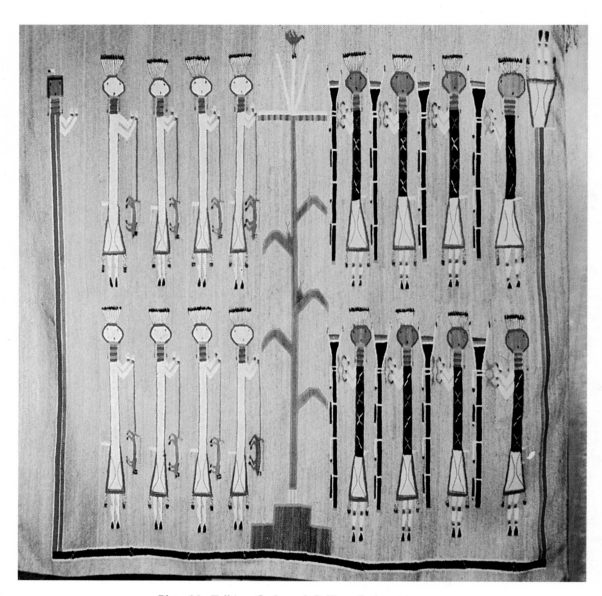

Plate 30. Talking Gods and Calling Gods with corn, Nightway. Sandpainting tapestry (63½" × 66") probably woven by Gladys (Mrs. Sam) Manuelito around 1932. Courtesy Lee M. Copus.

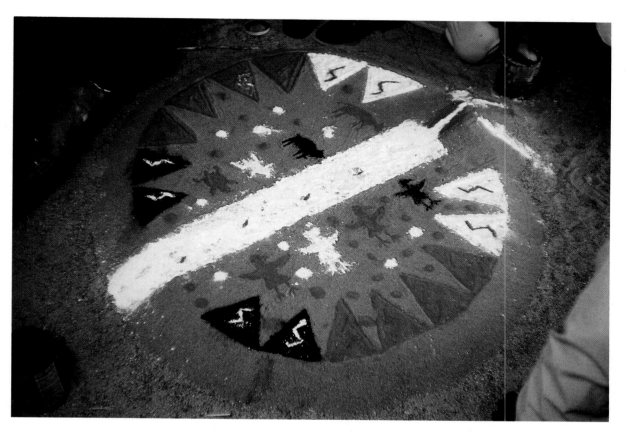

Plate 31. Making a Papago drypainting used in curing wind sickness. Outlines of four birds on the southern half of the design and of four animals on the northern side have been incised and filled with pigment, and little heaps of all colors (mountains that support the world) have been made in all empty spaces. Previous stages of the procedure are shown in Figures 109 and 110 A, B. Photograph, Bernard L. Fontana.

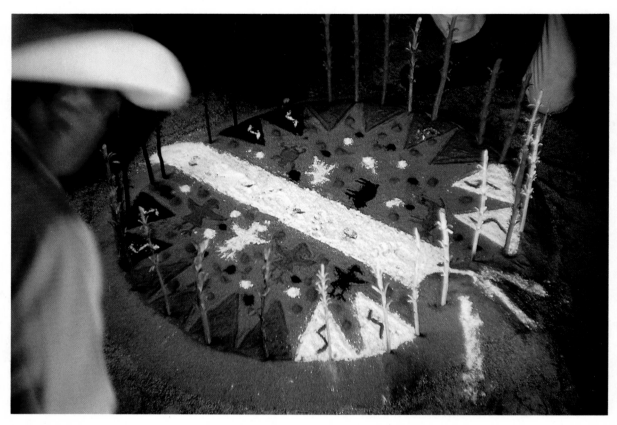

Plate 32. Making a Papago drypainting (continued). The completed drypainting with the twenty-eight flower effigies in place (white—east, green—south, black—west, red—north). Photograph, Bernard L. Fontana.

8

Small Sandpaintings for Special Purposes

Small sandpaintings are used in some of the ceremonials of most chants and in some accessory ceremonies that may be added to a performance. These paintings range in size from one foot to four feet across. They are employed in the sweat-emetic and big hoop ceremonies, in prayer ceremonies, in the shock rite, and in divination rites.

The Sweathouse of the Night Chant

The sweat ceremony of the Night Chant differs from other Holyway sweat ceremonials in that it is held not in the ceremonial hogan but in four small, domed sweathouses. One is contructed at dawn on each of four successive days. They are located in the cardinal directions about three or four hundred feet from the ceremonial hogan, the first one at the east, and the others in sunwise progression. All are made of poles, brush, herbs, and earth. Sometimes only one sweathouse is built and is used four times.[1]

The roof of the sweathouse is covered with sand and decorated with a small sandpainting. On the first and third sweathouses this may depict a rainbow and a crooked four-angled lightning crossed over the house, each with a human head at both ends, or rainbow and lightning garlands terminating in five feathers at both ends (Matthews 1902:50–52, Pl. II A, B). On the second and fourth houses, the design is simple—merely crossed double-ended arrows of cornmeal—or is omitted altogether (Matthews 1902:Figs. 6, 92). Sometimes on the eastern and western sweathouses only a single anthropomorphic rainbow is curved across the roof (Figs. 97, 98) (J. Stevenson 1891:Fig. 118, Pl. CXII, Pl. 240). Other variants of rainbow and lightning designs may be used. One rather elaborate sweathouse design has the crossed Rainbow and Lightning People and, in the quadrants between them, the four sacred mountains in directional colors connected by rainbow arcs, with a black Male and a white Female God seated on each one (see Fig. 115). The door of the house is surrounded by a curved rainbow.

The Sweat-Emetic Ceremony of Holyway Chants

In the sweat-emetic ceremony performed in the ceremonial hogan for Holyway chants,

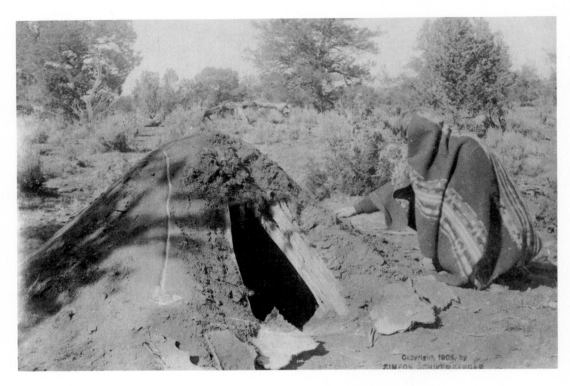

Figure 97. Singer making a drypainting of rainbows crossed over the sand-covered roof of a sweathouse for the sweat ceremony of a Night Chant. At least one of the figures is the anthropomorphic Rainbow. Dry pigments are on pieces of bark in the foreground. Courtesy Franciscan Fathers, Cincinnati, Ohio. Photograph, Brother Simeon Schwemberger, Saint Michaels Mission, Arizona, 1901–5.

small sandpaintings are used in three places: at the cardinal points around the central fire, to the left of which the wooden ceremonial fire pokers are laid; west of the fire, where the basket of emetic for the patient is placed; and northwest of the fire, around and behind the sand basin, where the patient kneels while vomiting.

Poker Paintings

The small paintings beside which the wooden pokers are laid contain symbols appropriate for the chant being given, such as snakes for Shootingway and Navajo Windway (Kluckhohn and Wyman 1940:Fig. 11) or horned toads and anthills for Red Antway (Wyman 1973:Figs. 1–4). In a Sun's House phase of Male Shootingway, the poker paintings on two days were two crooked lightning arrows, a straight sunray arrow, and a straight rainbow arrow (Reichard 1970:Fig. 29). When snakes are used, they may be slender snakes or Big Snakes, all four crooked or straight or two of each. Various combinations are used on different days of the ceremonial. They are made in directional colors on a platform of background

170

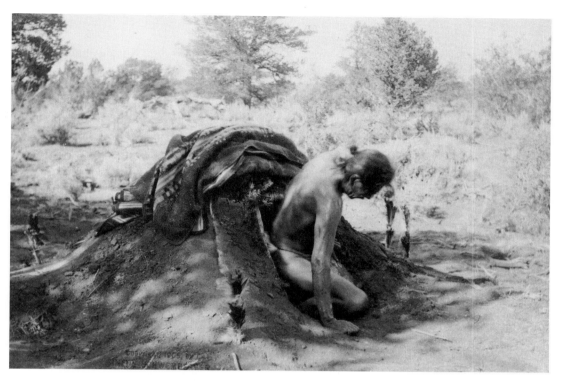

Figure 98. Patient emerging from a sweathouse of the Night Chant. Blankets that had covered the door are thrown up over the roof. Plumed wands have been erected at the ends of the dry-painted figures crossing over the roof. Courtesy Franciscan Fathers, Cincinnati, Ohio. Photograph, Brother Simeon Schwemberger, Saint Michaels Mission, Arizona, 1901–5.

sand about one by two feet in size, and are usually a little over a foot long.

In chants conducted according to Peacefulway subritual for attracting good, the snakes are made heading toward the fireplace, but in Injuryway chants that emphasize exorcism, such as Navajo Striped Windway, they head away from the fire (Wyman and Bailey 1946:222–23, 237–38). Moreover, their tongues are red instead of yellow, and on successive days they are moved away from the center of the hogan, the third set being made about two feet from the inside wall, outside the pokers and in line with them. The last set is made outside the hogan in the four cardinal positions, six or eight inches from the hogan wall. Two snakes may be made at the east, making the total five, an odd number associated with chasing evil. All these differences in procedure symbolize the exorcistic intent of the Injuryway chant.

Emetic Basket Paintings

The Navajo-type basket containing the decoction of emetic herbs may be placed on a small sandpainting of any one of several

designs: segmented clouds (Kluckhohn and Wyman 1940:Fig. 13); a keystone-cloud symbol with seven heads of People on successive days (as in Newcomb and Reichard 1937:Pl. XIX); the horned Sun or Moon; baskets of arrowpoints with lightning and rainbow arrows (Shootingway Evilway, Wyman 1970b:Pl. 44); or simply a few arrowpoints and rainbow bars (Red Antway, Wyman 1973: Fig. 62B). A curved rainbow bar or zigzag lightning bar partly encircles the basket, and four short rainbow bars, usually straight but sometimes curved, mark the places for the patient's hand and knees as he kneels to drink the emetic (Hailway; Wheelwright 1946a:163).

Sand Basin Paintings

A similar curved rainbow bar partly surrounds the sand basin into which the patient vomits, and short rainbow bars indicate kneeling spots for him (Kluckhohn and Wyman 1940:Fig. 12).

Big Hoop Ceremony Trails

In the big hoop ceremony of Evilway (and occasionally Holyway) chants, the patient approaches the hoops through which he is to pass along a drypainted trail ordinarily consisting of four mountains made of directional colors sprinkled on heaps of sand; similarly colored, a pair of bear tracks appears before (and sometimes after) each mountain. In some chants the mountains alternate with the hoops. In Male Shootingway Evilway, pairs of Big Snakes may be made in front of the mountains, and crooked lightnings on and behind them. The mountains are connected by a trail of cornmeal that leads through the hoops and into the ceremonial hogan. The trail continues sun-

wise around the fireplace to the emetic sandpainting, or to the small sandpainting upon which the prayer on buckskin is to be said. Four footprints of meal are made on this trail in the hogan. Sometimes the big hoop trail is more elaborate, including at various points a pair of Big Snakes, a pair of bears, a horned toad (Red Antway), a white cornmeal Sun disk at its beginning with Pollen Boy in yellow pollen on it, or a rainbow bar over each mountain or over an extra set of mountains (Wheelwright 1956:Pl. I; Wyman 1966:Figs. 1–7; 1973:Fig. 26; Reichard 1970:Figs. 6, 7).

The Liberation Prayer on Buckskin

When, as a continuation of the big hoop ceremony, the liberation litany is to be said on buckskin inside the ceremonial hogan, or at any time when it is performed as an accessory prayer ceremony, a small sandpainting is made over which the buckskin is placed. On four successive days, the painting may be the horned Sun, Moon, Yellow Wind, and Black Wind, each outlined with red (Shootingway, like the center of Pl. XVIII, Newcomb and Reichard 1937); it may depict the baskets in which these four symbols are carried (also outlined with red and surrounded by feathers); or it may show the sun, moon, and winds as disks, each with a pair of snakes crossed over it. More elaborate paintings may be used of the Sun disk with Pollen Boy on it (for a male patient) or the Moon with Ripener Girl (for a female patient; Newcomb and Reichard 1937:Pl. II); or merely of the Boy and Girl made on the buckskin. Alternatively, the painting may be a design of a mountain with stars, bear tracks, and rainbow bars (Big Starway, Wheelwright 1956:Pl. I); Thunder's house (Wyman 1973:Fig. 27); Horned

Toad Man and Emergence Place guarded by bear and wolf (Red Antway, Wheelwright 1956:Fig. 40); or a square Emergence Place, black for a male patient, blue for a female, with a two-tiered cloud symbol and a mountain at each side of the square (Big Starway). A similar design for the liberation prayer "out of the four directions," collected by Bertha Dutton and said to be used in Upward-reachingway, has the Slayer Twins between the southern and northern mountains and the cloud symbol. Reichard in her earlier writings called these small sandpaintings used for prayer ceremonies "prayer paintings," but she later discarded this designation because all drypaintings "are prayer paintings and the term has no meaning" (Reichard 1970:719).

In the Night Chant, a small sandpainting about three feet in diameter is made during the afternoon of the first day. The patient sits upon this painting while he repeats a long litany sentence by sentence after the singer. The painting is of the four sacred mountains made in relief in directional colors, with Pollen Boy made of pollen between them in the center, and a trail of white cornmeal with four footprints leading to him (for a male patient) or Ripener Girl with a yellow cornmeal trail (for a female patient) (Figs. 99, 100; see Matthews 1902:Pl. II C). In a similar painting, each mountain is surrounded by a rainbow, and there is a circular white seating place in the center, over which a buckskin is placed. According to Father Haile's notes, this painting is used when "a patient who is troubled by annoying dreams requests a liberation prayer."

The Shock Rite

The shock rite is an accessory ceremony that may be added to almost any chant if the patient or his family requests it and is willing to pay extra for it. It is a test used to discover whether the correct ceremonial is being employed. A sitting place for the patient is prepared, surrounded by a low ridge of earth, and a sandpainting may be made in it. A person dressed as a bear—sometimes accompanied by an impersonator of Holy Young Man or by two of the Ye'i, such as Talking God and a Female God (Nightway)—springs out from behind a blanket curtain as if to frighten the patient. This is done four times, and if the patient faints or is seized by a fit of trembling, it shows that the correct chant has been chosen to cure him. He is then resuscitated by a restoration rite (Wyman 1973:45, 56–58, Figs. 20–25).

Special sandpaintings are used for the rite which are different for each chant. In Shootingway they may be white Big Snake for a female patient, black Big Snake for a male patient, or Endless Snake (Newcomb and Reichard 1937:Pls. XII, XIII; Reichard 1939:Pl. XXI; Wyman 1970b:Pl. 37, showing the bear and Holy Young Man as well as Big Snake). In the Mountain Chant shock rite, sandpaintings may be the *Home of Bear and Snake* (Matthews 1887:Pl. XV; Wyman 1975:Figs. 3–6), *Changing Bear Maiden* (Wyman 1971:Fig. 18), *Bear's Den* (E. Curtis 1907, vol. 1:78; Wyman 1971:Fig. 19), or *Bear's Squatting Place* (Wyman 1971:Fig. 20). Except for the first, which is a full-sized sandpainting in which various kinds of snakes appear as main theme symbols, these Mountainway shock rite paintings are various arrangements of a circular black cave with People, or bears and bear tracks, in or around it. A similar design, *Bear's Sitting Place*, is used in the Evilway ceremonial, Upward-reachingway (Wyman 1975:Fig. 26). A reproduction of a shock rite painting for Plumeway has a black Person,

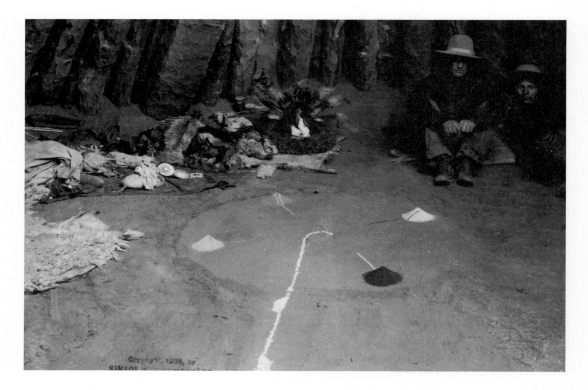

Figure 99. Small sandpainting for the liberation prayer of a Night Chant. The four sacred mountains, traditional boundary peaks of the Navajo country, are made in relief and of directional colors at the cardinal points. Each has a "door" (two lines) and a trail leading to it. A trail of white cornmeal with human footprints on it for the patient to follow leads to the center. The singer's equipment and the mask of the impersonator of Talking God, and other masks and items of costume, are in the background. Courtesy Franciscan Fathers, Cincinnati, Ohio. Photograph, Brother Simeon Schwemberger, Saint Michaels Mission, Arizona, 1901–5.

perhaps Gila Monster Man, in the center surrounded by twelve plumed wands. These are probably representations of actual wands that are stuck around the painting. One for the Chiricahua Windway has black Big Snake around four Whirlwind People with Sun and Moon in the center (Wyman 1962:Fig. 60).

The sandpainting used for the shock rite on the fifth night of the Night Chant is about four feet in diameter. It represents the Ye'i who are going to frighten the patient. From north to south they are Talking God carrying his symbol, Male Ye'i and Female Ye'i, or Calling God (J. Stevenson 1891:Pl. CXX; Matthews 1902:Pl. II D; E. Curtis 1907, vol. 1:118). Sometimes Talking God is accompanied by two Female Ye'i. His symbol is a quadrangular contrivance of four sticks tied together at their ends so that they can be

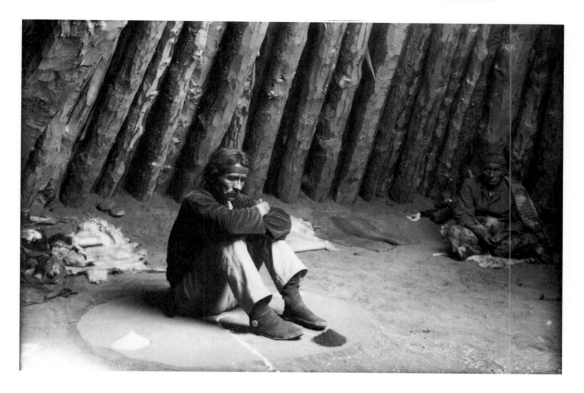

spread out into a quadrangle and folded up again. Talking God's impersonator places this around the patient. A cornmeal trail with footprints leads into the painting, called the picture of the trembling or shaking because of what is supposed to occur in it.

Another type of shock rite performed by special request is the rattle shock rite, so called because impersonators of the Ye'i pull on cords with rattles attached that have been strung over the smoke hole of the hogan above the patient. If this causes the patient to faint, stagger, or stiffen with paralysis, it shows that his trouble can be treated by Nightway. The sandpainting has a Male or a Female Ye'i in the center, and Talking God, Fringed Mouth, Calling God, and Humpback or Water Sprinkler in the cardinal positions (see Fig. 37).

Figure 100. Patient seated on small sandpainting (see Fig. 99) while repeating the litany after the singer seated in the right rear, in a Night Chant. Courtesy Franciscan Fathers, Cincinnati, Ohio. Photograph, Brother Simeon Schwemberger, 1901–5.

Drypaintings for Divination

Of the three methods of divination used by the Navajos to diagnose disease or determine proper treatment, listening is virtually or actually extinct; hand-trembling, the commonest form of divination used today, seldom if ever employs drypaintings in its rites; but stargazing is said to use them. The few examples of divination paintings that have been recorded were said to be for that rite. The one exception is a painting for smoke divination. This type of divination was accomplished by following the direction taken by tobacco smoke spiraling aloft from a stone pipe. The painting shows four diviners accompanied by Big Flies and surrounded by rainbow arcs with coyotes at their ends (Wyman and Newcomb 1963:Fig. 1). The drypaintings on record said to be used for stargazing seem to be portions of, derived from, or in some way associated with, the sandpaintings of the Big Starway chantway. Two designs are Blue Corn Girl surrounded by curving trails, rainbow arcs, spiral air currents, stars, and mountains (Wyman and Newcomb 1963:Fig. 2), and a blue mountain with bear tracks on it beside bears, stars, bows and arrows, and stone knives (Wheelwright 1956:Pl. II). A companion picture to the latter with different colors was also recorded. Separate symbols from certain Big Starway sandpaintings may be made in sand for stargazing rites; these may include the eastern or central stars from paintings of the Night Sky or from radial designs of *Star People* (Wheelwright 1956:Pls. IX, X, XI), or the bowl of medicine and basket of pollen from the *Earth* sandpainting (Wyman and Newcomb 1963:Fig. 3).

A sandpainting Mrs. Newcomb recorded has a center that she said was used in a form of divination called water gazing. This seems to have been a variety of stargazing in which the diviner gazed at stars reflected in a little pond or rock pool or in a bucket or small tub of water sunk in the ground. The circular black center with a red cross (fire) in the center with four white crosses (stars) on it is surrounded by brown, blue, yellow, and white segments, each supporting a Big Fly of the appropriate contrast color (white on the brown segment) (see Fig. 89). Outside each segment is a feather and a stone pipe of the same color (black with a brown segment). This is all that is used in the divination rite. The main theme symbols of the complete painting are black, blue, yellow, and white mountains. Upon each mountain are five Medicine Herb People with brown faces. A black and a blue deer, a yellow antelope, and a white mountain sheep are in the quadrants, each connected to the corresponding mountain by a zigzag trail. The unusual guardian of this painting consists of four separate curved Rainbow People with blue faces. Mrs. Newcomb thought this was a painting for Mountainway because of the mountains and animals, but it could just as well be for Plumeway.

Mrs. Armer (1931:657) described a stargazing rite and two sandpaintings used for it. Each was a rectangle of solid color (black for a male patient, blue for a female) with four bear tracks on it. This represented Sky-reaching Rock. In the rite the patient sat on the painting facing east while gazing steadily at a rock crystal placed on the floor of the hogan directly beneath the smoke hole.

Miscellaneous Small Sandpaintings

Judging from the notes made by various recorders, small sandpaintings are occasionally made for use in certain other cere-

monies and rites. Among the reproductions in collections are three designs containing horned toads, anthills, rainbow bars, and (in one) the Sun. It is said that these designs are made for offering ceremonies in Red Antway (Wyman 1973:Fig. 63). During the overshooting ceremony of the final night of a Red Antway Evilway chant the patient sits on a sandpainting that has one or two Horned Toad People in the center surrounded by mountains and anthills connected by trails (Wyman 1973:219, Fig. 37). Wheelwright published a radial painting of Thunders, which she said was for an outside altar of the Hail Chant, and paintings of the *Sun* and the *Moon* "used for small rites in the Hail Ceremony" (Wheelwright 1946a:165, 171, 173). Paintings of *White Thunder's House* and of the *House of Toad Man* were also said to be small sandpaintings, but their use was not specified (Wheelwright 1946a:167, 169).

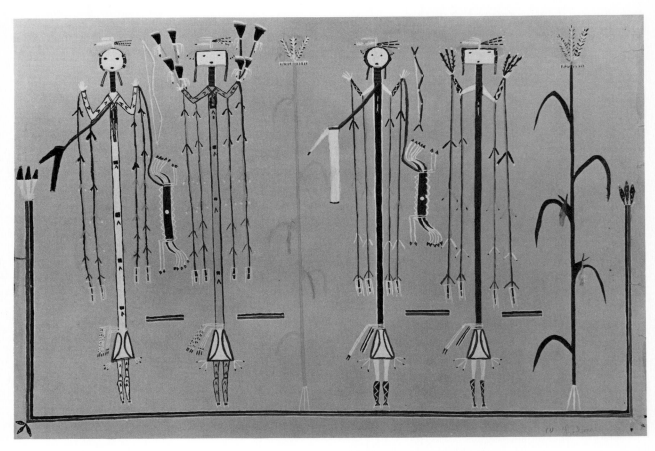

Figure 101. People of the Myth, Beautyway. Bear
Man pursuing Older Sister, the heroine of the
Female Mountainway myth (at the south), and
Big Snake Man chasing Younger Sister, heroine
of Beautyway (at the north), an illustration of
two chantway myths in one sandpainting. Cour-
tesy Wheelwright Museum. Photograph, Mar-
tin Etter.

9

Drypaintings as Illustrations of Mythology

Sandpaintings have been called "illustrations to a book of Navajo mythology," but few are frankly narrative as we understand narration. Rather, they indicate action mainly by symbolic devices. The Navajo beholder, if he is familiar with the origin myth of the ceremonial being performed and is versed in interpreting his tribe's symbolism, can read the paintings so that they bring forth the cardinal episodes of the stories, or at least remind him of them. If he does not know the myth, the painting is merely "an organization of symbols bringing one into the presence of the powers they represent" (Mills 1959:56). Some sandpaintings illustrate simultaneously the main themes of two myths. One such painting made for Beautyway was recorded by Mrs. Armer (Fig. 101). Although the figures in it, like those in the majority of chantway sandpaintings, seem to be merely standing around to be seen, familiarity with the myths and with drypainting symbolism allows the observer to get much more from it.

The Pueblo War, a major mythic motif of the Enemyway legend, also serves as an introduction to the myths of Beautyway and Female Mountainway. It establishes the background for the adventures of the two sisters who are the protagonists of these two myths (Wyman 1957:18–31, 45–123; 1962:57–58; 1975:127–36, 158–76). The Navajos and the Pueblo Indians were at war, and the two Navajo sisters had been promised to anyone who could take the scalps of two special Pueblo girls. Big Snake Man and Bear Man, who had taken the coveted scalps, were camped near where the Navajos were holding a war dance. Piqued because they had not obtained the prize that was rightfully theirs, the two old men lured the sisters away from the dance by means of sweet-smelling tobacco smoke. After spending the night with the two men, who had appeared to them as handsome youths, in the morning the girls were horrified to see two disgusting old men who had reverted to their forms as Big Snake and Bear. They fled in terror but were magically tracked by the two elders. Eventually the sisters parted, and here the separate myths of Beautyway and Female Mountainway begin. Beautyway is the story of Younger Sister, who was pursued by Big Snake Man until she arrived in the home of the Snake People, where she learned the lore necessary to establish the

Beauty Chant. Female Mountainway relates the relentless pursuit of Older Sister by Bear Man. Stumbling occasionally into the homes of the Bear People, she acquired from the supernaturals she met on her journey enough knowledge to establish the female branch of the Mountain Chant. Now let us look at the sandpainting (Fig. 101) that refers to these events.

There are four figures: their round and squared heads tell us that two males and two females are represented. The angles of their calves indicate that they are moving one after the other. The cornstalk in the center and the one at the south serve as markers indicating two separate events. Both male figures carry bows, arrows, and quivers—signs that they are up to no good. The white male figure at the north has characteristic snake markings on his body, as does the yellow female he pursues; so this pair obviously represents Big Snake Man going after Younger Sister. The black male hot on the heels of the blue female at the south must be, then, Bear Man chasing Older Sister. Their black lower legs and forearms marked with white lightnings are characteristic of People in Mountain Chant sandpaintings. Rainbow bars appear beside and in front of them, rather than under their feet in the usual position for means of transportation. This positioning reinforces the idea of rapid progression or flight toward the south. Thus, the sandpainting presents the central episodes of the myths of the two chants, although it would seem to an unknowledgeable observer to be static and uneventful.

Sandpaintings that are pictorially rather than merely symbolically narrative are exemplified in a publication by Reichard (1939:Pls. I–IX). These paintings might be called illustrations for the myth of Beadway. They show the Navajo boy in the eagles'

nest where he was treacherously placed by his Pueblo captors; his deliverance and transportation to the sky land by eagles, hawks, and arrowsnakes; the birds' houses he found there; the predatory hunting animals acting as messengers in arranging the corral dance held on his return and participating in it; and finally his revenge on the Pueblos by escaping in a final ascension to the sky, taking with him their valuable jewelry, which he had borrowed to wear in the dance.

Another example of fairly continuous pictorial narration is the series of drypaintings of the War Prophylactic Rite published by Oakes, Campbell, and King (1969). These illustrate in a connected manner the myth of Monsterway, especially the portion entitled *The Two Came to Their Father* (see Wyman 1970a:52–58). Pictured or symbolized are the Slayer Twins' mountain home and their means of transportation, some of the obstacles they overcame on their journey, the Sun's House, his doorguards, the Twins equipped with flint armor and weapons, the *Guessing Test,* Hot Spring, the scene of the slaughter of Big Ye'i, the Twins' encounter with Talking God, and the ceremonial at Navajo Mountain that was the prototype of present-day Beadway ceremonials.

A series of Plume Chant sandpaintings presented in Figures 102–107 and Plates 16–21 include a remarkable example (Plate 16) of a true "illustration" of an episode in the myth and a number of symbolic reminders of other episodes. Before describing these paintings, an abstract will be given of the Plume Chant myth, including only those portions to which the sandpaintings pertain. The legend consists of two major motifs, the *Hollow Log Trip* and *Witch Father-in-law* (Wyman 1962:50, 51). Three versions of the myth have been published (Matthews

1897:160–94; Wheelwright 1946b:9–15; Wetherill, in Wyman 1952:88–89). Two myths that have not been ascribed to any chantway could also be versions of the Plumeway myth (Goddard 1933:161–63; Sapir and Hoijer 1942:25–37). The *Hollow Log Trip,* one of the most widespread mythic motifs, also occurs in the myths of Nightway (J. Stevenson 1891: 278–79; Matthews 1902:171–97), of Waterway (Wheelwright 1946a:69–78, 92–94), and of Navajo Windway (Wyman 1962:138–42). In the Night Chant legend, the river trip is undertaken to obtain more ritual knowledge, and in the legends of the Water and Navajo Wind chants, it is specifically stated that the episode constitutes a meeting of these chantways with Plumeway (see K. Spencer 1957:164–76).

Myth of Plumeway

Hollow Log Trip

Self Teacher, the hero of the Plumeway myth, incurs the displeasure of his family for excessive gambling losses and decides to leave home. By burning out the interior of a cottonwood log he tries to make a boat in which to float down the San Juan River, but he is unsuccessful. Talking God and other supernaturals warn him against using his unsafe contraption and magically hollow out a spruce log for him. The Wind People enlarge the hollow by passing through it, and windows of rock crystal are made in the log. Meanwhile the supernaturals put seeds of beans, corn, squash, melons, and gourds under the wings of the hero's pet turkey. The supernaturals attach ropes of lightning and rainbow to the log to carry it to the river and guide it on its journey.

Provided with food, Self Teacher gets into the hollow log and embarks. His turkey and the supernaturals follow along the riverbank. Pueblo Indians attempt to intercept the log but are frustrated by the supernaturals. When the log gets stuck on rocks, it is freed by Fringed Mouth Ye'i. Water creatures pull the log down and take the hero to their underwater home where the door guards are two Water Horses. Among these creatures are Water Monster, Rough Frog, Big Fish, Turtle, Beaver, Otter, and others. The hero is rescued by Water Sprinkler, who has power over water, and Black God, who sets fire to the creatures' watery home. Arriving at a large whirlpool at the end of the river, the log spins around while the supernaturals stand around it before it is beached. In the versions associated with Nightway, the hero finds in the whirlpool a whirling cross of logs on which Holy People are seated. This is the origin of the well-known *Whirling Logs* sandpaintings. Self Teacher emerges from the log and has a joyful reunion with his pet turkey. In the course of his trip he has acquired much ritual knowledge from the beings he encountered—songs, prayers, sandpaintings— to be used when he returns to his people and establishes the Plume Chant. Self Teacher's turkey shakes his wings, the seeds under them drop out, and with these the hero plants a field. The plants mature rapidly (*The Farms* sandpainting).

Witch Father-in-law

Seeing a distant fire at night, the hero locates it by sighting through a forked stick. The next day he follows the line of sight, finds a hogan with a young woman in it, and is welcomed by her father. He marries the girl, but she is also her father's wife, for he is a witch and practices incest. Because of incestuous jealousy, the old man tries to

destroy his son-in-law by offering him poisoned tobacco or food, setting his fierce pet bears against him, or turning himself successively into a bear, a snake, Thunder, and a mountain lion and attacking the young man in these forms. Warned by the Wind People, the hero evades these attacks or turns them against his father-in-law. He brings corn and other produce from his farm to his new family and shows them how to cook it. In return the father-in-law, who is called Deer Raiser, and his daugher show the hero their underground game farm with compartments full of deer, antelope, mountain sheep, and elk. They teach him hunting magic, or he learns the use of deer and antelope hunting masks (head skins) from some Predatory-Animal People he meets. Thus he has acquired both knowledge of agriculture and power over game. Finally Self Teacher returns to his people, teaches them Plumeway, and departs for the whirling lake. In a version recorded by Wheelwright, the hero drinks at a pool, is swallowed by a big fish, cuts his way out with his stone knife, and is restored by his father-in-law. This reminds us of the *Swallowed by Fish* episode and sandpainting of Shootingway, and indeed we may suspect syncretism of that episode and the Plumeway myth. In this version, as in the Shootingway account, the hero is a son of the Sun.

Sandpaintings of Plumeway

Hollow Log Trip

Hollow Log Trip (Plate 16) is an unusually pictorial representation of a mythic event. The black foundation bar incorporated in the rainbow garland guardian is the San Juan River surrounded by white foam. The gar-

land has eagle and magpie feathers at its end. In the center is the hollow log with the hero in it, with a fawn representing the food he has taken with him for the journey. Short rainbow bars depict air holes, and six white rectangles are rock crystal windows in the log. From the top of the painting downward, pairs of figures represent Talking God and Calling God (south, north), Male and Female Ye'i, Fringed Mouth and Humpback, and Black and Blue Wind. They hold the rainbow ropes with which they carried the log and kept it afloat. The paired guardians of the east are white and black dragonflies, insect symbols of water.

Corn and Turkeys

In Figure 102, *Corn and Turkeys,* Pollen Boy is on a central blue lake surrounded by white foam and yellow pollen. The corn plants that Self Teacher raised are accompanied by ripe ears and Ripener Girls. The male and female turkeys in the quadrants symbolize the hero's pet turkey, which accompanied him, carrying seeds of domesticated plants. Short rainbow bars guard the eastern opening.

Thunders and Water Creatures

Thunders and Water Creatures (Plate 17) shows the Thunders, controllers of rain water, with the Water Creatures that pulled the hollow log containing Self Teacher down to their underwater home, the black center with clouds on it. Corn plants are in the quadrants with white beeweed, beans, squash, and tobacco. The Water Creatures (from southeast to northeast) are white frog, beaver, two turtles(?), Water Monster, otter, another kind of Water Monster, and a snake-like creature (perhaps a water snake). Paired guards are bluebird and white Ripener.

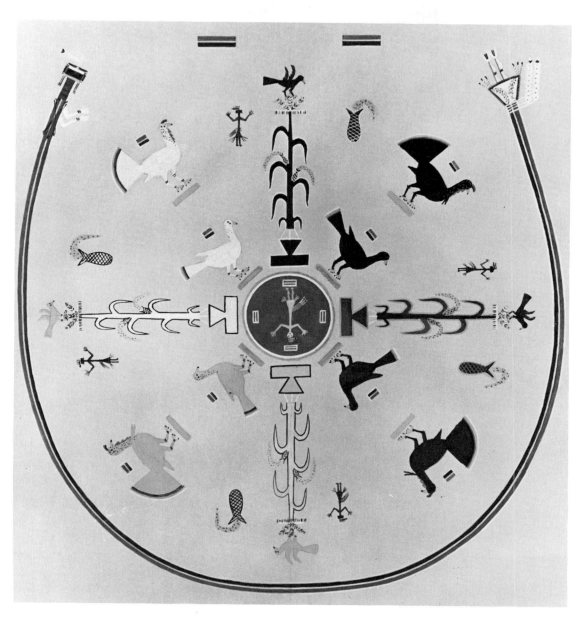

Figure 102. Corn and Turkeys, Plumeway. The corn plants and the hero's pet turkey, which accompanied him carrying seeds of domesticated plants under its wings, symbolize the hero's acquisition of knowledge of agriculture. Courtesy Wheelwright Museum. Photograph, Martin Etter.

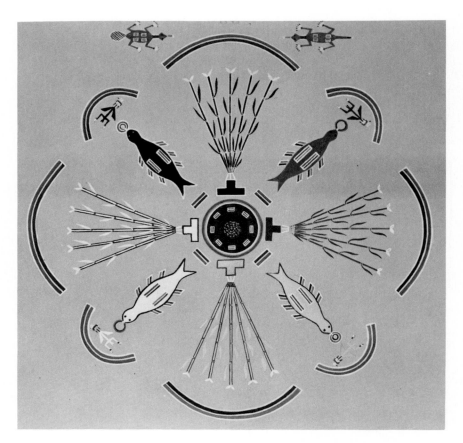

Figure 103. Big Fish, Plumeway. This and Plate 18 may commemorate the capture of Self Teacher by the Water Creatures. The interrupted guardian of curved rainbow-bars is unusual. The subsidiary symbols are medicine herbs. Courtesy Wheelwright Museum. Photograph, Martin Etter.

Big Fish

The lake in the center of *Big Fish* (Fig. 103) is the home of the Fish People, with pollen floating on it and foam and pollen around it. The Fish People had fields with all kinds of medicine herbs growing in them. According to the Navajo author, the plants in cardinal positions are seed grass (*Chenopodium* sp.), arrow reed (*Phragmites communis* Trin.), white seed grass (*Chenopodium album*

L.), and cattail (*Typha latifolia* L.). Each Big Fish has an air bubble or sack at its mouth symbolizing its ability to breathe under water. A Ripener accompanies each Fish, and otter and beaver guard the east. The broken guardian of curved rainbow bars is unusual. This and the next sandpainting may commemorate the capture of the hero of Plumeway by the Water Creatures, or it may be associated with a *Swallowed by Fish* episode as related in the myth recorded by Wheelwright (1946b).

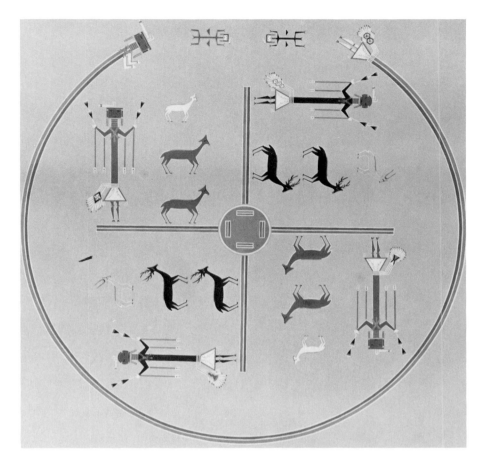

Figure 104. Whirling Logs (Turning Rainbows), Plumeway. Deer People and big-game animals emphasize the hunting theme of Plumeway. Courtesy Wheelwright Museum. Photograph, Martin Etter.

Swallowed (Captured) by Fish

In *Swallowed by Fish* (Plate 18), the central blue lake (dotted with pollen and surrounded by foam and pollen) is the home of the Fish People and Water Creatures. Big Fish are in the quadrants near it. Male and female People are in cardinal positions (earth people). Each one carries a feather bundle and a stone knife. With their knives they will be able to cut their way out of the air sack in which the Big Fish above them is about to encase them. Freed, they will go to the bottom of the lake, the home of the Water Creatures. Two Water Monsters and two Water Horses, the Water Creatures' door guards, are in the quadrants. The guardian is a garland of mist that comes from the water, and the paired guards are Ripeners.

Whirling Logs (Turning Rainbows)

In *Whirling Logs* (Fig. 104), the swastika-like arrangement with People and big-game

185

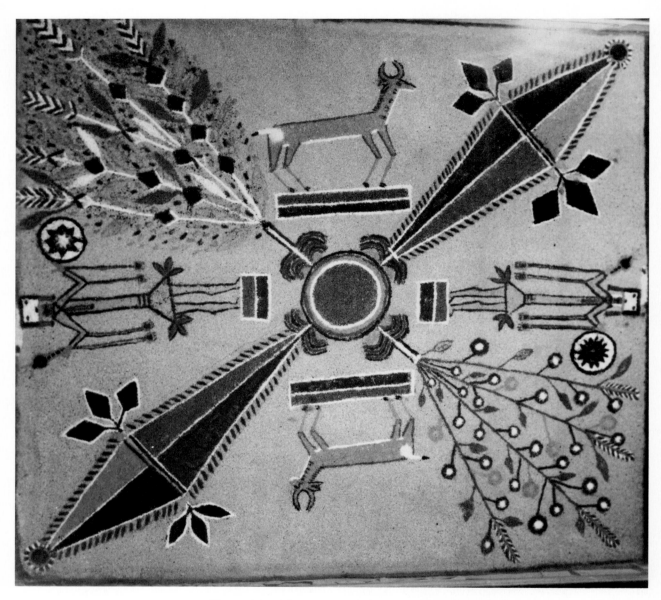

Figure 105. The Hero and Antelopes, Plumeway. Sandpainting made by Yellow Singer (Sam Chief) and left in the Arizona State Museum in 1918. It illustrates this singer's fanciful style and is an example of the hunting theme of Plumeway. Courtesy Arizona State Museum.

animals on it could be a reminder of the *Whirling Log* episode of the myths linked to Nightway. The People are said to be Deer People. The paired eastern guards are Big Flies.

Deer in Houses

The design of *Deer in Houses* (Plate 19) is primarily symbolic of the activities of Deer Raiser, the witch father-in-law of Self Teacher, but the corn with the deer in each house also signifies the agricultural theme of the hero's farm. This theme is reinforced by the presence of Pollen Boy in the central blue square (said to be the Sun's House). Sun and Moon and two protective white feathers are around the house. In three quadrants are the snake, bear, and Thunder, the creatures that Deer Raiser transformed himself into in order to attack his son-in-law. In the fourth quadrant is armored Black Wind, the monitor who warned the hero of impending danger. Lightnings and arrows roundabout symbolize the weapons used in the conflicts the hero had to endure.

The Hero and Antelopes

The Hero and Antelopes (Fig. 105) is an actual sandpainting, one of those made by Mrs. Wetherill's informant, Sam Chief, for the Arizona State Museum (see Appendix C). The People were said to be the heroes, carrying a rattle and a basket. The yellow animals are antelopes. The plants and forms in the quadrants were said to be tobacco and tobacco pouches. These are a good example of Sam Chief's fanciful style in making reproductions and even more fanciful use of colors. Here he uses green and purple as well as the usual colors. The game animals are characteristic of Plumeway sandpaintings.

The Farms

The design of *The Farms* (Plate 20) illustrates two episodes in the myth of Plumeway. The three corn plants and one squash vine in cardinal positions represent the farm planted by the hero with seeds provided by his pet turkey. The big-game animals on each side of the these plants represent the underground game farm kept by Deer Raiser. The wild food plants (deer food) in the quadrants—Rocky Mountain bee balm, pigweed, and so on—are rooted in cloud symbols on the central lake. Thus, this sandpainting symbolizes Self Teacher's acquisition of knowledge of agriculture and hunting.

Thunders and Sun

Four Thunders occupy the cardinal positions in the design of Sun and Big Thunder (Plate 21), and in the center is pink Big Thunder (symbolic of them all) with the blue-horned Sun on his back. Below the Thunders, the colored bars with birds on them (bluebird, blue swift, yellowbird, yellow-headed blackbird) are the Day-Sky sequence (dawn, midday, sunset, night). Zigzag lightning guards the picture, and blue and black winds (circles) guard the entrance. In this and in the next two sandpaintings the presence of the Sun or Moon does not appear to commemorate any specific event in the myth, but likely serves to invoke these sacred powers.

Moon with Big Game

The white Moon in the center of *Moon with Big Game* (Fig. 106) has its tobacco pouch and a head-skin hunting mask attached to its horns. There is a companion design with Sun in the center. The celestial bodies re-

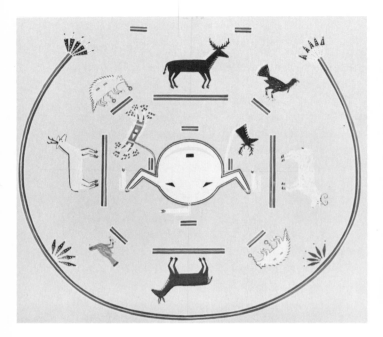

Figure 106. Moon with Big Game, Plumeway. The big-game animals, the tobacco pouch, and the head-skin hunting mask symbolize Self Teacher's instruction in hunting by Deer Raiser (see Fig. 107). Self Teacher's pet turkey is also shown. Courtesy Wheelwright Museum. Photograph, Martin Etter.

Figure 107. Sun and Moon with Big Game, Plumeway. Like Fig. 106, this sandpainting invokes the powers of Sun and Moon, and the animals and deer headskin hunting masks symbolize Deer Raiser's game farm and his hunting magic. Photograph, L. C. Wyman, Navajo Craftsman Exhibit, Museum of Northern Arizona, July 1967.

mind us of Deer Raiser's tobacco pouch decorated with pictures of the Sun and Moon, and his pipe inscribed with figures of big-game animals. The mask served in Self Teacher's instruction in hunting by Deer Raiser or by the Predatory-Animal People. In the quadrants are a male and a female turkey (Self Teacher's pet) and two porcupines.

Sun and Moon with Big Game

The symbolism of *Sun and Moon with Big Game* (Fig. 107), an actual sandpainting made in 1967, is the same as that of the preceding

picture. Here again the appearance of the Sun and Moon may serve merely to invoke their powers, but the deer head-skin hunting masks attached to them and the big game surrounding them symbolize Deer Raiser's game farm and his hunting magic. Moreover, we recall that in the version recorded by Wheelwright, the Sun is the hero's father.

Drypainting of the Apaches, Pueblos, Papagos, and California Indians

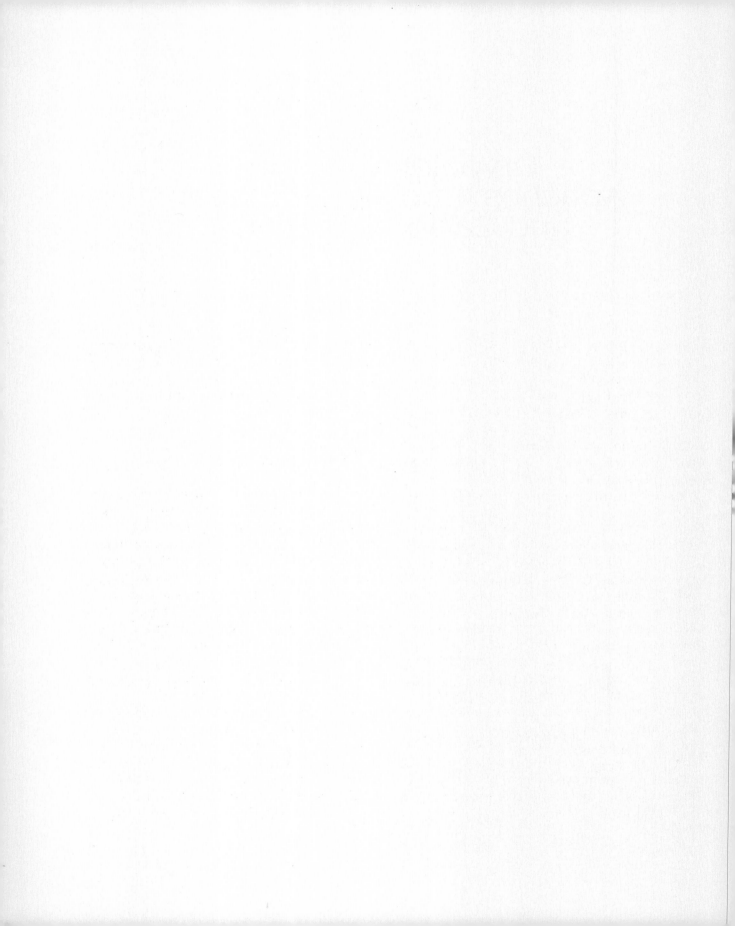

10

Apache Drypainting

Some of the various Apache bands, who, like the Navajos, are Athapascan speakers, are known to make drypaintings in their curing ceremonials. Although their rituals are not so elaborate as those of the Navajos and the range of their sacred symbols and combinations of symbols is not nearly so extensive, some of their designs are fully as complicated as an average Navajo sandpainting. Moreover, there are numerous procedural similarities in the drypainting ceremonies of the two Apachean peoples. These include: surrounding the painting with various objects stuck upright in the sand (the Apache fence and Navajo sandpainting set-up); making a trail with footprints on it leading into the painting, which the patient follows when entering; applying cattail flag or corn pollen and meal to the painting; seating the patient upon the painting for treatment; singing and praying over him; applying some of the dry pigments to his body; applying the objects from the fence or set-up to him; applying parts of the singer's body to corresponding parts of the patient; brushing sickness away from him; preserving small portions of the pigments to use as medicine; and performing a shock rite in connection with a certain drypaint-

ing. The practice of the art of drypainting has been documented, or at least reported, for the Jicarilla, Chiricahua, Mescalero, Lipan, Cibecue, White Mountain, and San Carlos Apaches.

Jicarilla Apache

The Jicarilla Apaches now live on a reservation in northwestern New Mexico just east of the traditional Navajo country, the Dinetah. The Jicarillas must have been long-standing neighbors of the Navajos before their western migration. It is not surprising, then, that there are many parallels in mythology and practice between the most ambitious single Jicarilla ceremonial, the Holiness Rite, often mistakenly called the Bear Dance, and two Navajo chantways, Female Mountainway and Beautyway. The Jicarilla rite is a cure for diseases believed to have come from improper contact with either a bear or a snake, while the Navajos have segregated their cures into two separate ceremonials, Mountainway for bear sickness and Beautyway for snake disease (Opler 1943:73–95; Wyman 1957:145–47; 1975:17–20). Opler concluded that the three ceremonials

belong to a "Navaho-Jicarilla ritual complex" and that the Navajos' emphasis on the close relationship between their two chantways provides for them "the unity of ritual defense against Bear and Snake which is achieved in a single ceremony, the Holiness Rite, by the Jicarilla" (Opler 1943:81, 94). We do not know whether the Navajo chants were derived from the Jicarilla rite or vice versa, or whether all three came from some other common source, such as the Pueblos.

The first description of the Jicarilla Holiness Rite and its drypaintings was published by Russell in 1898, and a few years later E. S. Curtis (1907, I:56–60) published a brief account, but the most complete report is the monograph by Opler, which also has a colored reproduction of the fourth drypainting (Opler 1943:Frontispiece). The following account is derived from Opler's work.

A circular enclosure about forty yards in diameter with an opening at the east is built of brush and young piñon, juniper, and spruce trees. The walls are the height of a man's head. Within this, at the west side, a large tipi is erected with its door to the east. Just after dark on the first night, the chief singer and three assistants begin the drypainting. An oval platform about six feet across is made of ordinary sand in back of the tipi, in a space outlined by the singer with pollen. The surface is smoothed with eagle feathers. The dry pigments are pulverized charcoal, white clay, red and yellow ocher, and blue made of a mixture of charcoal and white clay (Opler's illustrations also show brown and gray). The whole of the surface of the sand oval is blackened with charcoal and sprinkled with cornmeal, and on it are made four snakes, parallel to one another with their heads toward the west. The snakes—black, blue, yellow, and red—

represent four kinds of "wicked" snakes. They have directional significance, and the design also symbolizes the water that covered the earth at the time of the emergence of people from below. From its description, this design sounds much like snake sandpaintings of Navajo Windway, Beautyway, or Shootingway. A fence of twelve eagle feathers, two red-tailed hawk feathers, and two magpie feathers is stuck up around the painting, and an arrow and a little spruce tree are at the east. Finally a trail of four black-bear tracks is made leading to the painting from the southeast. Russell said that a sun symbol in white, black, and red was drawn around a shallow hole about six to eight inches in diameter in the center of the sandpainting that he saw in 1898.

About nine o'clock in the evening the patients enter the tipi, stepping on the bear tracks and pausing at the edge of the painting to sprinkle cornmeal (or cattail flag pollen—according to Russell) all over it. Then they sit on figures in the design facing east.[1] The chief singer and his assistants sit in front of the sandpainting facing the patients and begin to sing, the leader shaking a rattle. After four songs, a man painted black and covered with small spruce branches, impersonating a bear, rushes in and runs back and forth in front of the patients. If they seem to choke and faint, it means that a bear has caused their illness (trembling while on a snake sandpainting indicates snake sickness). The singer revives them with smoke from cornmeal thrown in the fire and from a pipe. Children should not see the making of a drypainting or be present at the performance of the "bear" lest they be frightened. This ceremony is practically identical, both in its theoretical rationale and its practice, to the Navajo shock rite (see Wyman 1973:45, 56–58; 1975:101–7).

After the shock rite, the chief singer removes his moccasins, gathers the articles in the fence and brushes the patients with them (brushing away sickness). At the same time, he treads on the sandpainting until he has obliterated it with his bare feet. Then he applies parts of his body, from feet to head, to corresponding parts of each patient's body (identification). Finally liquid medicine is administered to the patients and they leave the tipi. These procedures are about the same as those carried out in a Navajo sandpainting ceremony. The singers then push all the sand to the rear of the tipi, erasing the designs and the oval platform. The remainder of the night's performance consists of singing, accompanied by beating an inverted basket with the patients' moccasins and later by musical rasps, and dancing by all the people assembled for the rite.

The drypaintings of the three succeeding days are made in the morning, and the curing rituals in which they are used are like the ritual of the first night, except that no shock rite is performed. New sand is used for the background and the painting. The back of the tipi is raised and the sand from the previous ceremony is pushed out. The painting is begun about eight in the morning and is finished by eleven. The design of the second painting is of two mountains, a black one at the east and a yellow one at the west, with rainbow colors at their bases and animal trails leading to them. These are the two mountains that in the myth fused to form the gigantic emergence mountain on which the two heroines of the myth sat making baskets at the beginning of the story (Opler 1943:7, 28). The fence is placed around the painting as before, and a downy eagle feather is put on top of each mountain. These daytime events close with a feast. The drypainting of the third morning is like that of

the second, except that a blue mountain is placed between the black and yellow ones. This mountain stands for the south, and is surmounted by a small clay bowl of water representing the lake at Emergence Place. Little sprigs of spruce are stuck upright around the lake. Animal trails run up the other mountains.

In the ceremony witnessed by Russell (1898), the drypainting design of the second day contained bears, foxes, other animals, and here and there a snake. The painting of the third day was similar but with different animals; that of the fourth day showed two deities accompanied by all kinds of animals and was enclosed by a black circle. Opler (1943:11) said that "a ground drawing, particularly that of the fourth day, need not be precisely the same each time it is made, though of course the practitioner will confine himself to a limited number of religious symbols and mythological situations. Of the four sets of ground drawings I have been able to record and those described in the literature, no two seem to be exactly the same, though all belong to a clearly defined pattern."

The sandpainting of the fourth morning is the most elaborate of all. It has in the center four mountains ranging from east to west, with "all kinds" of animals south of them, and various birds, insects, wild fruit, and plants north of them (Opler 1943:Frontispiece). The creatures are shown because they used their powers to discover the guilty ones after Snake and Bear abducted the two girls. Standing in the eastern opening of the painting are two anthropomorphic figures in black and white. They are White God and Black God, the two most powerful Jicarilla supernaturals, who finally apprehended the girls' captors. The black band encircling the design represents the

waters around the world. It is bordered with colors and appears only in the painting of the last day of the Holiness Rite. Sometimes it is anthropomorphized with a head at the south end and feet at the north. When the patients are seated on the painting, the chief singer "sings of the gods and of how they looked into the hills for the girls. He sings of every one of the mountains and he sings to each direction even. Before he has sung of all the things in this ground drawing, he has sung forty-four songs" (Opler 1943:32–33). After the rite is over, the brush enclosure is left intact, to fall to pieces with the passage of time.

An abbreviated version called the Little Holiness Rite may be held in a tipi without the brush enclosure. It lasts four days and a drypainting is made on each day. These show "the picture of all those that make people sick, of the white-tailed deer, the antelope, the elk, the bear, the snake, all of them. Then the patient looks at them. When he sees the one that made him sick he shakes and cries. Then they know which one it is" (Opler 1943:44).

Another Jicarilla rite in which drypaintings are used is the ceremonial relay race (Opler 1944; 1946:116–34). This is now an annual affair held from September 13 through September 15. The runners are unmarried boys; each Jicarilla boy must participate at least once after he reaches puberty and before he is married. They are divided loosely into two bands, eastern and western (Llanero and Ollero in Spanish), that represent respectively the moon and plant life, and the sun and animals. The first race was held to resolve some confusion regarding the seasonal production of plant and animal food. The Sun, representing animals, and the Moon, representing plants and fruits, raced each other four times, taking turns

winning. Thus a balance of animal and plant food was established. Then the supernaturals gave the ceremony to the Apaches, who were told to continue it in order to ensure a balanced and plentiful food supply and not to let it lapse lest they starve. In time the people became careless about it, so at the instigation of four large birds the race was revived and two girls were offered as prizes, thus relating human fertility to abundance in nature. The winning side determines which kind of food, plant or animal, will be more plentiful during the coming year.

The race should occur at the same place each year. Spaces are cleared at each end of the race track, and in them, two circular enclosures about fourteen feet in diameter are built of little aspen and cottonwood trees and boughs. At the west end of the track is one made for the Llanero; at the east end is one made for the Ollero; their doorways face each other. The drypaintings are made in these holy places. A ceremonial leader has charge of the ceremony for each side, and each leader has three helpers. The leader marks the places where the paintings are to be, the background sand is smoothed with eagle feathers, and then the leader sings. While praying, he and his helpers drop pinches of the dry pigments from little buckskin bags on the places where the pictures will be. The symbols and designs do not have to be the same each year. The sun and moon are always shown, and usually two of the fast birds are depicted as well (Opler 1944:80 [drawing]). The birds may be changed each year. Sometimes they are big birds, sometimes small ones such as hummingbirds or cliff swallows. In a ceremony seen by Opler, there were four small paintings, each less than a foot across and separated from the next by about two feet,

in a single line beginning about a yard from the door and leading toward the northwest. In order, designs were a white sandhill crane, a blue and white cliff swallow, the circular blue moon with a red outine and rays, and the yellow sun. On another occasion the sun, made of yellow pollen, was nearest the door, the moon, made of black specular hematite, was next, and then there were four birds facing east—sandhill crane, prairie falcon, cliff swallow, and hummingbird. In a drawing made for Opler by an informant there were no birds, only four circles of solid color: brown (nearest the entrance), blue, yellow, and black, representing the earth, sky, sun, and moon. In the drawing published by Opler (1944:80), gray, green, and red are also listed.

The ceremonial relay race takes place during the third morning. In each enclosure the boys line up in two rows behind the drypainting, facing it. The old men sing while the boys dance in place. Then, as singing continues, the boys march out, stepping on each figure of the painting as they go. The procedure is the same in each holy place. After the boys have departed, the men left in the holy place rub themselves with sand from the painting "for health and good luck." Details of the ensuing dancing and the race may be found in Opler's description (1944:89–91).

Chiricahua Apache

Until the 1870s and 1880s, the Chiricahua Apaches roamed over, and largely controlled, extensive areas in southwestern New Mexico, southeastern Arizona, and portions of northwestern Chihuahua and northeastern Sonora in Mexico. Today the Chiricahuas live together with the Mescalero and Lipan Apaches on a reservation in south-central New Mexico not far from White Sands. Although they are known to have used drypaintings in their ceremonials, these have been scarcely documented. Mr. Gatschet, at a meeting of the Anthropological Society in 1885, described what he called a Chiricahua Apache "sun circle" or "magic circle" used to cure those who are sunstruck. The painting described, however, is so like those reported for the western Apaches that it is quite possible that he misattributed one of their ceremonials to the Chiricahuas. This opinion is strengthened because in the very same discussion, Mallery (1885) described a drypainting witnessed by Dr. W. H. Corbusier, of the U.S. Army, at Camp Verde, Arizona, in the summer of 1874 and said that it was made in a Yuman rite. Again, his description fits almost exactly those of western Apache medicine disks. Furthermore, no evidence has ever been found that the Yuman tribes practiced the drypainting art.[2] It seems certain, therefore, that Corbusier had seen an Apache ceremonial. Other than Gatschet's report, there is only a brief reference to "the ground drawing," which "may be an important feature of a particular rite" in Opler's book on the Chiricahuas, *An Apache Life-way* (1941:265). His informant said that the drawing was used "against epidemics as well as to foil the enemy," who cannot pass a picture made on the ground with pollen and left there.

Mescalero Apache

Morris Opler very kindly provided from his field notes the following account of the use of drypaintings in a Mescalero ceremony, as described by an elderly shaman.

This man used his ceremony for those who had been sickened by witches. It was a four-night ceremony, and in the course of it a ground drawing of four figures was made each night. The figures of the first and third nights were alike, as were those of the second and fourth nights. The earth on which the drawings were made was obtained from a sacred mountain. It was rid of impurities and sifted to make it fine and uniform. When the drawings were to be made, four piles of the earth were laid in a row running from south to north across the floor of the ceremonial structure. With the use of a bundle of sacred grama grass each pile was smoothed to a circular disk about one inch thick, six to seven inches in diameter, and flat on top. The shaman sang and drummed. He had an assistant who drew the figures in tule pollen on the flat tops of the disks. The figures of the first night were, from south to north, buffalo, bear, snake, and a cross. The head of the buffalo was toward the south, its feet toward the east. The bear was similarly oriented. After every set of four songs the assistant put pollen on the tongue of the shaman. The first prayer was to the buffalo asking him to keep evil away. Similar prayers to the other figures followed. When the praying and singing were finished tobacco smoke was puffed to the cardinal directions. Then some of the colored soil was placed on the tongue of the patient. Fresh earth was used every night. On the second night the figures drawn were mountain lion, a box-like figure with four streamers which represented the directions, a rake-like figure that stood for pollen, and a moccasin print (a symbol of long life or the path of life). At intervals during the ceremony liquid medicine was rubbed on the body of the patient. At the end of the ceremony the earth and pollen from the ground drawing were rubbed on the patient and onlookers. The shaman had a ceremony like this performed for him when he was about eight years old. Later he learned to conduct such a ceremony himself.

Lipan Apache

Although Opler was unable to obtain any indication that the Lipan Apaches used sandpaintings, he did obtain, from a very old Lipan woman, an account of the use of drawings traced on the ground in the girl's puberty rite. Opler has very kindly given permission to quote a portion of this account.

In the (first) evening the girl comes to the tipi again. The parents of the girl have asked a man who knows the ceremony to sing for her. He will sing for her for the four days. They have a fire in the tipi. The girl sits in back west of the fire and faces the east. The singer sits on the south side all the time, facing the north. The man who is hired to sing for Changing Woman traces figures of many animals on the ground. He doesn't use color, he just draws them on the ground with his finger. This is done the first day and the figures are left during the ceremony. On the last (fourth) night they are rubbed out. Now he starts the singing with two songs and the girl gets up and dances to them.

Western Apache

Of the various bands living on the adjoining Fort Apache and San Carlos reservations in east-central Arizona, drypainting ceremonies have been described for the Cibecue, the White Mountain, and the San Carlos groups (Reagan 1914, 1930; Goodwin 1938). Their circular drypaintings are called medicine circles or disks, or sometimes sun disks. They are used in curing ceremonies,

often as a last resort in terminal cases, and if the patient dies the ceremony is supposed to have ensured for him a pleasant life in the afterworld. Goodwin (1938:33) said that the drypaintings, which compare to those of the Navajos in complexity of design, may be made in six different ceremonies but that no one ceremony ever has more than a single painting. He also said that ceremonially painted buckskins covered with figures in various colors corresponding to those in the drypaintings may be used in curing or in battle and may be kept for repeated use (see Bourke 1892:Pls. VI, VII, VIII). The most complete descriptions of Apache medicine disks were published by Albert Reagan, who after a period as "U.S. Indian Farmer" at Jemez Pueblo in New Mexico (1899) was put in charge of the Cibecue division of the Fort Apache reservation in Arizona, where he said he had access to all ceremonies (Reagan 1914:278–82; 1930:333–42). In his historical novel, *Don Diego*, there is a colored line drawing of a medicine circle (Reagan 1914: 278).

West of the family dwelling, a level piece of ground about thirty feet in diameter is cleared and surrounded by a fence of brush, or recently by a canvas wall, with an opening at the east. The drypainting of the medicine disk is made within this enclosure; the painting is made in daylight, and must be used and destroyed before sundown. Of course it is partly destroyed by the practitioner during the ceremonial, who may be a medicine man or a woman, usually elderly. The dry pigments are made from white limestone, black charcoal, red sandstone, yellow ocher, and green leaves of various trees or plants dried near a fire and pulverized. A gray or bluish color is made by mixing ground limestone and charcoal. Numerous people help in grinding or crushing these materials. The pigments are strewn on a background of sand. The colors have directional significance: black for the east, blue or white for the south, yellow for the west, and white or blue for the north.

The design of the disk, which is around sixteen feet in diameter, consists of several concentric rings around a circular center that may be about three feet in diameter. On or within these rings are sets of various symbols, especially figures of supernatural beings in human form. These may be eight or nine inches long, and there may be from fourteen to thirty of them in a given circle. A painting described by Reagan (1930:338–40) contained eighteen supernaturals, each about two feet tall, standing on a rainbow circle about an inch wide—four black ones at the southeast, one of rainbow colors at the southwest, four red ones at the west, four green at the north, four white at the east, and a black one just north of the eastern opening. Outside of them was another rainbow ring with twenty-eight supernaturals standing on it and a gray figure of a goat north of the opening, around fifty figures in all in the design. Besides the humanoid figures there may be figures of various animals and birds and symbols of the sun, moon, lightnings, rainbows, land, and water. After the picture has been completed, an old man or woman sprinkles the central symbols and each circle of figures, beginning at the inside one, with cattail flag pollen while praying.

The patient sits upon or is carried onto the center of the medicine disk (on the sun symbol) while an old man chants over him, sometimes for two hours. Then an old man or woman enters the painting, presses a moistened palm to each of the figures and rubs the adhering pigment on the patient's body, repeating this until the patient's en-

tire body is covered with pigment. Some of the sand may also be collected from several designs and put in a bowl for future use. Then an impersonator of a supernatural being comes from a nearby thicket and performs over the patient in the same way. Finally the patient leaves or is carried out, and the old man or woman destroys all the figures, raking the sands to the center of the circle with his or her hands. After this ceremony, all who wish may roll in the painting, or collect some of the pigments to rub on their bodies or carry away to use as medicine. As the enclosure is torn down, men and boys rush in to seize handfuls of the sands. Then women toss sand in the air to let it fall on their children, or rub it on their children's heads.

Another method of applying sand to the patient is to gather some from each figure, walking around the circles beginning with the outer one, and to put it in a gourd or cup partly filled with water. This is set on the center of the sun-disk; the patient enters, walks around each circle, and sits in the center of the painting. Then, chanting, an impersonator of a supernatural comes from a thicket, dances around the enclo-sure, dips his hand in the cup, and rubs the muddied water on various parts of the patient's body, lifting his hands toward the sky and blowing away the sickness. As the impersonator leaves for the hills, the chief practitioner sprinkles him with sand from the painting. Then he too takes the cup and, while praying, rubs the mud in it all over the patient.

Another type of sun-disk, sixteen feet in diameter, was described by Reagan (1930: 341–42). Called the "sun father," it consists of a front view of a massive head with a crown for a hat and colored squares for a necktie. There is no nose, neck, or body. The mouth, eyes, and eyebrows are square. A long-stemmed pipe projects from the left of the mouth and sun's rays from each corner of the lips. The colors are red, white, black, gray, and green. Pigment is gathered in a bowl of water and applied to the patient by an impersonator and the practitioner as just described. Thus the patient is presented to the "father of day," who may cure him or take him to his "abode in the immensity beyond." The form of the "sun-father" may vary according to the practitioner's fancy.

11

Pueblo Drypainting

The Pueblo Indians of New Mexico and Arizona are not a single tribe; in fact, they speak languages belonging to four distinct linguistic families: Tanoan, Keresan, Zunian, and Shoshonean. Underhill (1948:41–46) expressed the opinion that all Pueblos practiced drypainting, but we have published reports for the Hopis, Zunis, and only ten of the seventeen principal eastern villages: six Keresan pueblos (due mainly to the energy of Leslie White), Zia, Santa Ana, Santo Domingo, Cochiti, Laguna, and Acoma; one of the five living Tewa villages, Tesuque, for which we have records of only a few simple meal designs; two Tiwa towns, Taos and Isleta; and the Towa village of Jemez. Most of what we have for the Hopis and Zunis and for the Zias comes from the prolific publications of Fewkes and Voth around the beginning of the twentieth century, before the Hopis had become as exclusive as they are now, and from the activities of the redoubtable Matilda Coxe Stevenson at Zuni and Zia.[1]

For decades, the eastern Pueblos have trained their children to conceal everything about their lives, especially their ceremonialism, from white people; a strict watch is kept to prevent any Indian from revealing cultural secrets. Parsons (1962:2) called it "an intelligent technique of self-protection against those who . . . would make changes in Indian culture" and said that another motive might be the belief that rituals lose their potency when divulged to the uninitiated. Today even the friendly Hopis seldom admit whites to their kiva ceremonies. Consequently the ethnologist must work with the few informants who can be persuaded to talk, in privacy, well away from the pueblo (White 1962:6–9).[2]

Among the Pueblos, a drypainting is part of a usually elaborate altar set up in a kiva (a ceremonial chamber that may be, but is not always, completely or partially underground) when an esoteric ceremony is to take place in it. A complete altar may consist of a drypainting on the floor, a carved and painted wooden screen or reredos erected near the rear edge of the painting, and paintings on the wall behind the reredos (Fig. 108, Plates 22, 23, 29) (Parsons 1939:Fig. 3, Pl. VI).[3] In addition to, or instead of, the wooden slat arrangement, fetishes (wrapped ears of corn, carved and/or painted wooden slabs or sticks, feathers, and other articles) may be set upright in a ridge of sand at the rear of the painting. The wooden slat altar

may be kept and used year after year, perhaps occasionally being repainted. The altar is sometimes called a "house of the supernaturals," who dwell within it, in their fetishes or images; certain border elements in a drypainting may be called planks of a house (Parsons 1939:479). Among some Pueblos, a slat altar is always accompanied by a drypainting, but on certain occasions the drypainting may be used independently (White 1962:317). The wall paintings are also permanent except in rare instances. They depict supernatural beings such as kachinas; supernatural animals such as the Zuni *kolowisi* (water serpent) or the knife-wing (*achiyelatopa*); natural animals and birds, or their tracks; heavenly bodies, symbols of phenomena such as clouds, rain, and lightning; corn plants; impersonators of the *koshari* (koshare sacred clowns), and cosmic symbols (Plate 23) (M. Stevenson 1904:Pl. XXXVI; Stirling 1942:Pl. 10, Fig. 1). Innumerable objects may be placed upon or near the drypainting, including the principal fetishes (wrapped corn ears, the Corn Mother); stone or wooden figurines of anthropomorphic supernaturals or of animals (often bears, mountain lions, badgers, wolves, and snakes); artificial flowers; models of fruit and vegetables; seed corn, bear paws, deer antlers, stuffed parrots, bear-claw necklaces, medicine bowls, and water jugs; stone implements such as arrowpoints and curiously shaped stones; ceremonial paraphernalia such as rattles or aspergillums; and supplies to be used in the ceremony such as prayer sticks, bowls of cornmeal, gourds of sacred water, and the like.

Except for the Hopi Snake Society altar, which is assembled at night, altars are set up in the daytime preceding the night ceremonial, often on the fourth day. They may be placed at the north of the ceremonial room (Hopi, Acoma) or on the side of the room away from the door (Zuni). North is the point in the directional circuit from which most ritual procedures are begun, but in other respects the east, associated with the sun, is favored with special significance. Altars often are placed facing the east, ritual roads lead to the east, and in some pueblos the ceremonial circuit begins in the east, as it does for the Navajos. Constructing the altar and laying out the drypainting is done reverently, often ritualistically with prayer and song.

It could be said that the Pueblos use two types of drypaintings, sandpaintings and meal paintings, just as the Navajos make sandpaintings in which charcoal is the only nonmineral pigment, and Blessingway drypaintings in which only pigments of vegetable origin—meal and pollens—are used. Pueblo sandpaintings, however, are seldom made of colored sands and charcoal alone. Vegetable pigments are usually used as well, and whole areas may be strewn with cornmeal (White called them "meal-and-pigment paintings"; 1942:330). Some Pueblos keep the use of meal and sand well separated, but others, especially the Hopis, do not distinguish meal and sand altars, using both at the same time. Parsons (1939:957) said that the Keres associate meal paintings with rainmaking and sandpaintings with curing. Underhill (1948:46) suggested that meal painting was developed by agriculturists concerned with growth ceremonies, whereas sandpainting was a tool of sha-

Figure 108. Carved and painted wooden slat altar and drypaintings of clouds, lightning, and mountain lion, of the snake society of the Keresan pueblo of Zia. From M. Stevenson (1894:Pl. XIV). Photograph, Martin Etter.

manistic healers, and that in the Southwest the two devices met and partly coalesced. Parsons (1939:1048) wondered whether meal designs might have been the basis for the development of sandpainting, evolving independently among the Pueblos. It is true that the Blessingway rites, which have a profusion of cornmeal and pollen trails leading to and from their drypaintings, are believed by Navajos to be older than the chantways and their sandpaintings (Wyman 1970a:6, 101). Meal paintings will be dealt with more specifically below.

The colors seen in Pueblo drypaintings are black, white, gray blue (a mixture of black and white), pale gray, blue, green or blue green, yellow, and orange or brown yellow. The Pueblos use the same pulverized white, red, and yellow sandstone and black charcoal employed by the Navajos, and also the following: *mineral colors*—black clay, shale, coal, or manganese minerals, and a natural mixture of magnetite and hematite; white sand, clay, or kaolin; red and yellow ochers (hematite and limonite); gray or gray blue sand; occasionally crushed blue turquoise; copper ore (malachite); and dull, dirty green sandstone; *vegetable colors*—black charred corncobs; white, yellow, and blue cornmeal, yellow and blue corn kernels (in a representation of a cornfield in the Hopi Flute Society altar), yellow corn pollen; pulverized blue flower petals, such as petals of larkspur (*Delphinium*), the "blue pollen" of the Navajos; and pulverized green leaves. Special songs are sung while grinding the pigments on stone slabs and during the making of the drypainting. Members of certain clans must fetch the sand for the altar. This is done while making offerings of prayer-feather strings and praying: "This I have made for you; you will have this, but I shall take your sand along" (Parsons 1939:289).

As in Navajo practice, the dry pigments are strewn with the fingers on the background or bed of ordinary tan or yellow sand taken from a sand hill in the valley or on the plain, which has been sifted through a basket sieve. A rectangular or circular space is covered to a depth of an inch or so. In Hopi kivas the painting may cover or surround the *sipapu,* a pit (shrine) in the floor representing the place of emergence and serving as a means of communication with the lower world. The chief of the organization holding the ceremony or his helpers make the painting, the chief directing his assistants. Women seldom help, but the chief priestess of a women's society may be a skillful drypainter. Contrary to Navajo usage, the Pueblos start at the periphery of a drypainting and work toward the center. This difference in practice has been interpreted as a difference in psychological disposition, but it may be merely a practical matter. It is easier to make the outlines and then fill them in. Since Pueblo paintings are seldom over four feet across, they can do this, whereas the Navajo with his much larger paintings has to work from the center outward to avoid defacing the design. Pueblo designs range from about twenty inches to four feet across. After completion they may be partially covered by the pinches of meal or pollen sprinkled on them for consecration. Just as the Navajos make meal and pollen paintings for their Blessingway rites (and on occasion a sandpainting for a chant) upon a buckskin or a cloth substitute, in some rites the Pueblos make simple designs on a buckskin; this is done at Zuni during the installation of a rain priest or a *pekwin* (sun speaker or watcher in charge of the ceremonial calendrical round).

Drypaintings made entirely of cornmeal, usually white, are simple and often repre-

sent clouds, terraced or stepped symbols or half circles (sometimes outlined with black charcoal) with rain lines falling from them, thus specifically referring to rainmaking. Bunzel (1932a:499) said that at Zuni every altar is erected upon a white meal painting of clouds, and White (1962:317) thought that sand or meal paintings always accompany the wooden slat altar at Zia, but meal designs may be employed without an accompanying reredos, as in the installation and other ceremonies of the Bow Priesthood at Zuni (M. Stevenson 1904:577, 598, Fig. 33, Pl. CXXXIV). Such designs may be called the "village" or "town" (Isleta), or "house of the clouds" (Zuni, Acoma, Zia). A rectangular area covered with meal serves as a seat for the fetishes.

A line of cornmeal strewn from the center of a drypainting, or from the chief fetish on the altar, to the foot of the ladder or door of the ceremonial room is a road for supernaturals to travel upon when entering to invest themselves in their images on the altar (see Plates 22, 23). Human participants also walk this trail, casting a pinch of prayer meal on or toward the altar (Hopi road marking). Initiates are led to the drypainting along the cornmeal road (Parsons 1939:360–65). Human footprints may be made in meal upon the road, and among the eastern Pueblos crosslines, feathers, or crossed pieces of yucca leaf laid on the trail —said to be the tracks of the chaparral cock or roadrunner—serve as stepping marks and preclude pursuit by witches. In funeral rites there may be a road of meal for the ghost to travel. As impersonators of kachinas are led from place to place, the leader sprinkles meal before them to make a road (Parsons 1939:Pl. V). The "spring" bowl of the altar is put at the junction of meal roads from all directions. Similar cornmeal trails with footprints on them

lead to the sandpaintings for certain Navajo rites such as prayer ceremonies, the big hoop ceremony, or the shock rite (see J. Stevenson 1891:Pl. CXX; Matthews 1902:Pl. II C, D; Reichard 1939:Pl. XXI; 1970:Fig. 8; Wyman 1970b:Pl. 37).

The symbols and designs of Pueblo drypaintings are, on the whole, less numerous and less complicated than those of the Navajos. Frequently they suggest the Pueblos' concern with rainmaking, such as clouds with rain falling from them, rainbows, lightning, or snakes (the animal cognates of lightning), and the cornfields or plants benefited by the rain. Heavenly bodies—sun, moon, stars, the galaxy—are frequent, as are cosmic symbols such as four or six lines crossed within a circle representing the directions. Occasionally depicted are animals, especially the mountain lion, birds, mythological creatures, and the anthropomorphic supernatural kachinas. Four or multiples of four are important ritual numbers in designs, as they are for the Navajos, but among the Tanoans five and its multiples are favored, as they are in a few Navajo sandpaintings such as those for Beadway (Reichard 1939:Pls. VI, VII). In drypaintings, as on ritual paraphernalia, directional color symbolism is important, except among the Tiwas, especially at Taos, where Parsons (1939:490) suspected that much of Pueblo ritualism was lacking. The Pueblos have six ritual directions (or five at Isleta and Taos)—the cardinal points, the zenith, and the nadir—whereas the Navajos attend only to the four points of the compass in their sandpaintings. The colors associated with the directions differ among the Pueblos. A common sequence for north, west, south, east, zenith, and nadir is yellow, blue, red, white, all colors, and black. The Tiwa circuit, which starts in the east instead of in the north, is the same as

one of the common Navajo sequences: white, blue, yellow, and black. In general the color of the north is yellow or black, west is blue (green) or yellow, south is red or blue, and east is usually white. The colors of the zenith and nadir may be reversed. There seems to be one color circuit for the Hopis, Zunis, and Keres (except for variations for zenith and nadir), and another for the Tewas and Tiwas that approximates the Navajo circuit.

Unlike a Navajo ceremonial, which is given for the benefit of an individual, a Pueblo altar ritual is part of a larger performance carried out to bring rain, grow crops, secure game, circumvent witchcraft, cure disease, and bring about all things desired by the people of the village. The altar provides a center of attention for the ritual. Both the Navajos and the Pueblos, however, hope to establish direct contact between humans and supernaturals so as to obtain from the supernaturals their power to accomplish human desires. Both believe that, attracted by their invocatory songs, prayers, and altar paraphernalia, the "spirits" or essences of the supernatural beings depicted in the drypaintings or by the images on the altar will enter over the cornmeal road and occupy their pictures or images (see White 1942:342). Once they are there, the Indians can gratify or coerce these beings in order to obtain their power. There is a much closer relationship between a Navajo chant and its sandpaintings and the origin myth of the ceremonial than there is between paintings and myth in any Pueblo ceremony. As Parsons remarked, Pueblo ritual is independent of myth support: "Let everybody forget the myth of the lost Corn Maidens, and the Molawia ceremony would go on just the same, just as in Christendom the rites of baptism and confession will go on after the

dogmas of Limbo and the Fall have ceased to circulate" (Parsons 1939:1158).

Just as the Navajo and Pueblo theories of how a drypainting works have much in common, so do some of their methods of using it. Participants in the Pueblo ceremony press their palms to the figures in the painting, breathe in from them, and rub the adhering pigments on their bodies. Sand, meal, or pollen from the painting may be taken home for similar use on relatives. Sand or meal from the altar may be placed under a store of corn or near it in the storeroom, buried in the cornfield, or, lacking a field, simply thrown into the river. In an initiation ceremony, the novice stands upon the drypainting to be whipped with a switch of yucca leaves by priests or by impersonators of kachinas (Parsons 1939:49, 467–76, Pl. VII). This confers on the child strength, power, and luck in various pursuits, as he is being initiated into the mysteries of the kachina cult. Meal or sand from the painting is rubbed upon his body. A prayer feather taken from the head of a drypainting kachina may be tied to the child's head, just as tokens are tied to a scalp lock of the patient in a Navajo sandpainting ceremony. After the child has been whipped, a kachina may step onto the drypainting to be whipped by other kachinas. Children may also be whipped by kachinas in exorcistic ceremonies.

Unlike Navajo sandpaintings, which are made, used, erased, and disposed of in a single day, Pueblo drypaintings may be allowed to remain for several days. Eventually the altar is dismantled, first by laying the fetishes and images down on their sides (because the spirits have left them) and then by effacing the painting and sweeping its materials into a pile. Someone does this cleanup with a hoe or broom, raking all the

sand into the middle of the space the painting occupied. Sometimes it is done by a female member of the society (Zuni). Some of the sand may be preserved in a small box. Most of it is put into a blanket and carried down into the valley by a male society member (Hopi), thrown into a pile eight or ten yards south of the kiva, deposited in the society spring (Zuni), or thrown into the river (Santo Domingo). At Taos a drypainting is not destroyed but is covered over with dry leaves. The Hopis even efface the elaborate wall paintings made for their Powamu ceremony. Parsons (1939:358) thought that the erasure and disposal of drypaintings among both the Pueblos and the Navajos was for the purpose of isolating supernatural power when it was not under the rigorous control of a ceremony. Certainly the Navajo practice is designed to get rid of the potentially dangerous sands so that they can do no harm.

Hopi

The Shoshonean-speaking Hopi Indians (*hópitu*, peaceful ones) live in eight communal stone villages on the tops of three mesas in northeastern Arizona (actually three fingerlike projections from Black Mesa); other Hopi settlements include a farming colony forty miles west near Tuba City, and three suburbs, one at the foot of each of the three mesas. On the first or easternmost mesa are Sichomovi and Walpi. The more recently established suburb of Polacca is below the mesa, as is the town of Hano, settled by refugees from the Rio Grande Valley around the beginning of the eighteenth century. The Hano residents still speak a Tewa language but are now Hopi in culture. On the second or middle mesa are Mishongnovi, Shipaulovi, and

Shumopovi (Shongopovi), and their suburb Toreva. On the western or third mesa are the old town of Oraibi and two recent colonies from it, Hotevilla and Bakabi, with New Oraibi below them. The village of Moenkopi near Tuba City is also a colony of Oraibi.

So far as is known, the Hopis make drypaintings for the following ceremonies: *wüwüchim*, *soyala* (winter solstice), *powamu* kachina (bean festival), *nimán* kachina (homegoing), snake-antelope, and flute; and for those of the three women's societies, *marau*, *lakon*, and *oaqöl*. The best-known Hopi drypaintings are the two made for the antelope and the snake societies' altars during the famous snake dance. They were the first Hopi drypaintings to be published, by Captain John G. Bourke in 1884, with drawings by Peter Moran, a Philadelphia artist who saw the snake dance with Bourke at Walpi in 1883. Moran's drawings have subsequently been published, sometimes more than once, in no fewer than ten different works written by six different authors.[4]

Wüwüchim *Ceremony*

The *wüwüchim* ceremony (adults' ceremony, according to Voth [1901]) in November is considered by the Hopis to mark the beginning of the ceremonial year, and in some ways it affects the rest of the ritual calendar.[5] It is performed jointly each year by the four men's societies—singers, *wüwüchim*, agave, and horn—into one of which every Hopi boy is supposed to be initiated. In a year when there are enough initiates to make it worthwhile, the *wüwüchim* is given in a long form that includes the initiation. Membership in a society is a prerequisite for impersonating the kachina supernaturals in public performances (kachina dances). The singers and the *wüwüchim* so-

ciety also have some clown functions (sacred buffoons), and the agave and horn societies have warrior duties, such as guarding the kivas when ceremonies are in progress, so in a sense the ceremony is a war rite. New-fire ritual—kindling new fires with fire drills—is also a part of it. Stephen (1936:960 ff.) gave a day-by-day account of a performance with an initiation at Walpi in 1891 that was quoted by Parsons (1939:606–20).

The only drypaintings mentioned in descriptions of the ceremony are two simple meal designs. Soon after sunrise on the first day, altars of the six directions are placed over the *sipapu* in the kivas of the participating societies. A circle of brown valley sand about two feet in diameter is sifted onto the floor, and three intersecting lines of white prayer meal are made on it, thus forming meal roads to the six directions. A bowl of water (a "spring") is set at the intersection of the lines. In other observances, similar altars of the directions are made in various places—sometimes on the roof of a kiva—and ears of corn of the directional colors and other objects may be placed at the ends of the roads (see Fewkes 1927:Pl. 1). The other meal painting is made in the horn kiva in front of a frame altar, the only painting used in the ceremony. Several piles of sand are made and bedecked with the corn-ear fetish badges of the horn priests (*tiponi*) or with stacks of prayer sticks. On a rectangle of valley sand laid out before these piles, a stepped cloud terrace symbol with a triangle on each side is made with white cornmeal (Fewkes 1922:Pl. 2). A meal trail is drawn toward the east, leading from this rain cloud to the kiva ladder.[6]

Soyal (*Winter Solstice*) Ceremony

In December, not long after the *wüwüchim* ceremony, the *soyala* society celebrates the winter solstice, the time when the sun arrives at his house. The *soyal* rite is primarily concerned with the annual progress of the sun, but it is also a prayer for increase, an occasion when the villagers plan for the new year, and a war ceremony. It is a time when the kachinas, who are masked impersonators of supernatural beings, return to visit the Hopis, with whom they will reside and dance from time to time until their farewell or home-going ceremony in July. Detailed descriptions of the winter solstice ceremony at Oraibi in the 1890s were published by Dorsey and Voth (1901) and quoted by Parsons (1939:556–70); the ceremony as performed at the Hopi-Tewa pueblo of Hano in 1898 was described by Fewkes (1899).

During the Oraibi *soyal* a meal painting is made in *ponovi* or chief kiva in front of a wooden reredos, piles of seed corn, and a line of corn-ear and other fetishes. The painting consists of six semicircular cloud symbols outlined in black and with rain lines "falling on the fetishes"; it is made on a layer of moist sand one and a half inches thick. The design is thirty-two inches long, the width of the altar frame (Dorsey and Voth 1901:Pl. I). A meal road set with crooklike prayer sticks leads to the painting.

In *monkiva* or chief kiva at Hano, a similar meal painting is made in front of the ridge of sand upon which the fetishes are set, but the design has only three elongated rain-cloud symbols with semicircular ends away from the altar (outlined with black), and about twenty alternating black and white corn-meal falling-rain lines (Fewkes 1899:Pl. XVIII). A meal road leads to the kiva ladder. In corner kiva (*tewakiva*), a slightly more complex drypainting is made in front of a clay effigy of the great water serpent. This effigy is three feet long with twelve eagle feathers stuck upright in it and horn, teeth, and eyes made of corn kernels. The drypainting design

consists of two squares of cornmeal, white at the east, light brown or pinkish at the west; four triangular clouds project from the south or front side, and two from each square, alternately white and brown. A zig-zag lightning-snake with lozenge-shaped head projects from the apex of each triangle. Each snake represents a lightning of one of the cardinal points—north and south, male; west and east, female (Fewkes 1899:Pl. XIX; 1920:Pl. 6). A straight meal road leads away from the junction of the meal squares. The Hopi-Tewas told Fewkes that their relatives in the eastern Tewa pueblos used similar altars.

Powamu *Kachina Ceremony*

Kachina dances are performed frequently, but there are only two kachina ceremonies, *powamu* and *nimán*. Both are in the charge of the *powamu* kachina society chief, and their altar rites take place in chief kiva. The first occurs in February and is much concerned with agriculture—with such matters as making rain, melting snow and banishing cold, cleansing the fields and putting them in good condition, ensuring against sand-storms and insect pests, and obtaining prognostications as to the success of the coming year's crops. The last is accomplished by secretly planting beans in chief kiva some time before the ceremony is to begin. If the beans grow high the crops will be good. The Hopis have such regard for this process that in speaking to whites they often call the ceremony the bean festival, bean dance, or bean planting. It has been suggested that this bean planting may be compulsive magic (Parsons 1939:449). The *powamu* ceremony is also an occasion for curing rheumatism (by whipping), for the exorcistic whipping of young children and providing them with godparents, and in some years for initiating

children into the *powamu* society. Eight days before the beginning of the main ceremony, a one-day introductory ceremony called *po-walalu* is performed in which a sun sand-painting is made. Originally this ceremony may have been independent of the *powamu* ceremony. Voth (1901) gives a detailed and well-illustrated account of both ceremonies, which he observed at various times between 1894 and 1901. Four drypaintings are described, more than for any other Hopi ceremonial.

For the introductory *powalalu* ceremony, a sandpainting of the sun is made that is much like Navajo sandpaintings of the sun or moon (compare Figure 95 and Plate 24) (see also Wyman 1962:Figs. 38, 53). Sand is brought in a blanket from a sand hill in the valley after depositing there two prayer feathers on strings with some prayer meal. On a layer of this sand and meal the blue green face of the sun is made, about one and a half feet in diameter, with white and red rays emanating from it. These rays represent eagle feathers and bunches of red horsehair that symbolize the "sun's beard" or rays. Around the sun, four concentric circles of directional colors outlined with black are made; from the center outwards, they are yellow for the north, green for the west, red for the south, and white for the east. Black stands for the zenith and all colors for the nadir, in this case probably represented by the background sand. The circles are called the house of the sun. At the cardinal points, four arrow-shaped projections from the outer circle are also made in directional colors with black outlines. Each has four lines of another color running through it (Plate 24) (Voth 1901:Pls. XLII, XLIII; Fewkes 1927:479–80). These projections are called house blossoms (houses are said to have imaginary blossoms and roots). A small quartz crystal with an eagle feather attached to it is placed in

the center of the sun and called its heart. Men sit around this drypainting smoking, praying, and singing, while the *powamu* priest throws meal upon it at intervals of four to six minutes. He repeats this act twelve times and then asperges it from a medicine bowl. By this time the painting is covered with the meal.

A sandpainting that is made only when children are to be initiated into the *powamu* society shows a square arrangement of four bars of directional colors (yellow, green, red, and white, representing north, west, south, and east) with their ends crossing each other (Plate 25). This is called a house and the bars are called planks. This design resembles somewhat the guardian composed of four straight rainbow-bars with feathered ends used for some Navajo Big Star Chant sandpaintings (compare Plates 14 and 25) (see also Wheelwright 1956:Pls. XII, XIII, XIV). At each end of the bar there is a terrace-cloud symbol with three black turkey prayer-feather offerings attached to it. The four small circles beside the bars, each with a square composed of quadrants of directional colors in it, and the larger one in the center of the design represent squash blossoms. The dots of various colors scattered over the sand background represent the blossoms of plants and grasses used by the Hopis for food and ceremonial medicine. Each of the four semicircular cloud symbols along one side of the design has a turkey feather offering attached to it (Voth 1901:Pls. XXXVIII, XLVII). The initiation takes place in the evening of the fifth day of the *powamu* ceremony. Children from five to ten years old may be initiated. A very secret kachina who never appears outside the kiva, *chow-ilawu* kachina, enters and dances on and around the sandpainting (Voth 1901:Pl. LI). The kachina chief, who has been standing west of the painting, goes out to deposit prayer offerings, and then returns as the singing stops. He sweeps up the sandpainting and deposits it a few yards to the south. Children are not whipped in this initiation, nor are they whipped in the regular whipping rite of *powamu*.

In a rite of general exorcism, children eight to ten years old are whipped with yucca-leaf switches by two *tüngwüp* or *ho* kachinas, first in public in the courtyard of the pueblo and after this in the *marau* kiva, the only one belonging exclusively to women. After this the children may see the impersonators of the kachina without their masks, may watch preparations for kachina dances in the kivas, and may even impersonate kachinas themselves. About ten o'clock in the forenoon several men make a sandpainting on the floor of *marau* kiva. An inch-thick layer of common sand is sifted onto the floor, and over this is added a layer of light brown ocher about three and a half feet square. On this is made the design *hahaiyi*, the mother of the kachinas, in the center with a whipper kachina on each side of her (Plate 26) (Voth 1901:Pl. LII). The mother's mask is blue green, the masks of her adjacent sons are black, and all three wear black and white costumes and carry bundles of yucca switches. Scattered colored dots symbolize blossoms of plants used by the Hopis. In the ceremony, the boys (nude) and girls (wearing dresses) stand on the sandpainting, each accompanied by a godfather, also nude, who holds up their hands while the two whippers standing east and west of the painting flog them severely (Voth 1901:Pl. LXIII; Parsons 1939:Pl. VII). Meanwhile the kachina mother stands at the southeast corner of the painting holding the supply of whips. After all the children have been whipped, the mother steps on the sandpainting and

is whipped by her sons, who then whip each other. Finally some old men sweep up the remains of the painting.

A smaller sandpainting representing the *sipapu*, the hole somewhere in the Grand Canyon from which humans emerged into this world, is always made at the southeast corner of the larger painting. The design is a small, pale yellow square surrounded by four concentric squares, yellow, blue or green, red, and white, which symbolize the four world quarters or the underworlds. Cloud terraces in directional colors, with turkey feathers attached, project from the four sides (the "blossoms" of the *sipapu*). A yellow line with four blue footprints and the four crooks of longevity on it runs from the center diagonally to the southeast, the way that the Hopis are supposed to travel (Voth 1901:Pls. LIII, LIV, LXIII; Parsons 1939:Pl. VII). An ear of corn and a stone chisel are laid outside each cloud terrace.

Nimán (*Home-going*) *Kachina Ceremony*

The departure of the kachinas to the San Francisco Mountain doorway to their underworld home, where they will remain for almost half the year, is observed in July by a ten-day ceremony that includes dramatization, group dancing, and kiva ritual conducted by the *powamu* kachina society. This is the second of the two kachina ceremonies of the Hopi. Parsons (1939:766–75) gives a day-to-day description taken from Stephen's account of the nimán ceremony he saw at Walpi in 1893 (Stephen 1936:493 ff.). On the fourth day the *powamu* society chief makes a meal altar of the six directions and sets his corn-ear fetish (*tiponi*) on the intersection of the roads (Fewkes 1927:Pl. 1). Directions-altar ritual is performed at sunrise each morning until the ninth day. On the

tenth day the entrance to chief kiva is covered with sand, and four rain-cloud symbols are made in meal on each side. Otherwise the only drypainting involved in the ceremony is a meal painting of seven semicircular cloud symbols (four clouds surmounted by three others) with the usual falling-rain lines (Fewkes 1897a:Fig. 1; 1927: Fig. 1).

Snake-Antelope Ceremony

The ten-day snake-antelope ceremony is performed primarily for bringing rain but also for treating snakebite and other ills. This ceremony has been publicized more widely in the literature, from newspaper articles to substantial monographs and even whole books, than any other Indian ceremonial (references to ten of the major works on it are given in note 4). This attention is due to the spectacular public performance on the ninth day, when, during the famous snake dance, members of the snake society carry live rattlesnakes and other species in their mouths. Parsons (1939:510–13, 654–75) gives two descriptions, the latter taken from Stephen's narrative of the ceremony he attended at Shipaulovi in 1892 (Stephen 1936:719 ff.). The earliest important account is Captain Bourke's book of 1884. The snake and antelope societies were once war groups, the snake warriors going out to battle while the antelope old men stayed home to make war medicine. Today the latter pray in kiva that the snakes may be tractable. As Parsons (1939:1148) remarked, the objective of the ceremony changed through time from controlling the enemy to controlling rainfall. The snake, antelope, and flute societies are like the Keresan weather and curing societies. Indeed, Zia has a snake ceremony that embodies almost all the Hopi features, such as a mountain lion sandpainting (see Fig. 108),

and the Hopis have a tradition that the ceremony was known at Acoma before it came to them (Parsons 1939:686, 975–76, 1044). Snake-antelope and flute ceremonies are given in August, in alternate years, thus relieving an overloaded ceremonial calendar, but the order varies in different villages so that each year both ceremonies are performed somewhere.

Meal altars of the directions are made in various places and at various times, in kivas or on the roofs of kivas, both for daily rites and when the snake and antelope chiefs pray for clouds to travel over the roads from all directions to converge over their kivas. Each representing one of the cardinal directions, four large designs of three clouds and falling rain may be made of meal in a line on a trail below the mesa, with prayer feathers stretched out from the middle cloud of each design. The long-distance racers who run at dawn—for good crops, for their quicker growth, and for long life—pass over these as they return to the pueblo (Parsons 1939:816).

Two large sandpaintings are made during the snake-antelope ceremony, one for the antelope society in chief kiva and the other for the snake society in their kiva. The antelope sandpainting may be made on the first, fourth, or fifth day. Detailed accounts of the process were given by Stephen (1936: 669–73), Fewkes (1894a:17–21), and Dorsey and Voth (1902:197–203). The old chief does not make the painting but, like the Navajo singer, directs his assistants. First the stone floor is swept, cracks are stuffed with corn husks (or filled later with background sand), and the *sipapu* is plugged. Then ordinary valley sand, from an ample supply brought in blankets or a canvas bag, is sifted through an open-meshed yucca basket tray over an area about five feet square around the *si-*

papu. The colored dry pigments stored in cotton sacks are made ready in bowls or trays. Next a smaller square or rectangle about three or four feet on a side is sifted lightly with white sand. Sometimes guides for the outlines of this square and the smaller concentric squares inside it are made by snapping a long cotton string held by two men on the background sand, but often the squares are strewn by eye only. Then the border square, the cloud symbols, and finally the lightning-snakes are made. With up to six men working at one time or another, it may take from two to four hours to complete the whole thing. Pinches of cornmeal and pollen are sprinkled on the painting until it is partially covered. A song service is held around the antelope altar by the antelope and snake societies in the morning and late afternoon or evening for four days while the antelope youth and the snake maid walk up and down behind it in step with the singing (Plate 27). When the altar is dismantled, pinches of sand are taken from the snakes, clouds, and border and put on the prayer sticks in a tray, to be deposited in a shrine below the mesa (Parsons 1939:816).

The design of the antelope sandpainting consists of a border of four concentric bands of directional colors around the white background square. In order beginning with the inner band, the bands are yellow, green, red, and white; they are outlined with black and represent the world quarters. This design is called rainbow house. Within this design, along the north side, are four banks of semicircular cloud symbols—four, or three and two halves, in each row. From north to south the rows are of the directional colors— yellow, green, red, and white for north, west, south, and east. Extending to the south from between the clouds of the southernmost row

are four zigzag lightning symbols or snakes, each with four angles, also of directional colors in sequence from east to west, or sometimes in the reverse sequence. The snakes have triangular heads. In various renderings of the design, they have curved horns on the left or on both sides, or two have horns (males) and two have square appendages (females), or all four have the square projections. Clouds and snakes are outlined with black, and twenty to forty black lines—symbolizing falling rain—extend from the outside of the border to the north (Plates 22, 27) (see note 4 for references to other published illustrations). There may be minor variations in this design in different villages (Fewkes 1897b). The remarkable similarity of the antelope sandpainting to Navajo Shooting Chant sandpaintings of crooked snakes and Snake People has been pointed out (Parsons 1939:1043). It is also like the snake designs the Navajos use in their Beauty and Navajo Wind chants (Newcomb and Reichard 1937:Pl. IV; Wyman 1957:Pls. I, II; 1962:Figs. 23, 25).

The snake society sandpainting, usually made on the seventh day, has a blue green square in the center with a border of four colored bands made as described earlier. It is about two feet square. On this background is a yellow mountain lion with black eyes and a red heart-line, with short black, white, red, and yellow lines projecting from his snout (his breath; Bourke [1884:Pl. XVIII] thought he was bleeding at the nose.) Until about 1850 there were two lions in the Walpi snake society painting, one spotted (a jaguar?) and the other yellow. The elimination of one of these lions is one of the rare known examples of innovation in Hopi ceremonial procedure (Stephen 1936:Figs. 351, 375; Parsons 1939:1119). Predatory animals are associated with war, and thereby with the snake society, who were formerly a group of warriors (Parsons 1939:186). Outside the central square of this painting is a broad black band on which are depicted four snakes of the directional colors, one at each side heading clockwise. Their eyes are black, and their rattles are blue or green. The yellow snake is outlined with black or red, the green one with white, the red one with yellow, the white one with green or blue. Finally a broad white border is added outside the black zone (Bourke 1884:Pl. XVIII; Donaldson 1893:69; Fewkes 1894a:54; Voth 1903a:Pl. CLXI; Stephen 1936 [notes from 1891–94]:Pl. XVIII, Fig. 350). Snake and antelope priests dance around the sandpainting (Voth 1903a:298–99).

Flute Ceremony

The drab or gray flute (extinct) and blue flute societies are associated with lightning and arrowpoints shot by lightning, so the flute ceremony, like the snake-antelope ceremony with which it alternates, not only promotes rainfall but also is used to treat lightning shock and arrow or gunshot wounds. Parsons (1939:708) said that in theory it dramatizes the passing of the town chieftaincy from the bear to the horn clan, the Emergence, and the fertilization of maize by lightning. It is a ten-day ceremony performed in August. Headquarters are in the maternal house of the chief of the society. Parsons (1939:703–8) quotes from Stephen's account of the performance he saw at Walpi in 1892 (Stephen 1936:768–817; see also Fewkes 1894b, 1895a, 1896b, 1900, 1920).

At sunrise of the first day, a meal altar of the six directions is made on the sand-covered floor of the flute house chamber, and clan chiefs gather around it to smoke, pray, sing, and asperge the altar with water from

the medicine bowl at its center. This is done only once, but the night performance around the main altar (which also involves playing the flute, whirling a bull-roarer, and sprinkling meal on the altar) is carried out on six nights.

The drypainting for the main altar of the drab (gray) flute ceremony at Walpi was a square terrace-cloud symbol outlined with a narrow black band on a sand background. It was made in front of the ridge of sand in which the other appurtenances of the altar were set. Near its base a semicircular mound of sand served as a support for the *tiponi* of the flute society chief, and black falling-rain lines ran from it over the sand ridge. The east half of the cloud symbol was covered with whole kernels of yellow corn and the other half with kernels of blue corn (Fewkes 1895a:Pl. I, Pl. 8). This drypainting design made of corn kernels is unique. At Walpi, and presumably at other villages, a long zone of valley sand some two feet wide is sifted from the middle of the *tiponi* ridge, and at right angles to it, halfway across the floor of the chamber. One side of this zone is covered with yellow pollen and the other side with blue or blue green "pollen." Along the division between the colored portions, four wooden bird figurines are placed, and between them are four footsteps represented by short lines of dark blue sand. A horned headdress guards the end of the parti-colored zone (Fewkes 1894b; 1896b:Pls. I, II; 1900:Pl. LXIV; Stephen 1936:Fig. 426, reproduced in Parsons 1939:Fig. 3). The altar is dismantled on the morning of the tenth day.

The usual symbols in meal—three semi-circular clouds with rain falling from them—are made at various times in various places (see Brody 1971:Frontispiece). At sunrise of the fifth day a series of these symbols is made on a sand-and-pollen trail leading from the altar to the roof. Four large ones are made on a long meal trail by the flute chief at the last of the springs that he and his party visited during the overnight visit from the seventh to the eighth day, and on these the flute children, a boy and two girls, throw offerings (Fewkes 1900:Pl. LXIII).

Marau, Lakon, *and* Oaqöl *Ceremonies*

The three women's societies of the Hopi, *marau* (*mamsrau*), *lakon*, and *oaqöl*, are quite alike in the supernaturals they invoke, their altar rituals, public performances, and functions—so much so that Parsons (1939:500, 869 n.) thought that there is much to support the tradition that they are variants of the same society developed in different towns. Formerly, the *marau* and *lakon* ceremonies were performed in September, alternating in successive years with the *oaqöl* ceremony, which was given in later October or early November. Now, however, the first two have lapsed altogether in most of the villages, and the *oaqöl* is given so irregularly that it seems to be disintegrating. The ceremonies, like those of most Hopi societies, function primarily to control weather (rain-making) and cure disease, but they also promote the growth and harvest of crops, ensure fertility of women, provide an occasion for the initiation of novices and, at least formerly, served as war rituals. Parsons (1939:680) suggested that perhaps all Pueblo women's societies are fundamentally war societies.

Lasting ten days, like most Hopi ceremonies, the *marau* ceremony is supervised by the chief priestess of the society, who makes the drypaintings. Sometimes she is assisted by men in setting up the main altar. Stephen (1936:884–929) described the ceremony he saw at Walpi in 1891, which was

quoted by Parsons (1939:675–80). On the second day a meal altar of the directions is made and the usual ritual is carried out. On the fourth day the main altar is set up. In front of the reredos, a layer of valley sand about thirty inches square is sifted onto the floor, and onto it, a layer of white. Upon this background is made a design of three semicircular rain clouds, with two lightning-snakes extending southward from them. The two clouds at the base are blue green, each with a smaller cloud on it, yellow at the east and black at the west. The cloud at the apex is red or pink. A red or pink zigzag lightning-snake shoots out from between the clouds at the east, and a white or yellow one from the west. All figures are outlined with black, and the usual rain lines fall from the base of the clouds (Fewkes and Stephen 1892:Pls. I, III; Voth 1912:Pl. V; Stephen 1936:Pl. XXIII). The sandpainting is renewed on the eighth day, and the sand is swept into a pile and carried out on the ninth day.

The sandpainting for the main altar of the *lakon* ceremony, completed on the fourth day, is the most elaborate one used by the women's societies. On a background of sifted brown sand about four feet square, which is covered with sifted white sand, a rectangular yellow area is made at the right (facing the painting) and a green one at the left. These are bordered with green, red, yellow, and white lines outlined with black. On the green field is made an anthropomorphic black male figure of *muy'ingwa*, the maize spirit of the Hopis, chief of the nadir and father of the underworld, who taught the Hopis all they know about seeds and vegetation. He holds lightning and a netted gourd bottle. On the yellow field is made the female figure of the *lakon* maiden wearing a white blanket and holding a basket with a yellow

cross on it. A row of semicircular clouds is made along the bottom edge of the painting (Fewkes and Owens 1892:Pl. I, Fig. 3; Fewkes 1896a:Pl. LXXII; Stephen 1936:Fig. 454).

Although the main altar of the *oaqöl* ceremony is one of the more elaborate known (Voth 1903b:Pl. I), the drypainting made in front of it is a simple design of three semicircular cloud symbols in a line, white with black outlines and falling-rain lines over the sand ridge behind it. At the apex of each cloud is a black, turkey-feather symbol (Voth 1903b:Pl. VI).

Zuni

The large pueblo of Zuni and its three outlying farming villages (Nutria, Pescado, Ojo Caliente) are west of Albuquerque, New Mexico, not far from the Arizona border. The inhabitants speak a language unique to themselves. Zuni ceremonialism has been discussed in numerous works, beginning with those of Frank Hamilton Cushing in the last two decades of the nineteenth century, but especially in the magnificent and massive monograph (634 pages) by Matilda Coxe Stevenson (1904) and her previous paper on the religious life of the Zuni child (1887),[7] and in two substantial works by Ruth Bunzel (1932a, 1932b). Elsie Clews Parsons also wrote profusely on Zuni, listing no fewer than twenty-one titles in her *Pueblo Indian Religion* (1939:passim, 1202–5), and Alfred Kroeber and Ruth Benedict touched on the subject. Parsons (1939:514–31) presented a ceremonial calender compiled by an educated Indian woman married to a Zuni man, and Fred Eggan (1950:202–10) gave a brief digest of Zuni ceremonial organization.

According to Bunzel (1932a:511), Zuni ceremonialism revolves around six esoteric cults: of the sun; the *uwanami* (rainmakers)

with their twelve priesthoods; the kachinas;[8] the priests of the kachinas (closely related but distinct); the war gods; and the six beast gods (mountain lion of the north, bear of the west, badger of the south, wolf of the east, eagle or the mythological knife-wing of the zenith, shrew or gopher of the nadir). The kachina cult, to which all adult males belong, is dominant (Bunzel 1932b:843). The cult of the beast gods is in charge of twelve medicine or curing societies or fraternities. All these groupings overlap and interweave intricately.

Each cult has ceremonies throughout the yearly cycle from one winter solstice to the next. The period of twenty days following the winter solstice in December is called *it-iwana*, "the middle" (of the ceremonial year); this is also the name for Zuni, "the middle place" or "middle of the world." Into its two ten-day periods are fitted the solstice ceremonies, and a few weeks after it important ceremonies occur throughout another period of five or six weeks. The usual ceremonial pattern involves a retreat (a period of seclusion of the priests for prayer and meditation) with an altar ritual involving manipulation of sacred objects, offerings (planting prayer sticks), and purification, followed by a public group dance (Bunzel 1932a:507–9). Altars are usually set up in one of the six kivas (one for each direction), which at Zuni are rectangular rooms in the dwelling-house blocks, not special subterranean chambers as in Hopi pueblos. The ceremonial calendar is determined by the *pekwin*, the sun watcher or speaker, a special priest of the sun, who is the most revered and most holy man in Zuni. The winter ceremonies are concerned with medicine, war, fertility, the promotion of snowfall, and the control of high winds. Summer ceremonies are for rain and good crops.

Like the Hopis, the Zunis use both meal and sandpaintings. The *pekwin* and the rain chieftaincies have only meal paintings. Bunzel (1932a:499, 529) said that every altar is set upon a painting of white meal representing clouds, and from its center a line or road runs to the door of the room or foot of the ladder.[9] In drypaintings and on all ceremonial objects, colors have directional significance: yellow for the north, blue (or blue green) for the west, red for the south, white for the east, all colors (variegated) for the zenith or above, and black for the nadir or below. Ceremonial procedures around altar drypaintings may include placing fetishes, figurines, prayer sticks, and other objects on them; sitting, marching, capering, or dancing around them; whirling the bull-roarer, playing the flute, or shaking a rattle near them; praying and singing over them; breathing in from them; blowing tobacco smoke on them; and asperging meal, pollen, and sacred or medicine water on them.

Initiation into the Kachina Society (Koko)

Boys are initiated into the kachina (*koko*) society in two ceremonies in which they are whipped with yucca-leaf switches by impersonators of various kachinas (as they are among the Hopis), first when they are between the ages of five and nine years and finally when they are between ten and fourteen (M. Stevenson 1887; 1904:94–107; Bunzel 1932b:975–1002; Parsons 1939:467). At the second ceremony the secrets of the kachina cult are at last revealed to them. The first ceremony is also the occasion of the arrival of the *kolowisi*—the mythological great plumed water serpent, represented by an effigy about five feet long, which, with its head thrust through a hole in a wooden tablet, is made to "vomit" water and seed corn

214

for the children (M. Stevenson 1904:Pls. XIII, XIV, XXXVI). In the preliminary initiation, members of the big firebrand society bring materials for a sandpainting to be made in the kiva. A disk about twelve feet in diameter is made of ordinary sand, usually from the bed of the river, a bowl of water from a sacred spring is placed in the center (the spring), and white sand is sprinkled all over the disk. Two circles of anthropomorphic figures, the *salimopiya* or whipper kachinas, in the six colors of the directions, are made on the disk, as many as there are children to be initiated (at Zuni there are twelve impersonators of these beings, two of each color). An elongated *kolowisi* surrounds the whole design (Plate 28) (M. Stevenson 1887:Pl. XXII). Plumes that have been laid on the heads of the figures in the sandpainting are tied to the children's hair (compare with Navajo token tying), they are told to step on the painting, and sand from it is applied to their bodies. Initiations into the kachina society used to be performed quadrennially beginning at the third full moon after the winter solstice (in March), but the practice is now lapsing.

Ceremonies of the Rain Priesthood

Simple meal paintings of one- to three-step terrace-cloud symbols are said to be made in the kivas during a number of Zuni ceremonies: one on the fourth or ninth and one on the fourteenth day of the winter solstice ceremony (M. Stevenson 1904:115, 129; Parsons 1939:572, 573); in the kiva and in the plaza in the *thla'hewe*, a rain ceremony commemorating the departure of the corn maidens and celebrating their return (M. Stevenson 1904:Figs. 6, 7); at an initiation of the wood society (M. Stevenson 1904:453); and during a summer retreat of a rain priest

(M. Stevenson 1904:179). Of these the most elaborate is the one made during a winter retreat of a rain priest.

Fourteen *a'shiwanni* (rain priests), the elder and younger bow priests, and a priestess of fertility make up the rain priesthood. The *a'shiwanni* fast and pray for rain. The meal painting shown (Plate 29) was made at the winter retreat of the *shi'wanni* (rain priest) of the nadir in 1896 (M. Stevenson 1904:173–78); Parsons (1939:692–95), however, thought he was the priest of the north. At the east end of a room of the house in which the supreme fetish of the priesthood is kept, a three-step cloud terrace is made with white cornmeal. Along a line of meal extending to the south from the apex of the cloud symbol, a line of six disks of white meal is made, diminishing slightly in size from north to south. The disks are outlined with yellow corn pollen and black powder from charred corncobs and terminate in two forking lines with a stone arrowpoint laid at the end of each one. Stone implements are also distributed over the cloud terrace, and a line of eight wrapped corn-ear fetishes is aligned along its base. Many stone fetishes of curious natural shapes are set along the line of meal disks, and numerous other objects are placed here and there around the altar (M. Stevenson 1904:Pls. XXXIV, XXXV). At the conclusion of the altar ritual, an assistant sweeps the meal and pollen into a heap, takes it to the river, and throws it into the water so that it may go to the kachina village under the lake west of Zuni.

According to Stevenson's observations of December 1896, at the installation of an associate rain priest of the north a white buckskin is laid with its head to the east on a blanket on the floor. A line of corn pollen is sprinkled from the tail to the head of the skin. Quantities of bead necklaces are laid

over this pollen line. When a *pekwin* is to be installed, a sun symbol is made on this line in the center of the hide. It is a blue green disk with black dots for eyes and mouth, encircled by blocks of black and white, and with a line of pollen extending from each of the four sides (M. Stevenson 1904:169). The novice stands on the deerskin as the ritual is carried out, and finally the pollen and pigments are gathered into a cornhusk, which is kept by the priest of the north.

Shi'wanakwe *Society*

The fourteen medicine or curing societies at Zuni (Stevenson called them fraternities) are associated with the cult of the beast gods and get their power to cure from these animals. Ten of them may be subdivided into orders, a medicine order (the dominant one), fire, jugglery, stick-swallowing, and some other orders (Tedlock 1979:502). Each society practices general medicine but also specializes in certain diseases. Their functions overlap those of other ceremonial groups, for all conduct rain ceremonies, plant prayer sticks, have initiations, and may present kachina performances and be concerned with war. The societies meet or hold ceremonies throughout the year except in April, May, and July.

In an initiation into the *shi'wanakwe* society, a drypainting concerned with celestial bodies is made. A formalized representation of the galaxy, a curious figure with a short curved body and a large snakelike head with black dots for eyes and mouth, is made of white meal and outlined in black. A meal road runs from it to the altar. The blue green sun disk, about five inches in diameter, is made at the left of it and the yellow moon at the right. Both are encircled first by black and white blocks, then by rather broad yel-

low and red outlines. Short rays of red, blue, and yellow extend from the four sides of each (M. Stevenson 1904:428, Pl. CII). Sun and moon are made of corn pollen, burned corncob, and crushed turquoise and other minerals. Meal from the symbol of the galaxy is rubbed on the initiate. Later the meal is gathered in cornhusks and deposited with prayer plumes in the society's shrine.

Thle'wekwe (*Wood*) *Society*

The *thle'wekwe* or wood society, also called the stick or sword swallowers, holds two annual ceremonies, in January and February, that serve to bring snow or cold rains, to initiate members, and to treat sore throat. In these they are joined by the stick-swallowing order of the firebrand society. At the west side of the ceremonial chamber, directly in front of the ledge under the wall paintings (see Plate 23) on which corn-ear and other fetishes are placed, a square bed of white cornmeal with the eastern edge scalloped to form six semicircular clouds is made on the third day. In front of this on the stone floor, a sandpainting is made of *achiyelatopa*, the knife-wing, about thirty inches long, with its head toward the east. This creature, horned and with wings and tail of flint knives, is the beast god of the zenith. It corresponds to the Thunders of Navajo mythology, and its Zuni depiction is somewhat like that of a Thunder in Navajo sandpaintings (see Plates 14, 17). A quartz crystal "heart" is put on its chest (purity of heart) with a line of corn pollen leading from it to its mouth (truth). A broad line of white meal bordered with black, on which stone arrowpoints are placed, leads to the east (Plate 23) (M. Stevenson 1904:Pl. CVIII, 444–85; Parsons 1939:Pl. IV, 695–703). On the fifth morning, members of the wood so-

ciety stand around the sandpainting, and after placing their hands near the figure (but not touching it) they bring their hands to their lips and breathe in. Then a female society member brushes the sand from the cardinal points toward the center with a native broom, gathers it with her left hand, and puts it in a blanket carried by a male to be deposited, along with prayer sticks, in the society's spring at the black rocks, so that it can go to the home of the knife-wing in the zenith.

Big Firebrand Society

Initiation into the mystery medicine order of the big firebrand society is done in November. For this occasion a sandpainting is made as follows. Four lines of white pigment are strewn to form a square, and segments of circles are drawn inside these lines using black clay pigment that symbolizes dark rain clouds. The rest of the square is covered with white pigment, and cones of white are made on the square. Material from these is placed on the heart of the initiate by a society member who sucks at the spot to draw out evil. A female society member treats girl novices in the same way (M. Stevenson 1904:490–503).

On the fourth afternoon of the ceremony of the sword division of the fire order of the big firebrand society, if an initiation is being held, a drypainting about two and a half feet square is made on a background of ordinary yellow sand half an inch deep on the floor near the altar. A line of yellow pollen runs through the center. Two human figures on it represent the original director of the society and his younger brother. A diagonal line across the body indicates a war pouch, a circular spot of corn pollen on the body is the heart, eagle wing feathers are held in

the hands, and zigzag lines extending out from each side of the figures symbolize lightning. Here and there on the painting, crosses with a single grain of corn on each represent stars. Pollen from the diagonal line and "heart" of each figure is collected in cornhusks for use as fertility medicine, and the kernels of corn are eagerly seized to be planted apart from other corn the coming year. Finally the director of the society brushes the meal around the altar to the drypainting with his eagle plumes, puts the sand in a bowl, and carries it to the river. If there is no initiation, the sandpainting is not made. A prominent feature in both the private and the public performances of the ceremony is sword swallowing by both male and female members of the society (M. Stevenson 1904:Pl. CXVIII, 504–11).

Cimex and Little Firebrand Societies

The cimex or bedbug society branched off from the little firebrand society after a factional dispute. It is so called because the chamber selected for the meetings of the new group was found to be infested with these insects. Although the rituals of the two societies are in other respects the same, their altars and drypaintings differ. In front of the altar of the cimex society, south of the meal road that leads eastward from the altar, a drypainting is made showing the bears of the cardinal points. They are depicted on a blue green square that is perhaps two feet across—a gray bear at the north, a black one followed by her cub at the west, a southern one also black, and a yellow bear at the east (instead of the usual sequence of colors). The background color represents the vegetation of the world. The square is surrounded by a border of black and white blocks (the cloud houses of the four regions) and

by other colored lines, and the whole lies within a circle of black and white blocks (the cloud houses of the world) (M. Stevenson 1904:Pl. CXXVI, 550).

The curing ritual and the initiation into the medicine order of the little firebrand society is an elaborate four-day ceremony. In the afternoon of the fourth day, several men make a drypainting about five feet in front of the slat altar, south of the meal road to the east. This painting is a disk about three feet in diameter surrounded by a wall of ordinary sand heaped four or five inches high to form a basin. This symbolizes the galaxy and is covered with successive blocks of powdered white sandstone, red sandstone, and charcoal, repeated numerous times, each block being a few inches long. An eagle is made within the wall. It has a black head, and wings and tail formed of banded medicine stones. Mounds of colored corn kernels dot the disk here and there (M. Stevenson 1904:Pl. CXXVII, 550–64). At dawn the next morning the novices step into the circle of the sandpainting, their feet and limbs are bathed with the sands, and a long prayer is said as they stand there. Then the painting is destroyed.

Shuma'kwe *Society*

The *shuma'kwe* society, named from a spiral shell, has the power to treat convulsions, rheumatism, and muscle cramps. Its drypainting is a simple cloud design of white meal made in front of the altar. The painting shows a square with two semicircular projections at the east, with a meal road leading eastward from between them (M. Stevenson 1904:530–49).

Cactus Society

The *koski'kwe* or cactus society, limited to males, is a fraternity of warriors who can cure dog bite or wounds made by arrows, bullets, or any pointed object such as cactus spines. In their initiation ceremony in October, a sandpainting is made on the floor in front of the altar. A disk of ordinary sand an inch thick is covered with powdered white kaolin, and on it in a circle are depicted the *kupishtaya*, lightning makers of the six directions, the mighty warriors who control the lightning arrows. A diagonal line symbolizing the galaxy crosses the disk, and upon it are different-colored kernels of corn that represent stars. Cloud symbols extend from the periphery of the design toward the altar. The initiate steps upon the painting and turns around four times, then steps off and gathers the corn kernels. The director collects the sands with eagle feathers into a piece of cloth and carries them to the place beyond the village where the novice was first struck with cactus (M. Stevenson 1904:569–76). Prominent features of the ceremony are dancing, whipping the initiate with long willow switches and branches of cactus, and slashing about with them in the plaza. The warriors fight each other with cactus. A man who is struck by a flying bit of cactus and is caught must join the society.

Bow Priesthood

The cult of the war gods, twin children of the Sun who led the Zunis to victory, is in charge of the elder and younger brother bow priests, the earthly representatives of the twins. Their functions are to lead in war, to protect the people and the ceremonial organization from malevolent magic of enemies and strangers, to combat witches, and to police the town. Membership in the bow priesthood is limited to those who have killed an enemy, so naturally the priesthood and its ceremonies have lapsed since peaceable-

ness has been enforced. Scalps, however, may still be kept as potent fetishes for rain-making (Bunzel 1932a:525–28).

At the installation of the elder brother bow priest (the office is held for life), a meal painting is made on the floor of a dwelling. In the center a disk of meal about eight inches in diameter symbolizes the world's waters. It is surrounded by a rectangular frame that represents the boundary of Zuni territory. A square on one side of this frame represents a mesa with rain falling on it, as indicated by three lines that extend from the center to it. A straight road of truth and two zigzag lightning arrows extend from the other side (M. Stevenson 1904:Fig. 33).

The great annual ceremony of the bow priesthood, the scalp ceremony, and the initiations—if they are to occur—take place at the winter solstice. There is a public dance after harvest in the fall. At sunrise on the twelfth day the *pekwin* makes a large three-step terrace-cloud design in cornmeal at the north side of the big plaza, similar to the one made in the west end of the ceremonial chamber of the bow priests, and the fetishes and other properties of the priesthood are placed on or around it (M. Stevenson 1904:Pl. CXXXIV, 576–607; Parsons 1924; 1939:622–38). Two warriors with long spears stand south of this altar to guard it. The usual meal-sprinkling, praying, dancing, and other performances take place around the altar, which is dismantled after the last dance.

Keres

The Keresan-speaking Pueblos are known (together with the Tanoan towns) as the eastern Pueblos, as opposed to the western Hopis and Zunis. The Keresans are themselves divided in two groups: an eastern

group situated along the Rio Grande and its tributary the Rio Jemez, in north-central New Mexico between Santa Fe and Bernalillo; and the western villages of Laguna and Acoma with their farming colonies, which lie forty to fifty miles west of the Rio Grande Valley, approximately due west of Albuquerque. The eastern Keres live in five towns, Zia, Santa Ana, San Felipe, Santo Domingo, and Cochiti. The only one of these for which we have firsthand observations, photographs, and drawings of drypaintings is Zia, which was studied by the Stevensons before the Indians had become as secretive as they are today. For all the other Keresan pueblos we have to be content with the statements of informants made in guarded conferences with ethnologists at a good distance from the informants' hometowns.

Zia

The pueblo of Zia (native name, *tsi ya*) lies on the north bank of the Jemez River a few miles below its confluence with the Rio Salado (Salt River) and about twenty miles west of the Rio Grande. Substantial monographs about this town have been published by Matilda Stevenson (1894) and by Leslie White (1962). In fact, Zia was the only Keresan pueblo studied systematically in the nineteenth century. James and Matilda Stevenson spent several weeks or perhaps months at the pueblo in 1879 and again in 1887, and after her husband's death, Mrs. Stevenson spent another six months there in 1890. White's studies were carried out at various times from 1928 to 1957. There are thirteen ceremonial societies in Zia: flint, *shima* (ant or eagle), giant, fire, *kapina*, snake, *shikame*, *katsina* (kachina), *gomaiyawic*, *shay-eik* (hunters), *koshairi* (koshare), *kwiraina*, and *opi* (warriors). All but the *kwiraina*, kachina,

and warriors serve to control weather and to cure. The flint, giant, and fire societies are the leading curing groups (White calls them "the big three"). White (1962:Table 28) gives a useful table showing their characteristics. Each society has or shares a house where ceremonies are performed (there are two circular above-ground kivas as well). Each has a wooden slat altar, makes its meal or sandpaintings and lays out its paraphernalia for its own ceremonies or initiations. These include the solstice (sun) ceremonies, a summer rain retreat, and the supervision of masked kachina dances. A society may also be called upon to assist another society in its performances, to participate in the annual communal curing ceremony at the end of the winter or at the time of the feast for the dead on November first, to perform for the warriors' society, or to carry out mortuary rituals.

Flint Society. The flint society, the leading one in Zia, can control both winter and summer weather and is closely associated with warfare and the warriors' society, so it can treat wounds from arrows, guns, knives, and war clubs. It is also associated with lightning and treats lightning shock. The patient is brought to its house for treatment. The treatment is carried out by blowing, brushing, or whipping the evil, disease-causing influence away with eagle feathers, or by sucking out foreign objects if necessary (the giant, fire, and snake societies also treat patients in their houses). A drypainting used for a rain ceremony has a semicircular black background outlined with white on which three semicircular clouds with falling-rain lines and an arrangement of two lightning arrows are made in white (M. Stevenson 1894:Pl. XXII). A similar design used by the flint or the associated ant society has

only two clouds and a band of black blocks bordered with white outside the base of the design (M. Stevenson 1894:Fig. 17, Pl. XXV; White 1962:Pl. 1). White (1962:Fig. 43) shows a painting containing the same elements used for curing by the flint society. In front of the fetishes on the altar is a band of alternating black and white sand blocks with four semicircular clouds of white sand in front of it on a background of finely ground spruce needles. Then there is another band of alternating black and white rectangles with two big clouds of white sand projecting from it, each with two crossed zigzag white lightnings with black points emanating from it. A meal road leads from between these to the door. The members of the society sit behind the slat altar and sing. Another drawing of a drypainting in front of a flint society slat altar with its corn-ear fetishes shows six semicircular clouds bordering a field divided into segments, with two lightning arrows and the meal road projecting from the front corners and the center (White 1962:Fig. 53).

Shima *Society.* The *shima* society, also called the ant or eagle society, is closely associated with the flint society, but each has its own slat altar, sandpaintings, and songs. The ant society treats diseases—sore throat or body sores—caused by ants entering the body by ascending the stream of urine when one is urinating on an anthill (see Wyman 1973:25–27). Mrs. Stevenson (1894:Fig. 18) published a crude sketch of a sandpainting made for her by the head of the ant society. In front of a semicircular cloud design in meal, a circular anthill is made with sand on each side of a meal road. On one side is the anthropomorphic figure of the ant chief wearing fringed buckskin clothing and carrying lightning in his left hand; on the other side

is the figure of an eagle. During a curing ceremony, prayers are said, asking the predatory animals to draw the ants to the surface of the patient's body, and when they appear they are brushed off onto the blanket on which the patient stands (they are actually tiny pebbles produced by sleight-of-hand). A song to the eagle asks him to come and eat the ants so that the patient may recover. Then the "ants" are carried out and deposited north of the village, the painting is erased, and the meal is rubbed on the patient's body. Members of the society also rub meal on their bodies.

Giant Society. The giant society, named for its monstrous mythological patron, conducts weather-control ceremonies for winter and summer and treats diseases—usually those attributed to witchcraft. A drypainting for a rain ceremony is a yellow rectangle, bordered on the long sides with alternating black and white blocks. One of these sides is edged with white semicircular clouds, and the short sides are probably bordered by black spearlike lightnings outlined in white. On the yellow background are three elongated semicircular clouds in black and white, each with two crossed black lightning arrows around it (M. Stevenson 1894:Pl. XVIII).[10] The painting is made in the eastern end of the ceremonial chamber, and the slat altar is erected behind it.

Fire Society. The fire society, the third of the "big three," is the only one to treat burns. It holds two initiation ceremonies, the first qualifying the initiate to participate in weather control and solar rituals, the second, held four or eight years later, qualifying him for curing. In the afternoon of the fourth day of the first initiation, a roughly circular sandpainting is made on the floor

in front of the slat altar, guarded on the east by a horned rattlesnake (water serpent) covered with body markings and curved around the design, and on the west by an anthropomorphic figure (a rainbow?) reminiscent of similar guardians of Navajo sandpaintings. Within these guards are four human figures (gods of the fire society), a butterfly and two dragonflies, two birds, a rabbit, a deer, a circle in the center, and stars scattered about. South of this design are the sun (west) and the moon (east) (White 1962:Fig. 13). Society members sit behind the altar while the initiate stands before it. The head of the fire society thrusts juniper twigs into his mouth and then rubs the candidate's body with the charred wood. Then all the members—and the initiate, if he is old enough—perform fire eating. On the morning of the fifth day the fire and *kapina* (spider) societies perform the sword-swallowing dance for the initiate in one of the kivas. In the evening, the same dance is held in the *kapina* ceremonial house, where there is also an altar with a sandpainting. In the second initiation the design of the sandpainting is somewhat different, depicting instead of game animals those from which the power to cure is obtained: mountain lion, bear, badger, shrew, eagle, wolf, snakes, and also human figures of nomadic enemies.

Snake Society. The members of the snake society, who have the ability to treat snakebite, handle and dance with living rattlesnakes and other species in their rain and initiation ceremonies, as do the Hopis in their snake dance. Snakes are put around the throat and over the head of the initiate and are asked to intercede with the cloud beings for rain. The drypainting made in front of the slat altar is in two parts. Next to the altar is a cloud and lightning design consisting of a

black rectangle with a band of small rectangles outlined in white along the side toward the reredos. On the opposite side are three white semicircular clouds with falling rain and four black lightning arrows shooting out from the corners of the rectangle and from between the clouds. In front of this design there is a yellow mountain lion enclosed in a square of yellow and blue lines. On each side of the square are the outlines of three semicircular clouds, yellow at one side (north), then blue, red, and white; and extending from each corner of the square is a zigzag lighting arrow, done in one of the four colors (Fig. 108) (M. Stevenson 1894:Pls. XIV, XV).

Fewkes (1895b:132–33) pointed out that this Zia drypainting combines all the symbolism of the Hopi antelope and snake societies' two sandpaintings in a single altar. The possible eastern derivation of the Hopi snake ceremony was mentioned earlier. In any case, there is evidence that snake ceremonies were once widespread among the Pueblos (White 1962:162–65).

Members of the society perform various acts around the altar, finally pressing the palms of their right hands on the mountain lion, breathing in from them, and rubbing the adhering sand over their bodies. A woman member then brushes the remaining sand from the cardinal points into the center with an eagle feather and takes it home to rub over the bodies of her male children. In a ceremony held in the morning of the fifth day in the snake society's small ceremonial house in the country some two miles west of the pueblo, a similar sandpainting is made, but with the addition of two diverging lines from the painting to the entrance of the house, one of corn pollen and the other of black pigment. The snakes are laid down between these lines with their heads to the east and sprinkled with pollen. At the end of the ceremony the society members erase the painting and rub the sand on their bodies. The snake and the *kapina* (spider) societies are closely associated, and the latter join in the snake ceremony but do not dance with the snakes.

Kachina Society. The function of the kachina society is to dance for the corn crop (rain) before planting and before and after harvest in the fall. The only drypainting recorded for the society is a simple meal painting of a rectangle with rectangular blocks along one side and a deep notch in the other side with the meal road leading out from it (probably a cloud symbol). This painting is used for an initiation when the mysteries of the kachina are first revealed to children (White 1962:Fig. 35). Whipping the initiates, a common practice among the Pueblos, is done at the option of the parents. The kachina society is not a curing group and, as mentioned earlier, the Keres associate meal paintings with rainmaking and sandpaintings with curing, so no doubt the society uses drypainted designs made only of cornmeal.

Shayeik (Hunters') Society. The hunters' society, whose patron supernatural is the mountain lion, magically helps hunters to kill game and may treat illnesses or injuries sustained while on a hunt. It may also take part in winter weather ceremonies. In 1957 only one member remained in Zia, so members of the society from other Keresan pueblos were invited to come to Zia to initiate a new member. The drypainting for the initiation was a rectangular geometric design with zigzag lightning arrows across it, made of yellow corn pollen and a black powder

(White 1962:Fig. 20). Numerous animal figurines, including two large stone mountain lions, were set on or near it.

Koshairi *and* Kwiraina *Societies.* The two clown societies, the *koshairi* (koshare) and the *kwiraina* (kurena), always associated in Keresan ceremonies, are much more than fun makers. They are primarily concerned with fertility, act as disciplinarians, and have other important functions. They derive their power directly from the sun and moon. The *koshairi* share the house of the giant society, and the *kwiraina*, that of the flint society. These groups are in charge of the so-called corn dance held on the day of the Roman Catholic patron saint of the pueblo (August 15 at Zia). The antics of the black-and-white-striped *koshairi* (the parti-colored *kwiraina* are less clownish at Zia) as they play their part as sacred buffoons during the intermissions of the corn dance are well known to the many white visitors who have seen the dance. The *kwiraina* do no curing, so they make only meal altars. One seen in a photograph of a rain ceremony being performed by the society appears to be a large rectangle crosshatched with diagonal lines (M. Stevenson 1894:Pl. XXIX).

Mortuary Rites. Four days after a death or burial, a ceremony is performed to send the breath (soul) back to the underworld from which it emerged. This is carried out by two or three members of either the flint, giant, fire, snake, or *kapina* society. They go to the house of the deceased where, among other procedures, they make a little meal painting on the floor on which they place their medicine bowl. Later in the ceremony this painting is renewed and the corn-ear fetish of the officiating society member is set on it. The design is a circle with two sets of three lines

each crossed in it. Zigzag lightning arrows point to the circle from the quadrants, and a set of two roadrunner tracks (crosses) and two three-toed turkey tracks is at each of the cardinal points (White 1962:Fig. 25). The road from the meal painting to the door consists of two lines, one of cornmeal and one of ashes, symbolizing life and death. At the close of the ceremony the society members clear away the drypaintings, pick up their paraphernalia, and depart to their ceremonial house.

Santa Ana

The pueblo of Santa Ana (*tamaya* is the native name) is on the north bank of the Jemez River about eight miles northwest of its confluence with the Rio Grande. Leslie White published an extensive monograph on this pueblo (1942). Ceremonialism is in the hands of five or six medicine societies, including two *shikame* (Santa Ana is the only pueblo that has two of these), a flint and an eagle (also called ant) society, and possibly vestiges of a bear and a fire society (the *kapina* has become extinct); the *shayeik* (hunters') society; the *koshairi* and *kwiraina*; the warriors (*opi*); and the kachina dance groups. There are two kivas, squash and turquoise, and the societies have houses in the dwelling blocks.

The principal function of these groups is to bring rain, but the medicine societies control the sun and the seasons in the solstice ceremonies and treat disease, often ascribed to witchcraft. In general the duties of the societies are the same as those described for corresponding organizations at Zia. One important role of society members is to preserve morale and foster conservatism. Meal and/or sandpaintings (White called them meal-and-pigment paintings) were men-

tioned by informants in connection with solstice ceremonies, curing rites, summer rain retreats, and mortuary practices (like those of Zia). The usual wooden slat altars are employed, and medicine bowls, figurines of various shapes and materials, wrapped corn-ear fetishes, prayer sticks or plumes, and other ritual appurtenances are placed on or around the drypaintings. White was of the opinion that the drypainting was the most important part of the altar, "the core of the ceremony, or, at least, the material embodiment or manifestation, of the spiritual core" (White 1942:330). He pointed out that the slat altar is not used as frequently as the drypainting, and in some ceremonies it is not used at all. The directional sequence of colors, like that of other pueblos, is yellow, blue, red, and white for north, west, south, and east, but the color of the zenith is brown, and the nadir is black. In contrast, the colors for zenith and nadir at Acoma are black and gray, at Laguna brown and green, and at Zia light yellow and "dark" (White 1942:83).

Shikame *Society*. At the beginning of their summer rainmaking retreat the *shikame* society members make a drypainting on the floor of their ceremonial house. A rectangular field of sparkling black pigment (a mixture of magnetite and specular hematite) is outlined with white cornmeal. Three crosses of white meal are made on it at each side (tracks of the chaparral cock), and four concentric semicircles ending in arrowpoint designs occupy the center. A road of meal runs across these at right angles with an X-shaped cross of meal at each intersection. From each front corner, a figure extends out toward this road. Each figure has a four-angled snakelike body and a round human-like face with a white meal neck and black eyes and mouth. The one on the right has

a blue green face and a blue body covered with alternating black and white spots. The left one has a red face and a black body with red and white spots (White 1942:Fig. 42).

Flint Society. A drypainting used by the flint-*koshairi* group in the summer solstice ceremony has a square black field with a curved front, outlined with white cornmeal; it represents the earth. Two concentric semicircles and a road of meal divide the field. A yellow disk on the right side and a blue one on the left are suns. There is a black water snake on each side made with white meal outlines and body markings. On the front part of the earth a blue crescent on the right and a yellow one on the left are moons. Meal lines from the road lead to these moons. The curved front of the earth is bordered by a rainbow. On each side of the earth, outside its outlines, are red zigzag lightning arrows, each with a white meal point (White 1942:Fig. 43). White's informant said that the drypainting used by the flint-*koshairi* group for the winter solstice ceremony is the same except that the moons, rainbow, and black ground under the moons of the summer painting are omitted.

A sandpainting used by the flint society in its curing ceremonies has a square black "earth" background with a white meal outline, and on it appear a road, three concentric semicircles, and a white meal figure of a bear on each side between the semicircles (White 1942:Fig. 44).

Koshairi *Society*. A sandpainting used by the *koshairi* society also has a square black "earth" background with a white cornmeal road bisecting it. On each side of the road, there is a corn plant (right side, blue; left, yellow) and a horned water snake (right, unknown color; left, yellow) with a pro-

truding red tongue. The corn has a tassel of yellow pollen and two blue green ears bearing silk made of pollen. Outside the earth there is a zigzag lightning arrow on each side, a red one on the right and a blue one on the left, both with outlines and points of white meal (White 1942:Fig. 46).

Santo Domingo

Santo Domingo, the largest and most conservative of the eastern Keresan towns, is on the east bank of the Rio Grande about eighteen miles north of Bernalillo. It has the complement of ceremonial societies and groups usual for Keresan pueblos and carries out an annual round of solstice and other ceremonies, rain retreats, various kinds of dances, and so on (see Parsons 1939:891–98). The four principal medicine societies, which "fight witches" and cure diseases caused by them, are flint, *shikame, boyakya* (possibly a Tanoan society), and giant. The *kapina* society became extinct in 1927, and the war society is extinct, but scalps are still kept, "fed," and washed. Each society has its ceremonial house, and there are squash and turquoise kivas. In addition there are some minor specialized societies—toad, ant, and snake—which treat ailments such as snakebite that are caused or supposedly caused by these creatures.

In Leslie White's sizable monograph on Santo Domingo (1935), only two drypaintings are clearly illustrated. One is a simple design of pollen, white cornmeal, and a "black powder" made in turquoise kiva on the last day of an initiation ceremony by the *koshairi* society. A large circle or disk in the center and a smaller one on each side of it at the front edge of a square field of pollen are divided into black and white halves or quarters (White 1935:Fig. 9). The usual meal road runs out from the large disk. The other painting is a design made by the flint society of the same materials. Made on the floor at one end of a room in the house of a patient undergoing treatment, it is a rectangle of black pigment, one edge deeply scalloped, with four smaller white meal rectangles on it and yellow pollen lightning arrows projecting from it (White 1935:Fig. 29). White said that it is a fair example of this pueblo's drypaintings, which are quite uniform in design. He also said that only the curing societies, the *koshairi,* and the *kwiraina* make meal paintings for initiations, curing ceremonies, and winter solstices and other ceremonies (White 1935:161). At the close of a ceremony the drypainting is swept up and usually, or perhaps always, thrown into the river.

Cochiti

Cochiti, west of the Rio Grande, is twenty-seven miles southwest of Santa Fe. This is another Keresan pueblo for which we have an early report, that of Father Noël Dumarest, which was translated and edited by Elsie Parsons (Dumarest 1919). Dumarest was sent to this village in 1894 and kept in touch with it until about 1896. The only active medicine societies today are the flint, giant, and *shikame.* There are the usual two clown groups and a two-kiva system, and the usual calendrical round of ceremonies is carried out (Parsons 1939:901–3).

The only drypainting discussed in detail by Father Dumarest is the meal altar made four days after a death, by three or four society members in a ceremony intended to dispatch the deceased to *shipapu,* the mythical place of emergence under a lake somewhere in Colorado (Dumarest 1919:Fig. 18, 167). The design is a simple triangle of corn-

meal with a road leading through it from its apex to the door of the room. Outside the triangle on each side of the road are human footprints and chaparral cock (crosses), turkey (three-toed), and rattlesnake (serpentine) tracks. These symbols represent the deceased going to the door to begin his journey to the middle world, placed by the medicine men under the protection of the three creatures whose tracks are shown and also of the mountain lion, bear, and eagle.

Charles Lange (1959:245) mentions a drypainting made of a mixture of white and blue cornmeal spread in the form of a cross with arms about eighteen inches long, made in turquoise kiva for the installation of a new *cacique* (political and ceremonial leader) who was the head of the flint society. A large black lava fetish, about six inches in diameter and fifteen inches high, stood on the center of the cross. During the installation speeches were made, and the heads of the giant and *shikame* societies sang several songs.

There are no significant descriptions of drypaintings in Esther Goldfrank's monograph on Cochiti, but she does mention altars with figures of birds drawn on the ground with cornmeal and meal paths leading to them (Goldfrank 1927:64, 70). We have no accounts of drypaintings for San Felipe, the other eastern Keresan town, located twelve miles north of Bernalillo.

Laguna

Of the two western Keresan pueblos, the large community of Laguna with its nine or more farming colonies, situated in the San José River Valley about forty miles west of Albuquerque in Cibola County, New Mexico, is, for historical reasons, the most Americanized of all the pueblos (see Parsons 1939:888–90; Eggan 1950:253–390). Its ceremonial system has suffered such disintegration that we have no important reports concerning drypaintings used in what is left of its ritual life. This used to revolve around the medicine, kachina, warriors', hunters', and clown societies as in other Keresan pueblos, but in the 1870s internal quarrels sent the conservative element to the colony of Mesita, and about 1880 the flint, fire, and *shahaiye* society chiefs moved to Isleta and became affiliated there with the two medicine societies called the town and Laguna fathers.

Acoma

The westernmost Keresan pueblo, the very conservative Acoma, is the celebrated "sky village" perched on a bare rock mesa 357 feet high, about fifty miles west of Albuquerque and the Rio Grande. Its farming colonies are located in the valley of Acomita some fifteen miles northwest of the parent town (Parsons 1939:881–87; Eggan 1950:223–52). At Acoma the ceremonial organization and activities and the functions of the various groups are generally like those described for the eastern Keresan pueblos, but there are some important differences. Situated about midway between the eastern and western pueblos, Acoma shows considerable western Pueblo influence; it has a six-kiva system like that of Zuni (only five now) and Zunian features in its kachina cult. There are three medicine societies, flint, fire, and *shiwanna* (thundercloud). The *kabina* society became extinct in 1927, and the war and hunters' societies have largely disappeared, their duties taken over by the three war chiefs. The *k'ashale*, the equivalent of the Rio Grande *koshairi*, is also virtually extinct, and there is no *kwiraina* society as such, it being identical with the kachina organization.

In Leslie White's detailed account of Acoma (1932), only one drypainting is illustrated and described, although he mentions sand-paintings being made, used, and swept up by the k'ashale in the past. Matthew Stirling (1942) obtained sketches of several more from some Acoma Indians when they were visiting Washington, D.C. The drawings were made by one of the younger Acoma men under the direction of the chief informant. It seems that the graphic art employed by the curing societies in their ceremonies is principally confined to wall paintings in their chambers. White gave illustrations showing rain symbols, the horned water serpent, a bear, an eagle, and a *koshairi* standing on the crescent moon, and mountain lions and kachinas were mentioned by informants (White 1932:Pls. 11, 12).

Child-naming Ceremony. Four days after a birth, a member of a medicine society who has been invited by the father comes with his wife to the man's home. He makes a drypainting on the floor in a space cleared for him. The design is a rectangle outlined with white (meal?) and quartered by white diagonal lines. The quarters may be in directional colors, and the outlines of a turtle are made on them in white (White 1932:Pl. 16). A horned toad might be used instead. Two or three wrapped corn-ear fetishes are placed on the turtle and a medicine bowl is set on its head. While the practitioner arranges his paraphernalia and sings, his wife bathes the baby. Just before sunrise all go outdoors, and the practitioner holds the baby out toward the rising sun as he prays, and then speaks the child's name. After a few other procedures he sweeps up the painting, picks up his equipment, and goes home. White (1932:133) said that this ceremony is absent among the eastern Keres.

Fire Society. A circular drypainting made for the fire society's altar has a blue rim (the sky) and at the top a crescent marked off by a pale gray line (Milky Way). On it are a red sun, a yellow crescent moon, and stars. Below the crescent is a birdlike figure with a yellow face, black hair, yellow spots on its body (the earth), and a red arrowpoint on its breast (heart, the center of the earth). This figure represents *iatiku,* a most sacred and important supernatural being called the mother of all Indians. Her home is in the place of emergence where every person goes to his mother after death, but during life she watches over all human beings (Stirling 1942:Pl. 10, Fig. 2a).

Ant Society. There is no ant society at Acoma now, but some members of other societies know how to make the altar and drypainting and to conduct the ceremony to treat diseases supposed to be caused by ants, such as body sores, itching, and sore throat. The circular design has a pale gray outline and spots of yellow cornmeal on the background. In the center is a green lizard or horned toad with yellow, blue, red, and white bands around its throat. This creature eats ants and gives the power to cure diseases caused by them. The same ideology is expressed in Navajo beliefs concerning ants and the ailments supposed to be caused by them, and the Navajos too make sandpaintings of horned toads in the Red Ant Chant they use to treat such illnesses (see Wyman 1973:25, 218–20, 222–26, and passim, Figs. 3, 39, 44–55). Above the horned toad is a red sun, at its right a yellow crescent moon, and at its left a blue star (Stirling 1942:Pl. 10, Fig. 2b). The patient is seated on the painting while the practitioner brushes off the ants (some gravel), and with them the

disease, using a grass broom. Then the gravel is collected in a cornhusk and buried.

Sun and Moon. Symbols of the sun and moon are made at Acoma on kiva walls or in drypaintings in order to obtain power from them, for they are the most potent of all forces. They are drawn as if alive, with black eyes and mouth. The round sun's face is red because it is male and gives a strong light; the moon's face is yellow, for it is female and its light is pale. The two rings around the sun are green (inner) and orange, those around the moon, green and red. Two short projections from the outer ring at the four cardinal points represent beams of light. On the forehead of each celestial being, a figure made up of brown and black triangles divided by white lines represents a squash blossom (Stirling 1942:Pl. 11).

Exorcistic and Mortuary Rites. Following a sickness that caused many deaths from "blisters all over the body" (possibly small-pox), a rite of trail-exorcism was performed. A drypainting was made on the south side of camp consisting of a line of four triangles (mountains), one above the other, each of a different directional color—yellow, blue, red, and white (Stirling 1942:67, Fig. 4; Pl. 15, Fig. 1). The people stepped on a mountain and on the valley between while the sickness was brushed off with feathers. At the end of the performance they stepped into a frame of yucca leaves to "spill out" the sickness. A similar rite may be used after a death to enable those concerned to escape from the ghost of the departed.

Tewa

Five modern pueblos speak the Tewa tongue, one of the three languages of the Tanoan linguistic family that are still in current use (the others are Tiwa and Towa). These pueblos are in the Rio Grande Valley from eight to thirty miles north of Santa Fe, New Mexico. These pueblos—Tesuque, Nambé, San Ildefonso, San Juan, and Santa Clara—are well known to tourists because of their skill in ceramic art, especially at San Ildefonso, the home of the late, internationally known potter, Maria Martínez. The chief feature of the social and ceremonial organization of the Tewa pueblos is the moiety system, the dual division of each pueblo into summer and winter people. Each has its own kiva. The moiety chiefs are the town chiefs, the winter chief and his group being in charge of ceremonies from autumn to spring, while the summer chief officiates from spring to autumn. Of the two clown groups, the *kossa* (*koshairi*) and the *kwiraina*, the latter is lapsing and is already extinct in some villages. Each moiety has its own *kossa*. There is no separate kachina society, but maskless kachina dances are held (for example, the turtle dance at San Juan). The war society is extinct, but there is a woman's group with a female war chief, which performs necessary duties. There is also a hunt chief, but no hunting society. The two outstanding curing societies are flint and fire, but there is another curing group, the eagle people. A calendar of ceremonies and dances is followed throughout the year (see Parsons 1939: 910–13).

Parsons said in her monograph on the social organization of the Tewas that with few exceptions it was difficult, if not impossible, to elicit direct descriptions of altars from informants (Parsons 1929:252–53). She illustrated three very simple cornmeal designs showing little more than the meal and pollen roads with the crosses on them representing chaparral cock tracks (Parsons

1929:Fig. 13, Pls. 16, 17). In the first a circle of meal on the ground, called the pueblo, with two roads to it is used in an eagle ceremony and at the installation of the winter people of Tesuque. Meal designs of rainbow and lightning are also mentioned but not illustrated. There is no way of knowing whether these observations reflect actual poverty of the drypainting art in the Tewa pueblos or successful concealment of their secrets from prying ethnologists.

Tiwa

The Tiwa-speaking pueblos of the upper Rio Grande Valley consist of a northern group of two, Taos and Picuris, some fifty or sixty miles north of Santa Fe, and a southern pair, Sandia and Isleta, twelve miles north and south respectively of Albuquerque. There is no material on drypaintings from Picuris or Sandia, so no discussion of them is possible.

Taos

The pueblo of Taos, noted for its high, five-story house clusters, has seven kivas; one of these is now used only as a shrine. Three kivas on the north side of the small stream flowing through the town belong to the big earring, day or sun, and knife people, and three on the south side are used by feather, water, and old ax people (a kind of dual division). One or more small societies are associated with each kiva. These include big hail (in charge of ceremonialism in winter), white mountain, black eyes (clown group), corn mother (curing society), bear (treats snake sickness), and *papta*. The black eyes wear black-and-white-striped body paint like the *koshairi*. The complementary clown group, the redpaint people, is ex-

tinct. The head of the bear society is the permanent war chief. No masked kachina dances are held, but there is a kachina cult and maskless dances are performed (for example, the turtle dance; Parsons 1939:932–38).

Elsie Parsons was able to secure only two drypainting designs. One is a sandpainting made by a person appointed by the head of the corn mother society for a one-day springtime ceremony performed by the kiva societies. It shows a corn plant growing from the sacred Blue Lake. The corn, about four feet tall, has leaves made of powdered green plants. The lake is a circle, two and a half feet in diameter, divided into quarters, of blue gray sand, light gray sand, yellow pollen, and brown sand (Parsons 1936:Fig. 5). The other design, made by the big earring people, is of seven zigzag lightning arrows of yellow pollen, pulverized blue flower petals, and yellow sand (Parsons 1936:Fig. 6).

Isleta

Every Isleta Indian belongs to one of the moieties, either the so-called black eyes, the winter people, or the red eyes (gophers), the summer people. These two groups are in charge of ceremonial activity in the corresponding seasons. Rites transferring ceremonial responsibility between moieties occur in late October and late March. All Isletas also belong to one of the seven corn groups that carry out winter and summer ceremonies for the sun (possibly solstices), during December 1–20 and June 1–20, in accordance with the ceremonial calendar. The two medicine societies are the town fathers and the Laguna fathers (*father* is an Isleta term for a ceremonialist). They do not specialize in any particular ritual function and, in addition to curing and initiating, officiate in

the solstice ceremonies, in rites of general cleansing or exorcism for the whole village, and in weather control. The Laguna fathers were probably originally organized by the Laguna immigrants who were welcomed by the Isletas about 1880 after the split-up of Laguna. No doubt they introduced some Keresan features into Isleta ceremonialism. The clown groups at Isleta have police duties as they do elsewhere. The kachina cult is not so well developed as in other pueblos, for there is no kachina organization proper and there are no masked dances, although there are maskless kachina dances (turtle dance). There is a permanent war chief and a hunt chief. The single kiva, built like a Keresan kiva, is called the round house. The scalps (Navajo) are kept and "fed" in it. The southern Tiwas were among the first pueblos to be subjected to Spanish contacts, so elements of Catholic ritual are more conspicuous in their yearly round than in the other eastern pueblos, where Catholic rites also occur along with Indian ones. The annual calendar is, therefore, quite full, and all ceremonial groups contribute to it systematically or as occasion arises (see Parsons 1932:254–357; 1939:923–32; 1962:1–12 and passim). Elsie Parsons's substantial monograph on Isleta (1932) was signally supplemented by her publication in 1962 (edited by Esther Goldfrank) of 140 remarkable watercolor paintings that were sent to her during the period from 1936 to 1941 by an Isleta Indian who had read her 1932 work and felt that it needed illustration. No fewer than fifteen of these pictures show drypaintings or portions of them.

In the available illustrations, Isleta drypaintings seem, almost without exception, to be simple cornmeal cloud designs or circular or shield-shaped patches of meal with rather broad roads leading to them, on which are placed a bowl of "medicine water," usually near the back of the design; stone fetishes, arrowpoints, and other implements; prayer feathers; bear paw skins; and so on. A bundle of feathers or a large stone point is often shown at the end of the road. The cloud design is called the "village" or "tribe." The meal altars of the medicine societies are placed in front of a clay or mud ridge in which are set the wrapped corn-ear fetishes (corn mothers) of the society members (Parsons 1932:Figs. 16, 17; 1962:Paintings 59, 60, 78). On the altars of the moieties and corn groups there are no mothers.

The cloud design for the winter solstice ceremony of the seven corn groups is a one-step terrace, trapezoidal rather than squared, with a short front segment and no road. Various stone objects and so on are laid in a line in front of the design (Parsons 1932:Fig. 10; 1962:Painting 9). A "salt circle" is made in the house of the town chief, from whom the chiefs of the corn groups must ask permission to hold their four-day ceremonies for the sun. This painting is a circle of cornmeal of all colors, two or three feet in diameter, with two lines crossed over it in the cardinal directions and a shorter line within the circle for up, down, and middle (Parsons 1962:Painting 33). A somewhat similar design, a roughly circular patch of meal with roads to it from the four directions, on which a member of the war society squats to be punished for having made a mistake, is shown in Parsons's (1962) illustration of Painting 103.

A nicely squared one-step cloud terrace with a broad road in front of the corn mother ridge is used by the town fathers in their exorcistic ceremony of general purification for the town (Parsons 1932:Fig. 16; 1962:

Paintings 58, 59, 60, 78). The meal altar used by the Laguna fathers in exorcistic, rain, or initiation ceremonies is a rounded, somewhat bean-shaped patch of meal with a short front segment from which two roads lead, one terminating in an arrowpoint shape (Parsons 1932:Fig. 17, 26; 1962:Painting 64). In one illustration a coiled snake design is in front beside this road. The initiate stands on the snake's head. Painting 63 is an excellent illustration of the murals in the chamber of the Laguna fathers, showing the curer animals (mountain lion, bear, badger, eagle, and four rattlesnakes); sun, moon, star, and rainbow; corn plants of the directions; two horned water serpents; and three masked kachinas (also see Parsons 1932:Pl. 17; 1962:Painting 54).

A more or less shield-shaped meal altar with a broad road leading from it is used in the following ceremonies: kachina dances in the Laguna fathers' house (Parsons 1962:Paintings 74, 75), the race for the sun (altar of corn of all colors in town chiefs' ceremonial chamber; Parsons 1962:Painting 88), the retreat of the black eye moiety chiefs (Parsons 1962:Painting 45), and the exorcistic ceremony four days after a death (Parsons 1962:Painting 30).

The meal altar made by the hunt chief in his house for a hunting ceremony is a four-sided cloud terrace design composed of four one-step terraces, one on each side of a square. He lays down the design within a circle of pollen that is broken by a gap at the east (Parsons 1932:Fig. 24; 1962:Painting 115). Painting 11 is a good illustration of the treatment of a man who had eye trouble because he had poured oil on an anthill and set it afire. The ant disease specialist is brushing the ants from the patient's body as he stands on an animal skin. The round

meal altar in this painting includes what seems to be a drypainting of a fat, crooked snake crawling out of it, instead of a meal road.

In certain rites a buckskin is used as an altar on which to set paraphernalia (Parsons 1932:280). In the rite of bringing in the horned serpent, a buckskin is so used, and two lightning arrows are painted on it with "powders" (Parsons 1962:Fig. 14).

Towa

The only Indians still speaking the Tanoan dialect called Towa are those of the pueblo of Jemez, on the north bank of the Jemez River some twenty miles northwest of Bernalillo, New Mexico. Among the inhabitants of this pueblo are the descendants of the handful of refugees from the abandoned pueblo of Pecos, some seventy miles to the east, who came to join their relatives in 1838. The ceremonial system of this conservative town is like that of the Keres and, indeed, it is only a few miles north of the Keresan pueblo of Zia. The Jemez snake society is doubtless modeled on that of Zia. The idea of duality, as among the Keres and Tewas, is outstanding in Jemez. There are two curing societies, flint (arrowhead) and fire; two kachina dance groups who perform maskless dances; two women's societies; two eagle-hunt societies (the eagle watchers or flute society was brought in by the Pecos refugees); and two influential clown societies associated with the two kivas, *tabö'sh* with turquoise kiva and *ts'un'tatabö'sh* (ice society) with squash kiva. The kivas are rectangular buildings like dwelling houses but with no windows or doors, entered by means of a hatchway in the roof and a ladder. There

are also a war chief and two annual war captains (Parsons 1925; 1939:905–10).

Parsons obtained very little information concerning drypaintings from this secretive pueblo. She did say that all altars have ground paintings of meal and sand and published two crude sketches (Parsons 1925:120, 121). An altar of the arrowhead society seems to be a rectangular affair with a star and a bird at each end, and a meal road with bowls set on it running between them (Parsons 1925:Fig. 17). Another set up two days after a death in the house of the deceased by members of the arrowhead or fire society consists of five rectangular spaces side by side, of different lengths, the longest one in the middle, all filled solidly with cornmeal. Parsons said that the sun is painted on solstice altars and the horned serpent is painted on all altars, but it is not clear whether she was talking about the drypaintings or the wooden reredos.

12

Papago
Drypainting

About eight thousand Papago ("bean people") Indians live, mostly in rancherías, or small collections of crude huts, on the 2.7 million acres of desert country that make up their reservation south and west of Tucson, Arizona.[1] Their linguistic kinsmen to the north in the Gila and Salt River valleys, the Pimas, are not known to use drypaintings today, and there is no record of their ever having used them, but it is possible that they might have done so in the past. The Papagos still make them on occasion, although Donald Bahr, the outstanding authority on Pima-Papago ceremonialism, knows of only two curers who use drypaintings in their ceremonies.[2] The curer who made one for the Arizona Sonora Desert Museum in 1970 said, "It's our way, not just now, but from long before. And it's still going but it looks like it's dwindling down. People who know this are dying out. I'm the only one left; something happens to me, I don't know what will happen then."

According to the Pima (Papago) theory of sickness and ritual curing (Bahr 1973:6–8; Bahr et al. 1974:passim), there are over forty kinds of "dangerous objects" in the world, beings or phenomena that were endowed with dignity and rights called "ways" (sim-ilar to contracts) at the time of creation (Bahr et al. 1974:Table 2, appendix, 284–98). Well over half of these are mammals, birds, reptiles, or insects (not unlike the Navajos' list of etiological factors; see Table 2). If a human behaves improperly toward a dangerous object—that is, trespasses upon its "way"—causal agents belonging to a class of objects called "strengths" enter the person's body and create symptoms called "staying sickness." Only Pimas are subject to these illnesses.[3] The "strength" may remain latent for years, causing trouble long after the person has forgotten the incident, as when a child runs through a whirlwind in play and as an adult suffers from wind sickness. If a person suffers from an illness, the services of a shaman are required to trace the disease to a "way" by singing to spirit helpers, blowing on the patient, and sucking out "strengths" from his body (diagnosis, Bahr et al. 1974:113–215, Table 3). Blowing is the central practice in both diagnosis and curing. The shaman's or curer's breath may be augmented by blowing tobacco smoke over the patient's body, fanning him with eagle feathers, and using quartz crystals ("shaman's shining stone") to "illuminate" the "strengths."

Once his disease is diagnosed, a patient is treated, not by a shaman but by a ritual curer, whose actions persuade the spiritual representatives of the "way" of the dangerous object to stop causing the sickness. He establishes a prayerful relationship with these spirits by singing to them and asks for their help on the patient's behalf. He also blows tobacco smoke on the patient and applies appropriate fetishes to the patient's body, introducing the curative strength of his breath and the fetishes into the body of the sufferer (Bahr et al. 1974:Tables 4–6, 219–76). Pleased at hearing the songs, the spirits cause the "strengths" that are sickening the patient to diminish. Each sickness has a standard ritual cure and each "way" owns specific fetishes representing its dangerous object, which were given to man for him to use (Bahr et al. 1974:284–98). These may be portions of animals' bodies, or their hair, whiskers, feathers, feces, or diggings; images of animals or plants made of paper, deer-skin, cactus ribs, or wood; ashes or coals, or honey; or actions such as wiping a cat's or dog's mouth and then wiping the mouth of the patient. Bahr thinks that the use of drypaintings is just a variation of the theme of pressing with fetishes. Papagos say that they are "means for blowing" (curing); "by means of designs he will get blown" (cured).

Drypaintings are used to treat diseases caused by three kinds of dangerous objects: owl, horned toad, and wind. Curing rituals for these diseases can also be carried out without the use of paintings, but if the officiating curer calls for them they have to be made. The rituals not only remove sickness from a person, they also put something into him, to strengthen him or "make him proper." This is also the purpose of certain large public ceremonials that are not usually thought of as cures, so in a sense the drypainting rites are intermediate between private curing rituals and public religious festivals. The rites, once undertaken, may be extended for the benefit of other persons who suffer the same sickness as the person for whom the rite is being held, so that they too can be cured. Thus, public notice should be given of a coming curing rite so that other people may take advantage of it. For this reason drypainting ceremonies are held outdoors, often in a public place.[4] One of Dr. Bahr's informants said that the ceremony could be held indoors, "but it is not good"; others said that "it is forbidden to make a drypainting inside of a house." Since the painting made in the cure for wind sickness is left for the wind to destroy, it must be made out in the open.

The curer directs his helpers in making a drypainting, doing very little of it himself. He incises the outlines of the design on the sand background or the bare ground with a stick, and then the helpers fill in the outlines, strewing the dry pigments with their hands. When a sand background is used, it is made of ordinary brown or gray sand from a riverbed or dry wash. The sand is sifted to ensure a uniform texture; sometimes a layer of fine tan-colored sand is spread on a platform of coarser, light-colored sand. The dry pigments and directional colors are white from thoroughly oxidized ashes (east); green from the dried, ground leaves of creosote bush (*Larrea tridentata* [DC] Colville) or from green sand; or blue from little balls of laundry bluing obtained from a store (south); black from mesquite charcoal (west); and red from ground rhyolitic rock, a "red earth," or "stuff that grows on big rocks" (north). The last may be lichens, which may be used as a source of yellow and other colors as well. Drypaintings are usually three to four feet in diameter, so as to permit the curers

to reach any paraphernalia that may be placed in the center of the design.

Drypainting ceremonies are commonly carried out in the daytime, although there seems to be no prohibition against nighttime performances. One informant said that either day or night was suitable. Probably a private rite would not be performed outside at night when ghosts are about. Curing ceremonies vary in length, depending on how many songs are sung and how many repetitions of the songs are used. A ceremony may last six to eight hours or sometimes all night; in order to save time, daytime rites are often shorter. Procedures during the ceremony consist of singing; touching, pressing, hitting, or whipping the patient (and the curers themselves) with objects placed on the painting; and touching the design and then the patient's body with the hands. Bahr believes that the actual pigments are not applied to the patient; what is transferred from the painting to the patient is not its visible substance. At least one curer said that he had made drawings of the designs on paper so that he would not forget them.

Cure for Owl Sickness

Excessive grieving for the deceased or ghosts tempting or haunting the survivor or acting as agents for a sorcerer may lead to owl sickness. "Owl way sickens the person because somebody has sorcerized him by means of the owl" (Bahr et al. 1974:307). This malady causes sleepiness, dizziness, palpitation, or trances and fits (Bahr et al. 1974:295). The cure is performed in the daytime, outside in front of the house.[5] The ground is cleaned and a bucket of gray sand ("appropriate for owls") is fetched from a stream bed. The lines of the rectangular design are incised into the earth. Sand is used only at points where the lines intersect. The design is a rectangle about three feet long with a smaller one inside it. The space between the inner and outer rectangles is divided into eight segments by diagonal lines at the corners and by lines that perpendicularly bisect each side. Small conical piles of sand, two or three inches in diameter at their base, are made at the intersections of the lines. No colored pigments are used, only the neutral gray sand, but one informant said that black charcoal and white ashes could be used on the lines. An owl feather is set upright in the center of the inner rectangle, which is used to "blow" (cure) the patient. The design "is their (owls') house." The size of the design is limited so that the curer can stay outside it and still reach the feather in the center. Each singer takes turns fanning the patient with the owl feather in the intervals between periods of singing.

Cure for Horned Toad Sickness

Injuring, killing, or even stepping on a horned toad may cause horned toad sickness, manifested as pains or swelling in the feet, legs, hands, and back; rheumatism; hunchback; or sores on the feet (Bahr et al. 1974:292). The design of the drypainting made for the cure consists of two circles, one inside the other. The outer one is divided into quadrants of the directional colors, white at the east, green at the south, black at the west, and red at the north. In the space between the two circles, pairs of small horned toads with their heads pointing outward are drawn (scratched) on the earth at the cardinal points and then filled in with the directional colors. An effigy of a horned toad about a foot long, carved from wood or saguaro cactus ribs, is placed in the center

with its head pointing to the east. Saguaro rib wood is preferred for carving lizard and horned toad images because it is a local product and is "infused with the substance of these animals since they live in dead cactus." The large central horned toad may also be made in sand, and in this case it is not touched during the cure. It is called the horned toad's "big one" (a word used also for chief). In the intervals between periods of singing, the wooden effigy is picked up and pressed on the patient.

Cure for Wind Sickness

Wind sickness may be contracted by anyone who comes in contact with a whirlwind by running into or through one, as children may do in play. The symptoms are pains in the legs or back (caused by stones blown by the wind), or dizziness. The legs especially are afflicted (Bahr et al. 1974:298). The curing ritual is performed in the daytime, always outdoors, beginning around noon ("when the whirlwinds are out").[6] A drypainting for this ritual was made at the Arizona Sonora Desert Museum in May 1970 by four Papago Indians from Sil Nakya Village (see note 1). The design was circular, about four feet in diameter (Figs. 109A–F, 110A–D, 111, Plates 31, 32). This painting was made in a model of a Papago hut for museum display purposes; in actual practice such a painting would be made outdoors. Ordinary sand was poured on the floor, formed into a circular platform, and smoothed on the top. A conical mound of sand was pushed up at the east side (a mountain). A flat stick was used to bisect the design and lay out the "sun's path" (aboout six inches wide) from east to west across the platform. White dry pigment was

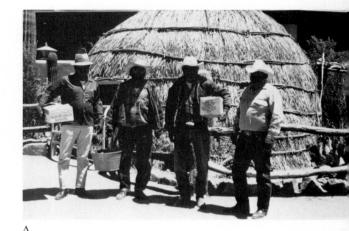

A

B

Figure 109. Making a Papago drypainting as used in the cure for wind sickness. A. The Papago ritual curer (second from right) and his three assistants from Sil Nakya Village before the model of a Papago hut in which they made the drypainting. B. The ritual curer and assistants spread and smooth the circular sand platform for the

C

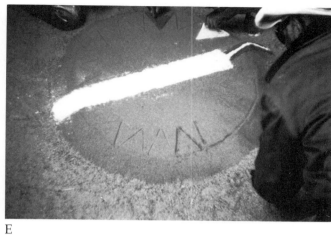

E

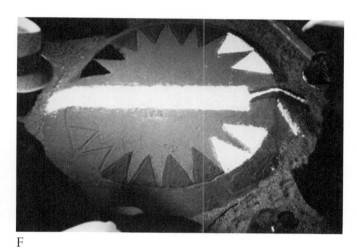

D

F

drypainting. C. After pushing up a conical mound of sand (mountain) at the east side, a flat stick is used to halve the design and lay out the "Sun's path." D. White pigment is applied to the "sun's path." E. A narrow extension of the "sun's path" has been made over the eastern mountain, the outlines of sixteen triangular clouds have been incised around the periphery of the platform, and pigments are applied to the clouds. F. Except for two of the western clouds, all have been filled in with pigments of directional colors. Photographs, Bernard L. Fontana.

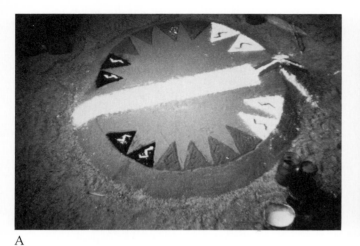

A

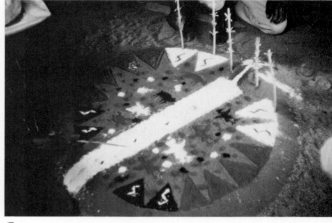

C

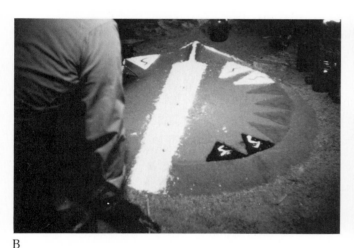

B

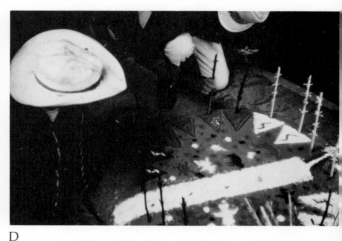

D

Figure 110. Making a Papago drypainting for curing wind sickness (continuation of Fig. 109). A. Zigzag lightning lines have been made on all the triangular clouds. B. Spots of red pigment (blood of wounded deer) are placed along the "sun's path." Further elaboration of the painting is shown in Plate 31. C. The drypainting has been completed and white flower effigies ("prayer-sticks") are being placed on each side of the eastern mountain. D. Red flower effigies are placed at the north while others are ready to be put in position. The completed drypainting is shown in Figure 111 and Plate 32. Photographs, Bernard L. Fontana.

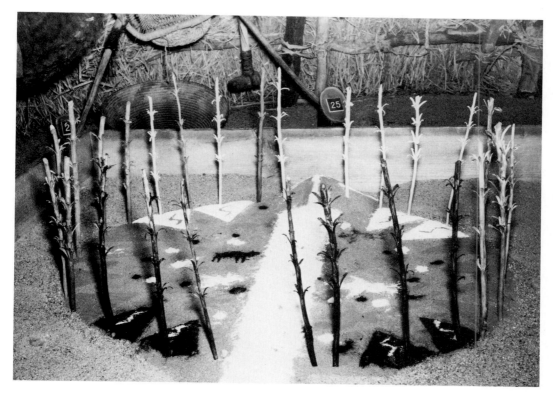

Figure 111. The completed Papago drypainting as used in the cure for wind sickness, photographed from the west side of the display at the Arizona Sonora Desert Museum. Courtesy Arizona Sonora Desert Museum. Photograph, Mervin W. Larson.

applied to the sun's path and to its narrow extension over the eastern mountain. Sixteen triangles were incised around the periphery of the platform with a stick (clouds). White pigment was applied to the four triangular clouds on the east side, green (ground creosote bush leaves) to the four on the south, black (charcoal) to the western ones, and red (rock) to those on the north. A zigzag lightning line was incised on each cloud and pigment was applied to it, black on white clouds, red on green clouds, white on black ones, and green on red ones. Red spots were made along the sun's path (blood of wounded deer), and deer and human tracks were incised on it (hunter following the deer). Outlines of four birds were incised on the southern half of the design and outlines of four animals on the northern side. Pigment was applied to these creatures, from east to west on the south side, black, green, white, red (eagle, hawk, wind-carrier bird, an unidentified bird), and on the north, green (mountain lion), black (bear), white (whip-

tailed lizard), and red (horned toad). Dots or little heaps of pigment of all colors were placed all over the spaces between animals and clouds (mountains that support the world). When the painting was completed, twenty-eight flower effigies ("prayer sticks") were stuck upright around the periphery, seven at each side painted with directional colors (white for east, green for south, black for west, red for north). These effigies were sticks a foot or so long, each bearing four blossoms with four petals, represented by sets of four undetached shavings one above the other (Fig. 111). According to Dr. Bahr's informants, these prayer sticks are made of stems of catclaw (*Acacia greggii* Gray) with the thorns removed. The red ones represent a spring-blooming wildflower that has red blossoms and is called sown-by-the-wind (penstemon?). Those painted with other colors represent "all kinds of flowers." One informant said that a bouquet of real sown-by-the-wind flowers is placed in the center of the painting or outside west of it, and another said that the wooden flower effigies are kept in a can west of the painting and not placed around it.

The following excerpts are from a translation of a tape recording dictated in Papago at the Arizona Sonora Desert Museum by the ritual curer after he had completed the drypainting there:

> The mound (in the east) is a mountain. The sun comes up from behind it and shines its rays all over the earth. A man gets up early every morning and hunts for deer. You can see the tracks of the man following the tracks of the deer (in the sun's path). The red spots are drops of the deer's blood. The man is following the deer to the west, to where the sun goes down, because that is where the opening, the gate, is. The wind gets us sick sometimes so we have to have this (painting) done to be cured of this sickness. But we always lean to the east because that is where good is, and the other way is not, the west. From the east comes these real white clouds when it's hot. And when it gets cold, from the west comes the black cloud. From the north comes the *jupin* (red) clouds. This is when it's getting warm all around, but we know it will again get cold. And wind is always coming from this direction all around. And when it's getting warm and it's raining a lot of the earth turns green. This is what the green of these (southern) clouds represents. The animals shown on the left (north) side of the path are all the animals mentioned in the song for the wind. First is mentioned the mountain lion, then the zebra-tailed lizard, then the horned toad, and then the one shown here (bear). This makes four and that's the end of the first part of the wind song. In the second verse are mentioned the eagle and the chicken hawk. In the third verse are mentioned the *si'si* (a bird) and the wind-carrier (bird). Altogether they are mentioned in the song and that's how they fit in the animals shown in the painting. They sing of animals on one side and then the other side, their songs. The mountains, when the earth was made the experts felt that these would hold up the earth. These are what they represent. All are different, none are exactly the same. The white lines (on the clouds) represent lightning. This is the way it has been from way before. This sickness affects the legs mostly, can't walk. And these sticks (flower effigies) are used to beat the people, however many there are, all over. This is a prayer stick. With this you touch the objects on the painting and then you beat the person and this is how he will be cured.[7] There's another curing where you just sit and sing and when it's time to blow on the person you just beat him. This is dangerous and it just shouldn't be done anytime, only to cure.

One of Dr. Bahr's informants, a ritual curer, had a sketch on paper of a somewhat different design for a drypainting for curing wind sickness, which he described as follows.

The eastern half of the circular rim around the design is white, the western half is black. In the center are two big birds with their heads to the west, a black eagle at the north and a white or gray (ashes) hawk south of it. At the east side of the painting is a red mountain lion and a white or gray small bird, at the south a red snake (not a rattlesnake) and a black lizard, at the west a white wind-carrier bird and a green mountain lion, and at the north a yellow or gray deer and a red horned toad. These animals "go around in the wind; even the lizard jumps around in the wind; the snake comes out in the wind; they think nothing about the wind (have no fear of it)" (Bahr:personal communication).

To treat the patient, the curer presses his hands on the figures in the drypainting at each direction and presses them all over the patient's body, especially his legs.[8] He also touches or hits the patient, who is lying west of the painting, with each of the flower ef-figies or with the real flowers if they are in season. As he does this, he encircles the patient four times, blowing on him and making a sound ("woo") like the wind. Then he applies the flower or effigy to parts of his own body, and replaces it where it was before. In performances that involve more than one singer, each does the same in turn. These actions are carried out in the intervals between sets of songs. At the close of the performance, the patient is told not to eat any lard, meat, or salt for four days.

There are several parallels with Navajo practice in this rite: applying pigments to the patient (although Bahr thinks they are not actually transferred), applying fetishes while doing so, and following the ceremonial with four days of dietary restrictions. It is not certain how exact these resemblances are; although the actions are the same, the reasons for them may differ between the two groups.

13

Southern California Drypainting

The art of drypainting has not been practiced by the Indians of southern California for many years. A group of tribes living along the coast from the Mexican border to a little north of Los Angeles did use the art. These are the groups that in recent years have been known collectively as the Southern California Mission Indians. The tribes known to have made and used drypaintings in ceremonial contexts were the Yuman speaking Diegueños (named for the Mission of San Diego) who lived on both sides of the border of Baja California, and six tribes speaking Shoshonean dialects who lived north of them. These were the Luiseños (named for the Mission of San Luis Rey de Francia), the Cupeños, the Juaneños (named for the San Juan Capistrano Mission), the mountain Cahuillas in the Santa Rosa and San Jacinto ranges, the Gabrielinos (named for the San Gabriel Mission), and the Fernandeños (named for the San Fernando Mission).[1] Today these groups have dwindled from sizable populations to at most a few hundred; some are practically extinct. Their old culture has also largely vanished, so what we know of their use of drypaintings consists of fragments gleaned from the memories of old informants during the early years of this century by Dubois (1908), Sparkman (1908), Kroeber (1908, 1925), Waterman (1910), Strong (1929), and others. Dubois said in 1908 that it had been fifty years or more since the boys' *toloache* (puberty) ceremony had been celebrated, and Sparkman writing in 1908 said that the girls' rites had not been performed since 1890, and the boys' rites not for forty years.

Drypaintings were used by the Southern California Indians in at least four kinds of ceremonies: in boys' and girls' puberty rites; in a supplement to the boys' ceremony, the ant ordeal, in which live ants were shaken over the youth's body so that he could demonstrate his courage, skill, quickness, and endurance (Dubois 1908:91; Strong 1929:317); and in the death rites for *toloache* cult initiates, in which the deceased's ceremonial feathers, headdress, and similar paraphernalia were buried in the hole in the center of the drypainting, made larger (up to eighteen inches in diameter) for the purpose (Kroeber in Dubois 1908:178; Strong 1929: 318). The design of the painting was the same as had been used in the deceased's puberty ceremony.

The boys' puberty ceremony was called the *toloache* rite (the Mexican name for *Datura metaloides* DC.) because an intoxicating decoction of the narcotic jimsonweed mixed with salt water was administered to the initiate to give him strength and fortune in the hunt and to render him impervious to arrows and bear and snake bites. The jimsonweed ritual was associated with belief in a supernatural being called *chungichnish*. The ceremonial chief delivered a long lecture on good conduct to the boys as they squatted around the drypainting, carefully explaining its significance as he named the avengers represented in it. Then he touched the forehead, shoulders, breast, knees, and feet of each boy with a lump of ground sage seed mixed with salt and put it in the boy's mouth. The boy then bent or knelt over the hole in the painting and spit the mixture into it. The drypainting was then erased by some old men or an old woman by pushing the pigments to the center and into the hole so that no uninitiated person could see the design. In the girls' initiation, several girls of the same clan were treated together according to the same procedure. The Cupeños were said to have put some dried meat into the girl's mouth instead of the sage meal and salt.

The dry pigments employed in southern California drypaintings were ashes, powdered soapstone, or white clay or sand for white; charcoal, a "soft rock" (perhaps graphite), or black seeds for black; red ocher or iron oxide (hematite); and powdered yellow bark or yellow seeds. Besides these pigments, which were the commoner colors, green and blue were also sometimes used. The designs were drawn by strewing the pigments on the ground with the fingers in an open ceremonial enclosure of brush a few feet high, with an opening to the east or with small gaps at north and south. According to Waterman (1910:300–304), the Diegueños made their drypaintings inside the house where ceremonial paraphernalia were kept. The paintings made for the girls' ceremony were not only different in design but, averaging two to three feet in diameter, were smaller than those used for the boys' rites. The boys' paintings were from four to six or twelve to eighteen feet in diameter, sometimes almost covering the space in the ceremonial enclosure. The hole in the center (Luiseño) or at one side (Diegueño) of the design (the spitting hole) was from three or four to eight inches in diameter, except when it was enlarged to receive the burial of a deceased initiate's equipment. This hole represented the navel of the universe or the abode of the dead.

Kroeber and other students of California Indians concluded that either the art of drypainting came to them from the Pueblo area of the Southwest very long ago or both California and the Southwest derived it from still more ancient cultural sources, each developing the art in its own characteristic fashion. In any case, if there was a direct connection between the ancestors of the Pueblos and the Indians of the Pacific Coast, it was severed by the intrusion between them of the Yuman people of the Colorado river region and later by the movements of other alien groups (Strong 1929:346; Parsons 1939: 987, 989).

Diegueño

Kroeber (1925:Fig. 56) published an illustration showing all the restorations of Diegueño and Luiseño ground painting designs of which he was aware. Diegueño drypaintings had a white circular boundary of pul-

verized soapstone representing the world's edge or horizon. Outside this boundary lay two or more small circular mountains. Within it, a broad white horizontal line almost crossing the interior space from east to west represented the Milky Way (the sky's backbone). West of this line was the full moon and below it, the new crescent moon. The sun and constellations were also represented. All heavenly bodies were made with red iron oxide. Round about were symbols of various animals: rattlesnakes, bear, mountain lion, and wolf, the four avengers sent by the supernatural *chungichnish* to punish humans for ceremonial offenses; also present were spider, crow or raven, coyote, and five kinds of snakes. Judging from published accounts, various other geographical features and even baskets or mortars and pestles have also been included in drypaintings. The navel of death was absent, but a spitting hole was made toward the west side (Waterman 1910:Pls. 24, 25, 350, 352; Kroeber 1925:Fig. 56 e, f). Kroeber remarked that the lost drypaintings of the Juaneños and the Gabrielinos were probably similar but distinctive in manner of execution.

Diegueño designs were maps of the Indians' visible universe, both the earth and the heavens. Some symbols of animals were mere lines bent at right angles, but others, such as sinuous lines made with various colored seeds to represent snakes, were more or less recognizable. Kroeber said, "Having mapped his world, the Diegueño proceeds to fill it with living beings. These are not mere heaps of pigment to which an old man can point while naming dangerous animals in his sermon on the punishment of disobedience, but actual representation, excessively crude, it is true, even abbreviated to a few strokes, but still pictures. The spider can be distinguished from the snake, the

snake from the wolf. This is not the case in any Luiseño painting" (Kroeber 1925:664). The symbolism of the latter was abstract and mystic, with mere lumps or patches of color representing celestial bodies and earthly creatures (see Harrington 1934:17).

Luiseño

According to Dubois (1908), the drypaintings of the Luiseños consisted of comparatively simple geometric designs reminiscent of basketry patterns. Those for the girls' adolescence ceremony consisted of three concentric circles open to the north, with a spitting hole in the center. In some there were flowerlike petals (triangles) around the hole, and in these triangles or between the central hole and the innermost circle, small heaps or circles of sand represented the avengers (Dubois 1908:Pl. 17; Sparkman 1908:Pl. 20; Kroeber 1925:Fig. 56 a, b). These designs were two or three feet in diameter.

Drypaintings for the boys' rite were larger, up to eighteen feet in diameter. The designs consisted of a circle divided into quarters in which the symbols of the avenging animals (bear, rattlesnake, raven, and spider) were placed. There was no northern opening as in the girls' paintings (Dubois 1908:Pl. 20, Fig. 2, 87–91; Kroeber in Dubois 1908:Fig. 5, 176–80; Kroeber 1925:Fig. 56 c, d, 664–65).

Strong (1929:293) referred to ropes of human hair leading from the painting to four sticks or canes planted in little mounds of earth on each cardinal side. Kroeber (1925:665) was not sure whether these were real ropes or only painted lines, but he said that the former was likely because ropes were used in a Fernandeño rite described by him. Strong (1929:314–15) also said that in final initiation rites a rectangular pit about three

and a half by four feet wide and two feet deep was dug, and three small rocks and several figures made with colored earths were put in it.

Cupeño

For the girls' adolescence rite, which was held once a year in November or December, a circular drypainting about twelve feet in diameter was created. Three holes were made in the center, the middle one representing the heart of the universe, and various figures were made around them (Strong 1929: 255–57). The drypainting for the boys' initiation was similar, and in addition a rectangular pit like that used by the Luiseños was dug.

Cahuilla

The mountain Cahuillas made a drypainting for the girls' adolescence ceremony in a shallow pit four or five feet in diameter. In it was a "web" of colors like the spokes of a wheel, made of red ocher, black graphite(?), and white clay. Strong (1929) told of a woman eighty or ninety years old who said that seventy years earlier she had seen this painting done three times.

Fernandeño

An old Yokuts Indian who had lived in southern California said that when he was a boy he saw a ceremony performed by the Fernandeños (Gabrielino division) that was done to make someone sick. Twelve men stood around a square, three on each side, and another man stood in the middle. The latter made a ground painting like a map of the earth. Then, holding twelve strings radiating to the twelve men around the square who held the ends of the strings, he shook them, the earth quaked, and the person he had in mind became sick. Kroeber said that this account refers to the use of drypainting by the Gabrielinos and shows that some form of symbolic representation of the world extended as far north as Gabrielino territory (Kroeber 1908:41, 1925:626).

PART III

Conclusion

14

Conclusion

Drypainting has been practiced for centuries all over the world—by North American Indians from the northern midwestern United States to Middle America, by the people of numerous parts of southwest Asia (India, Tibet, Nepal) and Japan, and by Australian aborigines. There are basic similarities in the drypainting process wherever it is done, but naturally cultural or environmental factors lead to differences in the pigments used, the backgrounds on which they are strewn, the techniques employed, the secondary appurtenances accompanying the performances, and the purposes for which the paintings are used.

In all parts of the world where drypainting is practiced, except in Japan, it is employed in religious or semireligious contexts. In Japan it is entirely secular, used for ornamentation or entertainment, but even there drypaintings may on rare occasions be made for quasi-religious purposes such as funerals, or by mendicant Buddhist priests. In Latin America, drypaintings, often large and elaborate ones made in the streets during Holy Week or on feast days of a church, have been pressed into the service of Christianity. In Asia, drypaintings are made as parts of shrines or altars to serve as aids to meditation or for ceremonies connected with cults of various gods or goddesses, or for weddings and other festivities. In Australia they figure in ceremonies associated with totemic beliefs, to avoid punishment for killing totemic animals, and in love magic.

Among the Indian tribes of the southwestern United States, the most elaborate and certainly the best-known drypaintings are those made by the Navajos in their religious ceremonials. In fact, theirs are the only well-known, extensively studied, and richly illustrated drypaintings, at least at present (except for the Papagos, whose ceremonials have only recently begun to be scrutinized by investigators). This lack of knowledge is due to the Pueblo Indians' strict secrecy concerning their ceremonial life; in recent years it has been difficult to study their drypaintings directly. The Apaches and Papagos have allowed only a few trusted outsiders to witness performances in which drypaintings are used, and among other southwestern tribes that practiced the art it has lapsed, so the only information we have comes from the memories of a few aged informants.

Three general aims are shared by the ceremonialism of all the southwest Indian tribes

that make drypaintings (Navajos, Apaches, Pueblos, Papagos). One is curing or preventing sickness or treating injuries. This is the special concern of the Navajos, Apaches, and Papagos, but among the Pueblos it is decidedly secondary to rainmaking. For the Pueblos, curing may be directed toward individuals instead of the village as a whole, which is the usual focus of Pueblo ceremonialism. Another aim is the circumvention of witchcraft and combating its effects. Allied to this is the exorcism of dangerous ghosts, either of natives or of aliens. Finally, drypaintings may serve to invoke all sorts of positive blessings, all things that man desires, either for individuals or perhaps more often for the group as a whole, such as good luck in general, protection of livestock and material possessions, abundance of crops and wild game, and a host of other benefits.

Drypaintings are widely used in the Southwest and were formerly used in southern California in ceremonials for the initiation of neophytes into religious societies, for the revelation of ceremonial mysteries to children, or in puberty rites or adolescence ceremonies (Apaches). As mentioned earlier, Pueblo ceremonialism is largely concerned with weather control. Because they are agriculturists, bringing rain is the main concern of the Pueblo Indians. Pueblo ceremonials also serve to ensure the fertility of living things, to install important religious society officials, to cure snake bite, to name children, to obtain power from sun or moon, and to inter the dead. The Navajos sometimes use drypaintings in divination rites, most commonly in the diagnosis of illness.

To complete the record for North America it may be mentioned that the nomadic tribes of the Great Plains of the midwestern United States used very simple drypaintings as parts of altars in their sun-dance ceremonies performed to fulfill vows made during times of crisis, or in ceremonies with medicine bundles (see Appendix D).

Since most of this book is concerned with Navajo Indian drypainting and since the Navajos use ceremonials chiefly to prevent or cure disease, a word about their theories of the causes and cure of illness is in order. Navajo curing ceremonies are not directed toward the physical symptoms of disease but are designed to exorcise or appease particular beings or etiological factors that are thought (or discovered by divination) to have caused the trouble. There are an enormous number of such factors; witches, incest, excesses, and improper behavior during or toward ceremonials may also bring sickness. There are only very loose associations between etiological factors and specific disease categories. Since only the particular supernatural beings related to specific causes of misfortune can avert the resultant malady, they must be appropriately summoned to the curing ceremonial. Representations of these beings and their doings in the origin legend of the ceremonial, of the etiological factors themselves, or of other creatures, human or animal, who figure in the myth are made in the drypaintings used in the performance. The threefold purpose of the pictures, therefore, is to attract supernatural beings and/or their power, to identify the one-sung-over (patient) with them, and to provide a two-way mechanism for the entrance of good and the absorption or banishment of evil.

Very little evidence bearing upon the history of drypainting art has been found during the course of this study. Although there are at least two very early literary references to it—one in the Old World, in India in the sixteenth century A.D. (Śrīkumāra), the other

in the New World from Spanish sources of the late sixteenth century concerning practices of the Uto-Aztecan Cáhita of northwestern Mexico (cited in Beals 1943)—between these references and our next knowledge of the art there is a great hiatus. Our next encounter with drypainting comes from the late nineteenth century in the accounts of Washington Matthews (1884) and James Stevenson (1891). This general lack of historical information is not surprising, given the absence of accumulated and preserved records among many of the peoples who practiced drypainting.

There is evidence that allows us to speculate on the origin of Navajo Indian drypainting, at least on the roots of its style and symbolic subject matter, in the rock paintings and pecked or incised drawings made by the Navajos in the late seventeenth and eighteenth centuries. Most of these are found in northwestern New Mexico and adjacent Colorado, often concentrated in places that are significant in Navajo mythology. Some of this art may have been used as, or in, religious shrines or to mark sacred environs. Certainly there are many similarities between the subjects and designs of the rock art and those of the sacred drypaintings used today. There is a consensus that the Navajos may have derived their rock pictures from Pueblo Indian sacred paintings, especially those made on the walls of ceremonial chambers (kivas). And, although there are some dissenters, there is a general concurrence that when the Navajos felt—perhaps because of pressure from intrusive Spanish or Anglo cultures—that they should transfer their sacred designs from permanent rock pictures to evanescent and easily destroyed creations in loose dry pigment, they also borrowed the Pueblos' practice of making dry-ground paintings on their ceremonial

altars. It is thought that the rock art flourished, and the subsequent shift to impermanent drypaintings occurred, during a period of intensive Pueblo-Navajo acculturation, when Pueblo refugees came to live with or near the Navajos after futile attempts to shake off Spanish domination. Before that time, however, the history of Navajo drypainting is, as Clara Lee Tanner (1948) remarked, "shrouded in a mysterious past."

Just as there is no history of Navajo drypainting because of lack of records, so there are no materials for the study of the early development of the art other than the transition from rock paintings to strewn dry pigments. This lack is because of the remarkable stability of the designs throughout the long period from which we have recorded examples, nearly a century. Except for minor variations, no greater than those occurring at one time among the creations of different practitioners, the sandpaintings observed and published by Matthews and Stevenson in the 1880s are amazingly like those of the same subjects made today; in fact, they are identical in most respects. Likewise there is an extraordinary sameness in the style of drypaintings made by Navajos all over their vast domain, a style so uniform that we could call it standard. There are only a few indications of local styles that suggest different schools of sandpainting, and here the differences are decidedly minor.

Although Navajo drypaintings are beautiful to our eyes, it is not necessarily fair to judge them according to our aesthetic standards. To the Navajo, his pictures made with dry pigments are sacred tools, much like the contents of his ceremonial bundles. He judges them according to whether they will function properly to attract supernatural beings, whether they are symbolically correct. They are not made as pictures to de-

light or entertain. There is internal evidence, however, that some regard for the beauty of the designs does combine with concern for function. Some students such as Mills (1959) and Hatcher (1974) have tried to derive correspondences between the formal characteristics of Navajo drypainting and psychological traits, but there is no evidence that the Navajos themselves interpret their art as manifesting particular features of Navajo personality.

What of Navajo drypainting today? Its ceremonial methods of production, designs and style, and uses have not changed and are not likely to do so while there are younger Navajos who are interested in their own traditions. However, although the paintings made in ceremonials are still surrounded by the time-honored restrictions to ensure their safety and effectiveness, there has been a sudden and far-reaching relaxation in the restraints against the use of sandpainting designs in secular contexts. The first examples of this practice were the sandpainting rugs or tapestries that date from the second and third decades of this century, and even then the weavers were protected by songs and prayers if the designs they wove were close to those of the sacred drypaintings (see Appendix B). Today, however, many women in widespread areas of the Navajo country are weaving great quantities of sandpainting textiles, and so far as we know they may be largely disregarding the former ceremonial precautions. A more recent development in the commercialization of Navajo sandpaintings is the more or less accurate imitation of sandpainting designs made by fixing dry pigments to stiff board backgrounds with adhesive. These are being made by the thousands and offered for sale in curio shops all over the West (Parezo 1980). Over four hundred Navajos, according to recent reports, are engaging in this type of "art."

As for the future, who can tell what will happen? There may be a religious revival for any one of a multitude of reasons, or the art may disappear entirely, as it has among other tribes of the southwestern United States. It is not likely, however, that this fate will overtake the drypainting art in the near future, probably not in the lifetime of anyone now living.

Worldwide Use of Drypainting

India

Powder painting was mentioned by Śrīkumāra in his Śilparatna, written in the sixteenth century A.D., where he spoke of two kinds, Rasachitra (now called Ālponā, or Rangole in southern India) and Dhūlichitra. Of the latter he said, "After powdering separately fire and other colours, a beautiful altar (platform) should be painted temporarily with these powders. The old painters have described this as Dhūlichitra" (Banerjea 1956:222–23). This may be the earliest literary reference to the art of drypainting, and in it the mention of "the old painters" is witness to the still greater antiquity of this art.

Pictures of divinities and associated mythological events are still made with colored dry rice powder or flour in temples and shrines in various parts of India (Banerjea 1956:222). At the time of various Vaishnava festivals, such drypaintings are made in many shrines in Bengal. The designs illustrate stories of the early life of Krishna, one of the incarnations of the god Vishnu (Fig. 112). A part of the shrine, usually in the *nātamandapa*, or dance hall, is set aside for this purpose. The drypainting is made on a raised platform, usually wooden. Banerjea (1956:222) said that "its purpose is mainly decorative and edifying." Part of the duty of the *devadāsīs*—"female servants of the god," the dancing girls institutionally attached to certain Hindu temples—is to ornament the floor of the temple with figures drawn in rice flour.

Professor Suniti Kumar Chatterjee of the University of Calcutta told Mary Wheelwright that the symbol of Purusha, the eternal, primeval person or universal man, made in red on a wall at the time of a boy's initiation, used to be made on the earth (Newcomb, Fishler, and Wheelwright 1956:95, Fig. 8). Wheelwright found this symbol to be almost identical to the Navajo Indians' representation in sandpaintings of the mythological creature Big Fly (Wheelwright 1956:87, Fig. 1).

In 1850, R. Spence Hardy described a ritual carried out by Indian Buddhists that involved circles of colored clay (Hardy 1850: 252–57). In this observance, called *pathawi-kasina* (earth-*kasina*), a priest wishing to attain supernatural powers sits and looks at the circle as he meditates, pondering the symbol over and over. This ascetic practice "frees the mind from all agitation." The de-

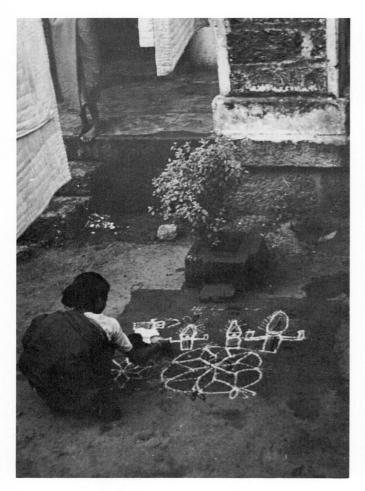

Figure 112. Woman making a drypainting (*Āl-ponā*) in the courtyard of an Indian boarding-house in Bhuvaneshvar, Orissa, India, during a local festival of Jagannath ("Lord of the Universe"; a form of Krishna, a manifestation of Vishnu). In it may be seen Jagannath (Krishna), his favorite brother Balarama, and their sister Subhadra. Photograph, L. C. Wyman, November 1953.

sign must be made in a threshing floor, a field, or any other place that has a limit, under a tree or projecting rock, or in a temporary shelter. The circle, *kasina-mandala,* must be small so the priest can fix his eyes on it, the "size of a winnowing fan" or "brazen porringer." The clay used to form it must be light red, the color of the sky at dawn or of sand deposited by the Ganges. The space outside the circle may be white. Cloth, a skin, or a mat is stretched on a frame of four sticks, and the clay is spread upon it.

The type of ground painting known as *Ālponā* (Alpana, Alipana) was described and illustrated in a Bengali book by Rabindranath Tagore (1921), which was translated into French by Karpelès and Chatterji; an abbreviated English rendering was published by the latter. Shorter illustrated articles have been published by Ray (1938) and Mookerjee (1939). As practiced today, *Ālponā* may not always be drypainting, strictly speaking, since it is usually done by mixing vegetable colors with rice powder and water and squeezing this liquid from a piece of cotton held in the hand or allowing it to run down the first finger from a rag soaked in it. Mookerjee (1939:5) said that it is likely, however, that the designs were originally made by "spreading white powdered rice or by drawing lines on a layer of this powder" and that "perhaps the necessity of drawing Alipana with a solution of ground rice first arose when it was intended to be drawn on walls and pillars." Mookerjee (1939) also described a design used in the Maghandal-Brata in which five circles are drawn by lines incised in the earth, the uppermost representing the sun and the lowermost the moon; the circles are then filled with colored powders. The first circle is filled with powdered *bael* leaves (green), the second with powdered tumeric (yellow), the third with burned

husk powder (black), the fourth, the moon, with powdered rice (white), and the fifth, the sun, with powdered brick (red). Tagore's book (1921) shows 120 designs and has two color plates from which we can see that although yellow and white were the colors mostly used, red, pink, blue, green, and black were also employed.

Tagore said that *Alponā* is a domestic art practiced only by women, being transmitted from mother to daughter, and that all motifs are born in the feminine imagination. Ray (1938) pointed out, however, that since the art has been practiced for centuries by the women of Bengal, where it is still a living tradition, without any perceptible changes, repetition and uniformity are its most fundamental characteristics. He said:

> Shapes, forms and motifs, and their combinations which have to be drawn by numberless people many times over generally become conventionalized to a certain extent for the convenience of successive generations of painters. So we find a fixed arrangement in the structure of Circular Alpana. . . . This conventionalization discounts variety and originality. Thus we find a certain mechanical monotony, a stereotyped symmetry in the designs of Alpana, yet the inherent vitality of the motifs of these designs is such that it invariably asserts itself through its conventional fetters (Ray 1938:6–7).

The designs are made only by lines that transform "reality into an abstract pattern and [are] thus ornamentation in its purest form" (Ray 1938:8).

The ground paintings of *Ālponā* are made both outdoors or in courtyards and on the floor in the house for weddings and festive occasions. They are made for semireligious ceremonies connected with the cults of various goddesses of the earth, of rain, of prosperity, and of beauty, or with gods such as Krishna. A circular design may serve as a holy decorative pedestal for a particular person on a particular occasion or for the image or symbol of a deity, especially during the worship of the goddess Lakshmi. Ray said, "The repetition and uniformity of the motifs in the designs gives a stable character to the Alpana and because of this stability the spectator or worshipper feels confidence in placing the seat of the gods on it and using it as a holy carpet" (Ray 1938:7). Some ceremonies aim to render fields fertile and are not consecrated to special divinities but are mixtures of popular festivals and ritual ceremonies. Some are reserved for young girls who may practice the art as early as five years of age. The different cults are intimately linked to the changes of the seven seasons, such as the cult of the month of Magh (January–February) celebrating the birth of spring, the defeat of winter, and the triumph of the sun. *Ālponā* designs are made every day in the month, and on the last day all the motifs previously drawn are shown simultaneously.

Designs of the same general style are found throughout Bengal, but in each village they appear with slight modifications. In general the designs are curvilinear, often floral in character, but some are reminiscent of hieroglyphics or show such objects as furniture, boats, houses or temples, gardens, or rivers (Mookerjee 1939:8; "pictographic marks"). There seems to be no limit to the subject matter. Among the wealth of symbols and designs may be found flowers, especially the lotus, fruits such as bananas, flowering trees, bamboo, vines, grains of rice, betel nuts, mollusk shells, insects, fish, birds, people, the earth, sun, moon, and stars. Designs made for the cult of the goddess Lakshmi may show her feet or footprints, or her jewelry, crown, comb, or sari.

Tibet and Nepal

Drypaintings are used in certain rites of Lamaistic Buddhism conducted by the lamas (Buddhist priests) of Tibet and among the Sherpas who live in northeastern Nepal near the foot of Mount Everest. The design is almost always a mandala (Sanskrit; *kyilkhor* in Tibetan), a holy, magic, or mystic circle or sacred surface representing the structure of the universe (Blofeld 1970:103) or the dwelling place of a deity and his retinue. Tucci said that as a visible projection of the scheme of the universe, the mandala is not merely a cosmogram but an actual transposition of the cosmos, a psycho-cosmogram—indeed it is the universe itself "led back from its material multiplicity to its quintessential unity" (Tucci 1949:318).[1] The mandala probably originated in India and then penetrated into Tibet.

These designs are used in initiation ceremonies, so that the initiate may see before his own eyes the mystery of the universe. Sharing the power transmitted by the rite, which enters his body and remains there, and grasping the way to true knowledge, wisdom, and understanding of the meaning of things, he is led eventually to spiritual maturity and release. The officiating lama identifies himself with the deity invoked and receives therefrom the power he desires. He summons the presence of the mandala deity so that its spiritual force may be communicated to the initiate. He may allot to the initiate an "indwelling deity" or "tutelary deity" (*yidam*) from among those represented in the mandala to dwell in the initiate's heart and help him attain enlightenment (Blofeld 1970:176).

The monks of the Tengboche monastery in Khumbu, Nepal, celebrate the great festival of Dumje in July, before the exodus of the villagers to their summer settlements (von Fürer-Haimendorf 1964:185–208). This six-day ceremony is an annual memorial rite for the patron saint of the monastery and for other noted lamas, and an annual expression of the solidarity of the participants. A raised triangular platform is fashioned of molded earth to serve as an altar for burnt offerings, and it is covered with a drypainting in several colors. A tripod supporting a pan of butter is set on this altar, a fire is lit on it, and substances such as butter, honey, and grass are burned. In the late evening of the fifth day, a dough effigy of the demonic fiend (typically, one described in a text governing the ritual) is pierced with miniature weapons by the senior lama, its parts are thrown into the fire, liquor is also thrown in, and as it blazes up a shout of joy greets the burning of the fiend.

Mandalas are drawn by knowledgeable lamas on the floor of a temple chapel, on a raised platform in the courtyard, or on a carefully cleared and swept, flat, smooth piece of ground outdoors that has been purified and consecrated with appropriate rites (Tucci 1949:270; 1956:37; 1969:37). The officiant takes great care to purify himself by fasting and bathing. A propitious day and time is chosen, and a secluded place—perhaps near a riverbank or lake north of a town—is selected for construction of the mandala. The dry pigments used are usually spoken of as "powders of five different colors" and may include rice powder or colored sand. The colors are white, yellow, red, green, and dark blue, corresponding to the five meditation Buddhas, the fivefold scheme of a center and four directions, the five components of the personality, and the five passions or perturbations. Black may also be used. The fundamental lines of the design may be laid out by means of two cords, a

white one and one composed of five intertwined threads, each of a different color. A cord is dipped in colored powder and laid on the prepared surface, the ends are held so it is taut, and it is raised and allowed to fall suddenly, making a straight line. By repeating this several times a schematic outline is obtained in which various designs may be drawn. Dry pigment may be applied to the surface through a funnel (Bernbaum: personal communication). An error, oversight, or omission renders the whole process useless.

Drypainted mandalas vary in size from a square with sides equal to the distance from the middle finger tip to the elbow of the lama who is drawing it (David-Neel 1959:60) to great mandalas many feet across. A *kalachakra* (wheel of time) mandala made for the Panchen Lama for a ceremony performed in October 1932 and illustrated by Gordon (1952:93) appears to be twenty to thirty feet in diameter.

Although originally mandalas were drawn on the ground, in the course of time they have come to be more often painted on cloth and used as objects of general worship; that is, they have become identified with the *pata*, or painted scroll or banner. Such scroll paintings are more widely used today as meditation aids because they are more convenient and can be rolled up and kept for future use.

In general, the design of a mandala representing a projection of the cosmos or the dwelling of deities has an outer enclosure with four gates and one or several concentric circles (of fire, of *vajras* [thunderbolts], of lotus leaves, and so forth) within which is a square or some concentric squares. In the center of the mandala is a blue disk with a lotus. The central square is divided into four triangular sectors by lines running from the central circle to the four corners, and in the center and in the middle of each triangle are five circles containing figures or emblems of divinities. The gods are shown in five main groups, and being thus invoked, they take their places in the mandala. Each part of the design has its significance and a particular name. The directional color symbolism is blue in the center, white in the east, yellow in the south, red in the west, and green in the north. In abstract mandalas, the deities are represented by symbols. Figures or symbols of deities are enclosed by circles drawn in the form of stylized lotuses. Less complex mandalas are simplified versions of this design or are detached sections of the grand mandala (Tucci 1949:318–20; 1969:37–45, 49–84; Blofeld 1970:102–9).[2] Waddell mentioned "elaborate circles of colored clay" and said, "I have seen diagrams of apparently similar character in Burmese Buddhism" (Waddell 1971:145, n. 3).

A mandala may be made for the use of a high lama when he worships on a special day with a special ceremony (Gordon 1952:92). Usually, however, it is made for the initiation (esoteric baptism) of a neophyte. A grand mandala is made upon the consecrated ground, and the prescribed rites are performed around and within it. Various objects are placed around it—vases or vessels of water, milk, or other substances and weapons, cakes, painted scrolls, and numerous other things. The officiating lama blesses himself and the mandala, and the candidate is admitted as the lama summons the mandala deities to be present; their knowledge and spiritual force are about to be communicated to the neophyte. The candidate prostrates himself before the lama and the mandala. Then he is blindfolded with black silk, symbolizing wisdom veiled by

ignorance, and led to the eastern gate of the design (David-Neel 1959:57–72; Tucci 1969:85–107). There the lama gives him a short stick of wood (like that used for cleaning the teeth in India) or a flower, which he throws on the mandala. The section on which it falls—center, east, south, west, or north—indicates the Buddha and the way best suited to the novice, and he is given a new name, depending on that section, which he must keep secret. Then he must try to identify himself with the essence of the Buddha or symbol thus selected. The lama removes the blindfold with a wand and asks what color the neophyte sees in the mandala. The color he sees most clearly indicates the nature of the wisdom predominant in him. Then the lama leads him, step by step, into the mandala, pointing with his wand to successive parts of the design and explaining them, instructing the neophyte more deeply in its mysteries as he approaches the center. Eventually the initiate finds himself physically in the center, where he realizes in himself the truth that the pattern symbolizes and becomes ideally identified with the center. Alternatively, the initiate may traverse the mandala simply by inward visualization of this centripetal journey. Whether by a physical or mental journey, the mandala is entered into, and the ceremony of initiation is a *pravésa*, an entry (Tucci 1949:318). This usage, strangely enough, reminds us of the Navajo term for a drypainting, which means something like "the entry of several," a place where supernaturals enter and leave. Finally the vessels of holy water are touched to four parts of the neophyte's body and a drop of water is poured on each, the middle vessel to the top of the head, the eastern one to the heart, the southern to the throat, the western to the navel, and the northern successively to each of these four places (David-Neel 1959:67–70). These applications are believed to purify and strengthen the initiate. At the end of the ceremony, which may last three hours, the mandala is obliterated. Some years later the initiate may be reintroduced into the mandala, and its mysteries may be revealed to him at a higher level of understanding (Blofeld 1970:108). A number of interesting parallels between Tibetan and Navajo drypainting design and use will suggest themselves to one familiar with the practices of the two cultures.

Australia

In Australia, drypaintings are used mainly by the aborigines of the central part of the continent, especially by the Aranda (Arunta) and Warramunga tribes of the Northern Territory north of the Macdonnell Ranges, but they have been seen in other places as well. The country, the travels, the camping places, or the rock or pool where some totemic ancestor first came to life is often the subject of the ground drawings. They may be made for ceremonies connected with ant, lizard, snake, emu, wildcat, fire, or other totems. The aborigines believe that a drypainting design actually is what it represents; the totemic creature, seeing itself in the painting, is pleased, comes to the ceremonial ground, occupies its likeness. Some ceremonies are rituals of atonement and propitiation to avoid retribution for the killing of totemic animals (Levine 1957:952). Throughout, there is intense concern for fertility and increase. Berndt and Berndt (1964:263) described Australian love magic, in which a man goes into the bush in secret, makes a sand drawing of two snakes, male and female, with a symbol of the girl between them, and sings over it.

The aborigines employ some unusual

techniques and materials in making their drypaintings. A patch of ground in a secluded spot is cleared and consecrated. It may be surrounded by an enclosure of branches. Among the Aranda and Warramunga, several men open veins in their arms and saturate a space about three yards square with blood, which is allowed to dry and harden (Spencer and Gillen 1927:154–57; 1938: 179–83; Berndt and Berndt 1964:229). Alternatively, the ground is made firm by sprinkling it with water and letting it dry. The design is made with white pipe clay, or kaolin, red and yellow ocher, coal, charcoal or black iron ore sometimes mixed with grease, and red and white bird down or vegetable down. The solid pigments are ground on a stone. The vegetable down is made by pounding grass or the white felty leaves and twigs of *Kochia,* a chenopodiaceous herb, between two stones and mixing the fluffy material obtained with powdered white kaolin or red ocher. The hardened surface may be covered with a layer of red or yellow ocher on which white and black designs are drawn or on which the colored down is arranged. Sometimes the design is not a drypainting, but the mineral pigments are ground with water to a semiliquid consistency and applied to the ground with brushes made of narrow strips of chewed bark or a frayed twig, or with a finger. The main designs are drawn by old medicine men, but others may help. Judging from the photographs published by various authors, the usual ground drawing appears to be from three to five feet by six to ten feet in size, but some are up to eighteen or twenty feet long.[3]

In general, the predominant designs are concentric circles, sometimes red and white circles alternating, and meandering lines. Groups of red and white lines may radiate from the circles (Basedow 1929:Pl. XXXVII).

A line of down or a background entirely covered with down may surround these motifs. A painting for the emu totem published by Mountford (1969:108) shows concentric circles surrounded by three-toed emu tracks. Another design symbolizing a place associated with a snake totem has realistic human tracks around it (Spencer 1928: Fig. 307). Levine pointed out that the importance of the food quest in a land of scarcity leads to great concern with identifying the tracks of men and animals; hence the animal track motif in Australian art reflects the life situation there (Levine 1957:961–62). Another emu design has two large yellow patches representing lumps of fat, but most of the surface is covered with circles and circular patches representing emu eggs in various stages of development, sinuous black, red, and yellow lines representing intestines, and white spots signifying feathers, with the whole enclosed by a line of pale pink down (Spencer and Gillen 1938: Fig. 29).

Sometimes the Arandas make a ground painting in a lightly scraped out depression in the soil, but often mounds of earth are covered with colored materials. The Warramunga make an image of their gigantic and fearsome mythical snake, believed to be 150 miles long, on a keel-shaped mound of sand about two feet high and fifteen feet long. The snake is a long wavy band four inches wide, with a swelling at the north end indicating its head. The rest of the mound is covered with innumerable dots of red and white down; the construction represents a sand hill where the snake stood up and looked around. A fence of boughs about fifteen by thirty feet surrounds the mound. It takes seven or eight hours to make the image, which is rubbed out, restored, or added to on the forenoon of the day following the

ceremony. The image is (usually) made anew on eight successive days, each time on the same spot in the ceremonial ground; each new drawing commemorates a distinct locality where, it is believed, the snake stood up and left spirits behind it.

According to Basedow (1929:281–82), if an unauthorized person happens to enter the sacred ground while a ceremony is in progress, he is killed and buried under the spot occupied by the design. The ground is then smoothed and the painting is made again. After a ceremony involving ground drawing, the drawing is carefully obliterated to prevent its being seen by inappropriate persons. The great snake ceremony of the Warramunga culminates in a spectacular performance. During the day, chanting goes on for hours while participants walk around the mound and stroke its base to appease the snake. At ten o'clock in the evening fires are lit and the participants sit, dance, and sing around the mound until four in the morning when, yelling wildly, they make a savage attack on it, hacking it to pieces until only a rough heap of sand is left (Spencer and Gillen 1938:463–67). This rite of "laying the snake to rest" is carried out to drive him down and force him to send rain or to grant other desires.

Mexico and Guatemala

Drypaintings are used in Christian observances in parts of Latin America during Holy Week or when the feast days of a church are celebrated. In Mexico these drypaintings are called "carpets" and are made of dyed sawdust, flower petals, and sometimes coffee grounds. They are made in the atrium of a church or in front of the houses of "humble folk." Drypaintings made for private houses are usually made only with flowers.

Scofield has given a description and a colored illustration of a large drypainting made of pine needles, sand, dyed sawdust, and flower petals, over which the massive platform with the figure of Christ bearing the cross is carried by many men in one of the processions of Easter Week in Antigua, Guatemala (Scofield 1960:408–12). Many such "carpets" are made in front of people's homes along the route of the procession. The bearers of the platform pause momentarily on the drypainting, shuffling their feet so as to blur the design. Scofield in four days witnessed five of these colorful processions, which combine Christian and Indian practices (see also de la Haba and Scherschel 1974:668–69).

Christian Drypainting in the Southwestern United States

A remarkable adaptation of Navajo Indian sandpainting for Christian purposes was made by the colorful Episcopal priest, Father H. Baxter Liebler, who founded St. Christopher's Mission to the Navajos at Bluff, Utah. Finding it difficult to present the meaning of Good Friday to the Navajos because of their dislike, indeed their fear, of talking or thinking about death in any way, he hit on the idea of making a sandpainting of the Crucifixion in front of the altar of the mission house while he read selections from the story of the event from the Franciscan Fathers' *Catechism* (Liebler 1969:67–70). He made the picture about a yard square using light-colored sand mixed with paint. The Indians accepted this; in fact, they were greatly intrigued by the idea of a white man making a sandpainting in one of his religious rites. Furthermore, it is an interesting commentary that they credited him with bringing plentiful and much-needed rain because he had made the sun in yellow sand and oblit-

erated it with black sand as he read of the darkness spreading over the land! Father Liebler made another sandpainting of the pierced heart of the Savior on Corpus Christi Day (Liebler 1969:76–77).

Japan

In Japan, an entirely secular form of drypainting is practiced, serving only for ornamentation or entertainment. On rare occasions, perhaps, its products may serve a semireligious purpose as ornaments for funerals or other solemn religious services. This is the art of tray landscapes or tray pictures made in black lacquered wooden trays (Koehn 1937, Yanagisawa 1955). Their origin, like that of Japanese temple gardens, was religious, however, for in earlier days the landscapes on trays represented realms with religious significance such as Hōraisan, the imaginary land of eternal youth referred to in Taoism, or the sacred Mount Shumisen of Buddhism (Sumeru, the central mountain of the universe of Hinduism). Traditionally the art is supposed to have originated in the reign of the Empress Suiko (A.D. 593–628), when the Emperor of China is said to have sent a unique incense burner to the imperial court of Japan. The top section of the vessel had a rock on it representing Mount Shumisen with coarse white sand around it. Later, on ceremonious occasions, it became customary to remove this upper part and use it as an ornament. From the fourteenth or fifteenth century there are many literary references to the art as a hobby of the upper classes. In the Edo period (A.D. 1603–1867), making tray landscapes became a major pastime and numerous schools developed.

There are three fundamental types of tray decorations, *bon-kei*, tray landscape proper; *bon-seki*, literally tray stone; and *bon-é* or *bon-ga*, tray picture. The first incorporates earth and tiny plants into the scene and thus is somewhat akin to the art of *bonsai*, making miniature trees. It does not concern us here. *Bon-seki* consists of making landscape scenes with sand, gravel, and small stones or pebbles, and hence is a kind of actual drypainting. The famous sand and rock garden of the Ryōanji Temple in Kyoto, a rectangle of sixty square yards containing only white sand and fifteen rocks, is *bon-seki* on a grand scale. *Bon-é* is like *bon-seki* but stones are not used, so its creations are true pictures in sand on a black lacquered tray; that is, they are real sandpaintings.

The materials used by the different schools vary somewhat. Some employ sand or gravel of natural colors only, white, brown, and black. The white sand is usually pulverized to a very fine powder. Others use artificially colored sands, and still others use both. Trays may be rectangular or oval, and they average one by two feet and one inch deep. The dry pigments are not strewn with the fingers as they are in other countries but are arranged with a variety of implements. These include sieves of different grades for spreading layers of sand over the tray, spoons of various shapes and sizes, feathers for depicting fine details, wooden molds or stencils for making lines or figures, and other tools such as small brooms or chopsticks. Designs appropriate for various occasions—weddings, birthdays, the new year, a festival day—or simply expressing auspicious thoughts, such as longevity, are made and displayed in the *tokonoma*, the niche for paintings or ornaments in a Japanese living room, or on a shelf in a side alcove. Of course the tray must ordinarily be kept flat to prevent the materials from sliding off, but they may be stabilized by mixing gum arabic powder with the sand and heating it. Treated in this way the tray picture may be hung on a wall or displayed slanted on a stand.

Figure 113. G. Paul Smith, a Chautauqua entertainer, making a "sand etching" by strewing colored sand upon a slanted surface. Photographed between 1900 and 1910.

Bon-é or *bon-ga* was derived from another type of Japanese drypainting that differs from the art of tray pictures in several ways that make it more akin to the sacred ground paintings of India and Tibet and to those of the American Indians. This is the art of *suna-é,* sand pictures, which men in the street practiced at various times in Japanese history. Designs were made on the ground or in the street with sand spread with the fingers or with various implements. At first natural sands were used but later artificially colored sands were employed. Such sand pictures were made by beggars hoping for remuneration from passersby. Occasionally Buddhist mendicant priests also used this art to obtain alms, thus giving it a quasi-religious function. Historical records show that the art of *suna-é* was practiced at least as recently as the An-ei era (A.D. 1772–81).

Chautauqua Drypainting

In the field of entertainment an individual adaptation of drypainting technique was made by G. Paul Smith, a Lyceum Bureau and Chautauqua entertainer, in the first decades of this century. He made pictures before audiences that he called "sand etchings" by strewing with his fingers cornmeal colored with dyes upon a slanted velvet surface (Fig. 113). In a personal communication the late Dr. Burnham S. Walker wrote: "When I was a little kid I was occasionally put into service handing him the bowls of colored 'sand' as he did his act. The sand was actually corn meal colored with Diamond Dyes. On his snow scene he would sprinkle a little so-called diamond dust . . . I have no idea what it was but it would make the snow sparkle. After the audience had admired and applauded, Paul would tunk the plush frame against the floor, vanishing the picture."

Sandpainting Tapestries

Although not drypaintings themselves, the class of Navajo textiles called sandpainting tapestries, which embody more or less accurate copies of sandpainting designs in tapestry weave, deserves some discussion. The great majority of Navajo blankets or rugs have geometric patterns, but as early as the mid-nineteenth century a weaver occasionally indulged her fancy by weaving realistic representations of birds and animals, humans, houses, railroad cars, or whatever appealed to her imagination.[1] Amsden published a picture taken in 1873 of a weaver with her conception of the American flag, and a blanket with birds and animals collected in the 1880s (Amsden 1934:Pls. 114, 115); and Kent showed a blanket in color from the same period with twenty-four cows on it (Kent 1961:Pl. 14). Pictorial rugs are still woven occasionally, such as the design of five trimotored airplanes published by Dutton (1961:27).

Navajo pictorial textiles are in no sense symbolic but are woven solely for the weaver's own amusement or at the behest of white patrons. The first attempts to adapt the sacred designs of drypaintings to textile art seem to have occurred in the San Juan River region (around Farmington, New Mexico)

about 1900. The result was the beginning of the great flood of so-called Yei (Yay) or Yei-bichai blankets, which show single figures or, more often, rows of figures that are modifications of the anthropomorphic figures in sandpainting designs. These blankets caught on with the buying public because, enhanced by the mostly fictitious stories of traders and curio dealers about their rarity and pseudoceremonial character, they provided something strange and exotic for the tourist and collector. Because they are sold for exceptionally high prices, the white buyer feels they must be extra precious. Their true place in the textile art, however, has been firmly stated by two of the leading experts on Navajo weaving. Amsden (1934:106) said, "Evidently the Navaho themselves regard the Yei blanket much as we would consider a parody of the Bible, as something in bad taste. Its bad taste from the artistic standpoint is beyond question . . . for once the aura of mystery is dispelled nothing will remain but an awkward human figure in garish coloring, infinitely less attractive than the simple geometric patterns which are truly representative of Navaho textile design." Reichard (1936:154, 156) remarked, "The designs . . . are hideous attempts at represen-

tation of the Navajo gods, ugly because false in every respect," and she added, "Of the many 'yay' blankets I have seen I have never seen one which had, in my opinion, the slightest claim to artistic value. . . . I consider the 'yay' blankets a perversion of the good technique of weaving and a prostitution of the noble art of sandpainting."[2]

One class of textile art is, as Amsden said, "but an invasion of the temple by the money-changers, although often possessed of both artistic and ethnologic value" (Amsden 1934: 106) and may be favorably "compared with any tapestries" (Reichard 1936:156). These textiles are the replicas of whole sandpaintings woven with colors resembling those of the dry pigments of that art. When made by an expert weaver who has exercised good taste in her choice of colors, they are really beautiful, but such rugs are a minority of recent production. Sandpainting tapestries were late in appearing because even the Yei blankets shocked and angered many Navajos, partly because of their offense to good taste, but mainly due to the sacrilege in reproducing the sacred designs in a permanent medium, in direct opposition to the injunctions of their supernatural originators. Many tales were told of the dire consequences of thus offending the deities—blindness, crippling, and other misfortunes (Coolidge and Coolidge 1930:105). Weavers sometimes sought to avoid such curses by omitting some details or otherwise modifying the design. Sapir published a paper on this subject (1935), listing thirty-four "errors" that his interpreter Albert Sandoval had pointed out in a blanket he had purchased in 1929. And so the weaving of sandpainting tapestries goes on, for as Reichard (1936:161) remarked, "The dollar dangling at the end of a string pulled ever shorter and shorter, has the same effect on the Na-

vajo as upon ourselves. It supercedes all other values, be they social, moral, or spiritual."

In her book on weaving, Reichard (1936) mentions a number of women who, braving supernatural displeasure, were weaving sandpainting tapestries in the early 1930s. The J. L. Hubbell Trading Post at Ganado, Arizona, was encouraging the use of red backgrounds in sandpainting tapestries (because customers liked the bright colors; see *Arizona Highways*, July 1974:39–40), black borders, and large size (some as much as fourteen feet square). She also described and illustrated the work of her weaving teacher, Atlnaba, who was the older daughter of the singer Red Point (Miguelito). One of Atlnaba's tapestries, *Sun's House with Sky People* on clouds (Shootingway; see Newcomb and Reichard 1937:Pl. XIX) is illustrated in two of Reichard's books (1934:28; 1936:Pl. IXb).[3]

The best-known and finest sandpainting tapestries, however, were the work of a male weaver, the famous singer Lefthanded of Newcomb, New Mexico, and two of his nieces.[4] Because he did weaving, which is women's work, and for other reasons, Lefthanded was known to the Navajos by a term that means *transformed* and is their word for a berdache or transvestite.[5] He was the great-grandson of the famous Navajo chief Narbona (1766–1849). He was born in 1867 and died of pneumonia in 1947. His biography, written by his long-time friend Franc Johnson Newcomb, gives the details of his ancestry, his career as a singer, and his activities as a weaver (Newcomb 1964:113–25, 157–64).

Lefthanded wove ordinary rugs during most of his life. Newcomb said the first one he wove completely by himself was the one he made in Chicago at the World's Columbian exposition in 1892–93 (Newcomb 1964: 113–15). It was not until 1919, however, that

he made his first sandpainting tapestry, the design of the Whirling Logs from Nightway.[6] Newcomb (1964:157–64) tells the circumstances which finally led him to chance putting the sacred designs into permanent form, and in a conversation I had with her on June 25, 1970, not long before she died, she said, "I persuaded Klah to let me make a painting of the *Whirling Logs.* I made one and hung it in my bedroom so as not to disturb the Navajos. Klah caught a glimpse of it two or three times and said, 'Well, if having it permanently has not hurt you it may do no harm to put it in a blanket.' No one had dared to do it before." Moreover, Lefthanded was confident that his ability as a singer and his knowledge of chants and prayers would protect him from supernatural reprisals. His first sandpainting tapestry was purchased by Mrs. King C. Gillette while it was still on the loom and later was purchased at the auction sale of her estate by Read Mullan of Phoenix, Arizona. It is now in his collection (Mullan 1964:no. 18) and was illustrated in color by Newcomb (1964:Frontispiece). Lefthanded's last tapestry, a large one of *The Skies* (cloud-symbol form; Shootingway), was unfinished on his loom at the time of his death. His nieces finished it and gave it to the Newcombs to repay the funeral expenses. The family still owns it (Newcomb 1964:164, 214, Illustration 190; now on loan in the Maxwell Museum of Anthropology, University of New Mexico, Albuquerque).

Two of Lefthanded's sister's daughters were married to brothers. The older one, Gladys (Hanesbah) married Sam Manuelito, and Irene (Althbah) married his younger brother Jim Manuelito. Hence they were known as Mrs. Sam and Mrs. Jim.[7] These men were grandsons of the famous Navajo headman Manuelito (1821–93), who was

the son-in-law of Narbona, Lefthanded's great-grandfather. When the orders for Lefthanded's sandpainting tapestries became more than he could fill, he decided to enlist the aid of these two nieces, supervising their weaving and protecting them by singing over them. Mrs. Newcomb (1964:162) said that at first he sang a nine-night Night Chant over them and that he "held a sing over Mrs. Sam every time she started a new tapestry" (Newcomb 1969:personal communication).

In July 1970, Sam Manuelito's grandson Roger, then living in Albuquerque, visited the Museum of Navaho Ceremonial Art in Santa Fe (now the Wheelwright Museum), and in September he and his grandparents, Mr. and Mrs. Sam Manuelito, spent an afternoon there talking with Richard W. Lang, at that time curator of the museum. The following data are from a letter from Lang dated September 15, 1970. Mrs. Sam examined all fifteen of the tapestries then owned by the museum, correcting the previous attributions in four instances and saying that four other tapestries attributed to "Klah's nieces" were woven by her alone. She pointed out four differences between her and Lefthanded's weaving: (1) in his earliest pieces he sometimes used a gray background, (2) his tapestries were larger than hers, (3) his figures had straight legs or only slightly defined calves, whereas hers had pronounced calves, and (4) his work normally had a narrower border of brown than hers. She said that Irene had a Plumeway performed over her for protection, and she had a Nightway so that she could weave tapestries. Mrs. Sam said that she never wove with Lefthanded, that Irene was the only one to work with him (Mrs. Newcomb had said that Mrs. Sam wove half or more of the tapestries attributed to the family and that often the nieces would start one and, being

in a hurry for the money, Lefthanded would finish it "in a hurry" [Newcomb 1970:personal communication]). Mrs. Sam told Lang that since Lefthanded's death she has continued to weave sandpainting tapestries but that Irene no longer weaves them, making only Two Gray Hills type rugs. Mrs. Sam's daughter Ruby, from the area of Shiprock, New Mexico, also weaves small sandpainting tapestries (*Arizona Highways* July 1974:36; one of Ruby's tapestries, 39 by 42 inches, showing the *Whirling Logs* of Nightway with corn plants in the quadrants, is in a private collection in New Jersey). She has woven with her mother and their work is indistinguishable. Recently they were said to weave only Nightway designs. Mrs. Sam regularly received a blue ribbon for her work at the Gallup Ceremonial. She kept a herd of brown sheep and used only the belly wool for backgrounds. Lefthanded used wool from all parts of the brown sheep, so his backgrounds are less regular in color. A correspondent in Farmington, New Mexico, in February of 1979 said, "Mrs. Manuelito can no longer talk, a condition her neighbors say was brought about because she dared to weave these sacred designs."

From the beginning the tapestries woven by Lefthanded and his nieces commanded high prices, from hundreds of dollars to a thousand or more. Mrs. Newcomb (1970: personal communication) said that the standard price for a small tapestry around eight feet square was $250.00, and that they were the only traders who dared to risk that much. Today, because of their artistic and historical value, some of these works in museums are appraised well up in five figures. More than forty years ago Reichard wrote, "I feel that hardly any price is too high for them, because their value should be measured not only in effort which can scarcely be mea-

sured, so extensive it is, but also in emotion" (Reichard 1936:158).

An attempt was made to discover the present locations of as many of the sandpainting tapestries woven by Lefthanded and his nieces as possible. Sixty-five were located in museums or private collections, and five more were found as illustrations in various publications (Table 4).[8] Of these seventy tapestries, twenty-two were known to have been woven by Lefthanded or are attributed to him by their owners; one other and possibly a second were made by Lefthanded and his niece Irene; another may have been by him or his older niece Gladys; and his last unfinished piece was completed by his three nieces. Gladys (Mrs. Sam) apparently wove thirty-two of the remaining forty-four and possibly four others; she and Irene made one; two others may have been made by her or Irene; and only one is attributed to Irene alone. The two tapestries now in the Denver Art Museum, and one in the University of Pennsylvania Museum, are of the style of the Lefthanded family group. Their size and certain internal characteristics indicate that they may have been made by Gladys (Mrs. Sam). Finally, four of the tapestries known only from illustrations could not be assigned definitely to a weaver.

There is uncertainty in the attribution of the smaller tapestries. As Mrs. Sam pointed out, Lefthanded's pieces were generally larger than hers. Table 5 shows that although the majority of the smaller ones were woven by the nieces, there is a group of eight that have been attributed to Lefthanded. Judgments based on size alone could throw some doubt on these attributions.

These seventy textiles certainly do not represent the entire output of Lefthanded and his nieces. One of Newcomb's daughters owns a tapestry made by Mrs. Sam

Manuelito. More than a half-dozen others have been mentioned by various people who once owned, saw, or heard of them, and doubtless still others have not been discovered. Moreover, it seems that some of those purchased by Wheelwright have been lost. Newcomb (1964:164) said that Wheelwright bought twelve that were woven by Lefthanded and nine that were made by the nieces and that all of these were in the Museum of Navaho Ceremonial Art in Santa Fe (as it used to be known; hereafter referred to as the Wheelwright Museum). The museum now has only ten tapestries that were received from Wheelwright: five by Lefthanded (two of these were stolen in 1973), one by him and Irene, and four by Gladys. If Newcomb's count was correct, eleven tapestries have disappeared.[9] Moreover, in the light of these findings, it seems likely that her estimate of the numbers woven by the family was too small. She said that "between 1919 and the time of his death in 1937, Klah wove twenty-five sandpainting tapestries and his nieces wove as many more" (Newcomb 1964:164).

Only six collections contain more than one or two tapestries by Lefthanded and his nieces (see Table 4). The largest number, seventeen, are in the Wheelwright Museum.[10] Seven are in the Museum of Northern Arizona, the gift of the late Mrs. Harold Gladwin of Santa Barbara, California; four, including the first one woven by Lefthanded, are in Read Mullan's Gallery of Western Art in Phoenix; seven, including four that were exhibited at the Chicago World's Fair in 1934, are in a private collection in Arizona, containing the largest number (six) woven by Lefthanded himself, now owned privately by one person; ten tapestries, nine woven by Gladys (Mrs. Sam) and one by her daughter Ruby, are in a private

collection in New Jersey, the largest number of textiles by Lefthanded's family privately owned by one collector; four woven by Gladys are in the possession of a dealer in northern New Mexico; and three, also by Gladys, belong to Mr. and Mrs. Earl J. Bowers of Colorado. Five others, presumably the work of Gladys, are owned by individuals in Colorado, Arizona, New Mexico, Michigan, and Oklahoma.

Sandpaintings of only five chantways are represented in the tapestries woven by Lefthanded's group, and two of these, Mountainway and Eagleway, are represented by only one apiece. The largest number of designs, twelve, is from the Night Chant (forty-nine tapestries), five are from the Hail Chant (nine tapestries), and five are from the Shooting Chant (ten tapestries) (see Table 4).[11] The first two of these chants were Lefthanded's specialties (Newcomb 1964:101–12). By far the largest number (eighteen) of any one of the woven designs are versions of the ever-popular *Whirling Logs* of Nightway. Three types are represented: one with four corn plants, one in each quadrant (eleven tapestries); one with the four sacred domesticated plants (corn, beans, squash, and tobacco) in the quadrants (six tapestries); and one with a corn plant and one of the domesticated plants in each quadrant (therefore an especially powerful design).

Five of the Nightway designs are unique among recorded sandpaintings: eight Talking Gods and eight Calling Gods with corn (Plate 30; property of Lee M. Copus, Oklahoma City; a similar design with four Calling Gods and four Female Ye'i is in the Haile collection); two sets of six black Male and six white Female Ye'i, each set approaching a blue cornstalk in the center (probably a variant of *First Dancers;* in a private collection in New Jersey); four quartets of Rain-

TABLE FOUR

LOCATIONS OF SANDPAINTING TAPESTRIES BY LEFTHANDED AND HIS NIECES

Chantway and Design	Wheelwright Museum Santa Fe, N.M.	Museum of Northern Arizona Flagstaff, Ariz.	Read Mullan Gallery Phoenix, Ariz.	Private collection Ariz.	University of Colorado Museum Boulder, Colo.	School of American Research Santa Fe, N.M.	Denver Art Museum Denver, Colo.	University Museum University of Pennsylvania Philadelphia	Lowe Art Museum University of Miami, Fla.	U.S. National Museum Washington, D.C.	Privately owned	From illustrations not located
Nightway												
Whirling Logs (4 corn)	G; G&I¹			K¹					K or G		G; G? (6)²	?
Whirling Logs (4 plants)	G	G	K; K								G	?
Whirling Logs (corn & plants)	G											
First Dancers	K&I³		G					G?			G(3)	?
Male & Female Ye'i with corn											G	
Talking Gods & Calling Gods											G	
Black Gods with corn	K³											
Black Gods on stars		K		K								
Fringed Mouths (linear)							G?			G or I	G(4)	?
Fringed Mouths (radial)	K											
Water Sprinklers	G										G	
Rainbow People (radial)						K(&I?)						
(Angled) corn with Ye'i	K; G	K		K							G	
Sweathouse—Night Sky	G	K		K								

Chantway and Design	Wheelwright Museum Santa Fe, N.M.	Museum of Northern Arizona Flagstaff, Ariz.	Read Mullan Gallery Phoenix, Ariz.	Private collection Ariz.	University of Colorado Museum Boulder, Colo.	School of American Research Santa Fe, N.M.	Denver Art Museum Denver, Colo.	University Museum University of Pennsylvania Philadelphia	Lowe Art Museum University of Miami, Fla.	U.S. National Museum Washington, D.C.	Privately owned	From illustrations not located
Hailway												
Storm People with corn	K											K
Thunder People with corn	G											
Storm People (radial)	K	K										
Rain People (radial)		G										
Night Sky	K	K									G	
Shootingway												
Monster Slayer on Sun	G											
Whirling Tail Feathers				K								
Earth and Sky				K			G?					
The Skies	K		K								K&G&I; G(3)	
Sun, Moon, and Winds											G	
Mountainway												
Mountain Gods (radial)				G or I								
Eagleway												
Eagle trap with decoys					I							
Number of Tapestries	17	7	4	7	1	1	2	1	1	1	23	5

[1]K—woven by "Klah" (Lefthanded); G—by Gladys (Mrs. Sam Manuelito); I—by Irene (Mrs. Jim Manuelito).

[2]In parentheses are number of tapestries with the design if more than one.

[3]Stolen August 26, 1973.

Figure 114. Corn with Ye'i, Nightway, Pollen Branch. Sandpainting tapestry (91″ × 99″) woven by Lefthanded, 1925–35 (compare with his sandpainting, Plate 10). Courtesy Museum of Northern Arizona.

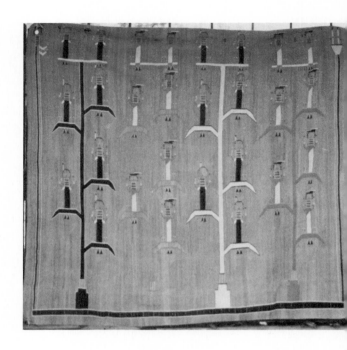

TABLE FIVE

DIMENSIONS OF SANDPAINTING TAPESTRIES

Larger Dimension (inches)	Woven by Lefthanded[1]	Woven by Gladys and/or Irene[2]
38–41		3
54–59		5
60–71	8	20
72–83		4
84–95	1	4
96–107	7	1
108–120	9	

[1]Including all known or supposed to have been woven by Lefthanded and three woven by him and his nieces.

[2]Including three woven by Gladys and Irene and one by Irene alone; thirty-three of these were woven by Gladys alone.

270

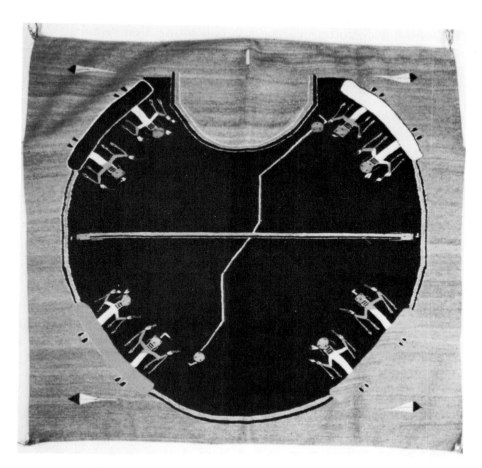

Figure 115. Sweathouse design, Nightway (see Figs. 97, 98). Sandpainting tapestry (62" × 65") woven by Lefthanded, 1920–30. Rainbow and Lightning People crossed over the roof, the four sacred mountains with a Male and a Female Ye'i seated on each one, and a rainbow around the door. Courtesy Museum of Northern Arizona.

bow People in radial formation (Wilder 1966:Pl. 4); the four corn plants with one or two Ye'i standing on each leaf or angle of the stem (Fig. 114, Plate 10); and the sweathouse design with pairs of Ye'i seated on the four mountains and the night sky covering the house (Fig. 115).

In recent years there has been a widespread resurgence of sandpainting tapestry weaving. Numerous women in scattered areas of the reservation are producing them in considerable quantities. Most of them are copied from designs in published works, many of them from Wyman's *Beautyway* (1957).[12] On the whole they are rather small (around five feet square), and with some exceptions the colors are garish, quite unlike the beautifully soft colors of Lefthanded's work.

Reproductions of Drypaintings in Collections

Afraid to disobey the injunctions of the supernaturals against making their sacred pictures in any permanent form, the Navajos have, except in rare instances, stoutly resisted the attempts of outsiders to photograph or copy them during ceremonial use. Therefore, only a handful of white artists and fewer Navajos have been able to make watercolor or crayon reproductions of the drypaintings. Various methods have been used by non-Navajo recorders: witnessing the paintings in ceremonials and making sketches from memory, which were then criticized by informants (Newcomb), making paintings under the direction of Navajo singers without actually seeing them in ceremonial practice (Oakes), making finished reproductions from notes made furtively or openly (depending on the temper of the hosts) while watching sandpainting ceremonies (Wyman and others), or in rare instances photographing paintings during ceremonials (Katherine Harvey, Leonard McCombe, Josef Muench, Charlotte Johnson [Frisbie], Kenneth Foster, Karl Luckert, and a few others). This list does not include the many photographs of sandpaintings that have been made when Navajo singers were demonstrating their art at public exhibitions such as the Intertribal Indian Ceremonial at Gallup, New Mexico, or at shows held in museums such as the Navajo Craftsman Exhibit at the Museum of Northern Arizona in Flagstaff.

While the manuscript of the present work was in preparation, a book by Donald Sandner (1979), a Jungian psychiatrist, appeared containing a fairly extensive account of Navajo ceremonialism, its practice, and its mythology. In addition to colored plates of twelve reproductions of drypaintings from the Wheelwright Museum, this book contains two colored photographs taken by the author of a Navajo making a sandpainting.

Non-Navajo Artists

Franc Johnson Newcomb, the widow of the Indian trader at Newcomb, New Mexico, and a lifelong student of the Navajos, made by far the largest number of sketches and watercolor reproductions of drypaintings executed by any single person, perhaps well over five hundred. She made all of the paintings in one important collection (Bush); fully half of those in the largest assemblage

of reproductions at the Wheelwright Museum in Santa Fe; and some of those in the Haile, Reichard, and possibly one or two other collections. Moreover, until her death, she retained in her personal collection in Albuquerque more than five hundred reproductions. Her collection is now in the Maxwell Museum of the University of New Mexico. She described her methods and her collection in her biography of the singer "Hosteen Klah" (Newcomb 1964:125–27).

Laura Adams Armer of Fortuna, California, made a sizable collection while living among the Navajos in the Black Mountain, Arizona, region. Most of her original paintings, or copies made by Margaret Schevill Link of Tucson, are now in the Wheelwright Museum or the Arizona State Museum in Tucson. In a note with Mrs. Link's paintings she wrote, "We made ninety-eight paintings for Mary Wheelwright" (that is, for the Wheelwright Museum). Maud Oakes of Big Sur, California, gave sixty-four of her collection of nearly a hundred reproductions to the Wheelwright Museum.

Among the students of the Navajos who assembled collections of drypainting reproductions without actually making any copies themselves were Father Berard Haile, O.F.M., the Franciscan missionary of St. Michaels, Arizona; Gladys A. Reichard, professor of anthropology at Barnard College, Columbia University, New York City; Katherine Harvey, the daughter of Fred Harvey, late president of the Fred Harvey Company; and Mary Cabot Wheelwright, who collected numerous examples that she had painted by various artists in her employ to add to the holdings of the Museum of Navaho Ceremonial Art, which she established in Santa Fe in 1937. Smaller collections of a dozen or fewer items have been made by several other people.

Navajo Artists

Some of the reproductions in certain collections, especially a number in the Wheelwright Museum, are of doubtful value for studying more than the general layout of the design because, as witnessed by written statements on the pictures themselves, they have been "corrected," "redrawn," or "repainted" by various artists other than the original recorder. Sometimes two, four, or even six persons had a hand in this process. In such copying and recopying, inaccuracies or changes in minor details are bound to creep in, and in instances where the original rough sketches made from drypaintings at or near the time they were seen by the recorders are present together with the finished copies, it is obvious that this is the case. Moreover, comparison of duplicates of a design in different collections made by the same recorder sometimes shows that she or he did not regard some minor details as significant. In the face of such manipulation of the reproductions, it is impossible to say without firm statements by informants which of the minor variations are symbolically meaningful and which are not. Reproductions of drypaintings made directly by Navajo singers, with one notable exception discussed shortly, are therefore more valuable records than those of non-Navajo recorders. Such reproductions deviate from actual practice only in slight changes sometimes made by the painter "to quiet doubts he may have had about the preservation of the pictures in a permanent medium" (Reichard 1970:190). Reichard thought that Red Point substituted green paint for blue for this reason, because in other respects "his paintings are remarkably consistent and accurate when compared with others and with the mythical description" (Reichard 1970:190).

Among the dozen or so Navajos who dared to defy the interdictions of the supernaturals, two individuals were most prolific, working on wrapping paper from the trading post or on drawing paper given them by collectors, on cloth, or on other materials. These were Sam Chief, who worked for Louisa Wade Wetherill of Kayenta, Arizona, between 1910 and 1918, and Red Point, better known by his Spanish nickname, Miguelito, who lived a mile south of the J. L. Hubbell Trading Post at Ganado, Arizona. These two men, however, made paintings that were stylistically quite distinct.

Most of the drawings made by Sam Chief in the Wetherill collection are decidedly unorthodox, nonstandard, if you will, both in form and in color. This may have been so for three reasons: Sam Chief's apparent delight in experimenting with the new kinds of materials—colored crayons of many hues, drawing paper, and so on—given him by Mrs. Wetherill; problems stemming from unfamiliarity with these media, such as the shape of the paper; and fear of both supernatural and human reprisals if the designs were made too accurately. In her notes, Mrs. Wetherill tells of his reluctance to make the sketches, of the secrecy he demanded, and of the fear he expressed of the consequences. Sam Chief also made six equally unorthodox actual sandpaintings in the Arizona State Museum in Tucson in 1918 and left them there, but unfortunately all but two have since been lost in attempts to ship them to other institutions (see Fig. 105). His paintings are, however, not without value for the study of the art. More or less orthodox copies of some of them made by Clyde A. Colville, modified toward standard sandpainting style, are available, and the collection is the only one of considerable size from the Kayenta–Monument Valley area; it may

contain evidence for a regional style (Wyman 1952:10, 14, 16, 114–15).

Miguelito, on the other hand, was notable for daring to be accurate. In her book about him and his paintings Reichard said, "He therefore took a chance that, by prayer and purification, he could atone for the sin of breaking the rules; and however wildly the conflict raged, he nevertheless made the paintings and made them accurately" (Reichard 1939:7). Reichard also said that when she met Miguelito in 1930 he was making a set of sandpainting reproductions for Roman Hubbell and that he had about twenty watercolors at that time (Newcomb and Reichard 1937:3). Four of these are still in the Hubbell Trading Post (a National Historic Site since 1967); Mrs. Roman Hubbell (Sun City, Arizona) has five of them; the late M. L. Woodard of Gallup, New Mexico, had one of buffalo from the Shooting Chant; another is in the Reichard collection, and photographs of ten others taken by Dane Coolidge are in the files of the Wheelwright Museum.[1] Another group of fifteen watercolors by Miguelito are in the Etnografiska Museet, Stockholm, Sweden (see Figs. 12, 26, 34). These were collected by Nils Hogner in 1929 or 1930, when he was living in Arizona, and given to the museum in 1939.[2] In 1924 Miguelito made twenty-six paintings from the Shooting Chant and one from the Bead Chant for John Frederick Huckel, founder of the Indian Department of the Fred Harvey Company in Albuquerque, under the direction of Herman Schweizer, manager of that department.[3] These are now in the Huckel collection in the Taylor Museum of the Colorado Springs Fine Arts Center (Wyman 1971).

The Mrs. Charles D. Walcott collection stored in the U.S. National Museum contains twenty-eight reproductions of sand-

paintings painted on dark tan-colored cloth by an old singer called Big Lefthanded between 1905 and 1912. He made them for Matthew M. Murphy, a trader and Navajo agent at Indian Wells and Tuba City, Arizona. They were purchased by Mrs. Walcott in 1932 and given to the museum in 1935 (Wyman 1970b).

Another sizable collection of reproductions made by natives, now a part of the Huckel collection, contains eighty-four watercolors made between 1902 and 1905 (Fig. 4) by four Navajo singers for Sam E. Day, Jr., an Indian trader at St. Michaels, Arizona, or his brother Charlie, who had a trading post at Chinle.

Besides these major groups, there are some five smaller lots of paintings made by Navajos in various collections. Some of the original sketches for paintings in the Haile collection were made by natives. In 1940 Bertha Dutton had two Indians from Canyon de Chelly, Arizona, make thirteen watercolors on paper and four real sandpaintings for the Museum of New Mexico in Santa Fe.[4] In 1940 the same two Navajos also made nine paintings for the General Charles McC. Reeve collection in the Southwest Museum in Los Angeles, California.[5] Reproductions of six sandpaintings for the Night Chant in the Museum of Northern Arizona were copied from designs made on wrapping paper in colored pencil by a Navajo from the Black Falls Area, perhaps around 1910 (Robert C. Euler collection, 1950). In 1968 the Honorable Barry Goldwater gave the Museum of Northern Arizona ten watercolor reproductions of sandpaintings from the Male Shooting Chant, which he said were "made many years ago by a Navajo" and which he thought were given to him by Bill Wilson, who managed the Rainbow Lodge and Trading Post near the Utah line in northern Coconino County, Arizona (Wyman 1972c).

Collections

Attempts to estimate the numbers of reproductions of drypaintings in major collections encounter difficulties like those that hamper the determination of the number of different designs. Most of the major collections contain, besides completed designs that are obviously distinct, duplicates of paintings in other collections, made by the same artists or by other copyists; duplicates made to improve crude original sketches that appear in the same collections; reproductions of small drypaintings used for purposes other than the sandpainting ceremony, such as the shock rite or sweat-emetic, bath, or prayer ceremonies; sketches of big hoop ceremony trails, prayer sticks, bundle properties, or designs for body painting; diagrams of the layout of ceremonial equipment or of articles and people in the hogan in specific ceremonials; and unfinished designs or sketches of single figures or symbols. In the face of this variety of items, it is difficult to decide which to count among the holdings of a given collection.

Perhaps the best solution is to enumerate only the complete or nearly complete representations of designs used in actual sandpainting ceremonies or drypaintings used in Blessingway rites, and to omit the crude original sketches and other duplicates in the same collections. This does not eliminate double-counting of designs that appear in more than one collection. Such a count is valid only for the time it is made because some collections (such as that of the Wheelwright Museum) are constantly growing through the addition of new items, completion of unfinished works already in them, and so on, and still others may be depleted

through losses incurred in various ways.

Using these criteria, it may be said that there are nine major collections containing from forty to over five hundred paintings. They are the Wheelwright Museum, by far the largest, and the Oakes, Bush, Huckel, Arizona State Museum, Wetherill, Haile, and Reichard collections. The last three are in the Museum of Northern Arizona in Flagstaff. In addition, there is the privately owned Newcomb collection in Albuquerque, New Mexico (now on loan in the Maxwell Museum). The important smaller collections are the Walcott, Hubbell, Stockholm, Goldwater, Harvey, and Museum of New Mexico collections. Besides these there are many other single reproductions or groups of two or a few more paintings, mostly privately owned, scattered throughout the United States. Most of these are duplicates of paintings in the major collections.[6]

Table 6 gives the numbers and distribution in ten important collections of reproductions of drypaintings from the Blessingway rites and from seventeen Holyway chantways.[7] It should be understood that the numbers are tentative only, being the judgment of the author and subject to the difficulties previously described. Totals include copies of paintings in other collections, but the numbers of these are given separately when feasible in the brief descriptions of the collections below. Awlway and Earthway are not included in the table because there are only the three (or two) designs for the Awl Chant in the Wheelwright Museum and the four for the Earth Chant in the Oakes collection (now in the Wheelwright Museum).[8]

Wheelwright Museum

The collection in Santa Fe is made up for the most part of reproductions of drypaint-

ings made by Franc J. Newcomb; a considerable number assembled by Laura A. Armer (Fig. 101, Plate 21); those collected by Mary C. Wheelwright, the founder of the museum, and painted by various staff artists; and occasional items from other sources. In addition, sixty-four paintings from the Oakes collection are in this museum. Eliminating all but the major designs used in ceremonials, as suggested earlier, a total of 422 items for Blessingway and the seventeen chantways was obtained from a count made while I worked at the museum in 1970.[9] In addition, there were the 2 paintings from Awlway, 7 from Upward-reachingway, an Evilway chant, 2 used in divination rites, 5 associated with witchcraft, and 13 miscellaneous unidentified items, making a grand total of 451. A count of 620 items was made by Caroline Olin in 1971, but she may have included the Oakes collection, the many original sketches, the 65 small paintings for accessory ceremonies, and other diagrams, as well as 36 duplicates in the collection (Olin 1972:73).

Huckel Collection

The collection in Colorado Springs assembled by John Frederick Huckel consists of 93 reproductions of designs for sandpainting ceremonies, 5 for prayer ceremonies in Shootingway and 7 for Navajo Windway, 1 shock-rite painting for Shootingway and 4 for Mountainway, and 2 for the sweat-emetic ceremony of Navajo Windway, 112 in all. They were painted on brown wrapping paper (since backed with cloth) by five Navajo Indians (Figs. 4, 7). A catalogue of the collection with seven illustrations of its paintings has been published (Wyman 1971).

TABLE SIX

DISTRIBUTION OF REPRODUCTIONS OF DRYPAINTINGS IN COLLECTIONS

Ceremonials	Wheel-wright	Huckel	Wetherill	Haile	Bush	Oakes	Walcott	Arizona State Museum	Museum of Northern Arizona	Newcomb[1] A	B	Totals[2]	
Blessing	20		3			15		1	3	?	14	42	
Hail	16				12	3		1	5	16	13	37	
Water	13		7		2					12	4	22	
Shooting	45	41	6	18	51		18	12	36	108	77	227	
Shooting Evil	6			2						9	7	8	
Mountain-Shooting	8	2		2	2		4	1			4	19	
Red Ant	35		1	3	1			1		12	21	41	
Big Star	42	3	4			4	1		1	47	47	55	
Mountain	37	6	5	5	3	4		6	3	27	29	69	
Beauty	38	2	14			12	2	4	2	30	52	74	
Night	10		4	9	5	1	1	6	7	37	16	43	
Big God	8			3		1		1	1		4	14	
Plume	35		8	8		6	1	2	3	66	52	63	
Coyote	6					5		3		4		14	
Navajo Wind	46	31	2		19			1	5	9	74	72	113
Chiricahua Wind	8		1		2					18	9	11	
Hand-trembling	6					7			3		3	16	
Eagle	11	2				4				12	11	17	
Bead	19	6	5	1	5			3	16	14	17	55	
Totals	409	93	60	51	102	62	28	46	89	486	452	940	

[1]A. Estimate made by Newcomb in the 1950s.
B. Estimate made by L. C. Wyman in 1979 from a computer printout of the collection.
[2]Excluding the Newcomb collection, since the figures for that collection are only estimates.

Wetherill Collection

Louisa Wade Wetherill's collection, now in the Museum of Northern Arizona, contains eighty-three items: fifty-one different designs made for her by Yellow Singer (Sam Chief) and nine others painted in standard style by Clyde A. Colville of Kayenta, Arizona, sixty designs in all, together with crude or unfinished sketches and small copies of the larger designs made by Navajos and by Colville. The pictures were made with colored crayons, watercolor, and ink on wrapping paper, drawing paper, tracing paper, and one on tracing cloth. A catalogue of the collection, with descriptions, discussions, and illustrations of all the different designs, has been published (Wyman 1952).

Haile Collection

Father Berard Haile's collection, also in the Museum of Northern Arizona, contains ninety-seven items: fifty-one designs for sandpainting ceremonies, twenty-seven copies of them, seventeen small designs for various purposes (prayer ceremonies, shock rites, big hoop trails, and so on), and two unidentified designs said to be associated with witchcraft (Figs. 23, 25, 28, 37, 40). Some of the copies were made for Father Berard by Mrs. Newcomb, others by "a priest in Gallup, New Mexico" (Haile:notes).

Bush Collection

The reproductions of sandpaintings in the Bush Collection of Religion and Culture, Department of Religion, Columbia University, were originally said to number 110, but if certain designs for small sandpaintings made on the same card are counted separately, there are 121. Of these, 102 are sandpainting ceremony designs and 19 are small designs mostly for prayer ceremonies. According to an inventory made in 1971, several of the paintings could not be found. The late Gladys Reichard was instrumental in obtaining the paintings, all made by Franc Newcomb, for Professor Bush, and many of the Shootingway designs were published in the book she wrote with Mrs. Newcomb (1937).

Oakes Collection

Maud Oakes of Big Sur, California, made ninety-two reproductions of drypaintings. She gave sixty-four of them to the Wheelwright Museum: fifty-six different designs for Blessingway and various chantways, including four from the extinct Earthway, six paintings for stargazing divination, and two copies. She retained the ten Beautyway paintings that were described in the book on the chant (Wyman 1957) and the eighteen for the War Prophylactic rite that she published first in 1943 (Oakes, Campbell, and King 1969).

Walcott Collection

The twenty-eight reproductions of sandpaintings given to the U.S. National Museum by Mrs. Charles D. Walcott have been described and published by Wyman (1970b). With them are four secular pictures of ceremonial scenes showing dancers or masked impersonators of the Ye'i performing in Nightway, or riders carrying the rattlestick of Enemyway. These paintings, together with one by Big Lefthanded (Shootingway dan-

cers in a Mountain Chant) that was bequeathed to the Museum of Northern Arizona by Katherine Harvey, were described and published by Wyman (1967).

Arizona State Museum

The collection of forty-seven items in Tucson consists largely of paintings made by Laura A. Armer or copies by Margaret Schevill Link.[10] There are also eight copies of paintings in the Wetherill collection made by Clyde A. Colville and another by him (*The Skies*, Male Shootingway) that is not represented in that collection.

Museum of Northern Arizona

In addition to the Wetherill, Haile, and Euler collections, the Museum of Northern Arizona houses the Reichard collection, which contains some thirty-nine items. Most of these are paintings by Franc Newcomb, either copies of her work in other collections or slightly different versions of them.[11] There is also a painting by Miguelito. The collection bequeathed to the museum in 1963 by Katherine Harvey consists of thirty-one copies of paintings, mostly from the Huckel collection (seventeen Shootingway, two Beautyway, twelve Beadway), made by Fred Geary, the Fred Harvey Company artist, primarily for the illustrations in Reichard's 1939 book; two paintings by Mrs. Newcomb (Night, Big God); and a copy of a Shootingway design in the Wetherill collection made by Clyde Colville. Finally there are fifteen paintings made by Wyman, four copies from the Wetherill collection (one Blessingway, three Plumeway), and eleven reproductions of sandpaintings seen in ceremonials (eight

Navajo Windway, three Hand-trembling Evilway; Plate 13). In all, the museum's collection of reproductions of drypaintings contains 273 items, 200 of which are Blessingway or sandpainting ceremony designs.

Newcomb Collection

According to a list that Franc J. Newcomb made in 1951 and additional information given in 1959, her personal collection contained 506 reproductions of drypaintings. The figures in Table 6, column A, are from her estimates. Mrs. Newcomb died in 1970, and it was only recently possible to inspect the collection. It has been said that her daughter claims there are about 800 paintings and drawings in it (Olin 1972:73), but later information indicates that this is an exaggeration. Recently the collection was purchased by Mr. and Mrs. Morton H. Sachs of Louisville, Kentucky; it is now on loan to the Maxwell Museum of Anthropology at the University of New Mexico, Albuquerque. A catalogue has not yet been published (I understand that one is in preparation), but through the kindness of J. J. Brody, director of the museum, Natalie Pattison, registrar, and Mr. Sachs, a computer printout of the inventory was sent to me. It contains 521 items (22 depict two or three drypaintings). Newcomb had not labeled all of the paintings and drawings (especially the latter) with the name of the ceremonial to which they pertain, so the figures in column B of Table 6 are partly based on identifications—either definitive or tentative—that I made from the somewhat inadequate descriptions in the printout. Eighty-three of the items could not be identified; fifty-six of these were unfinished designs or merely preliminary sketches. Thirty-eight of the identified items

were also unfinished. Four reproductions of drypaintings used in divination (Wyman and Newcomb 1963) and four for Upward-reaching-ingway (Wyman and Bailey 1943:39; Wheelwright 1949) are not included in the table.

Wyman Drypainting File

In the library of the Museum of Northern Arizona there is a file prepared by Leland C. Wyman containing 1,469 cards, one for each of the reproductions of drypaintings in all the important collections (except for the Newcomb collection). The file is complete up to 1970, and no major collections have been established since then, so it represents all reproductions available for study. Each card is six by nine inches and has on it a five-by-seven-inch black and white photograph of the drypainting and the following data: number of the card; name of the ceremonial; name of the design, either a rendering of the Navajo name or a descriptive title; the collection containing the reproduction and the number in the collection; the Navajo author; his home or the locality of collecting; the recorder or collector; date; any additional data concerning the use or circumstances of making the drypainting; composition; description of the design; bibliographic references to published illustrations of it or of similar designs; bibliographic references to descriptions of it or of similar paintings (up to 1970); comparisons with other designs in the file; and pertinent quotations from the collectors' notes or from publications. This file brings together all data for all known reproductions of drypaintings. Recently, a section on sandpainting tapestries has been added to the file. It contains well over seventy cards organized in the same way.

Plains Indian Drypainting

Although the nomadic buffalo hunters who once roamed the Great Plains of the northern midwestern United States were not southwestern Indians, the limited use of the art by the tipi dwellers of the Plains will be briefly described. Their chief use of such paintings was in the sun dance (sun watching or mystery dance), an annual ceremony originating among certain Plains tribes. In it, while enduring various forms of physical torture, "the Indian considered that he offered to Wakan'tanka what was strongest in his nature and training—namely, the ability to endure physical pain. He did this in fulfillment of a vow made in time of anxiety, usually when on the warpath" (Densmore 1918:85–86). Red Bird, a Sioux Indian, said, "The Sun Dance was our first and our only religion. We believe that there is a mysterious power greater than all others, which is represented by nature, one form of representation being the sun" (Densmore 1918:85–86). There is published information on the use of drypaintings in the sun dance among the Arapahos (Dorsey 1903), Blackfeet (Wissler 1912), Cheyenne (Dorsey 1905b), Poncas (Dorsey 1905a), and the Teton and Yankton Sioux (Densmore 1918). Observations and studies were made among these tribes after they had been removed to Indian Territory (Oklahoma) or to the reservations established in the northern Midwest (for example, among the Sioux on the Standing Rock Reservation, which straddles the border between North and South Dakota).

Usually the drypainting was part of an altar made in the sun dance enclosure or lodge, a circular barrier of posts, poles, brush, and buffalo hides about fifty feet in diameter, with an entrance at the east. The sacred pole, some thirty-five feet tall, stood in the center of the circle, and about fifteen feet west of it the intercessor (the official of the dance who prayed and sang on behalf of the people) while singing prepared the "sacred place." A square or rectangle of sod about twelve by eighteen inches, or sometimes about three feet square, was removed, making an excavation from three to six inches deep, and the exposed earth was finely pulverized. Dry pigments ("colored earth") were strewn on this excavation with the fingers. A bed of fresh sage was placed just west of this and a buffalo skull painted with red stripes from nostrils to horns was laid on it. Sage was used because the buffalo liked to roll in its fragrant leaves. A tobacco pipe given by the leader of the dancers was placed

283

leaning against a rack with its bowl on the skull (Densmore 1918:Pl. 20). After the ceremony was over, the intercessor took the pipe to his lodge for smoking. During the entire performance he sat to the west of the sacred place. Finally the buffalo skull, the drypainting, the eagle down that had been placed upon it, and the sacred pole with its offerings were left in the lodge for the elements to obliterate, as a sacrifice to the great mystery.

In the Arapaho sun dance the floor of the excavation in the sacred place was divided into equal parts by a black line. The southern half was then filled with fine, close black lines, and the northern half was filled solidly with red paint. The black symbolized the earth and the red, the Indians themselves (Dorsey 1903:Pl. LXI, 109–10). Wissler (1912:219–20) said that the altar or smudge place of the Blackfoot sun dance was the most elaborate one used by them. The sod that was removed was made into a wall on three sides of the three-foot-square excavation (none on the east), and the top was covered with creeping juniper. The bottom of the excavation was covered with fine, light-colored earth, and a yellow crescent moon with a black stripe in its center, stars, and other symbols were made on it. The designs were first traced lightly with an eagle tail feather and then boldly incised with the toe of a new moccasin for the right foot. Apparently this altar was made in a tipi.

The Cheyennes covered the floor of the excavation with plain sand poured from a bag to a depth of half an inch. Then this field was divided into five equal parts by four lines traced lengthwise across it with a stick. Pinches of black, red, yellow, and white paint were dropped in that order, one color at the beginning of each of the four lines. Then the chief official completed them in their respective colors and made a dotted line on each side of each one with sand the color of the line itself. The dotted lines represented stars; the black unbroken line represented the trail of the buffalo, the red one was the road of the Cheyennes, the yellow one was the path of the sun, and the white one was the road of the lodge maker and his wife. The entire design was a symbol of the morning star, or of the earth (Dorsey 1905b:Pl. XLVI, 142–44). In the rectangular sacred place of the Teton Dakotas (Sioux), two intersecting lines—parallel to the sides but not touching them—were incised forming a cross. The intercessor filled the incisions with tobacco that had been offered to the sky, the earth, and the cardinal points. Then he covered the tobacco with powdered vermilion paint and spread pulverized, shining white selenite (gypsum) over it. Finally he put bunches of downy white eagle feathers at the intersection and ends of the lines (Densmore 1918:Pls. 16, 20; 97, 99, 122, 127, 149–50).

In two important respects, the drypaintings for the sun dance of the Poncas differed from the paintings already described. Four different drypaintings were made, one in each of the four preparation tipis, and they were circular instead of square or rectangular. A circular area about five feet in diameter was cleared in the tipi, the ground was smoothed, and the space around it was covered with branches of sage, the butts pointing toward the tipi walls. The design of the first painting consisted of four concentric circles slightly excavated into the earth and covered with dried paint. The three inner ones, about six inches apart, were red (in the center), yellow, and green. Around them was a broad unexcavated ring covered with red paint reaching out to the sage. The second painting was a circle quartered by

two crossed black lines. At the ends of the lines were symbols of buffalo hooves representing these beasts. The lines were their paths and those of the four winds. The third design was a circular field of sand about two feet in diameter with a shallow trench two inches wide around it with its sides covered with red paint, representing the sun. Downy eagle feathers were scattered all over the whole, which represented the nest of the thunderbird. Finally, the fourth painting had four concentric circles. The inner one, about two and one-half feet in diameter, was blue, the next was red, the third was also blue, and the outer one was again red. This design was the sun's symbol of one of the four medicine worlds (Dorsey 1905a:Pls. VII, VIII, IX). On the fifth day of the ceremony a man sitting opposite the entrance of the tipi behind the drypainting made a small hole at the edge of the painting with his thumb and poured water into it. Then he dipped some sage into a cup of water and drew it across the mouth of each dancer. Finally he passed the sage back and forth over the sun symbol, destroying it. Food (dog meat) was given to the dancers and each one broke off a bit, raised it aloft while muttering a prayer, and dropped it on the center of the drypainting.

The Siksika (Blackfoot) Indians also made drypaintings on or around the smudge altars they used in ceremonies connected with their medicine bundles. Some vegetable substance was burned on these altars so as to produce a scented smoke, hence the name *smudge* (incense). Nearly every tipi had a smudge altar, because medicine bundles were universally used. Indians who lived in houses made drypaintings on a wooden tray filled with earth. Some were excavated to a depth of six inches; the sod was piled around three sides to make a wall and covered with creeping juniper. The designs were circular, triangular, or most often, square with sides from twelve to thirty inches long. The drypainting symbols—made with black, white, red, yellow, and green dry pigments—were mostly of heavenly bodies, the sun, crescent moon, stars, sundogs, and sunrays. Wissler pictured a number of these designs (1912:Figs. 10, 32, 35). The Blackfeet even made a smudge altar to treat a sick or exhausted horse. Incense was burned on an image of a horse track, rubbed on the animal, and given to him to eat.

COLLECTION DATA FOR ILLUSTRATIONS[1]

Collection	Figure	Recorder or Collector	Singer[2]	Locality[3]	Date of Collecting
Wheelwright Museum	24	Franc Newcomb	Ta'chini	Tanner Springs, Ariz.	1929 or 1930
	22; Pls. 4, 6, 8, 10, 16		Lefthanded	Newcomb, N.M.	1928–1933
	Pl. 5		Blue Eyes	Lukachukai, Ariz.	1930
	Pls. 11, 12		Bit'ahni	Newcomb, N.M.	1938
	89, 93		Policeman	Cedar Ridge, Ariz.	1950
	102, Pl. 18		Smiling Singer	Dilkon (White Cone), Ariz.	1948
	Pl. 17		Plumeway Singer	Sweetwater, Ariz.	1933
	103		Rock Canyon's Son	White Cone, Ariz.	1938
	106		Warrior Walking (?)	Mariano Lake, N.M. (?)	1955
	9		Gray Chief	Washington Pass, N.M.	ca. 1935
	Pl. 14		Very Tall Man	Sawmill, Ariz.	1930
	85	David McAllester	RC	Lukachukai, Ariz.	1957
	101	Laura Armer	unknown	Black Mountain, Ariz. (?)	1929 (?)
	Pl. 21		Massive One	Black Mountain, Ariz.	1929
	Pl. 19	Mary Wheelwright	Yellow Rock Center	White Cone, Ariz.	1941
Huckel	4, 7	Sam E. Day, Jr.	Speech Man	Canyon de Chelly, Ariz.	1902
Haile	23, 28	Fr. Berard Haile	Gray Man	Chinle Wash, Ariz.	1934
	25, 37, 40		Slim Curly	Crystal, N.M.	1930's
Arizona State Museum	21	Laura Armer	Massive One	Black Mountain, Ariz.	1929
	Pl. 20	Matthew Murphy	Big Lefthanded[4]	Tuba City, Ariz.	1905–1912
Etnografiska Museet Stockholm	12, 26, 34	Nils Hogner	Red Point (Miguelito)	near Ganado, Ariz.	1929 or 1930
Wyman	Pls. 7, 13	Leland Wyman	Curly Man's Son	Mariano Lake, N.M.	1937
Matthews	8	W. Matthews	unknown	Hard Earth (20 miles northwest of Fort Wingate, N.M.)	1884

[1]This table presents only the data for reproductions of drypaintings in various collections. Photographs were taken for Figures 16, 17, 30, 94–96 at the Navajo Craftsman Exhibit, Museum of Northern Arizona, Flagstaff, during the summers of 1959 to 1969, by Parker Hamilton and Paul V. Long, staff photographers at the Museum, and for Figures 13, 27, 29, 107, and Plates 2, 3, 9 by Leland C. Wyman. Photographs for Figures 11, 14, 15, 97–100 were taken by Brother Simeon Schwemberger O.F.M. of Saint Michaels Mission, Arizona, in 1905 or before. Similar data for other illustrations may be found in the captions for the figures.

[2]Singers' names are transliterations or English renderings of the Navajo nicknames by which they were known to the recorders.

[3]Localities are the singers' homes when known; otherwise they are the places where the paintings were seen by the recorder.

[4]Copy made by Margaret E. Schevill Link.

Notes

CHAPTER ONE

Introduction

1. In recent years, many Navajo Indians have been making large numbers of permanent reproductions of sacred sandpaintings for sale in curio shops throughout the West (see Joe, Bahti, and Branson 1978; Parezo 1980). These are done by strewing the dry pigments on a stiff board base covered with an adhesive. The designs are sometimes more or less accurate copies of actual sandpaintings, but usually they are modified. Although derived from the Navajos' ceremonial art, these pictures are used entirely for decoration. A few white artists have also produced such pictures, some of them antedating the Navajos' efforts along this line. The work of one of these was described and illustrated in the magazine *Think* (Halacy 1958:24–25). A European artist, Van Ransbeek of Hekelgem, Belgium, used this technique some thirty-five years ago to make copies of studio paintings.

2. In a personal communication (1954), Stella Kramrisch said, "Powder painting on the ground is referred to explicitly (for the first time) in the *Vishudharmottara*" (the supreme laws of Vishnu). This work is one of the *Purānas,* which are sacred texts of Hinduism, compendia of legends and religious instructions formulated in the Gupta Period (A.D. 320–ca. 540). If true, this would place the earliest literary reference at a much earlier date, but in a perusal of Kramrisch's translation of this work (1928) no reference to drypainting was found.

3. I am indebted to Edwin Bernbaum of Cambridge, Massachusetts, for detailed information concerning the drypainting used in a ceremony he witnessed recently at the Tengboche monastery in Khumbu, Nepal. It was made on the altar for burnt offerings as described in Appendix A. Accounts of Tibetan religion may be found in Li An-che (1950:251–69), Bell (1931), Snellgrove (1957), and Waddell (1971).

4. I am indebted to Señora María Isabel Rodoreda de Kirn of Puebla, Mexico, for detailed information concerning Mexican drypaintings (1958:personal communication). She said that a famous one is made in the church of del Carmen in Puebla on July 16.

5. I am indebted to several Japanese friends and to the Japan Society of New York who very kindly provided information and references concerning Japanese drypainting. I am also indebted to the late Kojiro Tomita, curator emeritus of the Asiatic Department of the Boston Museum of Fine Arts, and to the late Chimyo Horioka, Far Eastern librarian of that museum.

6. Beals (1945:202) suggested that dancing in the church during Holy Week (*Pascua*) was fostered by the missionaries as a substitute for dancing around the drypainting.

7. The *Memorias para la historia de Sinaloa* pre-

served in the manuscript collection of the Bancroft Library of the University of California consist of documents, mostly written by missionaries, copies of the *Anuas* of Sinaloa missions, and letters.

CHAPTER TWO
Navajo Drypainting

1. But see also Hall (1951), Smiley (1951), Robinson, Harrill, and Warren (1974:3), C. Schaafsma (1975:31–37), Hammond and Rey (1953:1059), Reeve (1956:229), and Bartlett (1932:29).

2. Numerous illustrations of the Navajos' way of life may be seen in McCombe, Vogt, and Kluckhohn (1951) and Kluckhohn and Leighton (1962).

3. Valuable studies of the social aspects of Navajo ceremonialism may be found in Chiao (1971) and Chisholm (1974).

4. Karl W. Luckert, assisted by Johnny C. Cooke, Navajo interpreter, and Irvy W. Goossen, linguist in Navajo, has recently edited and/or published two important works concerning Excessway and Mothway (Haile 1978; Luckert 1978). These works contain recordings and translations of the myths by Father Berard Haile, O.F.M., and materials from Luckert's own fieldwork. Luckert also published (1979) a detailed account of a nine-night Coyoteway ceremonial that he witnessed and recorded on Black Mesa, Arizona, in January 1974. English translations of most of the songs are given, and 136 photographs (including ten in color) illustrate every step in the ceremonial procedure. These constitute the most complete photographic record of a nine-night Navajo chant ever published.

5. In a performance of the rarely utilized Sun's House phase of Male Shootingway, a painted screen of rods of wood or reeds representing the Sun's permanent home in the eastern sky is set up in the west (back) side of the hogan on the fifth night of a nine-night chant and remains there throughout the remainder of the ceremonial (Wyman 1970b:15–18).

6. Details concerning ceremonial procedure

may be found in numerous publications; see especially Kluckhohn and Wyman (1940) and Reichard (1970).

CHAPTER THREE
The Origin of
Navajo Drypainting Art

1. There is evidence that the myth and ceremonial of Nightway were well established, perhaps widespread, by the first half of the eighteenth century, some hundred years after the earliest documented Navajo-Pueblo contacts and about 175 years after the earliest reported Apachean incursions on the eastern Pueblo frontier.

2. Frank Hamilton Cushing adumbrated this opinion when he remarked that since the Navajos have no suitable wall surface for pictorial treatment, their paintings have to be made on the ground (quoted in Mallery 1893:211). He also thought that at Zuni "powder painting" on the floor pertained to the lower regions of the Zuni universe, while paintings on the walls of the kiva pertained to the upper regions.

3. Dorothy Louise Keur agreed with Parsons's view that Pueblo sandpainting seems to have been derived from the Navajos (Keur 1941: 12). In her excavations on Big Bead Mesa, she found carefully cached raw materials for sandpaintings—friable yellow, red, and white sandstone, sometimes with charcoal (Keur 1941:64, 70). The Navajo hogan sites in that area were dated, however, in the latter half of the eighteenth century, after the period of Pueblo-Navajo acculturation in the Dinetah. The question of the direction of diffusion involves, of course, the perennial question as to which of their cultural traits the Athapascans brought with them into the Southwest. The testimony of the pictographs seems to indicate that when they were made, the Navajos had not yet developed their drypainting art to any great extent. Tanner (1948:31) suggested still another hypothesis, that both the Pueblos and the Navajos derived their sandpaintings from a common prehistoric source, the Anasazi.

4. See also Newcomb and Reichard (1937:Pl. XXVII), Reichard (1939:Pl.XXIV), and Wyman (1950:Fig. 1; 1970b:Pl. 21).

5. See also Wyman (1971:Fig. 15; 1975:Figs. 15, 16).

6. See also Hewett and Mauzy (1940:90–91), Sinclair (1951).

7. See, for instance, in Tanner (1957), the color plate following page 8, which shows a painted slab from the Kinishba ruins in east-central Arizona with a figure posed like a Navajo Thunder.

8. P. Schaafsma has illustrated this in an excellent diagram (1963:Fig. 54).

<div align="center">CHAPTER FOUR</div>

The Practice of Drypainting Art

1. Compare Fig. 8, an illustration from Matthews's monograph of 1887, with Fig. 9, a painting made by Mrs. Newcomb about 1935. The first sandpainting designs ever published were two line drawings of paintings from the Mountain Chant published by Washington Matthews in 1884, followed by colored reproductions in 1887. Sandpaintings for the Night Chant seen by James Stevenson in 1885 were published in 1891; Matthews began studying this chant in 1880 and published sandpaintings from it in 1902.

2. See also E. S. Curtis (1907, I:122).

3. For instance, a singer was observed making a drypainting of the Sun about three inches in diameter, with a face of blue pollen (dried, pulverized larkspur petals) and features of yellow corn pollen, on an overnight visit to Chinle, Arizona, where witches are thought to abound. After singing one song and making a jewel offering, he left the painting under a juniper tree and went to bed, no doubt feeling well protected against bewitchment.

4. Discussions and illustrations of Blessingway drypaintings are in Wheelwright (1942, 1949); Oakes, Campbell, and King (1969); and Wyman (1970a:65–102).

5. There have been reports that the Navajos use gypsum to make white dry pigment, azurite to make blue, and malachite for green (copper carbonates); see Cummings (1936:3) and Wyman (1952:14). These were used by the singer Sam Chief in making six drypaintings in the Arizona State Museum in Tucson, which were stabilized and left as permanent displays (all but two have since been destroyed); see Figure 105. The copper carbonates were used liberally, the entire background of a painting of the Earth being made of green malachite. The materials, however, were supplied by the University of Arizona. It is doubtful that azurite and malachite would be used very often, if at all, in chant practice because these minerals, although abundant elsewhere, are scarce in the Navajo country. Azurite is used to make blue water color for figure painting.

6. A thorough discussion of the symbolism of color may be found in Reichard (1970:187–240).

<div align="center">CHAPTER FIVE</div>

The Nature of Drypainting Designs

1. No attempt is made here to document completely all the published drypaintings showing the symbols under discussion. Only references to representative examples will be given.

2. Extensive discussions of the symbology of number may be found in Newcomb (1956:9–12) and Reichard (1970:241–49).

3. See also Newcomb and Reichard (1937:Pl. III), Wyman and Newcomb (1962:47–50, Fig. 6).

4. See also Newcomb and Reichard (1937:Pl. XVIII), Wyman (1970b:34, Pl. 4).

5. More details concerning the symbolism of red may be found in Newcomb (1956:16–18) and Reichard (1970:197–200).

6. See also J. Stevenson (1891:Pl. CXXI), Matthews (1902:Pl. VI).

7. See also Newcomb and Reichard (1937:Pls. IV, V), Wyman (1957:Pls. I–IV).

8. See Newcomb and Reichard (1937:Pls. XII, XIII), Wyman (1962:Figs. 27–30; 1970b:Pl. 30).

9. See La Farge (1956:130), Wyman (1962:Figs. 43, 44).

10. See Wyman and Newcomb (1962:Fig. 3), Wyman (1970b:Pl. 28).

CHAPTER SIX
The Nature of Symbols

1. See Wyman (1970a:65–102). Extensive discussions of sandpainting symbols are in Newcomb and Reichard (1937:42–87) and in Newcomb (1956:4–48).

2. See also J. Stevenson (1891:Pl. CXXII), Reichard (1939:Pls. XX, XXIV).

3. Other examples are the body of four inverted blue cloud symbols of Moisture Woman in an Upward-reachingway painting (Wheelwright 1949:161); Scavenger, the hero of Beadway, with a bird's body and wings in the final episode of the myth (Reichard 1939:Pls. VIII, IX); and the tapering bodies of Star People in some Big Starway paintings (Wheelwright 1956:Pls. X, XI).

4. Although the English term *god* does not convey the true nature of these supernaturals, it is retained in order to avoid the awkwardness of the longer designation, "the failed to speak one," and because it has been used by all who have written about Navajo ceremonialism since the late nineteenth century.

5. See Newcomb and Reichard (1937:Fig. 9, Pl. XVIII), Wyman (1970b:Pl. 4).

6. Examples of all these may be seen in Newcomb and Reichard (1937:Pls. IIB, D, XI), Wheelwright (1946a:171, 173, 179, 201), and Wyman (1957:Pl. XVI; 1962:Figs. 31–38, 52–56).

7. See also Wheelwright (1949:151), La Farge (1956:130), and Wyman (1957:Pl. XI; 1962:Figs. 43, 44).

8. See Newcomb and Reichard (1937:Pls. XXX, XXXI), Wheelwright (1946a:165).

9. See Newcomb and Reichard (1937:Pls. XXIX, XXXII, XXXIII), Wheelwright (1946a:199), and Wyman (1957:Pl. XIII).

10. Examples of the varieties and arrangements of snakes and Snake People may be seen in the illustrations of the works cited in this section.

11. See Newcomb and Reichard (1937:Pl. XVIII), Wyman (1970b:Fig. 34).

12. Extensive discussions of Big Fly and Ri-

pener, with illustrations of the variant depictions occurring in recorded sandpaintings, are in Wyman and Bailey (1964:137–44).

CHAPTER EIGHT
Small Sandpaintings for Special Purposes

1. A sweat ceremony that does not employ a sweathouse, called the outdoor or firing-pit sudorific or the trench sweat, may be used in Nightway. It is also described in detail in the myth of Female Mountainway (Wyman 1975:193). Four open fires are built on the ground or in a pit or trench dug in it at different cardinal points outside the hogan on successive days. When the fire has burned down, the ashes are cleared away, and the heated ground is covered with seven layers of piñon, juniper, and spruce boughs, and various herbs and grasses. The patient is laid on this bed with his head toward the hogan, covered with blankets, and left there while certain songs are sung.

CHAPTER TEN
Apache Drypainting

1. The number of patients varies. In the rite described by Opler there were three, two men and a woman. Women are not allowed to enter the tipi during the drypainting ceremony unless they are patients. Male patients are naked except for a loincloth; female patients wear a single garment. Details of the ceremony may be found in Opler's monograph (1943:17–23, 28–29, 31–33).

2. Dr. Corbusier's description of a supposed Yuman ceremony is also quoted in somewhat more detail in Mallery (1893:505–6).

CHAPTER ELEVEN
Pueblo Drypainting

1. Mrs. Stevenson is said to have made her way into the most secret and most sacred Pueblo ceremonials through a combination of persua-

sion and intimidation, even claiming to be a medicine woman herself, with supernatural power (White 1962:1–5). White found it difficult to define her attitude toward the Indians. There is no doubt that she had numerous good friends among the Zias and Zunis, but in one account she tells how she desecrated a Zuni shrine by removing sacred images to photograph them. "The aged officer was horrified on discovering the writer's intention and begged that the images . . . be not taken from the place where they had rested undisturbed for centuries of moons." She remarked, "But it had to be done." She also said that "these children of nature are like civilized beings of tender years, and can be controlled through kindness or firmness" (M. Stevenson 1904:204). In another connection she speaks of "the worst element in their barbaric nature" being aroused (M. Stevenson 1904:585).

2. Parsons wrote, "All students, old and new, have been faced with the baffling inequality of conditions for inquiry that exists in the eastern and northern pueblos compared with the western. In the East the very existence of societies, let alone their ritual, is hard to come by. . . . Not a single inside ceremony has been witnessed by any ethnologist, excepting at Sia, nor even an outside kachina dance" (Parsons 1939:940).

3. Rarely the reredos may be made of painted cloth. Painted stone slabs or ceramic tiles with designs of butterfly, locust, and clouds may also be used. Many illustrations of Pueblo altars, both in color and in black and white, may be seen in the numerous publications by Fewkes, Voth, M. Stevenson, and others cited here. As one goes northeast among the Pueblos, altar equipment becomes less elaborate, slat altars are not used at all, and drypaintings become less frequent (Parsons 1939:956).

4. Bourke (1884:Pls. XVIII, XIX [black line drawings]), Donaldson (1893:69 [Moran's colored line drawings]), Fewkes (1894a:18, 54 [colored drawings]; 1896a:Pl. LXXI [line drawing]; 1897b:Pls. LXXI, LXXII, LXXIII [black line engravings]; 1900:Pls. XLVI, LIII [color]; 1924:Pl. 6 [color]), Dorsey and Voth (1902:Pls. XCI [half-tone photo], XCII [color], CXXII [color], CXXV

[half-tone photo]), Voth 1903a:Pls. CLXI, CLXII, CLXIII [half-tone photos]), Stephen (1936:Pls. XVII, XVIII, XX [color], Figs. 350, 365, 394 [line sketches], and several crude line sketches or details [Figs. 330, 349, 351, 359, 364, 375]).

5. In a year when the *wüwüchim* society holds an initiation, the *powamu* ceremony is extended one day. At this time a meal altar of the six directions is made outdoors at a kachina shrine by the *powamu* chief. The altar is visited by kachina chiefs, and by clan mothers and *wüwüchim* initiates carrying basket trays of corn and spruce (Parsons 1939:507).

6. Inasmuch as the descriptions and illustrations of Pueblo Indian drypaintings are widely scattered in the literature, some in publications not easily accessible, all the significant accounts and illustrations will be described here in order to bring together these data for the convenience of interested students.

7. See Note 1. Mrs. Stevenson, accompanied by her husband James, spent six months of field work at Zuni in 1879 and another six months in 1881. After Mr. Stevenson's untimely death in 1888, Mrs. Stevenson carried on the work for many years, which culminated in her great monograph of 1904.

8. The Hopi words, *kachina* for the supernaturals who are impersonated by masked performers and *kiva* for ceremonial rooms or chambers, have become standard terms for their equivalents in most of the literature on all pueblo ceremonialism. The Zuni words for them are *koko* and *kiwitsine*.

9. Examples of cloud symbols and/or meal roads may be seen in Plates 23 and 29 in this work, and in M. Stevenson (1904:Pls. XXXIV, XXXV, LVIII, CII, CIV, CVIII, CXVI, CXXV, CXXVII, CXXXIV, and Figs. 6, 7, 33). Stevenson's Plate CXXVII is reproduced in Parsons (1939:Pl. VI).

10. The three drypainting designs published by Albert Reagan in his historical novel, *Don Diego* (1914), and attributed by him to knife and giant societies in the Towa-speaking pueblo of Jemez, are obviously copied from Mrs. Stevenson's (1894) Plates XVIII, XXII, and Figure 14.

CHAPTER TWELVE
Papago Drypainting

1. This chapter was derived entirely from personal communications from Dr. Donald Bahr, professor of anthropology, Arizona State University in Tempe, and from Dr. Bernard L. Fontana, ethnologist, Arizona State Museum, Tucson. I am much indebted to both for taking time from their busy schedules to answer my inquiries. The account of Pima-Papago theories of sickness and curing was taken from Dr. Bahr's writings, alone and with his Papago colleagues (Bahr 1973; Bahr et al. 1974). Dr. Fontana provided fifty-three color photographs showing every step in the process of making a drypainting. These photographs were taken during the construction by four Papago Indians of a drypainting display at the Arizona Sonora Desert Museum. Dr. Fontana also made available supporting notes and a translation of an explanation of the design by the curer who directed the process. Figures 109 and 110 and Plates 31 and 32 were taken from this set of photographs, and Figure 111 (see also Johnson 1960:Pls. 1–3, Fig. A) was kindly provided by the museum.

2. Dr. Bahr knows several other Papagos, however, who know about the drypainting rituals, including a man who conducted a cure for his wife, using a painting he made himself after getting oral instructions from an expert.

3. Besides the specifically Piman "staying sickness," there is a multitude of "nonsicknesses," such as the bites of venomous animals, effects of sorcery, digestive disorders, broken bones, deformities, childhood retardation, and forebodings. In addition, Pima theory allows for "wandering sicknesses," which may affect both Pimas and all other peoples. These include contagious diseases such as chicken pox, measles, whooping cough, colds, and influenza (see Bahr et al. 1974:19–109).

4. Tanner (1948:32), on the other hand, said that Papago drypainting ceremonies are performed in great secrecy in a desert wash away from the village with only the curers and the patient present, not even relatives being allowed to witness the rite. She did not, however, give the source of her information.

5. In an actual performance, described by a ritual curer, preparations for the ceremony began at about noon. The ground was cleaned, the patient's bed was brought out, and chairs were placed for the singers ("in old days the patient would lay on the ground and the singers would sit on the ground; now they would get stiff"). Arrangements were made for the five expected singers to come around three o'clock (sometimes the number of singers is limited to four).

6. A cure for wind sickness without a drypainting consists of singing, blowing on the patient, and whipping his legs with a switch of braided catclaw stems.

7. Dr. Fontana said that the stick used by the curer to demonstrate the process of pounding the sickness out of the patient was the one he had used as a stylus to incise the outlines of the design of the drypainting on the sand background, and not one of the flower effigies.

8. When the second type of design is used, the curer never presses his hands on the two large birds in the center.

CHAPTER THIRTEEN
Southern California Drypainting

1. The northern neighbors of these tribes, the Chumash (known as the Santa Barbara Indians), may also have made drypaintings, but firm evidence for this is lacking.

APPENDIX A
Worldwide Use of Drypainting

1. Tucci (1949:318) also said that a mandala may be thought of as a linear, pictorial scheme of the architectural form, the *stūpa*, a horizontal plan of it as seen from above. The *stūpa*, originally perhaps a burial mound but now a reli-

quary shrine or memorial, is also a symbol of the cosmos, and those who perform circumambulation around it go back from the expanded world to the source of all things, becoming unified with it. Tucci's book, *The Theory and Practice of the Mandala* (1969), translated from the Italian by A. H. Broderick is an excellent presentation of information concerning this art form.

2. Pictures or diagrams of mandalas may be seen in the books by Tucci (1949:passim), Gordon (1952:93), Blofeld (1970:102, 104), and Waddell (1971:144).

3. Pictures of Australian ground drawings and some of the ceremonies associated with them may be seen in Spencer and Gillen (1927:Fig. 49), Spencer (1928:Figs. 291, 307, 308, 336), Basedow (1929:Pl. XXXVII), and Spencer and Gillen (1938:Figs. 29, 297, 298, 299, 300, 306), Strehlow (1947:Pl. 4), and Mountford (1969:108, 109).

APPENDIX B
Sandpainting Tapestries

1. "The earliest example of 'figure-weaving' is believed to be that on a blanket taken from the body of an Indian at the Sand Creek Massacre in Colorado in 1864. This piece contains representations of four small ducks, which are almost obscured by the rest of the pattern. . . . The making of pictorial blankets did not really become important, however, until 1880" (Kent 1961:21). James published an early pictorial blanket (1922:28; 1970:Fig. 146; *Arizona Highways* July 1974:11) that Reichard (1936:153) said was "a fearful and wonderful combination of designs of a railroad scene." Other pictorial blankets may be seen in Reichard (1936:Pl. XVd, e), Mera (1949: 66, 67), Dutton (1961:35), Mullan (1964:31, no. 52), and in *Arizona Highways* (July 1974:30, 31). Kahlenberg and Berlant (1972) illustrate one dating from 1875–85 (no. 60) and one dating from 1880–90 (no. 61).

2. Illustrations of Yei blankets may be seen in Amsden (1934:Pl. 53) ("near Farmington, New Mexico, around 1910"), Mera (1949:68), Dutton (1961:36), Kent (1961:Pl. 15 ["around 1910, Farm-

ington area"]), Mullan (1964:20, 22, 23), Forrest (1970:Pls. 85, 117, 120, 121, 123), James (1970:Figs. 200–202), and in *Arizona Highways* (July 1974:Covers, 11, 24–27, 46).

3. Because of certain characteristics—such as gray backgrounds with many lazy lines, black borders, the use of green instead of blue and orange instead of yellow—some tapestries now in various museums and private collections may be Atlnaba's work or that of weavers in the same family or region. Among these are one showing the *Whirling Logs* (Nightway) in the Southwest Museum, Los Angeles, California, acquired in 1932 (illustrated in Amsden [1934:Pl. 54]); one of *Wind People Dressed in Snakes* (Navajo Windway) exhibited in the Wheelwright Museum, Santa Fe, in 1970 ("made near Lukachukai, Arizona, 1916"); and another of *Whirling Logs* owned by Read Mullan, Phoenix, Arizona (Mullan 1964:no. 58). Two privately owned Shootingway designs and still another *Whirling Logs* in Albuquerque, New Mexico; Tucson, Arizona; and Dallas, Texas, may also be in this category.

4. Lefthanded is the translation of a Navajo word that begins with a phoneme, the glottalized voiceless lateral affricate, which is difficult for us to pronounce and impossible to render accurately in our letters. It is usually anglicized as *Klah*, but perhaps *tl'ah* would be a better transcription. This singer's biography by Newcomb (1964) is entitled *Hosteen Klah*, that is, Mr. Lefthanded.

5. According to Reichard (1944:23), Lefthanded was a transvestite because as a baby he was emasculated in a Ute attack as his parents were returning from Fort Sumner. Although he wore men's clothes in his later years, he may have worn women's clothes in earlier days. Hill said that he dressed sometimes as a woman and sometimes as a man, but because some schoolboys made fun of his woman's dress he finally wore only men's clothes (Hill 1935:273, 279; see Haile 1950b:136–38).

6. Two published items are at variance with the date given by Newcomb. The Coolidges (1930:104, Illustration 106) said that "Hosteen

Tla" made the first sandpainting rug in 1910, but they may have been referring to a Yei rug that he had woven. In Newcomb's book *Navajo Neighbors,* a photograph of the Newcomb exhibit at the Shiprock All-Indian Fair shows two sand-painting tapestries (Newcomb 1966:38). One of these is now owned by Lee M. Copus of Oklahoma City (Plate 30). The date of the fair is given as 1914. In her account of the fairs of 1913 and 1914, however, Mrs. Newcomb said, "The next fall (1914) . . . we both attended the fair with a fine exhibit . . . of Navaho rugs," but she did not mention sandpainting tapestries (Newcomb 1966:27). At present, therefore, there is no reason to question her statements that Lefthanded's first tapestry was woven in 1919 and that it was later that he started his nieces working on them (Newcomb 1964:157, 162).

7. In Newcomb's *Navaho Neighbors* there is a portrait of Irene (Mrs. Jim), and in another picture she is the second woman from the left and the fourth is Gladys (Mrs. Sam) (Newcomb 1966:151, 199). Their younger sister Daisy never wove sandpainting tapestries (according to Mrs. Sam), but she has become well known for her Two Gray Hills type rugs. In fact, Dutton (1961:33) called her "an outstanding weaver of all time." These textiles are woven with natural brown, tan, black, white, and gray wools (Kent 1961:Pls. 21, 22; *Arizona Highways,* July 1974:18–20; Daisy's portrait is in the latter, p. 18). This weaver, known variously as Daisy Tagelchee, Tauglechee, Togelchee, Taugelchee, or Tahgahl-chee (apparently attempts to anglicize the Navajo term meaning red water), uses handspun weft yarn so fine that the thread count is seldom less than 90 to an inch, and her best efforts reach 110 to 120 to an inch. Her textiles bring prices of over a thousand dollars apiece, some up to five thousand.

8. In an article by Newcomb there is a picture of three sandpainting tapestries hung on a line, none of which have been located (Newcomb 1935:22). All are designs from Nightway: *Whirling Logs* with the four plants in the quadrants, *Fringed Mouths* with corn (linear), and First Dancers. A picture of Lefthanded standing beside a large tapestry of the *Storm People* with corn from Hailway is in another article by Newcomb (1936:25) and also in her biography of him (1964:142). This piece also has not been located. Another picture of Lefthanded standing beside a tapestry of the *Whirling Logs,* now in the Mullan collection, is in the Coolidges's book (1930:106). Finally, another unlocated tapestry of the *Whirling Logs* with four corn plants appears with the one owned by Lee Copus in the picture of the Newcomb exhibit at Shiprock in *Navaho Neighbors* (Newcomb 1966:38).

9. In some recollections of Mrs. Newcomb's (1970: personal communication) and in some autobiographical notes by Miss Wheelwright sent to Dr. Dutton, there are two versions of a story of some sandpainting tapestries being stolen from Wheelwright's place at Los Luceros, New Mexico. Moreover, in the archives of the Wheelwright Museum there is a letter dated February 10, 1959, written by Kenneth E. Foster, then director of the museum, to a donor thanking her for a tapestry woven by Lefthanded. This piece is now missing from the collection. It is a pity that the photographs and records of the sandpainting tapestries woven by Lefthanded and his nieces kept by the Newcombs were lost in the fire which destroyed their trading post in 1936 (Newcomb 1964:164).

10. The two that were stolen August 26, 1973, had designs from the Night Chant. One of *First Dancers* woven by Lefthanded and Irene showed fifty-six figures of Ye'i in four rows of fourteen each, the largest number of figures in any sandpainting tapestry. Each row contained six pairs of Male and Female Ye'i with Talking God at one end and Water Sprinkler at the other (see Fig. 29). The museum sells a color postcard of this tapestry. A similar sandpainting with forty-eight figures was published by Tozzer (1909:Pl. III). The other was a design of four quartets of *Black Gods* with a corn plant woven by Lefthanded. The same design with sixteen *Black Gods* is illustrated in Foster (1964b:609); La Farge (1956:130); and Feder (1967:Fig. 18).

11. Illustrations of reproductions of sandpaintings with the same or similar designs as

those in the tapestries may be seen among the pictures in the following publications: *Nightway*—J. Stevenson (1891); Matthews (1902), Curtis (1907, I); Tozzer (1909); Haile (1947a, 1947b); Wheelwright (1949:151); La Farge (1956); Foster (1964b); Feder (1967:Fig. 18); and in Figures 10–12, 17, 25, 40, and Plate 10 in this book; *Hailway*—Wheelwright (1946a); Foster (1964a, 1964b); *Shootingway*—Coolidge and Coolidge (1930); Newcomb (1931); Newcomb and Reichard (1937); Reichard (1939); Douglas and D'Harnoncourt (1941); Leighton and Leighton (1944:68); Schevill (1947:Frontispiece); *MD Medical News Magazine* (1966, 10:184); La Farge, Hodge, and Spinden (1970:Pl. X); Wyman (1970b); and in Figures 21, 27, and Plate 9 in this book; *Mountainway*—Matthews (1887); Brandon (1961:395); Wyman (1971:Fig. 17); *Eagleway*—Wyman (1971:Fig. 21). One of Lefthanded's tapestries now in the Wheelwright Museum with a Shootingway design (*The Skies*) is illustrated in color in La Farge (1956:69), and Read Mullan's *First Dancers* of Nightway is in *Arizona Highways* (July 1974:24).

12. In 1970 the Maxwell Museum of Anthropology, University of New Mexico, exhibited sixteen tapestries, all copied from plates in *Beautyway* (Wyman 1957:Pls. I–XVI, as stated in the brochure for the exhibition). Woven by six women, they were given to the museum by Edwin L. Kennedy of New Jersey, who had commissioned the weaving of designs from the sandpaintings of Beautyway and other chants. Illustrations of two of his textiles appeared in the University of New Mexico *Alumnus,* winter issue 1969–70. Pictures of some of the more successful tapestries of this type may be seen in Dutton (1961:37), Forrest (1970:Pls. 118, 122), Brody (1971:Fig. 22), and *Arizona Highways* (July 1974:4). Other tapestry designs adapted from sandpaintings are also in Forrest (1970:Pls. 86, 87, 119, 124) and *Arizona Highways* (July 1974:36, 37).

APPENDIX C

Reproductions of Drypaintings in Collections

1. All of the paintings in the Hubbell collection are from Male Shootingway except one from Mountain-Shootingway. The ten Coolidge photographs in the Wheelwright Museum include nine Shooting and one Night Chant subject.

2. The Stockholm collection contains six Male Shooting, one Mountain-Shooting, one Beauty, two Night, and five Bead Chant paintings, together with one from Nightway by an unknown artist. Several of the paintings in the various groups of Miguelito's work are duplicates. Three paintings—two from the Shooting Chant (Stockholm and Santa Fe) and one from the Bead Chant (Stockholm)—were published in the Coolidge's book (1930:Frontispiece, p. 222), and another Shooting Chant drypainting (Stockholm) was published by Wyman (1970b:Pl. 12).

3. Of these, twelve Shootingway, one Mountain-Shootingway, and one Beadway painting are of designs also represented in the Hubbell and Stockholm collections.

4. The four designs made with sand are from Female Shootingway. Those on paper are four from Mountain-Shootingway, four from Mountainway, four from Plumeway, and one for the liberation prayer on buckskin (Upward-reachingway).

5. These include one that is probably from Shootingway, two Mountain-Shootingway, one Nightway, two Plumeway, and three Navajo Windway. The Reeve collection also contains a Shootingway painting by Newcomb. These data are from a letter from the curator of the Southwest Museum received in 1947. According to another communication received in 1966, only five paintings made by the two Navajos could be located (one Shootingway, one Mountain-Shootingway, one Plumeway, two Windway).

6. Examples of these are four watercolors painted in a decidedly idiosyncratic style (one Shootingway, two Nightway, one unidentified), together with a Shooting Chant painting by the Navajo artist Harrison Begay, in the Gilcrease Institute, Tulsa, Oklahoma, and three rather crude small watercolors (Beautyway, Nightway, Navajo Windway) in the former Hubbell Trading Post in Winslow, Arizona. These watercolors look as if they had been made by an Indian and may have been collected by Roman Hubbell.

7. A similar table with figures valid for the time it was made is in the monograph on the Huckel collection (Wyman 1971:Table 1). The figures for column B of the Newcomb collection in Table 6 include all identifiable designs irrespective of their nature.

8. Tables of the paintings available for study at the times the books were written are in five publications as follows: *Navajo Windway and Chiricahua Windway* (Wyman 1962:Table 8); *Red Antway* (Wyman 1973:Table 10); *Blessingway* (Wyman 1970a:Table 3); *Shootingway, Shootingway-Evilway, and Mountain-Shootingway* (Wyman 1970b:Table 2); *Mountainway* (Wyman 1975:Table 1). These give the recorders or collectors of the paintings, the singers who made the originals or directed their making, their homes or the locations of recording or collecting, and numbers and references for those published previously. Similar data for *Beautyway* are in the texts of two publications (Wyman 1957:160–63; Wyman and Newcomb 1962:37).

9. This includes copies of one painting in the Huckel collection, forty-three in the Wetherill, nine in the Haile, thirty-six in the Bush, and ten in the Walcott collections. Besides the main collection of paintings, which are on cardboard about twenty-two by twenty-eight inches, thirty-seven exhibition panels eight feet square were made in oil on composition board. Selections from these are shown in the main hall of the museum. In the center there is a replica in sand of the double sandpainting from the Male Shooting Chant.

10. Included among these are copies of twenty paintings in the Wheelwright Museum, three in the Bush and two in the Walcott collections, four copied from Stevenson's (1891) and Matthews's (1902) illustrations of Nightway sandpaintings, and one duplicate.

11. These include four copies of paintings in the Wheelwright Museum (two Blessingway, one Shootingway, one sweat-emetic painting for Shootingway-Evilway), fourteen in the Bush (four Hailway, eight Shootingway, one Mountainway, one Navajo Windway), and one in the Huckel collections (Shootingway). There are also two other small designs for the Night Chant.

References

ABERLE, DAVID F.
1963 "Some Sources of Flexibility in Navajo Social Organization," *Southwestern Journal of Anthropology* 19:1–8.
1966 *The Peyote Religion Among the Navaho*, Viking Fund Publications in Anthropology, no. 42.

ALBERT, ETHEL M.
1956 "The Classification of Values: A Method and Illustration," *American Anthropologist* 58:221–48.

AMSDEN, CHARLES AVERY
1934 *Navaho Weaving* (Santa Ana, Calif.: Fine Arts Press).

ARIZONA HIGHWAYS
1974 *Southwestern Indian Weaving*, vol. 50, no. 7 (July).

ARMER, LAURA ADAMS
1931 "Navaho Sand-paintings," *American Anthropologist* 33:657.

BAHR, DONALD M.
1973 "Psychiatry and Indian Curing," *Indian Progress* 2:1, 4–9.

BAHR, DONALD M., JUAN GREGORIO, DAVID I. LÓPEZ, AND ALBERT ÁLVAREZ
1974 *Piman Shamanism and Staying Sickness (Ká:cim Múmkidag)* (Tucson: University of Arizona Press).

BANERJEA, JITENDRA NATH
1956 *The Development of Hindu Iconography* (Calcutta: Calcutta University Press).

BARTLETT, K.
1932 "Why the Navajos Came to Arizona," *Museum Notes* 5:29–32 (Flagstaff).

BASEDOW, HERBERT
1929 *The Australian Aboriginal* (Adelaide, Australia: F. W. Preece).

BEALS, RALPH L.
1943 *The Aboriginal Culture of the Cáhita Indians*, Ibero-Americana, vol. 19 (Berkeley and Los Angeles: University of California Press).
1945 *The Contemporary Culture of the Cáhita Indians*, Bureau of American Ethnology Bulletin no. 142 (Washington, D.C.).

BELL, SIR CHARLES
1931 *The Religion of Tibet* (Oxford: The Clarendon Press).

BERNDT, RONALD M., AND CATHERINE H. BERNDT
1964 *The World of the First Australians* (London: Angus and Robertson).

BLOFELD, JOHN EATON CALTHORPE
1970 *The Tantric Mysticism of Tibet* (New York: E. P. Dutton).

BOURKE, JOHN G.
1884 *The Snake Dance of the Moquis of Arizona* (London: S. Low, Marston, Searle, and Rivington).
1892 "The Medicine-Men of the Apache," in *Ninth Annual Report of the Bureau of American Ethnology* (Washington, D.C.: Government Printing Office).

BRANDON, WILLIAM
1961 *The American Heritage Book of Indians* (New York: American Heritage Publishing Co.).

BRODY, J. J.
1971 *Indian Painters and White Patrons* (Albuquerque: University of New Mexico Press).

BULLOUGH, EDWARD
1912 "Psychical Distance as a Factor in Art and an Aesthetic Principle," *British Journal of Psychology* 5:87–118.

BUNZEL, RUTH
1932a "Introduction to Zuni Ceremonialism," in *Forty-seventh Annual Report of the Bureau of American Ethnology* (Washington, D.C.: Government Printing Office).

1932b "Zuñi Katcinas: An Analytical Study," in *Forty-seventh Annual Report of the Bureau of American Ethnology* (Washington, D.C.: Government Printing Office).

CHIAO, CHIEN
1971 *Continuation of Tradition in Navajo Society* (Taipei, Taiwan: Institute of Ethnology, Academia Sinica).

CHISHOLM, JAMES STEWART
1974 "The Social Organization of Ceremonial Practitioners at Navajo Mountain, Utah," *Plateau* 47:82–104.

COOLIDGE, DANE C., AND MARY ROBERTS COOLIDGE
1930 *The Navajo Indians* (Boston and New York: Houghton Mifflin Co.).

CUMMINGS, EMMA
1936 "Sand Pictures in the Arizona State Museum at Tucson," *The Kiva* 1:2–4.

CURTIS, EDWARD S.
1907 *The North American Indian*, vol. 1 (Cambridge: The University Press).

CURTIS (BURLIN), NATALIE
1907 *The Indians' Book* (New York: Harper).

DAVID-NEEL, ALEXANDRA
1959 *Initiation and Initiates in Tibet*, trans. Fred Rothwell (New York: University Books).

DE LA HABA, LOUIS, AND JOSEPH SCHERSCHEL
1974 "Guatemala, Maya and Modern," *National Geographic* 146:661–89.

DENSMORE, FRANCES
1918 *Teton Sioux Music*, Bureau of American Ethnology Bulletin no. 61 (Washington, D.C.).

DITTERT, ALFRED E., JR., JAMES J. HESTER, AND FRANK W. EDDY
1961 *An Archaeological Survey of the Navajo Reservoir District, Northwestern New Mexico*, School of American Research Monograph no. 23 (Santa Fe: School of American Research and Museum of New Mexico).

DONALDSON, THOMAS
1893 *Moqui Pueblo Indians of Arizona and Pueblo Indians of New Mexico*, Extra Census Bulletin, 11th Census of the United States (Washington, D.C.).

DORSEY, GEORGE A.
1903 *The Arapaho Sun Dance: The Ceremony of the Offerings Lodge*, Field Columbian Museum Publication 75, Anthropological Series, 4:1–228 (Chicago).

1905a *The Cheyenne, Volume II, The Sun Dance*, Field Columbian Museum Publication 103, Anthropological Series, 9:57–186 (Chicago).

1905b *The Ponca Sun Dance*, Field Columbian Museum Publication 102, Anthropological Series, 7:61–88.

DORSEY, GEORGE A., AND HENRY R. VOTH
1901 *The Oraibi Soyal Ceremony*, Field Columbian Museum Publication 55, Anthropological Series, 3:1–59 (Chicago).

1902 *The Mishongnovi Ceremonies of the Snake and Antelope Fraternities*, Field Columbian Museum Publication 66, Anthropological Series 3:161–261 (Chicago).

DOUGLAS, FREDERIC H., AND RENÉ D'HARNONCOURT
1941 *Indian Art of the United States* (New York: The Museum of Modern Art).

DUBOIS, CONSTANCE GODDARD
1908 *The Religion of the Luiseño Indians of Southern California*, University of California Publications in American Archaeology and Ethnology, vol. 8 (Berkeley).

DUMAREST, FATHER NOËL
1919 *Notes on Cochiti, New Mexico,* trans. and ed. by Elsie Clews Parsons, American Anthropological Association Memoir, vol. 6, no. 3 (Menasha, Wis.).

DUTTON, BERTHA P.
1941 "The Navaho Wind Way Ceremonial," *El Palacio* 48:73–82.
1961 *Navajo Weaving Today* (Santa Fe: Museum of New Mexico Press).
1963 *Sun Father's Way: The Kiva Murals of Kuaua* (Albuquerque: University of New Mexico Press, School of American Research, Museum of New Mexico).

EGGAN, FRED
1950 *Social Organization of the Western Pueblos* (Chicago: University of Chicago Press).

FEDER, NORMAN
1967 *North American Indian Painting* (New York: Museum of Primitive Art).

FEWKES, JESSE WALTER
1894a "The Snake Ceremonials at Walpi," *Journal of American Ethnology and Archaeology* 4:1–126.
1894b "The Walpi Flute Observance," *Journal of American Folklore* 7:265–87.
1895a "A Comparison of Sia and Tusayan Snake Ceremonials," *American Anthropologist* 8:118–41 (old series).
1895b "The Oraibi Flute Altar," *Journal of American Folklore* 8:265–82.
1896a "The Micoñinovi Flute Altars," *Journal of American Folklore* 9:241–56.
1896b "The Tusayan Ritual: A Study of the Influence of Environment on Aboriginal Cults," in *Annual Report, Smithsonian Institution, 1895* (Washington, D.C.).
1897a "Morphology of Tusayan Altars," *American Anthropologist* 10:129–45 (old series).
1897b "Tusayan Snake Ceremonies," in *Sixteenth Annual Report of the Bureau of American Ethnology* (Washington, D.C.: Government Printing Office).
1899 "The Winter Solstice Altars at Hano Pueblo," *American Anthropologist* 1:251–76.

1900 "Tusayan Flute and Snake Ceremonies," in *Nineteenth Annual Report of the Bureau of American Ethnology* (Washington, D.C.: Government Printing Office).
1920 "Sun Worship of the Hopi Indians," in *Annual Report, Smithsonian Institution, 1918* (Washington, D.C.).
1922 "Fire Worship of the Hopi Indians," in *Annual Report, Smithsonian Institution, 1920* (Washington, D.C.).
1924 "The Use of Idols in Hopi Worship," in *Annual Report, Smithsonian Institution, 1922* (Washington, D.C.).
1927 "The Katcina Altars in Hopi Worship," in *Annual Report, Smithsonian Institution, 1926* (Washington, D.C.).

FEWKES, JESSE WALTER, AND J. G. OWENS
1892 "The Là'Là'-Kōn-Ta: A Tusayan Dance," *American Anthropologist* 5:105–29 (old series).

FEWKES, JESSE WALTER, AND A. M. STEPHEN
1892 "The Mam-zraú-ti: A Tusayan Ceremony," *American Anthropologist* 5:217–45 (old series).

FORREST, EARLE R.
1970 *With a Camera in Old Navaholand* (Norman: University of Oklahoma Press).

FOSTER, KENNETH E.
1964a "The Art of Sand Painting Practised by the American Navajo Indians," Supplement to the *Illustrated London News* 244: 608–11.
1964b *Navajo Sandpaintings,* Navajoland Publications, Navajo Tribal Museum, series 3 (Window Rock, Ariz.).

FRANCISCAN FATHERS
1910 *An Ethnologic Dictionary of the Navaho Language* (Saint Michaels, Ariz.: Franciscan Fathers).

GATSCHET, MR.
1885 *Chiricahua Apache Sun Circle Painting,* Smithsonian Miscellaneous Collections, vol. 34 (Washington, D.C.).

GODDARD, PLINEY EARLE
1933 *Navajo Texts,* Anthropological Papers of the American Museum of Natural History, no. 34, pt. 1 (Washington, D.C.).

301

GOLDFRANK, ESTHER SCHIFF
1927 *The Social and Ceremonial Organization of Cochiti*, American Anthropological Association Memoir no. 33 (Menasha, Wis.).

GOODWIN, GRENVILLE
1938 "White Mountain Apache Religion," *American Anthropologist* 40:24–37.

GORDON, ANTOINETTE K.
1952 *Tibetan Religious Art* (New York: Columbia University Press).

HAILE, FATHER BERARD
1938a "Navajo Chantways and Ceremonials," *American Anthropologist* 40:639–52.
1938b *Origin Legend of the Navaho Enemyway,* Yale University Publications in Anthropology, no. 17 (New Haven).
1943 *Origin Legend of the Navaho Flintway,* University of Chicago Publications in Anthropology, Linguistic Series (Chicago).
1947a *Head and Face Masks in Navaho Ceremonialism* (St. Michaels, Ariz.: Saint Michaels Press).
1947b *Starlore Among the Navaho* (Santa Fe: Museum of Navajo Ceremonial Art).
1950a *Legend of the Ghostway Ritual in the Male Branch of Shootingway* (Saint Michaels, Ariz.: Saint Michaels Press).
1950b *A Stem Vocabulary of the Navaho Language, Vol. 1, Navaho-English* (Saint Michaels, Ariz.: Saint Michaels Press).
1978 *Love Magic and Butterfly People,* ed. Karl W. Luckert and Irvy W. Goossen, American Tribal Religions series, vol. 2 (Flagstaff: Museum of Northern Arizona).
1979 *Waterway,* ed. Karl W. Luckert and Irvy W. Goossen, American Tribal Religions series, vol. 5 (Flagstaff: Museum of Northern Arizona).

HALACY, D. S.
1958 "Permanent Art from the Shifting Sands," *Think* 24:24–25.

HALL, E. T., JR.
1951 "Southwestern Dated Ruins, VI," *Tree-Ring Bulletin*, vol. 17, no. 4 (Tucson: University of Arizona).

HAMMOND, GEORGE PETER, AND AGAPITO REY
1953 *Don Juan de Onate, Colonizer of New Mexico, 1592–1628* (Albuquerque: University of New Mexico Press).

HARDY, R. SPENCE
1850 *Eastern Monachism* (London).

HARRINGTON, JOHN P.
1934 *A New Original Version of Boscana's Historical Account of the San Juan Capistrano Indians of Southern California*, Smithsonian Miscellaneous Collections, vol. 92 (Washington, D.C.).

HATCHER, EVELYN PAYNE
1974 *Visual Metaphors: A Formal Analysis of Navajo Art*, American Ethnological Society Monograph no. 58 (Boston, Los Angeles, San Francisco: West Publishing Co.).

HESTER, JAMES J.
1962 *Early Navajo Migrations and Acculturation in the Southwest*, Navajo Project Studies V (Santa Fe: Museum of New Mexico).

HEWETT, EDGAR L., AND WAYNE L. MAUZY
1940 *Landmarks of New Mexico* (Albuquerque: University of New Mexico Press).

HIBBEN, FRANK C.
1955 "Excavation of Pottery Mound, New Mexico," *American Antiquity* 21:179–80.
1960 "Prehistoric Paintings at Pottery Mound," *Archaeology* 13:267–74.
1967 "Mexican Features of Mural Paintings at Pottery Mound," *Archaeology* 20:84–87.

HILL, W. W.
1935 "The Status of the Hermaphrodite and Transvestite in Navajo Culture," *American Anthropologist* 37:273–79.

JAMES, GEORGE WHARTON
1922 "Indian Blankets and Their Makers," *The Mentor* 10:13–28.
1970 *Indian Blankets and Their Makers* (Glorieta, N.M.: Rio Grande Press).

JEANÇON, JEAN ALLARD, AND FREDERIC H. DOUGLAS
1932 *Indian Sand-painting, Tribes, Technics and Uses*, Denver Art Museum, Department of Indian Art, Leaflets 43, 44 (Denver).

JOE, EUGENE BAATSOLANII, MARK BAHTI, AND OSCAR T. BRANSON
1978 *Navajo Sandpainting Art* (Tucson: University of Arizona Press).

JOHNSON, BARBARA
1960 "The Wind Ceremony: A Papago Sand-Painting," *El Palacio* 67:28–31.

KAHLENBERG, MARY HUNT, AND ANTHONY BERLANT
1972 *The Navajo Blanket* (New York: Praeger).

KENT, KATE PECK
1961 *The Story of Navaho Weaving* (Phoenix: Heard Museum).

KEUR, DOROTHY LOUISE
1941 *Big Bead Mesa*, American Anthropological Association Memoir no. 1 (Menasha, Wis.).

KLUCKHOHN, CLYDE
1941 "Notes on Eagle Way," *New Mexico Anthropologist* 5:6–14.

1944 *Navaho Witchcraft*, Papers of the Peabody Museum of American Archaeology and Ethnology, vol. 22, no. 2 (Cambridge, Mass.).

1966 "Expressive Activities," in *People of Rimrock: A Study of Values in Five Cultures*, ed. Evon Z. Vogt and Ethel M. Albert (Cambridge, Mass.: Harvard University Press).

KLUCKHOHN, CLYDE, AND DOROTHEA LEIGHTON
1962 *The Navajo*, 1st ed. 1946 (Garden City, New York: Doubleday).

KLUCKHOHN, CLYDE, AND LELAND C. WYMAN
1940 *An Introduction to Navaho Chant Practice, with an Account of the Behaviors Observed in Four Chants*, American Anthropological Association Memoir no. 53 (Menasha, Wis.).

KOEHN, ALFRED
1937 *Japanese Tray Landscapes* (Peiping, China: Lotus Court Publication).

KRAMRISCH, STELLA
1928 *The Vishnudharmottaram (Part III, A Treatise on Indian Painting)* (Calcutta: Calcutta University Press).

KROEBER, ALFRED L.
1908 "A Southern California Ceremony," *Journal of American Folklore* 21:41.

1925 *Handbook of the Indians of California*, Bureau of American Ethnology Bulletin no. 78 (Washington, D.C.: Government Printing Office).

LA FARGE, OLIVER
1956 *A Pictorial History of the American Indian* (New York: Crown Publishers).

LA FARGE, OLIVER, F. W. HODGE, AND H. J. SPINDEN (EDS.)
1970 *Introduction to American Indian Art* (Glorieta, N.M.: Rio Grande Press).

LANGE, CHARLES H.
1959 *Cochiti: A New Mexico Pueblo, Past and Present* (Austin: University of Texas Press).

LEIGHTON, ALEXANDER H., AND DOROTHEA LEIGHTON
1944 *The Navaho Door* (Cambridge, Mass.: Harvard University Press).

LEVINE, MORTON H.
1957 "Prehistoric Art and Ideology," *American Anthropologist* 59:949–64.

LEVY, JERROLD E.
1972 "Indian Healing Arts," in *Look to the Mountain Top*, ed. Charles Jones (San Jose, Calif.: Gousha Publications).

LI AN-CHE
1950 "Tibetan Religion," in *Forgotten Religions*, ed. Vergilius Ferm (New York: Philosophical Library).

LIEBLER, H. BAXTER
1969 *Boil My Heart for Me* (Jericho, N.Y.: Exposition Press).

LUCKERT, KARL W.
1978 *A Navajo Bringing-Home Ceremony*, American Tribal Religions series, vol. 3 (Flagstaff: Museum of Northern Arizona).

1979 *Coyoteway, a Navajo Holyway Healing Ceremonial* (Tucson and Flagstaff: University of Arizona Press and Museum of Northern Arizona Press).

MALLERY, GARRICK
1885 *Yuman Sand-painting*, Smithsonian Mis-

cellaneous Collections, vol. 34 (Washington, D.C.).

1893 "Picture-writing of the American Indians," in *Tenth Annual Report of the Bureau of American Ethnology* (Washington, D.C.: Government Printing Office).

MATTHEWS, WASHINGTON

1884 "Mythic Dry-Paintings of the Navajos," *American Naturalist* 19:931–39.

1887 "The Mountain Chant: A Navaho Ceremony," in *Fifth Annual Report of the Bureau of American Ethnology* (Washington, D.C.: Government Printing Office).

1897 *Navaho Legends*, Memoirs of the American Folklore Society, vol. 5 (Boston: Houghton Mifflin).

1902 *The Night Chant, a Navaho Ceremony*, Memoirs of the American Museum of Natural History, vol. 6 (New York: Knickerbocker Press).

McALLESTER, DAVID P., AND
SUSAN McALLESTER

1980 *Hogans: Navajo Houses and House Songs* (Middletown, Conn.: Wesleyan University Press).

McCOMBE, LEONARD, EVON Z. VOGT, AND
CLYDE KLUCKHOHN

1951 *Navaho Means People* (Cambridge, Mass.: Harvard University Press).

MD MEDICAL NEWS MAGAZINE

1966 "Symbols and Medicine," 10:184.

MEMORIAS PARA LA HISTORIA DE SINALOA

1500s Manuscript collection (University of California, Bancroft Library, Berkeley).

MERA, H. P.

1949 *The Alfred I. Barton Collection of Southwestern Textiles* (Santa Fe: San Vicente Foundation).

MILLS, GEORGE T.

1959 *Navaho Art and Culture* (Colorado Springs: Taylor Museum).

MOOKERJEE, AJITCOOMER

1939 *Folk Art of Bengal* (Calcutta: Oxford Book and Stationery Co.).

MOUNTFORD, CHARLES P.

1969 *The Aborigines and Their Country* (Adelaide, Australia: Rigby, Ltd.).

MULLAN, READ

1964 *Read Mullan Gallery of Western Art* (Phoenix).

NEWCOMB, FRANC JOHNSON

1931 "Description of the Symbolism of a Sand-Painting of the Sun," in *Introduction to American Indian Art*, eds. O. La Farge, F. W. Hodge, and H. J. Spinden (New York: Crown Publishers).

1935 "Mystic Medicine," *New Mexico Magazine* 13:22, 41.

1936 "Symbols in Sand," *New Mexico Magazine* 14:24–25, 37, 38.

1940 *Navajo Omens and Taboos* (Santa Fe: Rydal Press).

1964 *Hosteen Klah* (Norman: University of Oklahoma Press).

1966 *Navaho Neighbors* (Norman: University of Oklahoma Press).

NEWCOMB, FRANC JOHNSON, STANLEY
FISHLER, AND MARY C. WHEELWRIGHT

1956 *A Study of Navajo Symbolism*, Papers of the Peabody Museum of Archaeology and Ethnology, vol. 32, no. 3 (Cambridge, Mass.).

NEWCOMB, FRANC JOHNSON, AND
GLADYS A. REICHARD

1937 *Sandpaintings of the Navajo Shooting Chant* (New York: J. J. Augustin).

OAKES, MAUD, JOSEPH CAMPBELL, AND
JEFF KING

1969 *Where the Two Came to Their Father*, Bollingen Series 1 (Princeton, N.J.: Princeton University Press).

OLIN, CAROLINE BOWER

1972 *Navajo Indian Sandpainting, the Construction of Symbols* (Stockholm, Sweden: Tre Ringer A).

1979 "Fringed Mouth, Navajo Ye'ii," in *Collected Papers in Honor of Bertha Pauline Dutton*, Papers of the Archaeological Society of New Mexico, vol. 4 (Santa Fe).

OPLER, MORRIS EDWARD

1941 *An Apache Life-Way* (Chicago: University of Chicago Press).

1943 *The Character and Derivation of the Jicarilla*

Holiness Rite, University of New Mexico Bulletin no. 390 (Albuquerque).

1944 "The Jicarilla Apache Ceremonial Relay Race," *American Anthropologist* 46:75–97.

1946 *Childhood and Youth in Jicarilla Apache Society* (Los Angeles: The Southwest Museum).

PAREZO, NANCY
1980 "Navajo Sandpaintings on Boards," *Discovery 1980* (Santa Fe: School of American Research).

PARSONS, ELSIE CLEWS
1924 *The Scalp Ceremonial of Zuni*, American Anthropological Association Memoir no. 31 (Menasha, Wis.).

1925 *The Pueblo of Jemez* (New Haven: Yale University Press).

1929 *The Social Organization of the Tewa of New Mexico*, American Anthropological Association Memoir no. 36 (Menasha, Wis.).

1932 "Isleta, New Mexico," *Forty-seventh Annual Report of the Bureau of American Ethnology* (Washington, D.C.: Government Printing Office).

1936 *Taos Pueblo*, American Anthropological Association, General Series in Anthropology no. 2 (Menasha, Wis.).

1939 *Pueblo Indian Religion*, 2 vols. (Chicago: University of Chicago Press).

1962 *Isleta Paintings*, Bureau of American Ethnology Bulletin no. 181 (Washington, D.C.: Government Printing Office).

PÉREZ DE RIBAS, ANDRES
1645 *Historia de los triunfos de nuestra Santa Fe, en las misiones de la Provincia de Nueva España* (Madrid, Spain).

RAY, SUDHANSU KUMAR
1938 "The Characteristic Features of Alpana," *Journal of Arts and Crafts, Calcutta* 1:6–8.

REAGAN, ALBERT B.
1914 *Don Diego* (New York: A. Harriman Co.).

1930 *Notes on the Indians of the Fort Apache Region*, Anthropological Papers of the American Museum of Natural History 31:279–345.

REEVE, FRANK D.
1956 "Early Navajo Geography," *New Mexico Historical Review*, vol. 31.

REICHARD, GLADYS A.
1934 *Spider Woman* (New York: MacMillan).

1936 *Navajo Shepherd and Weaver* (New York: J. J. Augustin).

1939 *Navajo Medicine Man* (New York: J. J. Augustin).

1944 "Individualism and Mythological Style," *Journal of American Folklore* 57:16–25.

1970 *Navaho Religion: A Study of Symbolism*, Bollingen Series 18 (Princeton, N.J.: Princeton University Press).

ROBINSON, WILLIAM J., BRUCE G. HARRILL, AND RICHARD L. WARREN
1974 *Tree-Ring Dates from New Mexico. B. Chaco-Gobernador Area* (Tucson: The University of Arizona, Laboratory of Tree-Ring Research).

RUSSELL, FRANK
1898 "An Apache Medicine Dance," *American Anthropologist* 11:367–72 (old series).

SANDNER, DONALD
1979 *Navajo Symbols of Healing* (New York: Harcourt Brace Jovanovich).

SAPIR, EDWARD
1935 "A Navaho Sand Painting Blanket," *American Anthropologist* 37:609–16.

SAPIR, EDWARD, AND HARRY HOIJER
1942 *Navaho Texts* (Iowa City: University of Iowa).

SCHAAFSMA, CURTIS F.
1975 *Archaeological Survey and Excavations at Abiquiu Reservoir, Rio Arriba County, New Mexico* (Santa Fe: School of American Research, Contract Archaeology Program).

SCHAAFSMA, POLLY
1962 "Rock Art of the Navajo Reservoir," *El Palacio*, 69:193–212.

1963 *Rock Art in the Navajo Reservoir District*, Museum of New Mexico Papers in Anthropology, no. 7 (Santa Fe).

1965 *Southwest Indian Pictographs and Petroglyphs*, Museum of New Mexico Popular Series Handbook, no. 8 (Santa Fe).

1966 *Early Navajo Rock Paintings and Carvings* (Santa Fe: Museum of Navaho Ceremonial Art).

1980 *Indian Rock Art of the Southwest*, Southwest Indian Arts Series (Albuquerque: University of New Mexico Press, School of American Research).

SCHEVILL, MARGARET ERWIN

1947 *Beautiful on the Earth* (Santa Fe: Hazel Dreis Editions).

SCOFIELD, JOHN

1960 "Easter Week in Indian Guatemala," *National Geographic* 117:406–17.

SHEPARDSON, MARY, AND
BLODWEN HAMMOND

1964 "Change and Persistence in an Isolated Navajo Community," *American Anthropologist* 66:1029–50.

SINCLAIR, JOHN L.

1951 "The Pueblo of Kuaua," *El Palacio* 58:206–14.

SMILEY, TERAH L.

1951 "A Summary of Tree-Ring Dates from Some Southwestern Archaeological Sites," *University of Arizona Bulletin*, vol. 22; *Laboratory of Tree-Ring Research Bulletin*, no. 5 (Tucson).

SMITH, WATSON

1952 *Kiva Mural Decorations at Awatovi and Kawaika-a*, Papers of the Peabody Museum of Archaeology and Ethnology, vol. 37 (Cambridge, Mass.).

SNELLGROVE, DAVID

1957 *Buddhist Himalaya: Travels and Studies in Quest of the Origins and Nature of Tibetan Religion* (Oxford: Cassirer).

SPARKMAN, PHILIP STEDMAN

1908 *The Culture of the Luiseño Indians*, University of California Publications in American Archaeology and Ethnology, vol. 8 (Berkeley).

SPENCER, BALDWIN

1928 *Wanderings in Wild Australia*, 2 vols. (London: Macmillan and Co.).

SPENCER, BALDWIN, AND F. J. GILLEN

1927 *The Arunta*, 2 vols. (London: Macmillan and Co.).

1938 *The Native Tribes of Central Australia*, 1st ed. 1899 (London: Macmillan and Co.).

SPENCER, KATHERINE

1957 *Mythology and Values: An Analysis of Navaho Chantway Myths*, Memoirs of the American Folklore Society, vol. 48 (Ann Arbor).

STEPHEN, ALEXANDER M.

1936 *Hopi Journal*, ed. Elsie Clews Parsons, Columbia University Contributions to Anthropology, vol. 23, 2 pts. (New York).

STEVENSON, JAMES

1891 "Ceremonial of Hasjelti Dailjis," in *Eighth Annual Report of the Bureau of American Ethnology* (Washington, D.C.: Government Printing Office).

STEVENSON, MATILDA COXE

1887 "The Religious Life of the Zuñi Child," in *Fifth Annual Report of the Bureau of American Ethnology* (Washington, D.C.: Government Printing Office).

1894 "The Sia," in *Eleventh Annual Report of the Bureau of American Ethnology* (Washington, D.C.: Government Printing Office).

1904 "The Zuñi Indians," in *Twenty-third Annual Report of the Bureau of American Ethnology* (Washington, D.C.: Government Printing Office).

STIRLING, MATTHEW W.

1942 *Origin Myth of Acoma and Other Records*, Bureau of American Ethnology Bulletin no. 135 (Washington, D.C.: Government Printing Office).

STREHLOW, T. G. H.

1947 *Aranda Traditions* (Melbourne, Australia: Melbourne University Press).

STRONG, WILLIAM DUNCAN

1929 *Aboriginal Society in Southern California*, University of California Publications in American Archaeology and Ethnology, vol. 26 (Berkeley).

TAGORE, ABANINDRANATH

1921 *L'Alpona ou les décorations rituelles au Bengale*, translated from the Bengali edition, *Banglar Brata*, by d'Andrée Karpelès and Tapapanmohan Chatterji (Paris: Editione Bossard).

TANNER, CLARA LEE

1948 "Sandpaintings of the Indians of the Southwest," *The Kiva* 13:26–36.

1957 *Southwest Indian Painting* (Tucson: University of Arizona Press).

TEDLOCK, DENNIS

1979 "Zuni Religion and World View," in *Handbook of North American Indians*, vol. 9, *Southwest*, ed. Alfonso Ortiz (Washington, D.C.: Smithsonian Institution).

TOZZER, ALFRED M.

1909 "Notes on Religious Ceremonies of the Navaho," in *Putnam Anniversary Volume, Anthropological Essays Presented to Frederick Ward Putnam in Honor of His Seventieth Birthday, April 16, 1909* (New York: G. E. Stechert).

TUCCI, GIUSEPPE

1949 *Tibetan Painted Scrolls*, vol. 1 (Rome: La Libraria della Stato).

1956 *To Lhasa and Beyond* (Rome: Instituto Poligrafico dello Stato).

1969 *The Theory and Practice of the Mandala*, trans. Alan Houghton Broderick (London: Rider and Co.).

UNDERHILL, RUTH M.

1948 *Ceremonial Patterns in the Greater Southwest*, Monographs of the American Ethnological Society, vol. 13 (Seattle: University of Washington Press).

1956 *The Navajos* (Norman: University of Oklahoma Press).

VAN VALKENBURGH, RICHARD F.

1941 *Diné bikéyah* (Window Rock, Ariz.: U.S. Department of the Interior, Office of Indian Affairs, Navajo Service).

VON FÜRER-HAIMENDORF, CHRISTOPH

1964 *The Sherpas of Nepal* (Berkeley and Los Angeles: University of California Press).

VOTH, H. R.

1901 *The Oraibi Powamu Ceremony*, Field Columbian Museum Publication 61, Anthropological Series, vol. 3 (Chicago).

1903a *The Oraibi Summer Snake Ceremony*, Field Columbian Museum Publication 83, Anthropological Series, vol. 3 (Chicago).

1903b *The Oraibi Oá cöl Ceremony*, Field Columbian Museum Publication 84, Anthropological Series, vol. 6 (Chicago).

1912 *The Oraibi Marau Ceremony*, Field Museum of Natural History Publication 156, Anthropological Series, vol. 11 (Chicago).

WADDELL, LAURENCE AUSTINE

1971 *The Buddhism of Tibet or Lamaism*, 1st ed. 1895 (Cambridge, England: Heffer and Sons).

WATERMAN, T. T.

1910 *The Religious Practices of the Diegueño Indians*, University of California Publications in American Archaeology and Ethnology, vol. 8 (Berkeley).

WHEELWRIGHT, MARY C.

1942 *Navajo Creation Myth* (Santa Fe: Rydal Press).

1946a *Hail Chant and Water Chant* (Santa Fe: Museum of Navaho Ceremonial Art).

1946b *Wind Chant and Feather Chant*, Museum of Navaho Ceremonial Art, Bulletin no. 4 (Santa Fe).

1949 *Emergence Myth* (Santa Fe: Museum of Navaho Ceremonial Art).

1956 *The Great Star Chant*, Navajo Religion Series, vol. 4 (Santa Fe: Museum of Navaho Ceremonial Art).

WHITE, LESLIE A.

1932 "The Acoma Indians," in *Forty-seventh Annual Report of the Bureau of American Ethnology* (Washington, D.C.: Government Printing Office).

1935 *The Pueblo of Santo Domingo, New Mexico*, American Anthropological Association Memoir no. 43 (Menasha, Wis.).

1942 *The Pueblo of Santa Ana, New Mexico*, American Anthropological Association Memoir no. 60 (Menasha, Wis.).

1962 *The Pueblo of Sia, New Mexico*, Bureau of American Ethnology, Bulletin no. 184 (Washington, D.C.: Government Printing Office).

WILDER, MITCHELL A.

1966 *Quiet Triumph* (Fort Worth, Tex. and Santa Fe, N.M.: Amon Carter Museum).

WISSLER, CLARK

1912 *Ceremonial Bundles of the Blackfoot Indians*,

Anthropological Papers of the American Museum of Natural History, no. 7 (New York).

WYMAN, LELAND C.

1950 "The Religion of the Navajo Indians," in *Forgotten Religions,* ed. Vergilius Ferm (New York: Philosophical Library).

1951 "Notes on Obsolete Navaho Ceremonies," *Plateau* 23:44–48.

1952 *The Sandpaintings of the Kayenta Navaho,* University of New Mexico Publications in Anthropology, no. 7 (Albuquerque).

1957 *Beautyway: A Navaho Ceremonial,* (with myths recorded by Father Berard Haile and Maud Oakes), Bollingen Series 53 (New York: Pantheon Books).

1959 *Navaho Indian Painting: Symbolism, Artistry, and Psychology* (Boston: Boston University Press).

1962 *The Windways of the Navaho* (Colorado Springs: Taylor Museum).

1966 "Snakeskins and Hoops," *Plateau* 39:4–25.

1967 "Big Lefthanded, Pioneer Navajo Artist," *Plateau* 40:1–13.

1970a *Blessingway* (Tucson: University of Arizona Press).

1970b *Sandpaintings of the Navaho Shootingway and the Walcott Collection,* Smithsonian Contributions to Anthropology, no. 13 (Washington, D.C.).

1971 *Navajo Sandpaintings: The Huckel Collection* (Colorado Springs: Taylor Museum).

1972a "Navajo Ceremonial Equipment in the Museum of Northern Arizona," *Plateau* 45:17–30.

1972b "A Navajo Medicine Bundle for Shootingway," *Plateau* 44:131–49.

1972c "Ten Sandpaintings from Male Shootingway," *Plateau* 45:55–67.

1973 *The Red Antway of the Navaho,* Navajo Religion Series, vol. 5 (Santa Fe: Museum of Navaho Ceremonial Art).

1975 *The Mountainway of the Navaho* (Tucson: University of Arizona Press).

WYMAN, LELAND C., AND FLORA L. BAILEY

1943 *Navaho Upward-Reaching Way: Objective Behavior, Rationale and Sanction,* University of New Mexico Bulletin no. 389 (Albuquerque).

1945 "Idea and Action Patterns in Navaho Flintway," *Southwestern Journal of Anthropology* 1:356–77.

1946 "Navaho Striped Windway, an Injuryway Chant," *Southwestern Journal of Anthropology* 2: 213–38.

1964 *Navaho Indian Ethnoentomology,* University of New Mexico Publications in Anthropology, no. 12 (Albuquerque).

WYMAN, LELAND C., W. W. HILL, AND IVA ÓSANAI

1942 *Navajo Eschetology,* University of New Mexico Bulletin no. 377 (Albuquerque).

WYMAN, LELAND C., AND CLYDE KLUCKHOHN

1938 *Navaho Classification of Their Song Ceremonials,* American Anthropological Association Memoir no. 50 (Menasha, Wis.).

WYMAN, LELAND C., AND FRANC J. NEWCOMB

1962 "Sandpaintings of Beautyway," *Plateau* 35:37–52.

1963 "Drypaintings Used in Divination by the Navajo," *Plateau* 36:18–24.

YANAGISAWA, SŌEN

1955 *Tray Landscapes (Bonkei and Bonseki)* (Tokyo: Yanagisawa Japan Travel Bureau).

Supplementary Bibliography

This list contains references to articles and books with discussions or illustrations of Navajo Indian drypaintings that were not cited in the text. The list is doubtless not complete, but it probably does contain most additional important sources. They vary from short paragraphs and one or two illustrations to more substantial accounts and from decidedly popular presentations to more scholarly ones.

ALEXANDER, C. I.
1971 *An Introduction to Navaho Sandpaintings,* 1st ed. 1967 (Santa Fe: Museum of Navaho Ceremonial Art).

ANONYMOUS
1923 "Navajo Sand Paintings as Decorative Motive," *El Palacio* 14:175–83.
1935 "Navaho Sandpaintings," *El Palacio* 38:72–73.
1936 "Sand Paintings of the Navajo," *Indians at Work,* U.S. Department of the Interior, Office of Indian Affairs 3:25–26.
1948 "Good Medicine," *Time* 55:71 (Feb. 23).
1951 "Magic in Sand," *Time* 58:81.
1968 *Navajo Centennial, a Century of Progress, Welcome to the Land of the Navajo* (Window Rock, Ariz.: The Navajo Nation).

ARMER, LAURA ADAMS
1925 "A Navajo Sand Painting," *University of California Chronicle* 37:233–39.

1929 "The Navajo Sand-Painters at Work," (as told to H. H. Dunn), *Travel* 53:25–27.
1931 "Sand-Painting of the Navaho Indians," *Introduction to American Indian Art,* pt. 2, pp. 5–7 (The Exposition of Indian Tribal Arts, Inc.).
1950 "Two Navaho Sand-paintings, with Certain Comparisons," *The Masterkey* 24:79–83.
1953 "The Crawler, Navaho Healer," *The Masterkey* 27:5–10.

BATEMAN, WALTER L.
1970 *The Navajo of the Painted Desert* (Boston: Beacon Press).

BERRY, ROSE V. S.
1929a "The Navajo Shaman and His Sacred Sand-Paintings," *Art and Archaeology* 27:3–16 (reprinted in *El Palacio* 26:23–38).
1929b "Red Indian Sand-Paintings," *Discovery* 10:120–24.

BOYD, PHYLLIS J.
1953 "Sand-Painting Doctor," *Family Circle* 43:84–89.

BUDLONG, BETTY
1935 "Navajo Sand Painting at Canyon de Chelly," *Southwestern Monuments Monthly Report,* August 1936, pp. 133–36.

CAMPBELL, ISABEL
1940 "Navajo Sandpaintings," *Southwest Review* 25:143–50.

CHAPMAN, ARTHUR
1921 "The Sand Painters of the American Desert," *Travel* 36:15–17.

CLARK, ANNA NOLAN
1940 "Medicine Man's Art," *New Mexico Magazine* 18(5): 20, 35–37.

CORRELL, J LEE
1968 *Historical Calendar of the Navajo People* (Window Rock, Ariz.: The Navajo Nation).

COVARRUBIAS, MIGUEL
1954 *The Eagle, the Jaguar and the Serpent: Indian Art of the Americas* (New York: Alfred A. Knopf).

CUMMINGS, BYRON
1936 "Navajo Sand Paintings," *The Kiva* 1(7):1–2.

DOCKSTADER, FREDERICK J.
1961 *Indian Art in America* (Greenwich, Conn.: New York Graphic Society).

DUNCAN, EMMET
1925 "Navajo Indians: The Best Sand Painters in the World," *Boston Evening Transcript* Nov. 21, pt. 5:3.

FOSTER, KENNETH E.
1963 "Navajo Sand Paintings," *Man* 45:43–44.

GILPIN, LAURA
1968 *The Enduring Navaho* (Austin: University of Texas Press).

HAILE, FATHER BERARD
1947 *Prayer Stick Cutting in a Five Night Navaho Ceremonial of the Male Branch of Shootingway* (Chicago: University of Chicago Press).

HALL, MANLY P.
1929 "The Sand Magic of the Navaho," *Overland Monthly* 87:137, 154, 160.

HENDERSON, ROSE
1928 "Indian Sand Paintings Decorate a New Hotel," *Southern Workman* 57:267–71.

HILL, WILLARD W.
1936 "Navaho Rites for Dispelling Insanity and Delirium," *El Palacio* 41:71–74.

JUNG, CARL G.
1969 *Man and His Symbols,* 1st ed. 1964 (Garden City, N.Y.: Doubleday).

KIRK, RUTH FALKENBURG
1936 "Grandfather of the Gods," *New Mexico Magazine* 14:28–29, 43–45.

KLUCKHOHN, CLYDE, AND KATHERINE SPENCER
1940 *A Bibliography of the Navaho Indians* (New York: J. J. Augustin).

KOENIG, SEYMOUR H.
1972 *Sky, Sand and Spirits: Navajo and Pueblo Indian Art and Culture* (Yonkers, N.Y.: Hudson River Museum).

LINK, MARGARET SCHEVILL
1956 *The Pollen Path* (Stanford, Calif.: Stanford University Press).

LINK, MARTIN A., ED.
1968 *Navajo: A Century of Progress* (Window Rock, Ariz.: The Navajo Nation).

MATTHEWS, WASHINGTON
1888 *Mythological Dry-Painting of the Navajos,* Smithsonian Miscellaneous Collections, vol. 33 (Washington, D.C.).

McCOMBE, LEONARD
1948 "The Navajos," *Life Magazine* 24:75–83.

NEWCOMB, FRANC JOHNSON
1936 "Navajo Symbols of the Sun," *New Mexico Quarterly* 6:305–7.
1949 " 'Fire Lore' in Navajo Legend and Ceremony," *New Mexico Folklore Record* 3:3–9.

O'BRYAN, AILEEN
1956 *The Diné: Origin Myths of the Navaho Indians,* Bureau of American Ethnology Bulletin no. 163 (Washington, D.C.).

OLIN, CAROLINE B., AND SALLY HADLOCK
1980 "Recording the Roots of Navajo Culture," *Exxon USA* XIX 2:26–31.

OVERHOLT, MARY E.
1933 "Pictures in Sand," *Art and Archaeology* 34:262–66.

PALMER, ROSE
1929 *The North American Indians,* Smithsonian Scientific Series no. 4, Pl. 15 (Washington, D.C.).

PEPPER, GEORGE H.
1905 "An Unusual Navajo Medicine Ceremony," *Southern Workman* 34:1–10.

REAGAN, ALBERT B.
1934 "A Navaho Fire Dance," *American Anthropologist* 36:434–37.
REHNSTRAND, JANE
1936 "Young Indians Revive Their Native Arts," *School Arts* 36:137–44.
REICHARD, GLADYS A.
1939 *Dezba, Woman of the Desert* (New York: J. J. Augustin).
1944 *The Story of the Navajo Hail Chant* (New York: Author).
REYNOLDS, DOROTHY
1936 "Navajo Sand Paintings," *School Arts* 36:153–57.
SCHEVILL, MARGARET E.
1943 *In the Garden of the Home God* (Santa Fe: Hazel Dreis Editions).
1945 "The Navajo Screen," *The Kiva* 11:3–5.
SHIYA, THOMAS S., ED.
1949 *Navaho Saga* (Saint Michaels, Ariz.: Saint Michaels Press).
SLOAN, JOHN, AND OLIVER LA FARGE
1931 *Introduction to American Indian Art* (New York: Exposition of Indian Tribal Arts, Inc.).
STIRLING, MATTHEW W., ED.
1955 *Indians of the Americas* (Washington, D.C.: National Geographic Society).

TOZZER, ALFRED M.
1905 "A Navajo Sand Picture of the Rain Gods and Its Attendant Ceremony," *Proceedings of the International Congress of Americanists*, 13th Session, New York, 1902, pp. 147–56.
TSCHOPIK, HARRY, JR.
1952 *Indians of North America* (New York).
UNDERHILL, RUTH M.
1965 *Red Man's Religion: Beliefs and Practices of the Indians North of Mexico* (Chicago: University of Chicago Press).
VILLASENOR, DAVID
1963 *Tapestries in Sand* (Healdsburg, Calif.: Naturegraph Co.) [unreliable; many errors].
WATKINS, FRANCES E.
1943 *The Navaho*, Southwest Museum Leaflets, no. 16 (Los Angeles).
WYMAN, LELAND C.
In "Navajo Religion: Ceremonial System,"
Press *Handbook of North American Indians*, vol. 10 (Washington, D.C.: Smithsonian Institution).
WYMAN, LELAND C., AND HARRISON BEGAY
1967 *The Sacred Mountains of the Navajo* (Flagstaff: Museum of Northern Arizona).

Index

313